Eliot offers . . . shrewd analysis.

—PEOPLE

"The author can spin a yarn."

—USA TODAY

"Has a tell-all quality, disclosing titillating tidbits about the star's persona . . .

—ERTISER

AMERICAN TITAN

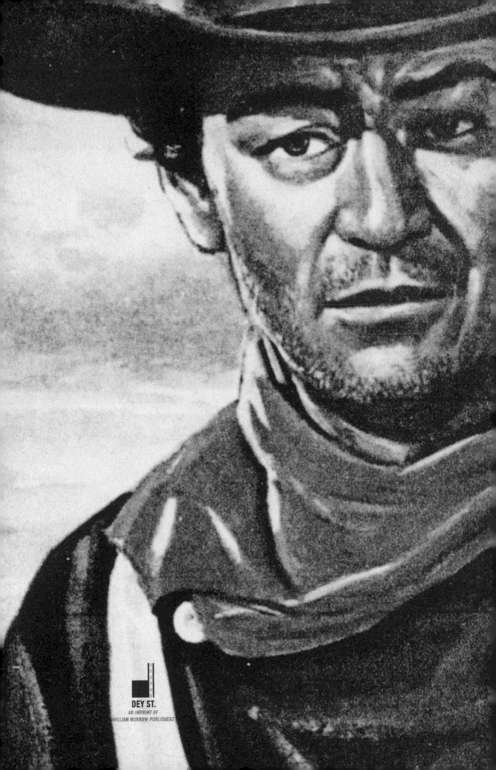

DEY ST.
AN IMPRINT OF
WILLIAM MORROW PUBLISHERS

AMERICAN TITAN

TITAN

Searching for John Wayne

MARC ELIOT

DEY ST.

AMERICAN TITAN: SEARCHING FOR JOHN WAYNE. Copyright © 2014 by Rebel Road Inc. All rights reserved. Printed in the United States of America. No part of this book may be used or reproduced in any manner whatsoever without written permission except in the case of brief embodied in critical articles and reviews. For information address HarperCollins Publishers, 195 Broadway, New York, NY 10007.

HarperCollins books may be purchased for educational, business, or sales promotional use. For information please e-mail the Special Markets Department at SPsales@ harpercollins.com.

A hardcover edition of this book was published in 2014 by Dey Street Books, an imprint of William Morrow Publishers.

FIRST DEY STREET BOOKS PAPERBACK EDITION PUBLISHED 2015.

Designed by Shannon Plunkett

Library of Congress Cataloging-in-Publication Data has been applied for.

ISBN 978-0-06-226902-7

15 16 17 18 19 OV/RRD 10 9 8 7 6 5 4 3 2 1

For bcb

CONTENTS

It's just like I always said, that John Wayne, an actor, was more important to the mass psyche than any single American president. His longevity, his penetration—all of that ultimately has affected how human beings behave, what choices they make, who they think they are, more than any straight pragmatic political action and groupthink.

—Jack Nicholson, *Vanity Fair,* August 1986

Prologue

**"If I'd known that, I would have put that eye patch
on forty years ago."**

—John Wayne

On April 7, 1970, the night of the forty-second presentation of the Academy Awards, Hollywood's annual celebration of industrial-strength narcissism, film's elite gathered at the Dorothy Chandler Pavilion in downtown Los Angeles to honor the pictures, actors, directors, cinematographers, screenwriters, and other skilled artists and technicians that were chosen by the Academy's voting members as the "best" of the previous year.

John Wayne, nominated for his performance in Henry Hathaway's *True Grit*, faced strong competition: Richard Burton in Charles Jarrott's *Anne of the Thousand Days*, a star vehicle for the hugely popular Burton and the odds-on favorite in Vegas; Dustin Hoffman for his scarily brilliant work in John Schlesinger's blistering *Midnight Cowboy;* Jon Voight in the same film for his poignant depiction of innocence corrupted; and the magnificent Peter O'Toole sorrowfully wasted in the cringe-worthy, no-chance musical version of *Goodbye Mr. Chips,* directed by Herbert Ross.

Three significant events took place that evening. The first was the official acceptance of late-bloomer Jack Nicholson into the Hollywood mainstream,

who would go on to dominate it for the rest of the twentieth century and into the first decade of the twenty-first. He was nominated in the category of Best Performance by an Actor in a Supporting Role, for his portrayal of the sympathetic, charming, and exceedingly vulnerable Hanson, a relatively small role that not only yielded an utterly unforgettable performance but signaled a cultural shift in American movies' image of who and what a hero was.

The second was the awarding of a noncompetition, honorary Academy Award to Cary Grant, one of the giants of the industry's golden age. Grant's film career began in 1932 and lasted until 1966, when, still at the top of his game, he wisely chose to retire from the industry and go out on top. Now, four years later, he was finally being recognized for his remarkable accomplishment in helping to establish the iconic image of the romantic Hollywood leading man. It was hard to believe that Grant, who had appeared in so many films for some of Hollywood's greatest directors (some greater than others, but most arguably made their best films with him), among them Alfred Hitchcock, George Cukor, Howard Hawks, Frank Capra, Leo McCarey, Stanley Donen, and Michael Curtiz, had never been officially acknowledged by his peers with a competitive Oscar. He was considered a troublemaker by the major studios because of his insistence on going freelance in an age of contract players, the first to do so and the first to pay for his freedom by being refused a real Oscar, was reduced to tears when, late in life, he finally received his honorary statuette.

The third, and perhaps most fascinating, was the competitive Best Performance by an Actor Oscar that John Wayne won for his self-parodic performance as Rooster Cogburn. Of the 164 movies he made in his long and brilliant career, including the twenty-four he did with John Ford, *True Grit* is perhaps the least Oscar-worthy in terms of pure cinema. However, for his long-overdue recognition—17 of the films he appeared in were among the 100 highest-grossing films of all time, collectively pulling in more than $400,000,000 (in twentieth-century dollars), and since 1951 he had consistently placed among the top ten box-office stars—this was the one Hollywood chose to acknowledge Wayne's great contribution to American movies.

Wayne's astonishing body of work, those 164 movies over a fifty-year span, where he upheld not just the law of the land but "the American way," defined him as Hollywood's definitive Indian-fighting (and later on Indian-

defending), two-fisted, six-gunned, wagon-trained, swinging-bar-doored, maiden-preserving, democracy-defending all-American hero, the most enduring on-screen symbol of the vanishing prairie. And, although he was never in the military, he fought America's enemies in World War II with patriotic propaganda films that came complete with recruiting stations set up in theater lobbies. He was an avowed enemy of Communism and especially American Communists. At the height of his career, he set about to rid Hollywood of both and did a fairly effective job. However, by age sixty-three, with the wear, the tear, the weariness on his craggy face, with cobra eyes that looked almost Asian, and the sagging body of a Hollywood life ridden hard and put away wet, he was considered passé by Hollywood's young '70s honchos, some not yet even born when Wayne made some of his best movies.

He had been nominated twice before, once as an actor in 1949 for Best Actor in Allan Dwan's no-frills war movie *Sands of Iwo Jima,* when he lost to Broderick Crawford in Robert Rossen's *All the King's Men* (a role Wayne turned down because he disliked the film's political message), and once as producer (Best Picture/Batjac, his own production company) in 1960, for his post-Disney "adult" version of the classic story of *The Alamo,* which he also directed. Wayne lost that time to producer/director Billy Wilder for *The Apartment.*

Why was Wayne perennially passed over? For one thing, he made enemies in the industry where many never forgave him for his politics, and because of it, some of his greatest performances, like Ethan Edwards in John Ford's *The Searchers,* were famously ignored by the voters of the Academy. Made during the height of the blacklist, *The Searchers* provides not just the best performance in any Hollywood film of 1956, but one of the greatest performances in any film anytime, anyplace, anywhere. Five years earlier, Stanley Kramer's monumental *High Noon,* a western written and coproduced by blacklisted Carl Foreman, was nominated for eight Oscars and won four, including Best Actor for Wayne's friendly rival for most of their careers, Gary Cooper. Why? Perhaps part of the reason is that Wayne was the former president of the radical-right Motion Picture Alliance, begun by Walt Disney, Sam Wood, and others in the early '40s, the tea-party-style posse of a politically divided Hollywood that helped ruin the careers of some of its best talent (and biggest moneymakers), including Foreman. In 1971, an unrepentant Wayne told *Playboy* magazine,

"I'll never regret having helped run Foreman out of this country." It was not hard to tell which side the Academy was on.

But it wasn't only politics. As larger than life as he was for audiences, to the Hollywood studios that employed him and the voting Academy members, Wayne was, almost to the end of his career, considered a glorified B movie actor, his films never considered "quality" or "art," certainly not worthy of Oscar. The studio book on Wayne was that he was just another Hollywood cowboy, that he didn't have the emotional range of a Jimmy Stewart, the gritty elegance of a Spencer Tracy, the spitting toughness of a Humphrey Bogart, the street smarts of a Jimmy Cagney, the beautiful pain of a Marlon Brando, the urban cynicism of a William Holden, or the inherent populism of a Henry Fonda, all Oscar winners. He was just *there,* Hollywood's unanointed Duke, as dependable as oats. Yet, as film critic and historian Andrew Sarris, promulgator of American auteurism, rightly acknowledged on the occasion of Wayne's *True Grit* nomination, his "forty years of movie acting and thirty years of damn good movie acting . . . Wayne's performances for John Ford alone are worth all the Oscars passed out to the likes of George Arliss, Warner Baxter, Lionel Barrymore, Paul Lukas, Broderick Crawford, Jose Ferrer, Ernest Borgnine, Yul Brynner and David Niven . . . ironically, Wayne has become a legend by not being legendary."

And after Wayne's Oscar win, Sarris explained his special appeal: "I remember responding to him in a relatively uncomplicated way though he seldom functioned as a conventional hero. He could be accursed or obsessed . . . And on many other occasions the characters he played faced a twilight existence of loneliness and dependency . . . Wayne's most enduring image, however, is that of the displaced loner vaguely uncomfortable with the very civilization he is helping to establish and preserve . . . At his first appearance we usually sense a very private person with some wound, loss, or grievance from the past."

THE NIGHT BEFORE THE OSCARS, Wayne was on location in Old Tucson, Arizona, shooting *Rio Lobo,* the third and weakest film of a trilogy of late-career westerns directed by Howard Hawks. When his day's filming was finished, Wayne flew in his private plane to LAX, where he was met by a limo and driven directly to the Beverly Hills Hotel. His third wife, Peruvian-born Pilar Pallete, and their three children, Aissa, fourteen, John Ethan,

eight, and Marisa, three, were already there, waiting for him.* They had arrived earlier in the day and checked into two of the hotel's exclusive private bungalows, one for Wayne and Pilar and one for the kids. A bungalow over was an already sloshed Richard Burton and his wife, the equally inebriated Elizabeth Taylor.

Wayne and Pilar spent a quiet night together, and the next morning he was driven alone downtown to the Dorothy Chandler Pavilion to rehearse for that evening's big event. His arrival drew the biggest reaction so far from the fans already filling in the bleachers on either side of the red carpet, some arriving at daybreak to catch a glimpse of their favorite stars. They didn't stop screaming, mostly positively, for Wayne from the time he emerged from the limo until he passed through the private entranceway of the Pavilion. Someone in the bleachers held up a sign that read JOHN WAYNE IS A RACIST. If he saw it, he showed no visible reaction.

After being made up in his dressing room and running through his paces—where to go, where to stand, what hand to use to accept the statuette if he won, which side of the stage to exit—there were still a couple of hours to go before showtime. He lingered backstage, an informal schmooze space for nominees and friends, to see who else had arrived. Fueled now with drink, he told all the stars there who were interested, and the few who weren't, that he didn't think he had any chance in the world of winning. For one thing, he went on, he was too old, that the Academy preferred younger winners to keep bringing new audiences to the movies. For another, in a Hollywood that was making *Easy Rider* and *Midnight Cowboy,* his films had gone out of fashion.

He hated both of those pictures. Their drug-taking, antiestablishment themes, and, to him, glorification of homosexuality were all the proof he needed that he and his MPA gang had won the political battle against Hollywood's "Commies" but had lost the moral war. *Easy Rider* was "perverted" and *Midnight Cowboy* "a love story about two fags . . ." And what did *Midnight Cowboy* have to do with anything about cowboys anyway? Always po-

* Wayne was married three times, divorced twice, and had seven children. He had four with his first wife, Josephine Alicia Saenz (1933–1945)—Michael Wayne, Mary Antonia "Toni" Wayne, Patrick Wayne, and Melinda Wayne. He had no children with his second wife, Esperanza Baur (1946–1954). Wayne married Pilar in 1954 and had three children with her, Aissa, John Ethan, and Marisa. They separated in 1973.

lite, when Wayne ran into Dustin Hoffman backstage he graciously told him that he enjoyed his performance in the film.

As for his own in *True Grit,* it was, as far as he was concerned, essentially the same character he'd played since John Ford's 1939 *Stagecoach* some thirty years earlier, the only difference being that he was older. They hadn't given him an Oscar for that one, and he figured they wouldn't give it to him now.

There were two more rehearsals, for lights, cameras, and sound. By 2:00 in the afternoon, as the dancers, techies, camera operators, lighting focusers, and stage managers with earphones and clipboards crisscrossed the stage, Wayne found himself alone in the crowd. His mood brightened at six when Pilar arrived. She had left the kids with a sitter at the hotel thoughtfully provided by the Academy, which frowned upon children backstage during the big night. He saw her and smiled, the familiar grin that buried his eyes inside a squint and spread out and flattened his thin-lipped face. He swooped Pilar up in his arms the way he once famously had Maureen O'Hara in John Ford's 1952 *The Quiet Man,* and the young Natalie Wood in Ford's 1956 *The Searchers,* and carried her that way back to his private dressing room. He poured them each a drink as they patiently waited for the stage manager to knock on his door, open it halfway without looking in, call "places," and shut it behind him.

The telecast began promptly at 7:00 Eastern Standard Time. The live TV show opened with a filmed montage of Hollywood's greatest all-time stars, after which Gregory Peck marched onstage, his eyes ringed with glasses, and in his stentorian voice introduced each of that night's nominees, as they walked out and took a bow.

Wayne received the loudest ovation.

The last to take the stage was the show's honorary host, Bob Hope (there was no single official host that year), wearing a patch over one eye to spoof Wayne's performance as Rooster Cogburn in *True Grit.* The audience roared. It was the best indication yet that Wayne might at last win his longed-for and long overdue Oscar.

Wayne took Pilar to their seats on the aisle down front. Like all the major category nominees and their spouses or dates, they were placed close to the stage, the lesser ones put farther back. As the ceremonies rambled on, Glen Campbell, one of Wayne's costars, came out to sing the film's theme, "True

Grit," one of the evening's five songs nominated as "Best." Campbell finished to a smattering of applause that sounded louder on TV than it did live, Wayne's cue to quietly slip backstage and prepare for his entrance as a presenter for Best Cinematography.

When he walked out this time, no sign of his famous, oft-parodied pigeon-toed small-step gait, he received a standing ovation and waited for the audience to quiet down before he spoke. "I'm an American actor," he said. "I work with my clothes on." A few giggles, a bit of applause. No one was quite sure in this era when it had become fashionable for actresses to "go nude" in mainstream films where he was going with that. His comic timing was, as always, less than perfect. "I have to. Horses are rough on your legs and your elsewheres." *Ah.* Laughter sprinkled throughout the house. He then opened the envelope and announced the winner, Conrad Hall, for *Butch Cassidy and the Sundance Kid.* Soon after he presented the golden statuette to Hall, the two left together, stage right. During a commercial break in the action, Wayne was escorted back to his seat.

Almost at the end of the four-hour-plus marathon, it was after eleven in New York, well beyond prime time, the Best Actor award was finally presented. The winner of the previous year's Best Actress Oscar, Barbra Streisand, handed it out. Streisand, sparkling in pink, after smiling and flitting around the stage in a grand star sweep, read the names of the nominees. Only three were actually present, and each had a TV camera trained on him. Jon Voight was standing in the wings, Richard Burton was in his seat looking supremely uninterested. Wayne, seated not far away from Burton, squeezed Pilar's hand. Babs teased the audience by opening the envelope as slowly as possible, looking at the name, and then saying, "I'm not going to tell you!" A light rumble of impatience rippled through the audience before she belted out in show-stopping ballad mode *"JOHN WAYNE IN 'TRUE GRIT'!"*

He bolted out of his seat, propelled as much by shock as glee. He unbuttoned his jacket as he walked briskly to the stage. Standing at the microphone, he looked a bit heavy, his unnaturally brown toupee sitting on his head like a muskrat, giving Wayne's face an oddly unnatural box shape. He kissed Streisand lightly on the cheek without looking at her as she handed him his award, and then let out a breath-filled "Wow" filled with a lifetime of hopes, dreams,

frustrations, and accomplishments. He lightly wiped a line of sweat from below his right eye with the knuckle of a bent forefinger and said, "If I'd known that, I would have put that patch on thirty-five years earlier." He waited for the genuine laughter to die down, then continued. "Ladies and gentlemen, I'm no stranger to this podium. I've come up here and picked up these beautiful gold men before, but always for friends. One night I picked up two—one for Admiral John Ford and one for our beloved Gary Cooper. I was very clever and witty that night, the envy even of Bob Hope, but tonight I don't feel very clever, very witty. I feel very grateful and very humble, and owe thanks to many many people. I want to thank the members of the Academy; to all you people who are watching on television, thank you for taking such a warm interest in our glorious industry. Good night."

That was it. Short and sweet, no long and meaningless list of people to thank that nobody knew or cared about. As he stepped away from the mike, the music came up and Streisand, who had been standing behind and to the left, took him by the arm, and led him off stage right, to a career's worth of resounding applause.

After, Wayne spent two hours patiently answering questions for the press and posing for the paparazzi, with and without Pilar. Then they were off to the traditional Governor's Ball, the most prestigious party of the night. They didn't get back to the Beverly Hills until nearly one A.M.

Burton, meanwhile, empty-handed, had left immediately after the ceremonies with Taylor, and the two went straight back to the hotel, skipping all the parties, preferring to be alone, where they could drink, piss, bitch at, and moan to each other.

A little after one o'clock in the morning a pounding came on the Burtons' door. When neither one opened it, fear washing over them in this era of Charles Manson paranoia, Wayne, alone now and completely wasted, kicked it in as easily as if it were a stage prop. A stunned and frightened Burton and Taylor clutched at each other as they stared at him in silent disbelief. A grim-looking Wayne walked over to Burton, held out his Oscar stiff-armed like he was ready to tackle someone with it, and said, slowly, in that each-word-is-a-sentence style of his, "You should have this, not me."

After that, the mood changed. All three stayed up the rest of the night,

drinking nearly 'til dawn, schmoozing and laughing and telling stories, along the way Burton confessing he was certain he would never win an Oscar, Wayne assuring him his day would come (it never did).

The next morning Wayne and Pilar and the children were driven to the airport for the flight back to Old Tucson. Playtime was over and for Wayne there were still a few more miles of film to shoot before he slept.

Part One

A Long, Rough Stagecoach to Fame,
Powered by a Ford

Chapter 1

Robert Morrison was born in 1782, the newest addition to the John Morrison British-Scottish-Irish clan of Counties Antrim and Donegal. While still a teenager, young Robert became active in the Free Irishman Movement that was opposed to the rule of the British Crown. Later on, when a warrant was issued for his arrest that would have certainly meant imprisonment and execution, he and the rest of the Morrisons hurriedly gathered their belongings and, in the black cover of the night, boarded a freighter bound for America.

They arrived in New York in 1799 and, still fearing the long reach of British justice and its East Coast thug enforcers, continued west, following along the rivers and trails of Ohio, Kentucky, and Illinois before settling in Iowa, where they believed they were safe at last. Robert became a ruling elder in the Presbyterian Church and a brigadier general in the Ohio militia. He married and had a son named Marion—an Old French derivative for Mary or Marie, used by the British and Irish for males since medieval times—who fought in the Civil War and was wounded in the Battle of Pine Bluff.

Marion's son was the outgoing and ambitious Clyde Morrison, who attended the University of Iowa, in Iowa City, to earn a degree in pharmacy. He hoped to start a practice in Des Moines, which was still mostly farm country, and although Clyde had never worked a yard of land in his life, he figured all these farmers, and their wives and children, would need medicine and family

supplies. Marion was not just smart; he was big and strong enough to make the university's all-star football team.

He had another, perhaps more surprising talent. "Doc," as everyone called him, possessed a deep and sonorous singing voice. Whenever he was asked to at the university's social gatherings, and even sometimes when he wasn't, he loved to break into song. If slightly annoying in its arrogant braggadocio, there was also something undoubtedly charming about a big, handsome, hulking athlete who loved to sing.

At one such university social gathering, a diminutive, vivacious blue-eyed redhead named Mary (Marion) Brown, sometimes called Molly, heard the tall, husky Doc perform, was charmed and, despite being pursued by all the handsomest and well-set young men at the college and in town, decided he was the one she was going to marry.

She made a plan.

In August 1906, at an especially intimate moment, she politely informed Clyde she was pregnant.

Because he was about to become a father, Doc had dropped out of the university, and before Mary started showing, he decided it might be best to relocate with her to Winterset, Iowa, the county seat and a robust farming community with a population of 17,770, forty-five miles southwest of Des Moines. There, Doc believed, he'd have a good chance of finding real work even without a degree. Soon after they settled in, they were married that September. The officiating was done by the Justice of the Peace at the Civil Hall rather than by a preacher at the local church. On May 26, 1907, Mary gave birth at home to a big baby boy, thirteen-pound Marion Robert Morrison; big babies ran in the Morrison family. Marion was named after his grandfather, who was in turn named after his grandfather, and his mother, Mary.

Doc took a job as a pharmaceutical clerk, a pill-pounder in M. E. Smith's, Winterset's only drugstore. The work was menial, the pay reflected it, and it was difficult for Doc to provide Mary the lifestyle she had dreamed of. It took three long years, but by 1910, Doc had managed to save enough money for a down payment on his own drugstore in nearby Earlham, where they moved as soon as his pharmacy was ready to open for business. Doc hired one pharmacist, business boomed, and soon enough he could afford to hire a second, and contractors to build a two-story Victorian house not too far from the store. On

Sundays, his day off, he proudly drove Mary and the baby around town in their new fancy one-horse carriage, pulled by Sadie, the family's beloved steed.

Everybody in town knew and liked Doc. They affectionately called him the town philosopher, for his broad smile and good nature. However, despite the outward appearances of affluence and harmony, the relationship between Doc and Mary had been a rocky one even before they tied the knot, and now Mary's material demands didn't help any; still, Doc worked hard to provide for his family. He lavished expensive gifts on Mary, believing he could afford it because business was good at the pharmacy. He didn't know much about running a retail operation. To Doc, cash flow meant success. And whenever he was flush with it, he was an easy touch for every sob story that came through the front door. As young Marion later remembered, "He couldn't pay his bills because he hated to press his customers to pay their bills."

Mary announced she was pregnant again, but despite her "condition," she took over the bookkeeping, and the business's margin of profit slowly improved, but it was soon apparent to her that it was too expensive to run and would never be able to break even. Five years after Marion's birth and two years after they had relocated to Earlham, the pharmacy that had once held such financial promise failed. On December 30, 1911, only a year after Doc had opened the store with such grand vision and hopes, and one day after their new baby was born—another healthy, but not as big a boy, who didn't rip up Mary's insides the way Marion had, who came forth with the help of a local midwife—the Morrisons were forced into bankruptcy.

For a while, Doc worked as a clerk for the new owner, eking out a living. Almost in the next breath, though, Mary kicked Doc out of the small house they were now renting and told him not to come back until he had a real job. His search for more lucrative employment led him to Keokuk, at the southeastern end of the state. There he could only find menial work, but the hard truth was that for all intents and purposes, he and Mary had separated.

In his absence, Mary raised the two boys by herself. The second boy she named Robert Emmett Morrison. Robert was her favorite name, and she had always called Marion Bobby, until her second baby was born. She then gave him Marion's middle name and had his birth certificate changed from Marion Robert Morrison to Marion Michael Morrison, so that there would be no confusion between the two boys.

Her newest baby was also her favorite. Mary believed he was destined for greatness. The fawning favoritism she showered on Robert instigated a lifelong sibling rivalry between the two sons. From the start, young Marion wanted to be his mother's favorite but knew it would never happen. It turned the boy distant and sullen. According to Pilar Wayne, "The happiest part of Duke's childhood ended the day his brother was born."

His missing father, whose presence would have likely been the solution to Marion's emotional conflict, made the turbulence that grew out of this Oedipal conflict worse. Marion's jealousy of his younger brother continued to cause problems between the two boys until one day with no advance warning Mary packed up Marion's things and shipped the boy off to Keokuk to live with his father. Marion had no complaints. Doc's presence more than made up for the separation from his mother and helped to restore some stability to the psychological merry-go-round he had had to endure.

IT WAS ALWAYS DIFFICULT FOR Marion to make new friends with a name like that. Despite his size, the other children at school picked on him because of it. In the local schoolyard they wanted to know why he had a girl's name, if he really was a girl, if he had snuck out of his house wearing boys' clothes instead of girls'. How, they asked, tauntingly, could anyone with a girl's name be a real boy? Marion decided the way to stop the teasing was to punch the biggest boy, the leader of the bullies. He did, got beaten up by the others, and came home covered in blood.

Doc was naturally strong and athletic but not a tough guy, a charmer rather than a fighter. He had taken up boxing as a teenager and after he cleaned the boy up, he showed him a few moves. Doc quickly realized that his boy had a natural athleticism about him that led Doc to dream that one day Marion would honor the family by attending Annapolis and playing football for the Naval Academy. But he also wanted his boy to grow up morally straight; otherwise Annapolis would have no place for him. As Wayne later recalled, "Doc gave me advice on any and all problems. He never had an unkind thought in his mind and rarely spoke harshly to me or anyone else. He never lectured me. But I remember three rules he taught me for living: Always keep your word, a gentleman never insults anybody intentionally, don't go around looking for trouble, but if you ever get in a fight, make sure you win it."

Before he lost his business and left Winterset, Doc had used his free time in the late afternoons to put together a football team at the town's Earlham Academy; his 1911 team was considered by scouts and local reporters to be the best of all the high schools in Iowa. Doc had hoped that Marion would one day play for it as a showcase for Annapolis. Mary had always thought both football and Doc's volunteer involvement with it were a foolish waste of time that could have been better spent working harder to save the family business. Her vision for Marion was to go to college to learn the profession of law.

After shipping Marion to Keokuk, Mary had seriously considered divorcing Doc, until he and the boy unexpectedly returned to Earlham. Doc had come down with asthma and tuberculosis, not uncommon in the Midwest of the early twentieth century; he was spitting up blood and needed Mary's care. He told her his only chance of survival was to move to a warm, dry climate to try to recover. If he stayed in Iowa, he would surely die. He asked Mary to go with him to California and she agreed. She couldn't let this sick man make that trip by himself. He was, after all, still her husband. Besides, in his absence she had come to realize that living without a man in the house was not as easy as she thought it would be. Now that Doc was back, even sickly and weak, she had to admit that it was good to have the family together, intact, and she nursed Doc during their journey west, in search of recovery for her husband and a new life for the boys.

IN 1914, THE MORRISONS ARRIVED in California, where land was cheap and plentiful, the climate warm and dry. The journey had been a difficult one, via covered wagon along the grueling trails through Death Valley, where the temperature reached a blast-furnace heat of 118 degrees by day and dipped to below freezing at night. The family finally emerged on the other side, into a small farming community called Palmdale, a stopover for covered wagons and a vital link on the Transcontinental to the small western towns up and down the coast. Palmdale was a dusty, near-treeless western town consisting of a post office, saloon, hotel, smithy, two churches, and a one-room schoolhouse. Iowa, by comparison, was a lively metropolis. Here there were no pharmacies, and no apparent need for any. Medicine in Palmdale was a shot of cheap whiskey. If an illness persisted, a second shot. For man, woman, child, it was the standard cure-all.

A year later, his health improved, Doc registered with the government as a homesteader and was granted a near-worthless plot of desert property on eighty acres on the outskirts of Palmdale. The land was full of wild brush that attracted rabbits, snakes, and rats, all living together and off one another. It was full of everything but crops. Doc determined to clear it and make it suitable for planting. He converted an old plow he found into a harrow, something that resembled a giant comb similar to a rake; then he had Jenny, the new family horse, drag it back and forth for hours every day to gather up the brush and debris, which Doc then burned in the late afternoon.

While Doc built a new house, the family settled in a temporary shelter, an empty shack with no running water; they pulled it from an outside pump well. They used kerosene lamps to keep the place lit and relied on a woodstove and fireplace for heat.

Every day after school, eight-year-old Marion's job was to literally ride shotgun alongside Doc on his rickety wagon and whenever he saw a rabbit or a rattlesnake, to blast it. The rattlers especially gave him nightmares; if he didn't get one quickly enough, it could start rattling its tail, strike, lock its viselike jaws around his ankle, and sink its fangs into him, after which he would likely die a horrible death from the venom. Because of that dread, his weapon was always loaded with shot as it lay across his lap, ready to be fired at a moment's notice. Rabbits and snakes were the last remnants of what had once been called the Wild West.

A lifetime later Wayne still had vivid memories of these times, when the family was forced to move eight times in five years because of a lack of funds to pay their way: "Riding a horse always came as natural to me as breathing. As far back as I remember I was riding. I guess I started playing cowboy when I was not more than seven years old. We lived on an eighty-acre farm near Palmdale, California, on the edge of the Mojave Desert. It was barren, deserted country in those days and Palmdale was in the middle of nowhere . . . our house was a glorified shack and the land was in miserable shape . . . It was a hard life and we were living close to the margin of starvation. Mostly we ate potatoes or beans or one for another. One Hallowe'en Mom gave us a big treat—*Frankfurters* . . . I'd be trotting late home in the afternoon, with the supplies tied to my shoulder, and there was a place in the road where it made a sharp turn around a cliff. I

would pretend there was a gang of outlaws lying around that bend, waiting to ambush me. I managed to scare myself to death, almost . . . then I'd dig my heels into Jenny and she'd gallop down the road . . ."

Mary hated everything about Palmdale. There was simply nothing culturally involving and no chance of a good eastern-style education for her boys. There was never any real food for her to cook, and nowhere to go out for a decent meal. She had no friends, and there was nothing at all to do at night except listen to the haunted, distant howling of desert wolves. The idea of divorce once again began to fester inside of her.

By now, any vestige of what could be called love between Mary and Doc was gone. All her affection went solely, and openly, to Robert. She literally smothered the boy, as if trying to protect him from the raw elements of the West, while she all but ignored Marion. As far as she was concerned, he was Doc's boy, and he could have him. One time she left Robert on the porch with Marion to watch him for a few minutes so she could take care of something inside, when a rattlesnake went for Robert. Marion, who was never without his shotgun, blasted the creature just before he struck, but instead of this lifesaving act to save her precious Robert endearing the older boy to his mother, it only made her hate the desert, and her husband for bringing her there, all that much more.

DOC JUST COULDN'T MAKE THE farm work. A nearby dairy farmer felt sorry for the Morrisons, especially the children, and left milk at their door at dawn every day, without ever mentioning it or sending a bill. Clyde was humbled and appreciative, but Mary felt humiliated by what she took to be pitiful charity. Any real food they managed to get came from Marion's jackrabbit kills. She hated rabbit meat.

By 1916, the Morrisons' Palmdale experiment came to an end. Barely a year after they had arrived, Doc threw up his hands in surrender; he hadn't been able to conquer the land, the land had conquered him. He reluctantly abandoned the homestead, pulled up the family's roots, such as they were, and headed farther west, to a little town named Glendale, not far from a patch of land called Hollywood and just beyond there the Pacific Ocean. Glendale was relatively urban, due mainly to the new business that had sprung up in Southern California—motion pictures.

GLENDALE (WHICH MEANS "VALLEY" IN Scottish or Gaelic, the likely origin of the name) is located at the east end of the San Fernando Valley, and by the time the Morrisons arrived, the community had proudly proclaimed itself "the fastest-growing city in America." It had once belonged to Mexico but was taken along with most of Southern California by the American government in 1848 as the spoils of victory from the Mexican War. Peace began a renewed wave of relocation to California supercharged by the historic gold rush that brought people, goods, services, and money to its rapidly developing townships. In 1906, with its plentiful citrus orchards and vineyards, Glendale was incorporated as a city with homes built in the popular California bungalow and Spanish Colonial Revival styles. The Southern Pacific connected Glendale to other communities and it increasingly thrived on the fast-growing moving picture industry's need for workers. Film brought a lot of money to the city. And movie theaters.

By 1916, the year the Morrisons arrived, Glendale's downtown already looked like a real city; it had commercial brick buildings, concrete sidewalks, and the houses all had inside plumbing, hot and cold running water, electricity, and a few even had the newest sensation, telephones. Over the next two years, Doc worked hard to make it in this thriving community. He got a job with the new Glendale pharmacy and became an active member of the Unity Chapter of the Royal Arch Masons. He rented a modest house at 421 South Isabel, and most nights after coming home from work he would take Marion out back to play football with him. He taught the boy how to run, cut, dodge, divert, tackle, throw, and catch. When Doc had enough money saved, he bought a car and every Sunday drove the family one hour to the beach at Santa Monica. Marion and Doc would race each other to see who could reach the water first. They would swim, splash, and play water football, coming out of the water soaking wet and laughing as they stretched out on their towels and let the sun dry and tan their skins. Mary was less thrilled with the beach. She felt uncomfortably overrevealed even with the typical Victorian bathing suits of the time, which covered women nearly head to toe. She put up with it because she believed that Clyde deserved his time of fun, as he had kept a good job, paid the bills, and provided a decent roof over their heads.

Although Glendale was a vast improvement over Palmdale, it was still a hard place for Marion to grow up. "From the time I was in the seventh grade," he

later remembered, "I had a paper route. I was eleven years old and delivered the *Los Angeles Examiner.* Had to get up at four A.M. because it was a morning paper. And after school and football practice, I delivered drug orders on my bicycle. Later on I worked as a truck driver, soda jerk, fruit picker, and ice hauler."

In 1918, Marion was going to the Sixth Street Elementary School in Glendale. He called his pet Airedale that he had picked out of a kennel "Duke." Duke followed him to school every day and slept outside the nearby firehouse number 1 while Marion went to class. Some of the firemen took to calling Marion "Big Duke," and then just "Duke." He loved the attention and companionship of the firefighters. He was their mascot, and they were his first image of what big, strong, healthy men looked and acted like, as opposed to his father, who lived under the domination of his never-satisfied mother. For the rest of his life, he would be attracted to tough, strapping male figures and look to them for guidance, support, and camaraderie. He soon started telling everyone his name was really Duke. Even his parents started calling him Duke.*

Marion now had a new name, and a new body. At the age of eleven, he had begun his growth spurt toward the six-foot-five height he would eventually reach. As his body filled out and he became stronger, he was still afraid of the bigger and tougher schoolhouse bullies, who, because he was the biggest kid in school, always wanted to challenge him and take him down to prove they were the toughest. One of them wanted to make Duke his personal punching bag and regularly beat him up after classes in the schoolyard. Following a pummeling, on the way to the firehouse to pick up Little Duke, a volunteer fireman saw him, took him inside, cleaned him up, and asked him what happened. He told him, and the fireman, who happened to be an amateur boxer, started giving Duke some lessons. The fireman knew more about fighting than Doc did, and he taught Duke how to defend himself so that the next time the other boy picked on him he would be able to take care of it. Soon enough, the bully started talking trash, in preparation of giving Duke another beating. Duke said nothing; then, before anyone knew it, he threw one carefully placed punch and flattened the boy. After that there would be no more name-calling, no more finger poking, no more tough talking from big-boy bullies. After that, when-

* Wayne sometimes varied this story. To Pete Martin, of the *Saturday Evening Post,* he said that he had gotten the nickname after acting the part of a duke in a high school play. He also liked how close Duke sounded to Doc.

ever anyone asked Marion how he had learned to fight, he always had the same answer: "Just call me Duke."

MEANWHILE, AS CLYDE CONTINUED TO struggle, he began drinking to ease his frustrations and to prefer the lively pool halls and straw-floor card-player bars to his proper living room at home. He usually lost at the card tables and, as was his nature, always ready to help out a friend who needed a few extra bucks. He was still the same old Doc, the easy-touch, amiable fellow going nowhere fast. He soon ran out of money and lost the small house he had rented, and only the kindness of the owners of the Glendale Pharmacy saved the family from being thrown out into the street, by letting them move into a too-small apartment above the establishment, meant for one, not four and a dog.

It wasn't until 1920, when Mary literally pulled him up by his ears and threatened to leave him and this time for good, that Doc straightened out enough to get some work picking apricots and oranges, and another job in a pharmacy, and eventually earned enough to put together a down payment on a new house. Soon enough, though, aces came up eights and he lost his new job and defaulted on his mortgage less than a year later. Doc was forced to find yet another place to rent. At one point there was so little money coming in they had to rely on Marion's meager seven-days-a-week *Los Angeles Examiner* paperboy income to make ends meet. On Sundays, when the papers were too heavy, Clyde got up with him at dawn and helped the boy make his rounds. Mary felt terrible about having to depend upon Marion's money for groceries and angry at Clyde for making her feel that way.

That summer, Marion was able to give up the paper route when he found work in the thick and aromatic orange and lemon groves, bean patches, and hay fields that surrounded the San Fernando Valley. The base of the Sierra Madre foothills was lush with fields of fruit, and Duke didn't mind working all through the long hot summer days. It felt good to be outside doing physical work in the warm California sun, with sweat running in rivulets down his bare muscled chest.

Not everything was great for Marion. Mary insisted that when he had free time, he should take Robert along wherever he went, even though he was five years older and distinctly different from his younger brother. Duke was tough, Robert was tender. Marion loved the outdoors, Robert wanted to stay home

with Mary and help her in the kitchen. The only place Marion could be completely alone, even from Robert, was when he snuck away by himself and went to the movies. As he later remembered, "Most of the Glendale small-fry were movie-struck because [we had a movie theater and], the Triangle Studios were located there." Robert didn't care for them, so it wasn't a problem for Duke to spend some weekdays alone, where for a nickel he could see the silent serials. He enjoyed *The Perils of Pauline,* the "cliffhanger" that virtually invented the genre of the never-ending damsel in distress. But westerns were his favorite, like Paul Hurst and J. P. McGowan's 1916 *A Lass of the Lumberlands,* or Edward Laemmle's 1921 *Winners of the West,* two of hundreds that were made.* Film historian William K. Everson once noted, "There is a period in every child's life when a cowboy on a galloping horse is the most exciting vision imaginable."

Marion loved movies so much, he often cut classes at school and went to them during the week (there were no truancy laws in Glendale in those years). Sometimes, he recalled, "I went, on average, four or five times a week."

IN LITTLE MORE THAN A decade, motion pictures had developed from the novelty of the individual viewer nickelodeon, approximately the size and shape of today's stand-alone ATM machines, to a booming industry with elaborate theaters that offered plush seats, live orchestra accompaniment, and big silver screens that played to packed houses of all ages and genders in every town with enough residents to support one. Smaller burgs eager to see movies rented out halls and hung sheets to see the latest releases. Going to the movies had become the latest craze, not just in America but around the world. At one point in the second decade of the twentieth century, Charlie Chaplin's character, "the Little Tramp," was the single most recognizable image on Earth.

Glendale had gotten its first real movie theater in 1910, the Glendale, and four years later, the grander Jensen's Palace, and both were filled to capacity from the first day they opened. Duke's favorite screen cowboys were the romantic, if stoic, save-the-damsel-in-distress William S. Hart; the flamboyant, athletic Tom Mix; rodeo-star-turned-actor Hoot Gibson; and most of all the reticent, unaffected dusty-clothed, manly but homely Harry Carey, whose lined face and worn-out hat translated on-screen into high moral heroism.

* Both films are considered "lost," due to neglect and deterioration. A "lost" film is defined as a film for which no known prints exist.

Throughout his decades-long career, Carey, who always wore his gun without a holster, tucked into his pants belt, never once played a villain. Years later, when John Wayne was himself a big cowboy star, he said, "I copied Harry Carey. That's where I learned to talk like I do; that's where I learned many of my mannerisms." One of Carey's signature poses was to stand with his right hip slightly out, his left arm crossed over and holding on to the upper part of his right. Wayne would one day pay homage to Carey by repeating the gesture in John Ford's *The Searchers*.

FILMS, BY DEFINITION, ARE ARTIFACTS of nostalgia; they chronicle the past. From Jesus to Jesse James, from Pearl Harbor to the Twin Towers, cinematic reenactment always follows hard-edged reality. In Hollywood's early years, as the novelty of the nickelodeon exploded into a big-screen million-dollar industry, nothing was more popular than the filmed reenactments of the "wild" West, the expansionist period following the Civil War glorified in the movies by gun-slinging "heroes," made more heroic by the convenient presence of "villains," who also almost always ran the saloon and the prostitutes upstairs (sanitized in films as "singers" or "dancers") and of course the interchangeable one-lump tribe of "Indians," almost always played by white actors.

The Sierra Madre foothills that encircled Glendale and the nearly always sunny climate made it easy for directors to shoot outdoors there and make today's West look like yesterday's on-screen. Many Hollywood studios had separate Glendale operations specifically for shooting cowboy movies. Their indoor facilities had pullback roofs so they could utilize natural light to shoot indoors. By 1919, seven hundred feature films a year were being made in or near Glendale.

That was where the twelve-year-old Duke, imagining himself a real-life amalgam of Hart, Mix, and Carey, joined the baddest gang at Glendale High School, whose "posse" only a year or so earlier had regularly beaten him up; now, membership was an emblem of his heroic stature. The only thing he didn't like was the burden of still having to take his little brother, Robert, along whenever invited to a party by the other gang members. If he didn't especially like Robert, he was still fiercely protective of him. If somebody made a disparaging remark or wanted him thrown out of the party, Duke always came to

his defense. At one such soiree, "After the cake and ice cream and punch was served . . . some wise guy said 'Get that little jerk out of here [meaning Robert].' I took a poke at this character and the party almost broke up in a free-for-all."

Just like in the movies.

IN JUNE 1921, FOURTEEN-YEAR-OLD DUKE graduated from Wilson Intermediate School, where he had lost his desire to be a loner and became a popular, good-looking student with real academic promise. In Glendale Union High School, he blossomed even further. He was president of the Shakespeare Club, cocaptain of the football team, a member of the French Club and the Drama Club, a winning member of the chess team, an effective leader of the debating team, a first-class bridge player, and he maintained consistently high grades that earned him honor pins. He was also an active participant in putting together *Stylus,* his senior class's yearbook. Because of all his good work, Marion was chosen class valedictorian.

He was also Glendale Union's best football player. In his junior year, as a running guard Wayne led Glendale Union to the state championship against Long Beach. Glendale lost the big game 15 to 8, but it didn't matter that much to Duke, because his superior playing had gained the attention of regional scouts, including one from the University of Southern California.

In 1925, his senior year, Glendale won the state championship. They not only went undefeated but were unscored on for the entire season, a record that would live in local lore as the greatness of the "Glendale Eleven." Duke graduated with an overall grade average of 94 (out of 100), and from two hundred seniors he was chosen class salutatorian. USC offered him a football scholarship. Duke was thrilled, so was Doc, and so, even, was Mary, but for a different reason. USC was in the process of building a new law school.

That fall, full of hopes and dreams of one day playing professional football, Duke became a USC Trojan, a full-fledged member of the legendary Thundering Herd.

Chapter 2

Soon after starting classes and attending practice at the University of Southern California, the reality of a limited football scholarship set in. As Wayne later remembered, "In September 1925, I entered USC. The scholarship just covered tuition. I washed dishes in the fraternity house for my meals [and waited on tables at mealtime]. That left me a little short of money for such things as shoes, suits, laundry, and buying pretty girls ice cream sodas at the corner drugstore. I got work from the phone company. They called me a map plotter and I charted where the old telephone lines ran. I never did find out the purpose of this job.

"Meanwhile, Dad's newest drugstore failed. He opened an ice cream company and this failed. He opened another drugstore and after that a paint manufacturing company. This didn't do well either. When he could afford it, he would send me five dollars a week."

Duke gave his dad free tickets to games. They cost $25 apiece, and for at least the first year, he had to pay for them out of his own pocket. And then things got worse, financially: "At the end of my freshman year I got bad news from the phone company. Seems they had run out of maps to plot. I desperately needed money."

He found handyman work at Warner Bros in Hollywood, and at MGM in Culver City, a bus ride a few miles to the west of the USC campus. He made a few extra dollars doing whatever they assigned him, as an assistant property

man, an electrician's helper, a gofer, an animal herder, and even as an extra or as it was called at the time, "wallpaper." Sometimes on-screen, mostly off, whatever they needed him to do he did it.

Wayne's first recorded appearance in a motion picture was as a stand-in for Francis X. Bushman, the popular silent screen star, in MGM's 1926 release *Brown of Harvard*. Directed by Jack Conway, it was a love triangle set among football players at the Ivy institution.* College football films were an extremely popular genre during the 1920s. The studio sent a film crew over to nearby USC to shoot some scenes of the team's football practice and Wayne appears in some of that footage. The same year, the nineteen-year-old was a spear carrier in the gallows scene of King Vidor's period piece *Bardelys the Magnificent,* set in the court of Louis XIII (an as yet unknown Lou Costello also had a bit part in the film, years before he teamed up with Bud Abbott).†

As it happened, cowboy movie star Tom Mix was a huge USC football fan. Early in 1926, at Mix's request, Howard Jones, the team's coach, got him a season box on the fifty-yard line. In return, Mix told Jones that if there was anything he could ever do for him, he should just let him know.

Now there was. Jones told Mix some of his players were hurting for money, and he wanted to send a few boys from the squad to the William Fox (Fox Hills) Studios on Western Avenue, where Mix was filming, to see if there was anything he could do to get the boys some extra work. Mix said sure, send them over.

The next morning, Duke and another member of the team, Don Williams, carried a letter of introduction to the "Tom Mix Lot," a Fox set built to look like the main street of a frontier town to be used only by Mix and his production team.‡ Duke first saw his childhood idol standing in the middle of the fake street, a bit shorter than he had imagined, resplendent in his ivory-white ten-gallon hat and shiny clean cowboy clothes, looking like a movie poster of himself. Timidly, the two walked over and Duke handed Mix the letter. He read it, looked up, and grinned. "Man," he said, smiling, "a star owes it to his

* *Brown of Harvard* is available on DVD.
† Thought lost after MGM destroyed the negative over a contract dispute, in 2006 a nearly complete print of *Bardelys the Magnificent* was found in France, missing only reel three. It was restored using production stills and footage from the film trailer to stand in for the missing reel. It was made available in 2008 for U.S. theatrical and DVD release.
‡ The sets were built one-eighth smaller than in real life, to make Mix look bigger.

public to keep in fine physical condition. I want you two to be my trainers. Report to me personally when school is over." It wasn't exactly what Jones had had in mind, but the thought of working out with Tom Mix seemed like a great deal to Duke and Williams, certainly better than the grunt work of being human wallpaper or moving around heavy scenery.

"What had excited me was the prospect of becoming a sparring partner for Mix, who just happened to be my hero," Duke later recalled, but he and Williams were disappointed when they learned that Mix only wanted them to watch him box with his regular partner.

The morning after his last class, Duke, by himself this time, reported for work to the Fox studio, hoping to pick up some work, but he couldn't get past the front gate. Just then, Mix happened to arrive in a big black chauffeur-driven "locomobile," as Wayne later remembered "about two blocks long." He called out Mix's name, smiled, and waved. Mix nodded as if he didn't know who Duke was and signaled his driver to continue on. The nod was enough, however, for the front gateman to let him pass through.

Wayne had no trouble finding day labor work at Fox, and occasional assignments in the extra pool. His first on-camera job at Fox that summer was as an unbilled extra in Lewis Seiler's silent western, *The Great K and A Train Robbery.** The film starred Mix, who did all his filming on location in Glenwood Springs, Colorado. Duke made ten dollars that day, money he sorely needed.

After *The Great K and A Train Robbery,* Duke became a regular part of a "swing gang" set-dresser crew, carrying furniture and props and physically arranging them for the set designer, at a starting salary of $35 a week. Sometimes the work was easy, more often than not difficult and demeaning, especially wrangling untrained animals.

It was during one of these assignments that Duke first met director John Ford. According to Pete Martin, "Ford was the founder and guru of a Hollywood cult of brawn. Like Frederick William I, who combed Europe for giants for his Potsdam guard, Ford liked to surround himself with non-runts." Ford especially liked football players. He later remembered, "At that point everybody in the picture business had USC fever. Wayne fell to my lot [on-set] and I made him a fourth-assistant property man."

* Available on DVD and instant download from several video servers.

Wayne later recalled: "They sent me [on an assignment] to Lefty Hugg, assistant director to John Ford. Ford was shooting *Mother Machree*. The title loosely translates to 'Mother of my Heart.'" The film is a sentimental journey of loss, journey, and redemption. A woman (Belle Bennett) is forced to leave Ireland after her husband is lost at sea. Her travels bring her to America, the circus, and trouble. The authorities take her son away. Broke and alone, she becomes a domestic. In the last reel they are finally reunited—the daughter of the wealthy family she works for has miraculously fallen in love with her long-lost son. The film has elements of Ford's later family sagas and features one of his early "family" of players, Victor McLaglen, already a star earning $1,200 a week.*

For his work on the film, Duke earned $35 a week. *Mother Machree* is notable for being the first time he was directed by John Ford.† *Mother Machree* wasn't released until 1928. Caught in the transition to sound, the silent version was pulled twice by Fox, first to add a synchronized score and again to add synchronized sound optical track. "The Irish scenes were shot on a set that was supposed to be a small street in an Irish village. Ford wanted a flock of ducks and geese to add a touch of atmosphere . . . during a break in the shooting Ford suddenly called to me: 'Hey, gooseherder!'" Duke's first impression of the director was that he was "huge and strong, mentally as well as physically, a tough, sarcastic character." Ford asked Duke if he was one of Jones's bright college boys. "Yes, Mr. Ford." The director asked if he played guard. Duke nodded. Ford then asked him to get down in position and show him. Duke got down on one knee. Ford scoffed. "You call yourself a guard? I bet you can't even take me out."

"I'd like to try," Duke said, softly but with conviction. Ford went twenty feet downfield and Duke took off after him. Ford attempted to fake a move to

* Released in 1928, produced and directed by John Ford (unaccredited as director). Of the more than sixty silent features Ford made, few survive. Of the thirty-six he made before 1920, at Universal, Ford's resident studio before he moved to Fox, only ten survive. *Mother Machree* was a Fox transition-to-sound film, with a song performed in it to show off the studio's ability to produce sound. Only five of its seven reels remain in existence. Wayne worked as an animal wrangler on the film.

† Prior to *Mother Machree*, Wayne had appeared in Jack Conway's *Brown of Harvard* as an unbilled football player, King Vidor's *Bardelys the Magnificent* as an unbilled swordfighter, Lewis Seiler's *The Great K and A Train Robbery* as an unbilled extra in the Tom Mix feature, John S. Robertson's *Annie Laurie*, released in 1927, as an extra in one scene wearing kilts; Millard Webb's *The Drop Kick*, released in 1927, as an unbilled football player. He and ten other college football players from Stanford, USC, and UCLA all appear as stand-ins and extras during the film's climactic game.

his left, but Duke anticipated it and hit him hard with a leg to the chest. Ford looked up and glared. A heavy pause followed, then he burst into laughter. It was a jolt-of-electricity moment for Duke. Ford's challenge had been a test, a measure of Duke's ability. He would remember it across his lifetime. Decades later, he described the events that day as "the beginning of the most profound relationship of my life—and I believe the greatest friendship."

Overlooked by Mix, Duke had discovered John Ford, or, more accurately, been discovered by him. As the director later recalled, "I could see that here was a boy who was working for something—not like most of the other guys, just hanging around to pick up a few fast bucks. Duke was really ambitious and willing to work. Inside of a month or six weeks we were fast friends and I used to advise him and throw him a bit part now and then." At the time Duke had no idea who Ford was, what other pictures he had made, just that he liked him, and he trusted him. Like a father.

ALTHOUGH JOHN FORD WOULD GO on to become one of the titans of cinema, if his film career that began in 1917 had ended after 1928's *Mother Machree,* he would still have left a mark in the history of American film. However, it would take several more years for Ford to be recognized as a "pantheon" filmmaker, a director of sharp intellectual insight, deep emotional compassion, and profound vision. In the early days of silent filmmaking, many young and ambitious men were drawn to Hollywood as much, if not more, for the easy money and beautiful women than the opportunity to express themselves making movies. Film itself wasn't yet considered an art, just a novelty of the new electricity phenomenon, a pulpy, disposable entertainment, which is why so many films made in the first half century of moviemaking were thrown away without a thought that they might be worth anything more. Virtually no one in the business, except perhaps Charlie Chaplin, had any notion of the intrinsic value of what he or she was doing, or the foresight to preserve it. Films were disposable commodities, like the daily newspaper, and depended upon fresh material to keep the audiences buying tickets. Yesterday's films were as useless as yesterday's newspapers.

Enterprising, restless, and bright, the Cape Cod–born and –raised young John Ford drifted west, to where he believed his best chance was to make money; to do that, he learned how to make movies. There is nothing in Ford's

background that suggests he had a preternatural calling to film, or for that matter, any of the arts. His first love was fishing, something he hoped he could make a living at, and when he realized he couldn't, he decided to head west to join his brother, Francis, twelve years his senior, whose deep-set eyes, thick, dark wavy hair, and handsome face had helped him become a successful silent film actor. Years later, when the always-reticent John Ford was asked how he first came to Hollywood, the director replied, "By train." He adopted the same last name his older brother had when he entered the film business.* John Ford had always claimed he was born Sean Aloysius John O'Feeney (his real birth name was the less floral John Martin Feeney).

Ford was the tenth of eleven children born to immigrant Irish parents, of which only six lived into adulthood. Upon graduating from high school, after failing to gain an appointment to Annapolis, in the fall of 1914, he enrolled in the University of Maine, but his heart wasn't in it, especially when part of his chores included kitchen service, which he detested. Early on, he got into a fight with a junior, who called him a shanty and he threw a plate of food in the student's face. He was brought before the dean and, afterward, he left the campus and never returned.†

Three weeks after he dropped out, he wrote to his brother asking if he could help find a job for him at Universal. Francis, known to the public as Frank Ford, specialized in Civil War adventures (he portrayed Abraham Lincoln in several films) and westerns, or "oaters" as they were sometimes called (the term was first coined by *Variety,* Hollywood's daily industry publication). Francis wrote back, telling his brother to come out, that there was lots of work he could do behind the scenes.

John arrived at Universal in the fall of 1914 and soon had steady work as Francis's stand-in, with a small part thrown in here and there in the prodigious output of films he starred in.

* Francis Ford, John's older brother, began as a stage actor before heading to Hollywood to become a movie star. One opening night in New York, the lead actor got drunk, and Francis, the understudy, went on in his place. The actor's name was Ford. According to John Ford, "From then on he could never get rid of it; neither could I."—Peter Bogdanovich, *John Ford,* University of California Press, Berkeley, 1978, revised edition.

† Thirty-three years later, in 1947, the university made Ford an honorary doctor of humanities. Later, the school named its Dramatic Arts division after him. He jokingly told reporters that if the school had treated him better when he was a student, he never would have left and gone to Hollywood.

He first learned how to operate a camera while serving as assistant director on several of his brother's films. To pick up some additional pocket change, John donned a white sheet and played a faceless racist in D. W. Griffith's *Birth of a Nation*. Ford was mesmerized by Griffith's masterful direction of his epic. He studied his techniques and became friendly with the director, and he later claimed Griffith was one of the major influences of his own style of filmmaking. In 1917, "John Ford" directed his first film, a western called *Tornado*; westerns would comprise fully one-fourth of his total output. (*Tornado* no longer exists. Almost all the films Ford made between 1917 and 1921 are lost.) He soon overshadowed his brother, who became bitterly jealous of his younger brother's success, and he left the bright lights of Hollywood for the natural sunshine of the South Seas.

Also in 1917, Ford directed *The Soul Herder* (western slang for a preacher). It too is lost but is remembered today as the first of twenty-four movies he would direct that starred Harry Carey. Carey was a Bronx-born law school graduate who had wanted to be a baseball player before D. W. Griffith brought him to Los Angeles, when the director relocated his operation from Queens to Hollywood. Carey became one of Hollywood's primal stoics, whose hard, unsmiling American face became his trademark. His acting style was purely external, reflecting the cowboys he played rather than opening a window to offer a glimpse of his soul. Ford loved Carey because he so perfectly projected the director's image of himself. They fed creatively off each other; Ford learned how to use Carey's stoicism as the foundation for a directorial style that was becoming more expansive without being grandiose, and Carey learned how doing less could reveal more in front of a camera.

Despite Ford's having made him a star, their four-year collaboration ended over Carey's resentment of other members of Ford's growing company of players getting what he felt was more attention. Ford, meanwhile, had wearied of Carey's inflating ego. Ford had made Carey a major star who earned $2,250 a week, to Ford's own $150 salary at Universal. Audiences tired of Carey as well, and he blamed his director for that. In 1921, when Ford got an offer to move to Fox, which offered him higher budgets and a starting salary of $600 a week, it ended the Ford/Carey collaboration of twenty-six westerns and left the director in search of his next great projected screen other.

Ford's first western for Fox was *The Big Punch* (1921). It starred Charles

"Buck" Jones, a Hollywood actor who, in Ford's view, didn't have what it took to be the next Harry Carey. He kept looking when, a few years and several pictures later, a new, unknown, tall, strong, and handsome stagehand literally stumbled into Ford's world. His name was Marion Morrison.

IN 1926, AFTER TWENTY YEARS of marriage, on May 1, Clyde and Mary legally separated. According to public records in the Superior Court of Los Angeles, almost immediately after, Molly filed for divorce. She took Robert and moved in with her parents, who had since relocated to Los Angeles to be near their daughter. Clyde quickly found himself a new girlfriend. Florence Buck, an attractive twenty-nine-year-old who worked in Glendale as a clerk at Webb's department store, was divorced and had a young daughter named Nancy. They fell for each other quickly and lived together while waiting for Clyde's divorce to become final. It would take nearly five years before the courts granted it, on February 20, 1930 (not an unusual amount of time in those days as divorce was discouraged by the California courts especially when there were children involved). Clyde then took Florence, Nancy, and his few possessions and rented a small house in Beverly Hills, not yet the movie star glamour spot it was soon to become, to be nearer to his son. He found work at a nearby electrical supply store, even as his health continued to fail. The asthma and tuberculosis that had caused him to move west had brought on heart disease, something he hid from his fellow employees when he applied for the job.

And he married Florence.

Duke couldn't bear the thought of his father having a new woman and child in his life. When Clyde told Duke he could meet his wife, he said no. Although he never completely forgave his father for leaving his mother, eventually he became close to Florence because of how well she took care of Clyde, and how encouraging and uncritical she was. She brought him a measure of peace, and that meant something to Duke.*

He also had a new girlfriend of his own. He had first met the beautiful,

* "Eventually, Wayne bonded with his stepsister, who later became Nancy Marshall, and with his stepmother, and he played an important role in their lives. As gracious letters from Nancy Marshall to John Wayne indicate, he quietly provided financial support for his stepmother's medical bills in her declining years, and he gave Nancy Marshall occasional work reading and evaluating novels for possible motion picture consideration. . . . Wayne's actions reflect his abiding sense of basic loyalty."—Goldman, *John Wayne: The Genuine Article,* p. 28.

dark-haired Spanish Josephine Saenz, from a prominent Catholic family in the Hispanic section of Los Angeles, at a dance in Balboa he went to with some of his frat brothers. Duke's prearranged date for the evening was Josephine's older sister, Carmen Saenz. After the dance, all the boys and girls went out for ice cream. Joining them was Josephine, whom Duke somehow got to sit next to; according to Maurice Zolotow, he "happened to look into Josephine's eyes. He felt as though something had hit him and suddenly realized that, for the time in his life, he was in love . . . he remembered feeling so hypnotized by the girl that he doubts whether he spoke a dozen words all evening."

The following weekend, only a few days before practice was to resume at USC in preparation for the fall schedule, Duke drove to Balboa to spend some time with Josie, as he was now calling her. Because it was the summertime, he had let his hair grow longer than allowed at USC. It was a look he picked up from some of the other cowboy actors at the studio, who wore it that way for westerns.

This Friday night, during which he was with her in a supper club, someone tried to pick Josie up right in front of him. As Wayne later remembered, "Some punk alongside pipes up, 'Forget about him, lady; not with that long hair.' So I sat her down and went over and explained very quietly to him that if he would step outside, I'd kick his fuckin' teeth down his throat. That ended that."

Saturday during the day, and on Sunday after church, he took Josie to the beach. On his off days he had become a proficient bodysurfer, and wanted to show off for her. She watched from the sand as he had himself towed by speed-boat out to the bigger waves. He caught one too late and was slammed all the way to the bottom of the ocean. When he bobbed to the surface, he felt severe pain in his upper body. He had separated his right shoulder and broken his collarbone. The next day he could barely use his right arm, and at practice, Coach Jones, unaware of his injuries, accused him of having no guts and demoted him off the first string. For the rest of that year, Duke had to wear a specially fitted harness that restricted his movements and made it difficult for him to play.*

The next fall, he was dropped from the team and lost all his privileges, including team workout meals, which he had counted on to save food money. He

* In 1973, Wayne gave a speech to the National Football Foundation and Hall of Fame, in which he claimed it was his leg that had been broken, not his shoulder. There is no evidence that it was his leg, and all other accounts say it was a shoulder injury.

was ostracized for those meals by some of his fellow classmates who were not on football scholarships and resented his free ride. He spent his sophomore year trying to stay in school without being able to play football, but it was no use. In the spring, he quit USC, moved out of the garage apartment he'd shared with his friend, and found a small, run-down place in Beverly Hills, not far from where Clyde was now living.

His father was extremely disappointed when he found out, and Mary was furious. She believed USC was her son's only chance to become a lawyer. And she had her hands full trying to bring up Robert by herself. The boy, as handsome as his older brother, was not nearly as ambitious. He wasn't interested in studies, working, or anything except going to the beach. When he dropped out of high school at the end of the 1927 academic year, Molly blamed Marion for having set a bad example by leaving USC and insisted that he had to let Robert move in with him. She claimed she couldn't take care of him anymore; he was too lazy and she was too tired, and Clyde too sick to take him in. Maybe living with his older brother would be good for the both of them.

Duke reluctantly agreed even though he didn't appreciate Robert again tagging along wherever he went. He spent a lot of time talking with the boy, and he eventually convinced him to go back and finish high school, which he did. Robert later attended USC and played football for the team as a fullback, in 1932 earning the letter that his older brother never got. Nonetheless, Duke was happy for him.

Despite Clyde's and Mary's continuing to separately try to convince Duke to return to school as well, he insisted his mind was made up. He had seen the last of USC, and it had seen the last of him. Dropping out also put an end to his relationship with Josephine. At first, he was too embarrassed to face her. When he finally did call, she told him her parents, the diplomat Dr. Saenz and his wife, who were well set in their community, did not approve of his lack of social status and his association with the "dirty" film industry. Worst of all, he was Presbyterian, not Catholic. That sealed the deal for them. She said they forbid her to ever see him again.

Morose and lonely, Duke drowned his sorrow in eighty-proof self-pity. As he later recalled, "They don't tell you that love hurts. They never tell you how much it hurts. They don't tell you it hurts from the start and I guess it never stops hurting . . . why don't they tell you how much it hurts?"

That May, still afflicted with lovesickness, he drifted up to San Francisco, and when he heard of a steamer about to leave for Honolulu, he decided to stow away and steal himself a free trip to Hawaii. Soon enough, with nothing to eat and unable to sleep, he turned himself in to the captain, in the hopes he would at least feed him. He did, after throwing him in the brig. A month later, when the ship returned to San Francisco, the captain handed Wayne over to the San Francisco Police Department. They declined to press criminal charges and put him on a train back to Los Angeles.

Flat broke and despondent, Duke sought out John Ford at Fox, confided in him, as if he were his father.

Ford felt sorry for the young man and let him hang around the studio and during downtimes on-set, taught him the card game "Pitch," or, as what Pappy's friends liked to call it, "Claiming Low," an old New England game Ford had learned as a child, a version of "High/Low," where each side bets, draws a card, and the high one wins.

As Wayne later remembered, that wasn't the only thing the director showed him. "In the years to come, Ford would teach me everything I knew about filmmaking."

Chapter 3

For the next two years, Duke worked at Fox as a low-paid nonunion property man, putting in a lot of overtime to help his brother stay in school and send whatever was left over to his mother. Through hard work, and toughness, he gradually made himself a valuable team player, mostly under the supervision of "Pappy" John Ford, as good on a movie set as Coach Jones was on a football field. "In those days," Wayne later remembered, "you could operate in every department of pictures. You didn't need a union card. I was a carpenter. I was a juicer [electrician], I rigged lights. I helped build sets, carried props, hauled furniture. I got to know the nuts and bolts of making pictures . . . at the time I had no ambition beyond becoming the best property man on the Fox lot, [because] a chief property man was getting a hundred and fifty a week . . ."

In 1928, not long after *Mother Machree* was released, Duke made his next appearance on-screen, as an unbilled walk-on in Ford's *Four Sons,* a melodrama about the agonies suffered by the mother of four boys in Germany during World War I.* Ford later remembered this incident that happened during one of the most important scenes in the film, an outdoor shot done within the

* *Four Sons* was thought to be lost for seventy years until a print was found in Portugal that was restored by the Film Archive at the Motion Picture Arts and Sciences and Fox. The Duke's face is plainly visible in the restoration. Ford claimed it held the attendance record at New York's Roxy when it was first released.

confines of a Fox stage set: "John Wayne was the second or third assistant prop man, and I remember we had one very dramatic scene in which the mother had just received notice that one of her sons had died, and she had to break down and cry. It was autumn; the leaves were falling, the woman sitting on a bench in the foreground—a very beautiful scene. We did it two or three times and finally we were getting the perfect take when suddenly in the background comes Wayne, sweeping the leaves up. After a moment, he stopped and looked up with horror. He saw the camera going, dropped the broom, and started running for the gate. We were laughing so damn hard—'Go get him, bring him back.'

"They finally caught up with him and he came back sheep-faced. I said, 'All right, it was just an accident.' We were laughing so much we couldn't work the rest of the day. It was so funny—beautiful scene and this big oaf comes in sweeping the leaves up."

Work continued to come Duke's way. He made two unbilled appearances in Ford's *Hangman's House,* a Foreign Legion epic starring Victor McLaglen, in a fantasy sequence of a man about to be hanged and again as a spectator at a horse race who gets so excited he breaks down the fence (only one scene survived the final cut). He also worked on Michael Curtiz's *Noah's Ark,* in which Duke and a young and slim Andy Devine did stunt swimming. He then found himself back with Ford for *Strong Boy* (1929), again starring McLaglen. Duke did props and worked as an unbilled extra.* For Benjamin Stoloff's *Speakeasy* (1929) he once again did props.†

James Tinling, a former Fox prop man himself turned director, gave Duke his first on-screen credit, "Duke Morrison." He had seen him around the lot, liked his looks, and cast him in a frat-boy musical, *Words and Music,* about college students competing for the attention of coeds, a film Fox made to show off its newly developed ability to make films that could talk and sing and appeal to young ticket-buying audiences.‡ In it, Duke played an undergraduate. He wore a tuxedo and danced the fox-trot with Lois Moran, an actress who could not

* The only existing print of *Strong Boy* is believed to be in a private collection in Australia.
† *Speakeasy* is considered lost, although some of its sound track is believed to have survived on Vitaphone-style disks.
‡ *Words and Music* still exists but may not be currently available in complete form.

make the transition to sound films and soon after retired. (F. Scott Fitzgerald later fell in love with Moran and described her as "the most beautiful girl in Hollywood." She may have been the model for Rosemary Hoyt in Fitzgerald's novel *Tender Is the Night*.)

Duke followed his work in that movie with Ford's *The Black Watch* (1929), the director's first all-talking film, a British-army-in-India saga again starring McLaglen.* Duke was put in charge of props and did an unbilled walk-on, along with the then-unknown Randolph Scott. For Ford's 1929 *Salute*, an Army-Navy football film, he did props and extra work on the field, along with some members of USC's 1929 football team, each of whom was paid $50 a week (up from the $35 they were offered, after Duke successfully argued with the studio for the extra $15 for him and each member of the team).†

One of USC's players was Wardell (Ward) Bond, whom Ford liked because he was strong-looking with a face like a bulldog, and thought it would make Bond stand out. Upon reviewing the team Ford yelled out, "I want the big ugly guy." Bond, however, was nearly fired during filming for exceeding his daily food allowance of $20 a day. He was a big eater, especially when the food was (almost) free. When Duke stood up for Bond, he was fired instead; he was rehired only after Bond organized a strike among the football players and Ford, in a move of solidarity, purposely exceeded his own food per diem, daring the studio to fire him too. Duke was quietly rehired and the strike went away. Ford liked both boys: "Ward Bond and Wayne were both so perfectly natural, so when I needed a couple of fellows to speak some lines, I picked them and they ended up with [unbilled] parts."

Duke and the entire USC team went directly into Eddie Cline's footballer, *The Forward Pass*, followed by A. F. Erickson's *The Lone Star Ranger*, an oater in which he served as a horse wrangler, stunt double, and bit player. John Ford then directed a film called *Men Without Women* (during production known as *Submarine*), the story of fourteen men trapped in a disabled submarine, noteworthy among other things as the first collaboration between Ford and screen-

* *The Black Watch* is occasionally shown on Turner Classic Movies.
† *Salute* is available on DVD.

writer Dudley Nichols.* *Men Without Women* starred George O'Brien, and to give Duke a chance to earn more money, Ford hired him to perform several stunts during the film's diving sequences, and to act in two unaccredited parts, a sailor in the doomed submarine and a radio operator on the rescue ship.

With the assistance of the U.S. Navy, which loaned the production the use of a fleet submarine, Ford wanted to shoot a scene on location both on and near the island of Santa Catalina that required a stuntman to jump from the ship into the sea. A yacht was anchored offshore with an air pump ready to agitate the waters for the duration of the shoot, but it wasn't needed because a storm had churned up the ocean. That made it an even more dangerous stunt; since the weather couldn't be controlled, the two assigned stuntmen refused to make the dive, even with the extra hazard pay of $75 for each scene.

Pappy was furious. According to Hedda Hopper, an on-set observer at the invitation of the director, "Ford turned to Wayne who was standing around, cranking the pump and said, 'Over you go. Show these chicken-livered slobs up.'"

Ford himself later recalled the incident this way: "A blank of a blank blank [*sic*] storm came up and our two blankety blank [*sic*] stuntmen who were supposed to come up in bubbles, like they'd been shot out of an escape hatch, said it was too rough to work . . . Well, Duke was standing on the top deck of this boat we were on. He wasn't supposed to go in the water at all, but I asked him if he'd try this stunt. He never said a word, except 'Sure.' Dove right into the cold water from that deck. I knew then that boy had the stuff and was going places."

Although he figured he was due the extra money for all the stunt work he did that day, when it came time to sign his work sheet, Duke saw he was only being credited $7.50 for pump cranking. When he asked the production paymaster why, he was told that he wasn't listed as a stuntman, and therefore, he couldn't receive stuntman pay. He desperately needed the extra money but said nothing about it. He didn't want to be seen as a troublemaker, especially to Ford, who hated complainers. "I haven't a thing to squawk about. I'm just a lucky ham," was all he would say. On the twenty-six-mile boat ride back to the mainland,

* *The Forward Pass* is believed to be lost, but some elements exist at UCLA's Film and Television department. *The Lone Star Ranger* was the third remake of a popular novel. Ford's version was billed as "Zane Grey's first all-talking picture." A print exists in the UCLA Film and Television Archive. *Men Without Women* exists as an international sound version held by the Museum of Modern Art, in New York City.

he made up his losses by winning $600 in a high-stakes poker game with some of the crew.

IN ADDITION TO ALL THE work and extra money he had in his pockets, after taking care of Robert, his mother, and his father, he still had enough left over to ask Josie out. She accepted, and after only a few dates, he told her he had a steady job with enough money to be able to take care of her, and he asked Josie to marry him. She said yes, if her father gave his approval. Duke went to him and once again he didn't. He left empty-handed and disappointed but took it like the man he told Josie he had become. He was sure he would eventually be able to change her father's mind.

BY THE END OF 1929, Duke had become a familiar face with the Fox Studio stars, contract players, and off-screen workers who busily crisscrossed the lot like ants on a hill. He met and became good friends with one of them, Ewing Scott, a young assistant director who liked to have a good time at the end of the working day. They started hanging out together nights, for dinner and drinks, sometimes skipping dinner and going straight to the drinks. After a few, they would confide their sorrows and complaints to each other about the injustices of those who worked at the low end of the studio. Duke also poured his heart out to Scott about his problems with Josie. Scott listened patiently and his answer was always the same. *Let's have another round.* By eleven each night, they were both pretty much done, Duke in his cups, Scott feeling no pain.

Somehow, the next morning, he always made it to the studio on time no matter how early the call, available for whatever anyone needed him for that day, all the while keeping his eyes and ears open, watching how the stars did their magic in front of the cameras, and how the crews could build a dream out of two-by-fours, hammers, nails, paint, and lights. He continued to get unaccredited walk-ons and extra work mostly in props, a job made easier by the massive air-hangar-size prop warehouse Fox had; if he couldn't find what he wanted there, nearby rental outlets kept full inventories of whatever junk a director might want to use.

Ford used him off-screen whenever he could because he liked him: "He was just a rangy, overgrown boy who looked too tall for his clothes. But there was something about the confident way he carried his body that caught my eyes."

He used Duke again for *Born Reckless,* Dudley Nichols, a sequel of sorts to *Words and Music.* Andrew Bennison was originally supposed to direct it, but he was fired after only four days and replaced by Ford (Bennison shares director screen credit). Duke did props on the film, which turned out to be a real stinker. Even Andrew Sarris, one of Ford's greatest admirers, called it, "By any standard, one of the worst movies ever to come out of Hollywood."

Next up for Duke was Sidney Lanfield's *Cheer Up and Smile* (1930), another football film, this one with music and song. The film starred Arthur Lake, who would go on to play Dagwood Bumstead in the *Blondie* movies. Duke received screen credit for his bit in *Cheer Up and Smile,* again as "Duke Morrison." After that, he played a card player in two scenes with a single line of dialogue in A. F. Erickson's *Rough Romance,* with no accreditation.*

And then, after years on the thankless sidelines, Duke Morrison was reborn as John Wayne, baptized on the road to stardom not by Ford, but former D. W. Griffith silent-actor-turned-director Raoul Walsh.

If Ford was a director whose love of and devotion to family drove the action of his films, and Howard Hawks's were action-oriented stories that propelled his characters through and out of their emotional entanglements, Raoul Walsh's fall somewhere in between, with characters driven by a perverse love of power. Ford divided by Hawks equals Walsh.

The wildly handsome and gruffly macho Walsh, who had helmed a number of silent films, played John Wilkes Booth in Griffith's landmark 1915 *The Birth of a Nation.* After that, he appeared in or directed a number of silent films until 1929, when, along with Irving Cumming, he got a chance to direct Fox's first western "talkie." It was called *In Old Arizona* and proved a huge hit with audiences.

The film introduced two new things to American moviegoers, the character of "the Cisco Kid," here played by Warner Baxter (later in movies and TV by Duncan Renaldo), the first screen appearance of the character that originally appeared in O. Henry's short story, "The Caballero's Way." Baxter won an Academy Award for his performance, and the film was nominated for four more. Walsh had originally been set to play the Cisco Kid himself until he was in a freak auto accident when a jackrabbit crashed through the windshield

* *Cheer Up and Smile* is available on DVD. *Rough Romance* is available on DVD.

of the vehicle he was driving. It cost him his right eye, which he kept covered with a black patch the rest of his life that put an end to his acting career. The other thing the sound film *Old Arizona* introduced to the world was the singing cowboy. In the film, when Baxter, as Cisco, sang "My Tonia," a new and absurd genre was born.

Following the huge commercial success of *In Old Arizona,* William Fox bought a new script for Walsh to direct called *The Big Trail,* the most expensive, most ambitious film the studio would make that year. He had heard that Paramount Pictures had developed something called Magnafilm, a 56 mm negative frame that enlarged and widened the movie screen from the standard 1.33.1 ratio that had been in place since 1892, to 1.65.1. Fox ordered his technical people to come up with something better. In 1929, they developed "Grandeur," a 70 mm process that could project a widescreen 2.20.1 image (65 mm for film, 5 mm for optical sound tracks). Fox then ordered Walsh to film *The Big Trail* in Grandeur.

The studio head had a lot riding on this film. Fox had recently tried, unsuccessfully, to take over MGM, which itself was caught in the expensive silent-to-sound upgrade, and when he failed, he faced an arduous and expensive lawsuit from the government, instigated by Louis B. Mayer, who had strong connections in the nation's capital, charging the studio with having violated antitrust laws. Fox now needed a hit, a big one, to fight the lawsuit and keep his studio. A bad car accident he was in and the stock market crash made things even worse.

WALSH'S FIRST CHOICE TO PLAY the leading role of Breck Coleman in *The Big Trail* was everybody's first choice for any western, Tom Mix, who was at the time making another film and had to turn down the role. Walsh's second pick was Gary Cooper, red-hot after Victor Fleming's 1929's *The Virginian* and Josef von Sternberg's *Morocco,* in which, as a member of the French Foreign Legion (where, curiously, everybody speaks English), he drove Marlene Dietrich and every woman in America crazy, until at the end of the movie, Dietrich, in an act of symbolic sexual submission, removes her shoes and follows him into the desert. Women loved it, believing they would follow their man into the desert as well, if he looked like Gary Cooper. These were only two of the ten movies Cooper made between 1929 and 1930, but they were the two that made him the hottest star in Hollywood. He wanted to take the role in *The Big*

Trail but was under contract to Samuel Goldwyn, who refused to lend out his valuable star to anyone.

Bill Fox had already invested more than $100,000 in preproduction (not counting the cost of the technical development of Grandeur) but because he was still recovering from his auto accident, he assigned Winfield "Winnie" Sheehan, the head of production at Fox, to sit on Walsh to make sure he got the film made on time and without going over budget. Sheehan, a former secretary to the New York City police commissioner, was a tough, no-nonsense executive who had helped Fox fight off the notorious Motion Picture Patents Corporation, otherwise known as the Edison Trust, in the pioneering days of early Hollywood. Fox kept the pressure on Sheehan, and he kept it on Walsh, who, despite all the urgency, hadn't as yet shot a foot of film because he still didn't have a leading man.

Then, one afternoon while walking through the studio on the way to the commissary, Walsh happened to pass by and watch as a young man, shirtless and muscles rippling, dropped a large table he was carrying, balanced on his head, out of one of the studio's prop warehouses. Walsh noticed that this furniture mover "had a western hang to his shoulders and a way of holding himself and moving which is typical of a westerner . . . He was tripping over the light cables, but he was big and looked like a he-man. . . . His hips were flat enough to fit into a pair of cowboy pants." And there was something else. He had a face that, although not traditionally handsome in a leading man sort of way, bore more than a passing resemblance to Gary Cooper's.

Walsh asked the furniture mover if he could act.

"Don't be silly," Duke said, "I can't act."

For the first time Walsh heard the halting, slightly high-pitched voice that was to become familiar to audiences around the world. "Maybe you could learn."

"I couldn't learn in a thousand years."

Walsh decided to screen-test him anyway.

He scheduled one for Duke, which he failed because his voice sounded too nasal on film. The director told him to go to the top of Mulholland Drive and scream out loud until he was hoarse, so he would sound like a man of his size and build. He then tested Duke again. Walsh liked what he heard and wanted to cast him on the spot, but Sheehan still wasn't sure; this was a big, expensive movie to put on the shoulders of a complete unknown. Bill Fox had a lot

riding on this, he reminded Walsh, and that it might be too risky to use someone in the lead whose acting abilities had not been proven. The next day, over Sheehan's strong objections, Walsh gave Duke the part anyway. "I had to find someone immediately . . . What I needed was a feeling of honesty, of sincerity, and Wayne had it."

Sheehan, realizing he couldn't prevent the young unknown from being in the film, then argued that the name Duke Morrison was too long for a marquee and didn't suit the star of a western movie. He and Walsh spent a few hours together running down names. Walsh later remembered, "We called him Joe Doakes and Sidney Carton and all those sort of names—and I remembered I had read a book that I liked one time about 'Mad' Anthony Wayne. I thought this Wayne was a great character. So I said, 'Let's call him Anthony Wayne or Mad Wayne or whatever the hell you want to call him, call him Wayne.' Well, they called him John Wayne. That's how he got his name." Short, tough, and sounding a lot like John Payne, who was a big star. If people bought tickets thinking they were going to see John Payne, that would be all right too.

Wayne remembered it this way: "The studio decided that Marion was not exactly a proper name for an American hero and Duke sounded a little too vulgar, for some reason. So they came up with John Wayne. It's worked all right for me." Some believe Wayne himself came up with John as an homage to John Ford.

As production began in the spring of 1930, Duke Morrison cross-faded into John Wayne. "I was determined to be as cooperative as possible," Wayne later wrote in an unpublished memoir. "After all, Fox had given me a great many opportunities, first as a prop man and then as a stuntman and an actor. They started what was called a star buildup campaign for me. Who was I to complain?"

Walsh then sent Wayne to the studio's resident voice and acting coach, Lumsden Hare, a Broadway veteran who was a master teacher of the neutral sound of Eastern Standard speech. Fox hired Hare after the arrival of sound to train the studio's actors and actresses how to speak for the microphone. Wayne hated it. "My teacher had me rolling my r's like I was Edwin Booth playing Hamlet. I felt ridiculous."

Despite all the lessons, his voice remained higher than a baritone, accompanied by an intimidating squint of his eyes whenever he spoke, and the jerky arm and neck movements that made it look as if he were about to throw a

punch every time he turned his head. To learn how to toss a knife for the picture, he was trained by stuntman and good friend Steve Clemente, and for roping, gun handling, and horseback riding, by another Fox pro, Jack Padgin.

Production on *The Big Trail* began with a three-hundred-man crew on location in Yuma, Arizona, where Wayne referred to Walsh in football rather than film terms, as "Coach." Wayne played Breck Coleman, a young trapper who is enlisted by the government to help cross the Oregon Trail and open up the Wild West to commerce, trade, and land development. A band of pioneers assembles at the Mississippi to begin their historic quest. Early on, Coleman is suspected of having killed a trapper for his furs while he suspects one of the other trailblazers, wagon boss Rod Flack (played by the handsome Broadway star Tyrone Power Sr.). Meanwhile, Coleman finds love with young Ruth Cameron (Marguerite Churchill), who is close with a gambler friend of Flack. Coleman and Flack lead the settlers west, while Flack does everything he can to have Coleman killed. Flack and his gambler friend have joined the caravan to avoid being hanged for previous crimes. The settlers' trail ends in the Willamette Valley of Oregon, where Coleman kills Flack and his friend, and settles down with Ruth.

After a week of filming, with all the other actors sounding like Broadway actors trying to sound like cowboys, a disgusted Walsh told Wayne to forget everything he'd learned in his speech lessons, to just speak in the halting way he normally did, and to leave in that funny walk of his. Years later that walk and talk would become every comic impersonator's bread and butter.*

* There are several versions as to where Wayne got his trademark walk from. Later on, Wayne would give the credit to Enos Edward "Yakima" or "Yak" Canutt, a former rodeo rider and stuntman, who, when he realized he could get paid for being thrown from a horse in the movies, became one of the most sought-after stuntmen in Hollywood, especially for western films. Canutt also taught Wayne how to fall from a running horse without getting hurt, the physical techniques of staged barroom brawling, and the right way to draw and shoot a gun. Wayne gave Canutt a fair measure of credit for helping develop the famous stylistics of his familiar stance: "I even copied Yak's smooth-rolling walk. And the way he talks, kinda low and with quiet strength."—John Wayne from Don Allen, *The American Weekly*, November 30, 1957. Also influential in helping Wayne to "screen fight" were stuntmen Allen Pomery and Eddie Parker. Harry Carey Jr. claimed Wayne's walk didn't fully develop until nearly a decade later, and that it was Paul Fix who helped Wayne find his trademark trot: "Duke was kind of heavy-footed and used to trudge more than walk. Paul told Duke to point his toes when he walked, and the 'John Wayne walk' was born . . . When Duke first did it [in *Stagecoach*], it was ballsy as hell. As the legend began to form, the walk became more pronounced."—Harry Carey Jr., *Company of Heroes*, pp. 72–73.

The production was mired in Yuma for twenty-eight days, during which time Wayne kept mostly to himself. He didn't drink with the other actors. Nor did he have much to do off-screen with the film's leading lady, Marguerite Churchill—a Broadway actress discovered by Sheehan who was also being given the big studio buildup—after she made it clear to Wayne when he'd made a pass at her that he'd be better off spending whatever free time he had studying his lines.

After finishing up in Yuma, the caravan moved to Sacramento, where Walsh wanted to film a river sequence. It was in Sacramento that the production began to come apart. Part of the problem was the widespread weariness among the cast and crew, who weren't used to doing so much traveling to make a movie. At the time, most Hollywood films were shot on soundstages in Hollywood, where it was possible to re-create almost any setting, indoors and out. Few, if any connected to the production, including Sheehan, had agreed with Walsh's decision to take the film on location but Walsh argued, convincingly, that shooting in Grandeur was going to make fake sets look even more unreal than usual. He insisted that for the widescreen, they had to shoot *The Big Trail* outdoors in Sacramento.

As soon as they were set up, crates of bootleg whiskey suddenly arrived for the cast and crew, much-needed balm imported by them to get through the increasingly long and difficult production. Walsh demanded throughout the location shoots that the actors be ready to film at dawn, so he could catch the all-important first rays of golden sunlight and before the heat became unbearable. The actors, mostly out of the New York theater, where they could sleep all day and perform at night, hated him for it, and he had little use for them. As Walsh later recalled: "Sheehan and [Bill Fox's executive assistant] Sol Wurtzel figured this boy [Wayne] should have some help. They sent back to New York and they engaged five prominent character actors, the most prominent actors of the day, and brought them out and surprised me with these fellows . . . I knew none of them had ever seen the sun rise or the sun set—I knew I was going to have a hell of a time with them. We got on location, got started and I called John and said, 'sit beside me when I'm directing these character actors, because they're the best and you'll learn something from them.' Well, the night before, a bootlegger got in to them and they were pretty well oiled up for this scene. Not only did they scare the Indians that were sitting around, they scared the hawks and the crows that were in the trees . . . these great character men stayed

loaded all through the picture, and things finally got so bad we nicknamed them Johnnie Walker, Gordon Gin, and several other names of whiskey."

The script, too, was a problem. It suffered from a lack of any stylistic cohesion, having been written by committee—story by Hal G. Evarts, dialogue and sequences woven together by Marie Boyle, Jack Peabody, Florence Postal, and Fred Sersen—which on location made it difficult to get the quick rewrites necessary to adapt the reality of the locales to the logic of the story.

Finally, the massive and delicate Grandeur equipment was extremely difficult to set up, break down, and move from site to site. Dozens of expensive motors for the cameras burned out and had to be replaced. Every scene had to be shot at least three separate times, once for the Grandeur format, once in the standard 35 mm so it could be distributed in cities where there were no theaters equipped with the widescreen equipment, which was most of them, and once in German (Walsh was helped with that version by Lewis Seiler), part of Fox's still-grand scheme to become the king of world cinema. Having some of the actors try to speak phonetic German proved a nightmare for Walsh, and after a lot of wasted time and money, much of the German version was eventually overdubbed.*

EVEN WITH ALL THESE DIFFICULTIES, Walsh continued to drag his cast and crew across the face of the American West another four months, to Jackson Hole, Wyoming; the Grand Teton Pass; St. George, Utah; Sequoia National Park; Moise, Montana. And it paid off. Many of the wagon train sequences shot by cinematographers Lucien Andriot and Arthur Edeson are stunning, and Walsh's use of natural sound was innovative and exemplary.

* Some but not all the scenes for the American version were shot only in Grandeur and then trimmed to fit the standard format. There were actually several more foreign versions made of the film. Fox jobbed out the shooting script to France, where it was directed by Pierre Couderc. The Spanish version was directed by Walsh, David Howard, and Samuel Schneider. There was also a separate Italian version. In the early 1980s, the Museum of Modern Art in New York City acquired the original 65 mm nitrate camera negative for *The Big Trail* and wanted to restore the film, but the negative was too fragile. They then took it to Karl Malkames, a cinematographer and a specialist and pioneer in film reproduction, restoration, and preservation. He designed and built a special printer to handle the careful frame-by-frame reproduction of the negative to an anamorphic (CinemaScope) fine grain master. A two-disc DVD version of the restored film was released in the United States on May 13, 2008, followed by a Blu-ray edition in September 2012.

However, the physical strain on machines and humans continued to take its toll. Wayne became seriously ill during filming: "I was three weeks on my back with *turistas*—or Montezuma's revenge, or the Aztec two-step, whatever you want to call it. You know, you get a little grease and soap on the inside of a fork and you've got it. Anyway, that was the worst case I've ever had in my life. I'd been sick for so long that they finally said, 'Jeez, Duke, if you can't get up now, we've got to get somebody else to take your place.' So, with a loss of eighteen pounds, I returned to work while I puked and crapped blood for a week."

In the end, the biggest problem with the film's star was not his health but his acting. Wayne's lack of real-life experience showed in his on-screen lack of authority. Breck Coleman is the key character of the story, a star turn, the one who keeps all the plot strands of the film together. Much of Wayne's acting comes off overly stiff, with exaggerated hand gestures and facial expressions meant to "show" what he was thinking, instead of illustrating what he was feeling. And when it came to the love scenes with Marguerite Churchill, the uptight Wayne had absolutely no idea how to approach her or them. Some of the other actors giggled at his attempts to be romantic (as audiences would when the film opened). They came off tentative, imitative, and artificial.

Walsh realized too late that the big difference between John Wayne and Gary Cooper was something all the lessons and lenses in the world couldn't fix. Cooper sizzled on-screen, a quality that got him through the most ridiculous of scenarios, like *Morocco*, but Wayne plainly had no heat. He acted at room temperature, and it would keep him from ever becoming a romantic leading man.

As visualized by Walsh, *The Big Trail* was a metaphor for the journey of life, with its Chaucer-like multiplicity of stories that emerge from under the umbrella theme of progress. However, with too many writers to make it a unified whole, and with the limitations imposed by having to shoot in Grandeur, the momentum of the Great American Dream is viewed only from an external viewpoint, too much vista, too little vision.

The Big Trail premiered November 1, 1930, a noisy, flashing, lavish spectacle of a night, complete with klieg lights rotating in front of Grauman's Chinese Theater, followed the next day by awful reviews and after that, mediocre box office. Walsh was, at this point in his career, still directing with an actor's eye rather than a director's, and it limited his ability to construct a convincing mise-en-scène.

Wayne, too, had to share some of the blame. He had not had enough training or experience to carry a major motion picture. His acting was full of exaggerated motions he had learned watching silent film. He didn't yet know how to do more in front of a camera by doing less, to trust that the camera could look into rather than just at him.

THE RECRIMINATIONS FROM THE FILM'S failure ran deep. *The Big Trail* all but ended Marguerite Churchill's run as a movie star. She never again starred in a major motion picture. It was Tyrone Power Sr.'s only "talkie" and his last film. He died the next year of a heart attack, in his star-to-be son's arms. After finishing out his contract with Fox, Walsh moved to Paramount and floundered for nearly a decade before he landed at Warner Bros and found his auteurist soul directing *The Roaring Twenties* in 1939, with Humphrey Bogart and James Cagney as the *yin* and *yang* of Depression-era crime.

The Big Trail was seen in its original intended Grandeur form in only two theaters, the Roxy in New York and Grauman's in Los Angeles. The rest of the country and the world saw it in standard 35 mm, which is to say they didn't really see it at all. After the film's brief run ended, William Fox warehoused all his Grandeur equipment, and widescreen 70 mm would not be used again until the early '50s, when it was revived as part of the dying industry's attempt to combat the ubiquitous but small television screen.

The film's financial failure signaled the end of William Fox's career as a Hollywood mogul. He eventually served six months in jail for perjury, having to do with the government's antitrust lawsuit. When he was released, he declared bankruptcy and retired from the film business. In 1935, under new management, the studio was taken over by Twentieth Century in what was politely called a merger. Under the leadership of Darryl F. Zanuck, Twentieth Century Pictures became Twentieth Century–Fox. William Fox moved back to New York City and died in obscurity in 1952 at the age of seventy-three. No Hollywood producers came to his funeral. (In his unpublished memoirs, Wayne graciously gave William Fox and his studio credit as the person and institution that gave him his first big opportunity in Hollywood.)

With his star turn a bust, Wayne did not appear in another movie for a year and a half. Zanuck finally put him in one after demoting him to the Bs, the

cinematic dead end for has-beens or never-wases. The whole experience left him bitter and broke: "So I was the star of a super-spectacle $3 million picture. What a laugh. My salary was all of $75 a week."

Without money, without a future, and without a dream, he did what any twenty-three-year-old would do in his situation.

He decided now was the perfect time to think about setting down and getting married.

Chapter 4

"I can't act and I couldn't learn in a thousand years," Wayne had warned Raoul Walsh when he cast him in *The Big Trail*, and he made good on his prediction. After, whenever anybody asked him why the film failed, he manned up and refused to blame anyone else for the film's failure, citing only his own inability. That was his way.

He determined to better himself. According to one friend, "He was obsessed with the idea of becoming a good actor." After *The Big Trail*, he tried to repair the real damage that had been done to his career. Sheehan and Wurtzel ignored him whenever they passed Wayne at the studio, as if he didn't exist.

With the Fox studio in disarray, and little in the way of a big-name talent pool, early in 1931 the studio finally threw Wayne a bone. He was cast in his twentieth film as the lead in *Girls Demand Excitement,* another college campus coed comedy romance, with Wayne in the lead and Marguerite Churchill as his female counterpart. Teaming them together again in this B movie spoke volumes about what the studio thought about the two. Also in the film was Charlie Chaplin's discovery, Virginia Cherrill, the blind flower girl from *City Lights*. Wayne told his friend and biographer Maurice Zolotow he had had a brief but intense affair with Cherrill during the making of *Girls Demand Excitement.**

* *Girls Demand Excitement* exists in an unreleased print held by UCLA.

Variety quickly dismissed *Girls* and Wayne this way: "John Wayne is the same young man who was in *The Big Trail* and also is here spotted in a farce that does little to set him off." In the film, the male students want all the female students thrown out of their college (try selling that script today!). Wayne always considered it the silliest film of his career. He probably wasn't wrong. And if he needed any more proof that his star, however brief, had fallen, the *Variety* review provided it. One day he ran into the great Will Rogers ("Oklahoma's favorite son") on the lot, and Rogers, who hardly knew Wayne, patiently listened as Duke spilled his guts to him. When he finished, Rogers smiled, put a hand on the young actor's shoulder, and reminded him how lucky he was to be working at all in these hard times. The chance meeting with Rogers gave Wayne a boost. He only had one more film left on his Fox contract, and after that if he worked again, he would do it, as Rogers told him to, with his chin up.

Fox next put Wayne into *Three Girls Lost* (1931), produced and directed by former jazz musician and vaudevillian Sidney Lanfield, who would go on to direct a number of Bob Hope comedies, about as far away from Wayne's world as possible. In *Three Girls Lost,* from a script by Bradley King, and costarring Loretta Young, Wayne played a gentleman architect in something resembling a western drama. He was woefully miscast and knew it. After the film's failure at the box office, the studio declined to renew his contract and cut him loose.*

The only thing going right for him was his relationship with Josephine, and it wasn't going well at all. They had been dating now for five years (with that brief breakup when he quit school), since they first met when she was sixteen and he nineteen. Because of Wayne's busy schedule, and her father's strict rules regarding Josephine's social life, they only saw each other one night a week. The first face he saw whenever he came by to take her out was that of the unsmiling Dr. Saenz, which was also the last face he saw when he brought her home. Dr. Saenz continually made it clear he didn't like Wayne. He had no use for actors, especially unemployed ones, especially this one. Wayne may felt some measure of guilt for not being able to remain true to Josephine with Virginia Cherrill, and his flirtation with Churchill, and dealt with it by deferring to Dr. Saenz's hard rules. Maybe the good doctor was right; maybe he wasn't good enough for his daughter.

* *Three Girls Lost* is available on DVD.

WITHIN A MONTH OF HIS contract expiring at Fox, in the spring of 1931 Wayne signed with Columbia Studios. Its founder was the "I don't get ulcers, I give 'em" Harry Cohn, a former streetcar conductor who had worked for a time at Paramount before starting Columbia Pictures in 1922 with his brothers and Joe Brandt.* Cohn liked Wayne's looks, thought he had some talent but had never been used correctly at Fox. Cohn was willing to take a chance on Wayne because it wasn't that much of a risk; he signed him to a five-year contract, at $250 a week, with six-month out-clauses for each side.

Located on North Gower Avenue in Hollywood, the "Poverty Row" of moviemaking studies, Cohn was looking to expand his stable of actors by signing other studios' discards on the cheap. Some were available because their previous pictures hadn't done well, as was the case with Wayne; others wanted more say in what pictures they made and thought they could get it going freelance, like Cary Grant, who signed nonexclusive deals with Columbia and RKO after a bumpy start at Paramount. Already acquired by Columbia were Katharine Hepburn, Mickey Rooney, and Humphrey Bogart.

Cohn wasted no time putting Wayne to work in George Seitz's *Men Are Like That*. Seitz was a journeyman director who had made his reputation directing Pearl White Saturday morning serials. *Men Are Like That* was a remake of a remake, this version written by Robert Riskin, a young and successful Broadway playwright Cohn had brought to Columbia to write scripts for the studio.† *Men* went into production that May, a five-day shoot to be ready for release in August. In it, Wayne plays an army lieutenant in yet another college-football-based romantic comedy, this time opposite silent film sensation Laura La Plante, who was trying to make the transition to sound. *Men Are Like That* was produced for very little money and managed to turn a profit, but Wayne fell flat on his face at Columbia when Cohn thought his new leading man was sleeping with the same actress that he was. Cohn angrily confronted Wayne. "When you work for this studio, you keep your pants buttoned," he said pointing his finger in Wayne's

* Originally called CBS Film Sales Corporation, and disparagingly referred to as "Corn beef and cabbage" among the other studio heads, Brandt left over differences with the brothers. Harry Cohn then became the sole head of the renamed Columbia Pictures.
† Also known as *Arizona,* the title of the August Thomas Broadway play it was based on. Riskin would go on to write many of Frank Capra's Columbia films and marry Fay Wray, of *King Kong* fame. No DVD is currently available.

face as he did so. Whether or not he actually slept with one of Cohn's many paramours, Wayne apologized and promised it wouldn't happen again.*

In his next film for Columbia, Louis King's 1931 *The Deceiver,* Wayne played a dead body. After, Cohn called Wayne into his office and sarcastically told him it was his best performance yet.

Despite Cohn's fury at him, at the end of his first six months Wayne asked for and got a renewal and a raise to $350 a week. The vindictive Cohn agreed to the extension and the raise to punish Wayne. The star of Fox's grandiose *The Big Trail* was permanently reduced to making cheapies, and was humiliated by having to appear in them. He did D. Ross Lederman's 1931 sixty-four-minute *Range Feud,* made for all of $25,000 (at Cohn's directive, all B movies had to run no longer than an hour), to keep production costs to a minimum. The film's star was the dark-haired, square-jawed Buck Jones.† In the film, Jones is the sheriff. Wayne is the son of a rancher falsely accused of killing a rival rancher. He is redeemed when Jones finds the real villain, the bank robber/cattle rustler/murderer.

In his next assignment, Edward Sedgwick's 1931 *Maker of Men,*‡ Wayne's role is little more than a bit part, a dishonest college athlete in bed with gamblers. The film is notable for featuring former Olympic swimming champion and the future Flash Gordon, Buster Crabbe, and Wayne USC teammate Ward Bond (who had by now dropped the "en" from his first name). *Makers of Men* was yet another college football film, a genre that still had some low-test left in its gridiron tank, set in mythical Western University, a thinly disguised version of USC; Wayne felt uncomfortable with the studio's publicity tour that touted his and Bond's successful careers playing football together at USC as a way to add a touch realism to the film.

On the advice of friend and fellow actor George O'Brien, who had come up with Wayne through the Fox system and had also signed with Columbia, Wayne met with Al Kingston, a former Hollywood beat reporter now an agent for the Leo Morrison Agency, located in the Roosevelt Hotel on Hollywood

* In his biography of Wayne, Zolotow claims his friend was innocent of any philandering and that the unnamed starlet had made up the stories about her affair with the Duke to make Cohn jealous.

† Jones had toiled in a series of westerns at Fox that were considered secondary to the Mix films they made. The low point of his career is generally considered to be the films he made at Columbia. *Range Feud* may be downloaded for free from the Internet.

‡ A.k.a. *Yellow. Makers of Men* is available on DVD.

Boulevard. The Morrison Agency had a talented crop of players, including Jean Harlow, Buster Keaton, Francis X. Bushman, and a young up-and-comer by the name of Spencer Tracy.

He was not familiar with taking business meetings and was nervous about meeting Kingston. A few minutes into their conversation, Wayne broke down in tears as he recounted the sad story of his professional downward spiral. Kingston listened patiently, used to the emotional high wires that actors walked. Kingston saw in this weeping giant the potential for bigger things than bit parts at Columbia, and decided to take him on. His first objective was to get his client out of the prison of Columbia Pictures. At the end of the next six-month cycle, Kingston informed Cohn that Wayne was not going to renew. After finishing up his last B for the studio, D. Ross Lederman's *Texas Cyclone*, at the start of 1932, Wayne was free to work for any studio that wanted him.*

The problem was, none did. It took several months for Kingston to secure a modest, nonexclusive deal for Wayne with B movie and serials maker Mascot Pictures, fifteen hundred dollars for three serials. Kingston convinced his reluctant client to take it. He knew that Wayne's strength was his physical abilities, which would be put to ample use in an action-cycle adventure, and his weakness was expressing his emotions (his best performance to date had been in Kingston's office that day).

Mascot Pictures, the brainchild of Leo Levine, was so sparely run it made Columbia seem luxurious by comparison. In 1926, Levine had caught a wave with "chapter pictures," or "serials," Saturday morning supplements that helped build a following among teens in a time period that had previously left movie theaters almost empty until the early evening. Levine had put together a troupe of actors composed of hopefuls, veterans, and has-beens that included Yakima "Yak" Canutt, whose superior physical abilities were crucial for the action-packed serials that depended upon a "death-defying cliff-hanger"; Harry Carey, John Ford's former leading man; and a talented dog named Rin Tin Tin, to which he now added John Wayne.

Duke went to work as the star of a new Mascot serial, *Shadow of the Eagle*, playing Craig McCoy, a stunt pilot, with an endlessly loyal, beautiful, faithful, and chaste girlfriend named Jean, played by Dorothy Gulliver.† In the serial,

* *Texas Cyclone* is available on DVD.

† All twelve episodes of *Shadow of the Eagle* may be seen on YouTube.

Jean doesn't know it, but she is the daughter of McCoy's nemesis, Nathan Gregory, a.k.a. "the Eagle" (Edward Hearn). *Shadow of the Eagle* was written and directed by Ford Beebe, who would also go on to direct the greatest serial of all, 1940's *Flash Gordon Conquers the Universe*. Following the sensational transatlantic flight of Charles Lindbergh, pictures about heroic pilots had become the newest craze.

The first day of shooting of *Shadow of the Eagle*, on location in Antelope Valley, Levine sat in the backseat of his Packard and had the driver pick up Wayne in Beverly Hills at four in the morning, with a bagged breakfast of coffee and Danishes to make the three-hour traveling time easier. By the time they arrived at the set the crew was set up and ready to start filming. Levine demanded and got seven-day weeks and fourteen-hour days from his cast and crew, and more than a hundred camera setups each session. Afterward, an exhausted Wayne skipped the long ride back home with Levine, zipped himself into a sleeping bag, and slept under the stars, a bottle of Irish whiskey his only company. The shoot took twenty-one days at a cost of $50,000, mostly at Antelope, with a few scenes shot in Bronson Canyon, in Griffith Park. This quickie serial was the best film work Wayne had done to date. Kingston had gotten it right: removing the dialogue and increasing the action for an actor like Wayne was a winning combination.

The first episode of *Shadow of the Eagle* was released to theaters February 1, 1932, and received unexpectedly good reviews. It proved a hit, grossing $60,000 in rentals, a 20 percent profit for Mascot.

That July, Wayne began work on his second serial for Mascot, *The Hurricane Express,* directed by Armand Schaefer and J. P. McGowan, playing an entirely new hero, Larry Baker.* Baker's father, a railroad worker, has been murdered during a robbery, prompting Baker to find and apprehend the killers, who happen to work for a competing train company. Early on, the audience learns the "mastermind" behind the crime is "the Wrecker," played by Conway Tearle, whose secret and evil identity is only revealed to the others in the twelfth and final episode, after an endless series of misdirections, false leads, and red herrings. Shirley Grey, with whom Wayne had previously appeared in *Texas Cyclone,* plays the endlessly loyal, beautiful, faithful, and chaste girlfriend, the

* *The Hurricane Express* is available for free download at the Internet Archive, FreeMoovies Online.com, Amazon, and YouTube.

daughter of one of the men falsely accused by the police of being "the Wrecker." All twelve chapters were shot in three weeks on location in Newhall, Saugus, and at Palmdale, California, with the same $50,000 budget *Shadow of the Eagle* had. When it was released, it earned ten times what *Shadow* did, and, perhaps more important, confirmed that Wayne could star in a film, or at least twelve minifilms, that made money.

While Wayne was busy resurrecting his film career, Warner Bros had decided to remake some silent Ken Maynard westerns they owned as the result of their acquisition of First National studios. Maynard had been a hugely popular film star whose career was irrevocably hurt by his long-term addiction to alcohol. When he proved unable to star in the remakes, Kingston suggested Wayne to the project's producers, Sid Rogell and Leon Schlesinger (the latter would eventually head Warner's animation division after selling his own cartoon studio to them). The idea was to use as much footage from the original silent Maynard films as possible and substitute an actor for close-ups and dialogue scenes. Rogell tested Wayne and loved him (he bore a slight resemblance to a young Maynard), telling Kingston they could start as soon as Schlesinger agreed on the deal.

However, before it could happen, Rogell reversed himself and killed it, telling Kingston Warner Bros would never hire an actor who was a drunken womanizer. When Kingston relayed the message to Wayne, he became enraged. He knew immediately where that story had to have come from, a vengeful Harry Cohn. When Kingston went back to Rogell, who had no love for Cohn (nobody in Hollywood did), he changed his mind again and, with Schlesinger's approval, signed Wayne up for six Maynard remakes, at $1,500 per picture.

Duke was thrilled. Not for the work, which was great, but because for the first time he would have enough money to go back and ask Josephine to marry him. He believed there could be no way now Dr. Saenz could say no.

He didn't. As 1932 came to a close, Wayne officially asked Dr. Saenz for his daughter's hand in marriage and he reluctantly agreed. Because the wedding couldn't take place in church, Loretta Young, who had befriended Wayne during the making of *Three Girls Lost*, and who Wayne always referred to by her real first name, Gretchen, offered her mother's house in Bel-Air, with its enormous garden area, for the wedding. Josephine initially rejected it. She

wanted her wedding to be steeped in social propriety, a respectable societal event rather than a garish Hollywood spectacle. However, upon visiting the locale, she changed her mind. It was, she told Wayne, the perfect place for their wedding after all.

They tied the knot June 24, 1933. Wayne's ushers were his former teammates from USC. His brother Robert was the best man. The ceremony was conducted by Monsignor Francis J. Conaty, a longtime Saenz family friend who had given Josie her First Communion.*

The newlyweds skipped a formal honeymoon and went directly to their new home, a Spanish-style three-room garden apartment rental on Orange Grove Avenue, along the edge of the socially acceptable Hancock Park, close enough to Hollywood for Wayne to continue his early studio hours. He would have preferred living either in Hollywood or even Beverly Hills, but knew Dr. Saenz would never allow his daughter to live in those neighborhoods. Hancock Park was the first of the many suburbs that would emerge to provide decent housing for the film industry, what Westchester would become to Manhattan in the postwar years. Dr. Saenz insisted she be within walking distance of him.

Barely nine months after their wedding, Josie proudly announced to the world that she was expecting a baby.

THE COMING OF FATHERHOOD COINCIDED with Wayne's career taking another and unexpected step down from the already low rung on Hollywood's ladder of success. Having finished the Ken Maynard remakes, he learned that Kingston had been let go by the Morrison Agency and would no longer be representing him or any other client. Morrison was a shrewd handler of talent but also a degenerate gambler whose losses resulted in his having to close part of the agency.

Wayne continued to get up early every morning, as if he were going to work, and instead he went to what was then (and now) known as Gower Gulch, "home of the Bs," a small stretch of Hollywood Boulevard that serviced the needs of the nearby studios with costume shops and prop outlets. It was also the favorite meeting place for the so-called Gower Gulch cowboys, as the actors who hung out there were called, with its coffee shops, luncheonettes,

* Josephine became Josie Morrison, as "John Wayne" was not his legal name.

bars with western motifs where beer substituted for coffee, and the Columbia drugstore—booths in the front, counter in the middle, apothecaries in the back, until late afternoon when the liquor flowed freely. This mild deception Duke was pulling on Josie echoed his father's difficulties earning a living and his mother's preoccupation with status in the community. Wayne had married a woman just like the one who married dear old Doc, and now he was afraid he was turning into him.

Hanging out at the Gulch sometimes led to work. If a studio needed a "cowboy" for a day job all the unemployed actors rushed to dress themselves up in boots and bangles and ten-gallon hats and try to land the gig before anyone else. Wayne became good enough at the game to find intermittent work, mostly on westerns with Tim McCoy, a cowboy whose career would be resurrected in the '50s when many of his B features were recycled for television. It was something, but not steady enough to provide a decent income, and despite the many films Wayne appeared in at this time for several different studios, one even back at Columbia, they didn't pay very much and he was almost always running out of money.*

His good friend Loretta Young helped Wayne, desperate to find steady employment, land his first decent job after the Maynard cycle, a week's worth of work playing a prizefighter in a big-budget Warner Bros film Young was starring in opposite Douglas Fairbanks Jr., Sylvan Karp's 1933 *Life of Jimmy Dolan*.† In the film, Wayne plays a prizefighter, a small but good role in a larger story about a couple (Fairbanks Jr., Young) who want to help save a sanatorium for orphans, raising money by sponsoring winning fighters. The film gave Wayne a much-needed break from making B westerns and also a chance to show off his solid physique and bare chest. Wayne's fighter in the film fore-

* They include Stephen Roberts's *Lady and the Gent*, 1932 (Paramount Pictures); D. Ross Lederman's *Two-Fisted Law*, 1932 (Columbia Pictures); Fred Allen's *Ride Him, Cowboy*, 1932 (Warner Bros); Tenny Wright's *The Big Stampede*, 1932; Tenny Wright's *Telegraph Trail*, 1932 (Warner Bros); William Wellman's *Central Airport*, 1933 (First National); Philip Whitman's *His Private Secretary*, 1933 (Showmen's Pictures); Mack V. Wright's *Somewhere in Sonora*, 1933 (Warner Bros); Armand Schaefer and Colbert Clark's *The Three Musketeers* (a.k.a. *Desert Command*), 1933 (Mascot Picture Corporation); Alfred E. Green's *Baby Face*, 1933 (Warner Bros); and Mack V. Wright's *The Man from Monterey*, 1933 (Warner Bros).
† A.k.a. *The Kid's Last Fight*. The film was remade in 1938 as the better-known *They Made Me a Criminal*, directed by Archie Mayo, starring John Garfield. *Life of Jimmy Dolan* is in the public domain and available on DVD.

shadows another movie where he would play a prizefighter, Trem Carr's 1936 *Conflict,* and his role as the retired boxer with a dark past in John Ford's 1952 *The Quiet Man.*

He didn't make any real money from *Life of Jimmy Dolan.* Desperate, he called Kingston, who had resurrected himself as an independent agent, to ask him to represent him again. The problem, Kingston explained, was that Wayne was still tied to the Morrison Agency by contract for seven more years. Kingston said he would be willing to represent Wayne if he could get Morrison to let him go.

Wayne set up a meeting with them and, not surprisingly, they refused to let Wayne out of his contract. Kingston himself then called Morrison and agreed to split any money he made. Morrison agreed.

Almost immediately, Kingston found Wayne work, with Trem Carr and Leo Ostrow, two producers who had formed a new Poverty Row studio, Monogram Pictures, on Santa Monica Boulevard. It had only one soundstage to turn out all the B-movie westerns and action adventure films they could make. Kingston took Wayne over to meet the two mini-moguls and he left with a deal for eight westerns a year at a salary of $2,500 per picture. It was the most money Wayne had ever made in his life. To seal the deal, Carr and Ostrow gave him a one-thousand-dollar advance. It was money he sorely needed. He was seriously behind in his rent and also owed the phone company, the electric company, and the local grocery that knew Mr. Saenz and had extended credit to the newlyweds.

The studio put Paul Malvern in charge of Monogram's division of westerns, Lone Star films, and once again Wayne found himself in another cycle of similar and forgettable films. The first was *Riders of Destiny.** Written and directed by Robert N. Bradbury, the film's story was about the battle for water rights for ranchers—a film with an actual *plot*—told in fifty fast and

* *Riders of Destiny* is available on DVD, and from several download sites on the Internet. It is also available as part of a recent collection of John Wayne westerns, *The John Wayne Western Collection* (2009), that includes: *Blue Steel, Winds of the Wasteland, The Dawn Rider, Randy Rides Alone, The Lawless Frontier, Paradise Canyon, Sagebrush Trail, The Star Packer, The Trail Beyond, The Man from Utah, Mclintock!* (Widescreen Edition), *Angel and the Badman, Rainbow Valley, Riders of Destiny, The Lucky Texan, Hell Town, 'Neath the Arizona Skies, West of the Divide, The Desert Trail,* and *Texas Terror.*

action-packed minutes. It was shot in August 1933 on location in Palmdale and nearby Lancaster with a budget of $15,000. In it, Wayne hooked up for the first time with an actor who would become one of his lifelong friends, George "Gabby" Hayes, who played the heroine's father. He would appear with Wayne in fifteen Lone Star westerns, always as the cranky sidekick, a role he would play in one form or another for the rest of his career. The "beautiful girl" in the film, Fay Denton, was played by Cecilia Parker, whose first and only kiss with Wayne comes, with Papa Denton's approval, at the end of the film as a kind of reward for saving her ranch and her water rights. Parker was a young blonde who resembled Jean Harlow and would go on to play Mickey Rooney's older sister in the *Andy Hardy* films. "Yak" Canutt played one of the villains. In the film, Wayne is undercover government agent Singin' Sandy Saunders, first seen riding into town on a white horse strumming a guitar and singing a song.

Malvern wanted to cash in on the new singing cowboy craze. As Wayne later remembered, "They made me a singing cowboy. The fact that I couldn't sing—or play the guitar—became terribly embarrassing to me, especially on personal appearances. Every time I made a public appearance, the kids insisted that I sing 'The Desert Song' or something. But I couldn't take along the fella who played the guitar out one side of the camera and the fella who sang on the other side of the camera. So I finally went to the head of the studio and said, 'Screw this, I can't handle it.' They went out and brought the best hillbilly recording artist in the country to Hollywood to take my place. For the first couple of pictures, they had a hard time selling him, but he finally caught on. His name was Gene Autry."*

THE CANADIAN-BORN CECILIA PARKER'S REAL-LIFE sauciness attracted Wayne off-screen as much as her character did on it. His desire for Parker was symptomatic of what was wrong with his outwardly idyllic marriage. At home he was John Morrison, reverent soon-to-be father and head

* Wayne's voice was originally dubbed by a baritone studio singer, an uneasy fit and an obvious poor match due to Wayne's naturally high-pitched speaking voice. Autry had also worked for Mascot and had had a successful recording career before he became Hollywood's favorite singing cowboy.

of a household run by his strictly Catholic wife, who expressed no interest in his work other than the paycheck it produced, or in lovemaking for any other reason than to procreate. At work he was John Wayne, rough, tough protector of women, a good-looking movie actor who could have his pick of the prettiest females on the lot. Like Cecilia. It was an inner conflict Wayne suffered that only got worse after the birth of his child in November 1934, when he admitted to himself for the first time that his marriage was a restrictive trap rather than a loving and liberating retreat from the cold hard world outside.

In his heart, he knew it was that cold hard world outside he preferred.

AS THE GREAT DEPRESSION CONTINUED into the 1930s, to survive, businesses that made their living from film were forced to consolidate. Smaller, independent studios were gobbled up by bigger ones, and if they didn't agree to be bought, they were forced out of business by a lack of distribution, which was by now controlled exclusively by the majors. Herbert Yates, a bald-headed, bulldog-faced, "dese, dems, and dose" Brooklyn-born New Yorker, sensed an opportunity. According to Ford biographer Joseph McBride, Yates was "a notorious philistine, [who] punctuated conversations by spitting streams of chewing tobacco" and the biggest film processor of movie film in Hollywood. His company, Consolidated Film Laboratories, oversaw the development of virtually every negative foot of film converted to print. Because both Monogram and Mascot were forever running short of money, Yates had willingly extended large credit lines to keep them in business, until the balances became too big for them to pay off. Then he pounced, taking control of Monogram and Mascot and merged them with several other struggling companies he had acquired in the same way into one conglomerate he named Republic Studios. He set up shop in the Fairfax section of Hollywood (where CBS's Television City is today), believing he could push his independent studio to the same level of success as the majors by offering them a profitable distribution deal they wouldn't turn down.

Through Kingston, he retained the services of John Wayne, whose on-the-cheap "cowboy" films were among the biggest successes coming out of Hollywood. Yates offered Wayne a lot of money and promised him better

scripts, because Republic could pay the best writers and directors in town. Republic's pictures would still be Bs, only better. B pluses.*

After signing with Yates, Wayne used part of his advance to buy himself a small boat and quickly came to love the peace and the solitude he enjoyed going out on the ocean by himself for a day. He mostly enjoyed traveling by himself to the small island of Catalina, twenty-six miles off the coast of Southern California, where he could get away from everyone and everything—the film business and his family—and cool out.

It was on Catalina one Friday night in 1934, at Christian's Hut, a popular island watering hole for industry people who, like him, wanted a place to go off the mainland to relax and unwind, that he ran into his old friend, the hard-drinking, womanizing film director John Ford. Ford owned his own boat, *The Araner,* a 110-foot ketch he'd purchased in 1926 named after the Aran Islands, where his wife's family was originally from. It brought back to life his first love, sailing. He used to joke to friends that for every three films he made, one went to pay for and support *The Araner,* one was to pay the IRS, and one was to pay for everything else. Ford loved being at sea so much he enlisted in the United States Naval Reserve on October 3, 1934, at the rank of lieutenant commander, what would be the start of a long and distinguished career of military service, both in peacetime and when the country was at war.†

PAPPY SPOTTED WAYNE FIRST, ALONE at the bar, and sent his eleven-year-old daughter over to fetch him. After several rounds, the two men fell quickly back in sync, and Wayne soon became part of Ford's inner circle of coworkers and friends that included Ward Bond, and the preternaturally lean and mean Henry Fonda, who a few years later would star in Ford's

* Wayne finished out his original contract with Monogram for eight films, averaging one a month, and then reprised his "Singing Sandy Saunders" in at least one more film (for some reason, Sandy became Randy), 1934's *Randy Rides Alone,* directed by Harry Fraser, costarring Gabby Hayes and Yak Canutt. For reasons not clear, but likely had to do with Wayne's attraction to Cecilia, Alberta Vaughn was a last-minute replacement for Parker as his fade-out love interest/kiss partner. After Republic bought out Monogram, Yates continued to use Gene Autry as his studio's resident singing cowboy. John Wayne never sang atop a horse again.
† It is believed he used *The Araner* to help gather intelligence for the navy under the guise of its being a pleasure boat.

Young Mr. Lincoln. Fonda was an actor Ford liked and hoped would turn out to be his next Harry Carey, a role that he still hadn't been able to fill.

It was an unexpected and auspicious meeting for Wayne that began one of the greatest creative collaborations in all movie history. It would change everything about the movies they made, and the lives they lived.

Chapter 5

In 1936, to make room for his growing brood—Josephine had given birth to their second child, a girl they named Mary Antonia, "Toni"—Wayne managed to save enough money to buy a two-story Spanish-style mansion on North Highland Avenue, not too far from Hancock Park, where Josie's parents still lived. As soon as they moved in, Josie set about to decorate it. She wanted a stylish showcase, but her taste tended to run to nouveau riche, a choice Wayne especially disliked. It made him feel less like he was living in a real home and more like on some fancy movie set. One time coming home late and tired, he sat down on a new and elegant-looking chair in the living room Josie had bought; it collapsed under his weight and he wound up on the floor like the hapless victim in some two-reel comedy.

He insisted to Josie he had to have one room for himself, what today would be called a man cave, with big old comfortable chairs, a large wooden desk, and an oversize sofa he could stretch out on without having to take off his boots. In a house that otherwise had so much activity, with decorators and Josie's parents and friends, and their own two little children running around, or screaming, or crying, Wayne increasingly sought comfort and solitude.

Josie, meanwhile, became active in the elusive upper-crust strata of Hollywood's non-moviemaking social set, and often insisted Wayne accompany her to the seemingly endless black-tie events, even if they went on well past his

regular bedtime. He did so reluctantly, to keep peace in the family, even if it meant he didn't get enough sleep for the next day's early call.

Imbedded in Josie's newly acquired social sophistication was her unspoken rejection of being married to a movie actor. Josie felt the need to compensate for his work by elevating her status, for the good of the both of them. Redecorating their home was the same as dressing up her husband in a tux to make him more acceptable. Wayne felt caught in the peculiar web of Josie's double dissatisfaction, her need to appear to be the picture of the perfect wife in public, and in private her inability to disguise her revulsion for the field in which her husband worked. To Josie he was, as her father had warned her, just a struggling actor and a failure as a husband. Because of it, she no longer felt she should be with him in bed at night. There could be no reward for failure. Wayne was well aware that the passion had gone out of his marriage, like the air out of a flat tire. He had no idea how to save it nor was he even sure he wanted to.

BOTH WAYNE AND FORD WERE at crossroads in their respective careers. While Wayne was trapped running on the gerbil wheel of western cheapies, Ford's career felt stuck in second gear. He was hoping to make a filmed version of Liam O'Flaherty's 1925 novel *The Informer*, the story of an Irish Communist rebel, Gypo Nolan, who turns in a comrade for the twenty pounds' reward during the Irish Civil War of 1921–23. The novel, with its Judas-like hero, had already been filmed once before in England, in 1929, but that version had never been released in America.

Getting *The Informer* made, Ford knew, was not going to be easy, and not just because of its controversial subject matter. He was having trouble getting any films produced. It was partly a sign of the changing times, and partly his own antiauthoritarian ways. With the arrival of sound, and as with so many other silent directors, including D. W. Griffith, one of the early giants of the industry whose career ended as talking pictures took off, Ford's style of moviemaking was thought by many in Hollywood to be out of fashion, more suited to the days when pictures moved but didn't speak, and Ford had no *Birth of a Nation* on his list of accomplishments. His best film to date had been 1928's *Mother Machree*.

What made it even more difficult for Ford was his reputation as a trouble-

maker. He was known to be disagreeable on-set, to carry a gigantic chip on his shoulder when it came to studio executives, especially if they tried to butt into the production of his films and tell him how to make them better, meaning more commercial. And he was an alcoholic. His first all-talking feature, 1929's *The Black Watch,* starring Victor McLaglen and Myrna Loy, a spy thriller set in India during the early days of World War I, was not well received, making every project for him that much more difficult to get made.

The same year William Fox had begun what would be made his disastrous attempt to take over Loew's Inc., Ford took the opportunity to have his contract renegotiated, fearing his career would get lost in the reshuffle. Agent Harry Wurtzel successfully arranged for Ford's new deal at Fox to be nonexclusive, a move that would prove crucial to his career.

Because of it, Ford was able to make his first important sound film, 1931's *Arrowsmith,* an adaptation of Sinclair Lewis's Pulitzer Prize–winning novel, screenplay by Sidney Howard, for independent producer Samuel Goldwyn, released through United Artists. However, Ford had a falling-out with Goldwyn over the condition, in writing, that he would not drink while making the film. Ford failed to keep his part of the bargain and tried to rush the film to completion, partly to get Goldwyn off his back, and mostly to get his hands on more booze. The two butted heads continually during production, and despite the film's becoming a huge commercial success when it was released, and earning four Oscar nominations (Best Picture, Best Adapted Screenplay, Best Art Direction, Best Cinematography), Goldwyn swore Ford would never work for him again. During filming, Ford had walked off the set and gone on an extended binge in Catalina. Goldwyn demanded that Fox Studio pay him the $4,100 fee he had paid them to use Ford. Fox paid it and promptly fired Ford, releasing him from any and all further obligations.

He then made films for Universal and MGM before being rehired by Fox in 1932, in a nonexclusive multiple-picture deal, the most important being the three films he made with Will Rogers as his leading man (1933's *Doctor Bull,* 1934's *Judge Priest,* 1935's *Steamboat Round the Bend*). Rogers, a witty, satiric figure in the mold of Mark Twain, was a natural for motion pictures, and, perhaps more significantly to Ford, the actor he had been searching for since parting ways with Harry Carey, whom Rogers physically resembled. However, where Carey was reticent and wary, Rogers was folksy, funny, and homespun.

Audiences loved him and Ford believed he had found his perfect on-screen other, until the actor's tragic early death in a 1935 plane crash.

Even before then, because Rogers was not always available, Ford turned to his other favorite leading man, Victor McLaglen, the "Irish tough guy" side of Ford's externalized self, darker and more self-destructive than the sunny Rogers, to make two pictures, the second being *The Informer*. The project was rejected at every studio before it landed at fellow Irishman Joseph P. Kennedy's RKO Studios.* Executive producer Merian C. Cooper, who had produced and directed *King Kong* there, had long urged Kennedy to sign Ford, even with his difficult reputation. Cooper liked Ford's films and believed that with the right material, despite his personal demons, Ford could make great movies. However, Kennedy sold out his remaining interest in the studio before Ford had made his first picture there. *The Lost Patrol,* released in 1934 before Rogers's death, turned enough of a profit for the studio to green-light *The Informer.* The atmospheric drama was set in Dublin, where Ford wanted to film it, but RKO's new owners insisted that to save money it had to be done at the studio.

With Dudley Nichols as the screenwriter, and McLaglen as Gypo, *The Informer* was released in 1935 and proved a modest hit in America, until it brought Ford his first Best Director Academy Award, and one each for screenwriter Nichols, actor McLaglen, and musical score composer Max Steiner. The film was rereleased and doubled its initial profit, and while it elevated Ford's reputation as a director, it also identified him as a troublemaker of a different sort, a political rebel in a conservative industry.†

The Oscar presentations were held that year at the Biltmore Bowl of the Biltmore Hotel in downtown Los Angeles, with a banquet that preceded the radio broadcast of the handing out of the Awards. However, despite the urging of Frank Capra, the president of the Directors Guild, that Ford, the guild's treasurer, attend the Awards as a demonstration of unity between the Academy and the guild, Ford begged off, claiming he was too busy with the guild's contentious salary negotiations. He told Capra he felt he couldn't in good conscience show up and rub shoulders with those on the other side of the hostile

* Kennedy formed RKO in 1928 with David Sarnoff.

† It was widely believed that the vengeful Louis B. Mayer used his influence within the Academy to have them give the Best Picture Oscar to his *Mutiny on the Bounty*.

bargaining table. When Ford won his Oscar, Capra accepted it for him and delivered it in person a week later.

Nichols also refused to attend, but when he won his Oscar and Capra accepted it, the next day Nichols told Capra he didn't want it at all. Capra then had the statuette sent to Nichols's house, and he promptly returned it to Capra with a note saying, "To accept it would be to turn my back on nearly a thousand members [of the WGA] who ventured everything in the long-drawn-out fight for a genuine writers' organization." Capra sent it back to Nichols again, and again Nichols returned it. The statuette eventually found its way back to the Academy headquarters, where it remains this day.

A week after that, for accepting his Oscar, the Directors Guild admonished Ford for sleeping with the enemy and voted him out of office.*

Ford's and Nichols' difficulties with the Academy and the guilds that year marked a turning point in Hollywood's burgeoning civil war, a battle between management and workers that had existed since the earliest days of filmmaking. Movies were a product of the Industrial Revolution, a technological marvel greatly enhanced by Thomas Edison, who envisioned film as an instrument of information rather than entertainment. Once the novelty became big business, the so-called factory of dreams, those who made the movies were treated as workers in that factory, including actors, writers, directors, and all ancillary help. The writers were the first to form a guild to fight for better wages and working conditions. To counteract the growing union movement, the studio heads formed a house union, the Academy, and to reward their workers, instead of pay raises, conceived an annual awards ceremony. As more guilds formed, the DGA and the Screen Actors Guild (SAG) made considerable gains against the studios. In retaliation, the studios redefined the financial battle as a political one, accusing the unions of being anti-American, having been infiltrated and influenced by the Communist Party.

With the impending outbreak of World War II, John Wayne, a young, quiet, polite, hard worker and one of the least political actors in Hollywood through-

* There are conflicting reports about what actually happened. According to Dan Ford, the director's grandson and biographer, it happened; according to McBride, Ford kept his post until 1938, when he was elected to the SDG board of directors, and remained a major figure in the guild for the rest of his professional life. The guild's records are unclear about whether or not Ford was actually voted out of office.

out the '30s, would eventually become one of the leaders in the industry's battle against the unions, putting him on the opposite side of Ford and Nichols, believing, as the studios did, they were all Communist fronts using films to deliver subversive messages to the American public and thereby posing a threat to the very democracy that allowed them to do it.

FOR NOW, THOUGH, FRUSTRATED AFTER each day's shoot, just like the one yesterday and the one to come tomorrow, and in no rush to go back to his expensive, noisy, and well-appointed but supremely uncomfortable new home, Wayne increasingly chose to spend his nights out drinking with a regular crowd of rough-and-tough buddies who called themselves the "Young Men's Purity Total Abstinence and Snooker Pool Association." They met regularly at the Hollywood Athletic Club on Sunset Boulevard, in the heart of Hollywood. The group included craggy character actor Paul Fix, one of those familiar faces-without-names who most often played tough guys, who also fancied himself a playwright; former competitive swimmer and the movies' newest Tarzan, Johnny Weissmuller; stuntman extraordinaire Yak Canutt; and Wayne's closest and oldest friend in Hollywood, former USC teammate Ward Bond. Wayne and Bond hunted and fished together and also loved to let off steam by getting drunk and fist-fighting each other. They didn't do it in a ring, with gloves, and rounds or referees; it wasn't anything as formal as that. They liked to street fight like a couple of wildcats, for fun, not sport, pulling no punches, hitting as hard as they could, just to see how much the other could take.

They had a brawl one night at the Hollywood Athletic Club that became legendary when it spilled out onto the streets and back inside again, all because of a disputed pool shot. According to one witness, "Duke knocked Ward into a row of lockers, then Ward got up and knocked Duke down, and after that everybody else let them have the place to themselves until they were finished." When it was over, Wayne and Bond laughed, shook hands, hugged each other, chipped in to pay for the several thousand dollars' worth of damage they had caused, and went home to sleep it off.

In 1935, Wayne's non-exclusive contract with Republic expired, and Yates offered him a second renewal at $24,000 to make four more westerns. The money was tempting, and with all the spending Josie did it seemed he never

had enough, but he turned it down because he felt burned-out. He couldn't face the idea of having to make any more cowboy cheapies.* To earn fast cash and to impress his wife and father-in-law, he briefly took a position at a brokerage firm where both he and they hoped to cash in on his fame. Neither did, and he turned to real estate, but again failed to make any big scores. He then decided to become a prizefighter, and even had a few professional matches in California and Nevada under the name "Duke Morrison."

When he wasn't fighting, which was most of the time—he wasn't that good against real opponents—he would make his way out to Catalina, to meet up with Ford and Bond at Christian's Hut. Wayne quickly became something of a legend at the bar. Although probably apocryphal, the story goes that he could drink sixteen martinis at one sitting and never fall down or throw up.†

Wayne, Bond, and a few others sometimes would join Ford on *The Araner*, for longer trips, the only rule and the main attraction being that no wives or girlfriends were allowed. Ford's favorite destination was Mazatlan, where he and whoever else happened to come along would cavort among the natives.

Wayne loved killing time hanging out with the boys, but the hard truth was he needed money. He was offered and accepted a role in a stage production, even though he had never acted professionally before a live audience. Wayne's friend and vocal coach, Paul Fix, had written a play called *Red Sky at Evening*, set on the docks of San Francisco, staged for pennies outdoors in downtown Los Angeles, at a time when that was the biggest skid row in the country. Fix wanted to produce the play there because he thought it approximated San Francisco's atmosphere.

But Wayne couldn't handle it, and during rehearsals he developed a hard case of stage fright that built up until opening night, when he asked his brother, Robert, to bring him a bottle of scotch and he finished most of it before curtain time.

During the production, his costar Sally Blane was supposed to hit him in the head with a vase. When she really did, Wayne looked confused, upset, and out of character. The stunned audience sat in silence staring at Wayne, whose eyes became glassy and unfocused. From the fifth row center came a ringing voice

* Technically, Yates retained the option rights to use Wayne in westerns only for Republic.
† Zolotow points out that Wayne's drinking also served as something of an escape from his increasingly unhappy marriage to Josephine, who considered him not just a failure, but a failure in a field that was unworthy of her.

of criticism for his being drunk. It was Josephine, yelling at her husband as if they were in the privacy of their living room, "Duke, you are a disgrace! You are just a disgrace!"

"Duke was so frightened of live theater that he overdosed on booze and made a total ass out of himself," Harry Carey Jr. later said of the incident. Wayne never acted in another stage production.

IN 1936, EXECUTIVE PRODUCER TREM Carr left Republic for Universal, a much better-organized studio with far deeper pockets. One of the first things Carr did was to call the out-of-work Wayne and offer him a deal similar to the one he had tried to get for him to re-sign with Republic, $6,000 per picture for six films, but with one big difference. Knowing Wayne did not want to do any more cowboy movies and that Republic still held that option, Carr promised that none of the six films he would make over the next two years would be a western. Wayne was eager to get back into the movies and took the deal, hoping for one more chance to make an important film, the dream he had been chasing ever since the failure of *The Big Trail*.

It didn't happen. Of the six films he made for Universal, not one proved a breakout hit. In Frank Strayer's 1936 *The Sea Spoilers,* he played the commander of a U.S. Coast Guard cutter assigned the unglamorous task of battling seal poachers who have also kidnapped his girlfriend, played by Nan Grey (who later married singer Frankie Laine). *Variety* dismissed it as "Dimly realized . . ." and it quickly died at the box office.[*] That was followed by David Howard's *Conflict,* in which Wayne plays a lumberjack and a member of a gang that conducts fake prizefights. He meets Jean Rogers (of *Flash Gordon* serial fame), who gets him to see the light. He wins the fight and her.[†]

Conflict was better received than *The Sea Spoilers. Variety* called it "a very satisfactory program offering . . ." and "An ideal vehicle for John Wayne . . ." Next came Arthur Lubin's *California Straight Ahead,* a remake of a silent film,

[*] A.k.a. *Casey of the Coast Guard,* the film was shot in two weeks on a budget of $75,000 ($65,000 was put up by Universal, Carr Productions put in the last $10,000). *The Sea Spoilers* is available on DVD.
[†] A.k.a. *The Showdown.* Based on the Jack London short story "The Abysmal Brute," shot for $75,000. *Conflict* is available on DVD.

in which Wayne plays a truck driver who has to complete a delivery before a labor strike shuts down the train awaiting his goods.* Louise Latimer played his love interest. It was another turkey. After that came Arthur Lubin's 1937 *I Cover The War,* in which Wayne plays a newsreel cameraman.† In this one his love interest is Gwen Gaze, making her film debut. The film had better production value than the previous three but like the others, failed to make any noise at the box office. Next was Lubin's 1937 *Idol of the Crowds,*‡ in which Wayne plays a member of a professional hockey team pressured to throw the championship game. This film gave the Wayne a chance to show off his athletic prowess. *Variety* called it "Old-fashioned hokum . . ." Wayne's leading lady was Virginia Brassac, who would go on to make sixty films in her career. His sixth and final film at Universal was the aptly named *Adventure's End,* another 1937 Lubin-directed production.§ In it, Wayne plays a Pacific Isle pearl diver who marries the captain's daughter, who is pursued by the evil first mate. Diana Gibson is his love interest.

None of these six Universal films were good enough to elevate Wayne to the ranks of an A-list star. Even though they had better production values than the movies he had made at Republic, they still looked and felt like B movies. When his contract was up, he parted ways with Carr, who made no real effort to keep him.

Scrounging for work as a freelancer, broke again and needing to make some money, he was hit with the devastating news that on Sunday, March 4, his father had died of a heart attack in his sleep, after not feeling well enough to go to a football game Robert was playing in for the Los Angeles Dons, a semi-pro team at the Los Angeles Coliseum. Wayne was grief-stricken, and cried in the car all the way to the funeral.

Mary did not attend.

An inconsolable Wayne leaned on the big shoulders of John Ford for comfort. If Ford was tough and mean, Wayne was always the obedient son for his Clyde surrogate, who played the role of paternal martinet with great delight. It

* *California Straight Ahead* is available on DVD.

† *I Cover the War* is available on DVD.

‡ A.k.a. *Hell on Ice, Idol of the Crowds* is available on DVD.

§ *Adventure's End* is not available on DVD, but may be seen in its entirety on YouTube.

would become the oddest and most effective real-life faux father/fake adopted son working relationship in all of cinema.

Aboard *The Araner* one weekend not long after his dad's death, Wayne confided to Ford about how bad things were going and asked the director, "When is it my turn?" Ford, never one to turn to for sympathy, barked, "Christ, if you learned to act you'd get better parts!" He then changed his tone, as was his way. "Just wait. I'll let you know when I get the right script."

That wait would soon come to an end.

IN THE SUMMER OF 1937, Ford's sixteen-year-old son read a three-thousand-word story in *Collier's* magazine called "Stage to Lordsburg" by Ernest Haycox, about a group of eight easterners making a pilgrimage across the country by stagecoach that would take them through New Mexico's dangerous Apache territory. The story was a very loose and Americanized adaptation of Guy du Maupassant's "Boule de Suif."* When he gave it to his dad, Ford read it and was convinced he could turn it into a character-rich western. He hadn't made an oater in eleven years, since *3 Bad Men,* a silent 1926 feature.† After the failure of *The Big Trail,* not just Wayne but most westerns had been relegated to B pictures and serials. The studios believed *The Big Trail* proved that adults were no longer interested in "cowboy" movies. Ford bought the rights to the story for $4,000 and assigned Dudley Nichols to try to turn it into a workable film script.

And Ford wanted Wayne to star in it, which would make it an even harder sell. Getting a studio to green-light the picture was one thing; getting Wayne approved as its lead quite another. He had already made sixty-five films, none of which had been a big enough hit to make him a bankable star.

* "Boule de Suif" is de Maupassant's most famous short story. Published in 1880, translated as "Dumpling," or "Butterball," or "Ball of Lard," it was one of his collection of stories set in the Franco-Prussian War. Ten residents of Rouen, recently occupied by the Prussian Army, decide to escape, by covered wagon, to Le Havre, still free. The wagon's passengers are a microcosm of French society. De Maupassant's story is itself loosely derived from Chaucer's *The Canterbury Tales.* Ford was already familiar with "Boule de Suif" and had wanted long wanted to make a film of it, but couldn't come up with workable concept until Haycox's adaptation appeared in *Collier's.* Some have questioned "Boule de Suif" as the source of the Haycox story and suggest it is actually derived from Bret Harte's "The Outcasts of Poker Flat," a story Ford first adapted into a silent western in 1919, starring Harry Carey.

† The eleven-year gap was the largest in Ford's filmography without a western. Of the more than two hundred feature films Ford directed, fifty-four, fully a quarter, were westerns.

Nichols completed his film script adaptation of "Stage to Lordsburg" (screenplay credit was shared with Ben Hecht) and renamed it *Stagecoach*. One night not long after, during a weekend-long poker game aboard *The Araner* whose players included actor Grant Withers, Victor McLaglen, Nichols, Wayne, and Ford, the director tossed everyone a copy of the manuscript with the directive to read it immediately.*

The following evening, during a break in the marathon game, Ford called Wayne on deck to discuss the film. The director decided to toy with him a little, saying that he had signed Claire Trevor to play the female lead, and that almost all the male leads were already cast, with George Bancroft, John Carradine, Thomas Mitchell, and Andy Devine. The problem he was having, Ford said, was that he couldn't think of any actor to play the Ringo Kid, the young rebel who helps guide and protect the wagon train safely through Indian country. Wayne meekly suggested Lloyd Nolan, a good actor who had recently been in King Vidor's *The Texas Rangers*. Ford said no, he was looking for a different type, handsome, strong and tough, and tender with the ladies; someone with star quality. Wayne assumed that didn't mean him and they both went below deck to play more cards.

The next night, Ford took Wayne back up, turned to him suddenly, and said, "Duke, I want you to play the Ringo Kid." According to Dan Ford, the director had wanted Wayne for the part from the very moment he finished reading the short story. It was Ford's way. Years later, Ford himself would explain his reasons for choosing Wayne: "I wanted John Wayne to play [Ringo]. He was by no means a finished performer, but he was the only person I could think of at the time who could personify great strength and determination without talking much. That sounds easy, perhaps, but it's not."

And according to Wayne, "Well, I had made a lot of cheap pictures after Raoul Walsh saw me on the set and gave me the part in *The Big Trail*. He needed a man of my type, and I was a prop man and handy. Funny thing, John Ford remembered me in that picture."

This time, Wayne promised himself that despite his easygoing manner and his reputation of being the type of actor who did what he was told and never complained, he wasn't going to let anything or anyone—not the film's temper-

* *Stagecoach* is available on DVD and may also be seen in its entirety on YouTube.

amental producer David O. Selznick, not even kick-ass John Ford—ruin what might very well be his last real shot.

Not even Josephine. Despite or perhaps because of her strict limitations on their sex life, the family had kept growing. During their first six years of their marriage, Josephine had given birth to two children—Michael in 1934, Toni in 1936, and now was pregnant with their third, Patrick, due in 1939 (they would have a fourth child, Melinda, in 1940).

In 1940, after the release of *Stagecoach*, Wayne complained to his friend and press secretary Beverly Barnett that there was no longer anything sexual about his relationship with Josie. Barnett pointed out she had given him four children, and Wayne bitterly replied, "Yeah, four times in ten years."

Chapter 6

Ford was ready to start production on *Stagecoach* for David O. Selznick. The independent producer wasn't the biggest fan of Ford, but he admired Merian C. Cooper and wanted to work with him now and in the future. As far as Selznick was concerned, *Stagecoach* was not a major project, just another western. To maximize its commerciality, he told Ford it needed big-name stars, not John Wayne.

Selznick insisted that Ford instead use Gary Cooper to play the Ringo Kid, and he also wanted Marlene Dietrich, a much bigger star at the time than Ford's good friend Claire Trevor, to play Dallas, the young prostitute run out of town and hoping to start a new life. Dietrich had, after all, made her reputation playing one in Josef von Sternberg's 1930 *The Blue Angel,* and she had just finished a solid turn in George Marshall's satirical western *Destry Rides Again* as the happy hooker Jimmy Stewart falls in love with. Ford, however, remained adamant about both Claire Trevor and Wayne, claiming Cooper and Dietrich were both too old to play these roles, even though he knew they weren't. In truth, Ford could see Cooper as the Ringo Kid, but Dietrich's Germanic man-devouring dominatrix-with-a-heart-of-ice was something he wanted no part of. When Ford refused Selznick's casting, and after Selznick tried to lure Ford off the project by offering him a number of others, including the film version of *Gone with the Wind,* none of which interested Ford, the producer threw his arms up and killed the deal.

Interest in *Stagecoach* was revived by independent producer Walter Wanger, who had made a string of successful films in the '30s, among them James Cruze's 1932 *Washington Merry-Go-Round,* and Frank Capra's 1933 *The Bitter Tea of General Yen,* both at Harry Cohn's Columbia. Wanger then decided to go independent, created Walter Wanger Productions, and signed an exclusive distribution deal with Universal. Unfortunately, the first seven films Wanger made there all lost money. In 1938, when he first became interested in *Stagecoach,* the studio agreed to let him make it, but only if he could bring it in for under $400,000, which necessitated the film being shot in black-and-white and eliminated the possibility of big money to attract any major stars to be in it.* Ford signed a contract for $50,000 to direct, with a healthy percentage of the back end after the film recouped its negative cost, and final say on casting. The rest of the company received a combined total of $65,000 in salary. Wayne signed on for $600 a week against a minimum of $3,000, a salary that Cooper would have laughed at.† Trevor received $15,000 as the female lead; Thomas Mitchell, $12,000; Andy Devine, $10,000; and Tim Holt, in a relatively small role, $5,000.

The film was sold with the tagline "The Powerful Story of 9 Strange People!" None are conventionally respectable and all are seeking redemption of one sort or another. The characters aboard the stagecoach are going against the grain of their own lives, seeking salvation (in the film, the stagecoach moves from west to east, from Tonto, Arizona Territory, to Lordsburg, New Mexico Territory, against the grain of the country's natural and morally self-justified expansion west). Ford's direction and the Nichols/Hecht script offer a heavy dose of morality in the telling of the characters' individual stories that separates and elevates the film above the rest of the shoot-'em-ups being made after *The Big Trail.*

Trevor received first billing over Wayne in the front credits, but not above the title; Ford gave no one star treatment. Louise Platt played the young and pregnant Lucy Mallory, taking the stage to meet her U.S. Cavalry husband in Lordsburg. In many ways Lucy is the opposite of Dallas—one is fleeing from her past, one is rushing toward hers. They are linked by the en route delivery

* Wanger put up $250,000, a little more than half the film's budget. Universal put up the rest, in return for distribution rights.
† Cooper's price in 1939 was $150,000 a picture.

of Lucy's baby. Dallas assists, helps save Lucy's life, and by doing so finds new meaning in her own.

Wayne's Ringo Kid, as directed by Ford, comes off as a character with the exterior charm of Roy Rogers and inner darkness of Harry Carey. Ringo is a fugitive from justice headed for Lordsburg to avenge the death of his brother and father at the hands of Luke Plummer (Tom Tyler), who he knows will be there waiting for him. George Bancroft is "Curly" Wilcox, the shotgun-riding marshal there to protect the passengers from any and all danger, especially from the Apaches. The balance and the contrast of the characters continues—Wilcox is a lawman, Ringo is a fugitive from the law.

Andy Devine plays Buck, the stagecoach driver, while the marshal looks for Ringo (Ward Bond was Ford's first choice to play Buck but said he couldn't drive the coach for the film's necessary long shots; most of the medium shots were done with a fake stagecoach on springs, and using rear projection). Physically soft, Buck is the opposite of the lean and tough Ringo kid.

John Carradine is the elegant white-hatted "Hatfield," a southern gentleman and degenerate gambler in search of new worlds (and bank accounts) to plunder. Henry Gatewood, the stiff, brusque, white-haired Berton Churchill, is a bank clerk who is absconding with $50,000 of the bank's money. Both their lives are ruled and ruined by money—one wants it, one has it, both steal it. Thomas Mitchell is Doc Boone, a drunken doctor from the North, a veteran of the Civil War whose skills have been corroded by alcohol. Salesman Samuel Peacock (Donald Meek, known for playing soft but sensitive characters) sells whiskey. One is a man whose life has been ruined by alcohol; one is a man who makes his living off it.

When they begin their treacherous journey, they are warned by a young cavalry officer, Lieutenant Branchard (Tim Holt), that Geronimo is on the warpath; therefore his troops will accompany the coach, but only as far as their destination, the fort at Dry Fork. Early along the way, Ringo is found walking the trail after his horse has gone lame. Ford gives Wayne an unmistakable star entrance, as the camera swoops down from the POV of the marshal to the smiling and beautiful face of the squinty-eyed, grinning Ringo.

During production, Ford had wanted Wayne to do something special. They came up with twirling his rifle in a circle, the barrel passing under his right

armpit. The only problem was, the rifle was too long. Ford then had a few inches chopped from the end of the barrel so Wayne could perform the trick. It was a decision and a moment fraught with meaning. That single, swooping shot, with the camera high above Ringo (which also signals Ford's control of Wayne by keeping him below eye-level in the shot), the gun twirl was at once a symbol of the Ringo Kid's toughness, and an extension of his manhood, a preening, phallic moment (which makes Ford's "cutting" of the gun even more significant). The rifle was what got Ringo in trouble and will also serve as the weapon of his redemption. The twirling became a signature move for Wayne, copied by endless other "cowboys," and used by him again most notably when he twirls his pistol in *The Searchers* just before he tries to kill Debbie (in that film, the gesture hints at a repressed sexual desire for her, one more reason Ethan has to kill her).

It was a striking move by Wayne, and gave him a moment of sexuality he otherwise rarely displayed in his films, where his desire was usually married to his stoicism.

Although Curly must eventually arrest Ringo for murder, he allows him to join the other passengers. Not long after, Ringo finds himself attracted to Dallas; this moment signals the beginning of his redemption, and hers.

After arriving at Dry Fork, the cavalry must go on by itself to Apache Wells, to fight Geronimo's band of warriors. The stagecoach passengers vote on whether to turn back. The majority decides they should continue on to Apache Wells unescorted, intending to reunite once again with the cavalry. Lucy then goes into labor, and a shaky Doc Boone delivers the baby, another act of self-redemption. As Dallas emerges from the makeshift delivery room in the stagecoach holding the newborn, Ringo is moved by her maternal caring and affection and knows now that he loves her.

When the stage reaches its next intended destination, Lee's Ferry (each act of the screenplay is neatly divided by these stops), the passengers find it decimated by the Apaches. At this point, Curly releases Ringo from his cuffs, so he can cut and attach logs to help float the wagon across the river. Just as it appears everything is going to be all right, the Apache furiously attack, and Ringo heroically jumps on the lead horse to help steer the wagon train (most but not all

of the stunts here were done by Yakima Canutt).* Then the cavalry arrives to save the day, in one of the most rousing rescues ever filmed, and the surviving passengers complete their trip to Lordsburg.

There is, however, unfinished business. Ringo must now face Luke Plummer (Tom Tyler) and make him answer for the murder of his brother and father. He cannot start a new life with Dallas until this act of vengeance is fulfilled. The marshal knows it, and does not try to stop him. The final shoot-out in the empty streets of Lordsburg is beautifully staged and dramatically exciting. We do not see the actual gunfight, only the start of it as Ringo hits the dirt. And we do not see the end of it, only the result, when Plummer pushes his way back through the swinging doors of the bar, apparently the victor, until he falls forward, dead. The film ends happily, as Ringo and Dallas redemptively escape the shadow of death and ride off into the sunset.

There are seeds of several Ford/Wayne films to come planted in *Stagecoach*. Ringo anticipates Ethan Edwards in *The Searchers* with his determined vengeance; the attack on the wagon train by the Indians anticipates the cinematic formalism of the Indian attacks in *Fort Apache, The Searchers,* and *The Horse Soldiers;* and the courage of migration is once again on display in *The Man Who Shot Liberty Valance.* These Ford signature themes would be repeated over and over with and by Wayne, as each refined his personal style through the other.

And it is in *Stagecoach* that Ford finally found the cinematic persona he had been searching for to replace Harry Carey. Wayne had Carey's toughness, stoicism, and all-American strength and the charm (if not the wit) of Will Rogers. Together, Ford and Wayne would make the best films of both their careers, as Wayne visualized Ford's individual characters, and Ford deepened Wayne's onscreen character. According to Andrew Sarris: "*Stagecoach* has been clarified and validated by what followed [in both Ford's and Wayne's careers]. Its durability as

* In an undated profile of Yakima Canutt, AP writer Bob Thomas wrote about Canutt's stunt work in *Stagecoach*: "The stunts . . . had the beauty and precision of a ballet filled with danger." According to Zolotow, Wayne did some of the stunt work as well. When Walter Wanger saw him jumping onto the top of the stagecoach, he was, reportedly, horrified. Wayne later told a reporter, "Hell, he didn't know I'd been doing stunts like that for years, just for eatin' money."—quoted by Dick O'Conner, *Los Angeles Herald Examiner,* January 5, 1954.

a classic is attributable not so much to what people thought about it at the time as to what Ford himself spun off from it in his [and Wayne's] subsequent career."

Ford's direction was tough and unforgiving and illustrated those aspects of his personality that had always been so off-putting. He appeared to take sadistic pleasure belittling Wayne in front of everyone, grabbing him under the chin and humiliating him for acting like a statue (to get, he later claimed, the best performance possible out of him). The more Ford dished it out, the more Wayne took it, which in turn made Ford dish it out all that much more. The first day of shooting he called Wayne a "dumb bastard, a "big oaf," and made fun of his acting: "Can't you even walk, for chrissake, instead of skipping like a goddamn fairy?" Wayne secretly sought both consolation and coaching from his old friend and stage director Paul Fix. After his daily tongue-lashings from Ford, Wayne would meet with Paul at his house in Hollywood to rehearse the following day's shoot.

According to Patricia Bosworth, "With this film Ford took the western from pulp status into one of the greatest American movie genres of the Twentieth Century . . . Wayne was mesmerizing as the naïve young outlaw seeking redemption . . . but Ford baited him cruelly during the shooting and made fun of all the 'B' movies he'd been in . . . Nobody could ever figure out why Duke took so much abuse from Ford . . . years later Wayne told Maurice Zolotow that he thought Ford was simply after artistic perfection . . . 'Sure he got me angry,' he said about the making of *Stagecoach*. 'He would turn me inside out. First of all he was making me feel emotions and he knew he couldn't get a good job out of me unless he shook me up so damn hard I'd forget I was working with big stars like Thomas Mitchell and Claire Trevor. I was insecure . . . He also knew that putting a relatively unknown actor like me in a key role, well, there's an unconscious resentment among the veteran actors; there has to be . . . Mr. Ford wanted to get these veterans rooting for me and rooting for the picture, not resenting me [so] he deliberately kicked me around, but he got the other actors on my side.' For reasons that remain mysterious, Ford at his most creative was often his most mysterious."

So iconic is the mise-en-scène of this film that its stagecoach rescue by the cavalry—the confrontation between Manifest Destiny and the guerrilla tactics of the Native Americans—became part of the basic vernacular of Western movies, the heroics of the good (white) men against the bad (Indians). *Stagecoach* is, in every way, a classic of American cinema.

STAGECOACH OPENED FEBRUARY 15, 1939, the start of what has often been described as the greatest year in the history of Hollywood. Also released in that twelve-month period were Victor Fleming's (and George Cukor and Sam Wood's) *Gone with the Wind,* Frank Capra's *Mr. Smith Goes to Washington,* Fleming's *The Wizard of Oz,* Ernst Lubitsch's *Ninotchka,* William Wyler's *Wuthering Heights,* Henry King's *Jesse James,* George Stevens's *Gunga Din,* George Marshall's *Destry Rides Again,* and Ford's own *Drums Along the Mohawk.* In this crowded group of official greatness, *Stagecoach* stands tall.

If the failure of *The Big Trail* initiated a decade of B westerns and relegated Wayne to playing two-dimensional caricatures rather than three-dimensional characters, *Stagecoach* restored respectability to both him and the genre. And to Ford. *Stagecoach* confirmed Ford's cinema was a poetic sound-and-sight medium capable of realism and emotion in a way that was (and still is) at once contemporary, historical, and ultimately timeless. Ford balanced his shots of the stagecoach beneath the western skies and the expanse of Monument Valley with the interior scenes shot in expressionist deep focus and with low ceilings; it is this clash of the free, great outdoors and the confines of civilized living that creates a visual conflict that is as confrontational as any of the physical battles in the film.

It is also impossible to separate the physical film from Ford's passion for making it. The director put up a furious fight to keep the shooting script intact. The chief censor of the Production Code Administration, or PCA, Joe Breen, wanted Ford to eliminate Dallas's character completely, although in the script she is never referred to as a prostitute and is seen being run out of town by the women of "the Law and Order League." Breen also disapproved of the marshal letting Ringo go free at the end, and with Dallas. According to production papers related to the film on file at the Academy Library in Beverly Hills, California, after a long and protracted battle with Ford, Breen did not give final approval to the shooting script and an official seal of approval until two weeks before production began.

THE FILM PREMIERED SIMULTANEOUSLY AT the Fox Westwood Theater in Los Angeles, on the lip of UCLA's campus, and at Radio City Musical Hall in New York. The response was unanimous; the public loved it and so did the critics. *Variety* raved about "[t]he beauty of *Stagecoach,* not in its

action nor its story, but in the powerful contrasts of personalities, the maturing of characters and the astounding suspense that director Ford achieves." *Life* magazine described it as "*Grand Hotel* on wheels," and Archer Winston, in the *New York Post,* called it "[t]he best western since talking pictures began. It is so beautiful and exciting that maybe it ought not to be called 'A Western.'" William K. Everson, in his excellent history of westerns, called it "[a] superb film [that] caught the imagination of both critics and public. It was both entertainment and poetry, and it made an instant star of John Wayne. More to the point, it was directly responsible for the biggest single cycle of large-scale Westerns that the movies had ever known." Frank Nugent wrote in the *New York Times*: "In one superbly expansive gesture . . . John Ford has swept aside ten years of artifice and talkie compromise and has made a motion picture that sings a song with his camera. It moves, and how beautifully, across the plains of Arizona, skirting the sky-reaching mesas of Monument Valley, beneath the piled-up cloud banks, which every photographer dreams about."

As Roberts and Olson stated in their biography of John Ford, first in *Stagecoach* and then ever after, John Ford, with the help of his cameraman Bert Glennon, "transformed Monument Valley into the archetypal Western landscape . . . lone, haunting, a land that dwarfs people, plays tricks on the human eye and seems undaunted by civilization." According to Ford, "My favorite location [became] Monument Valley. It has rivers, mountains, plains, desert, everything the land can offer. I feel at peace there. I have been all over the world, but I consider this the most complete, beautiful, and peaceful place on earth."*

The success of the film reached across the Atlantic and was given the star treatment by that most eminent of French film critics, André Bazin. In his

* In his interview/study of John Ford, Peter Bogdanovich asked the director how he came to use Monument Valley in *Stagecoach.* Ford said, "I knew about it. I had travelled up there once, driving through Arizona on my way to Santa Fe, New Mexico."—Bogdanovich, *John Ford,* pp. 69–70. However, John Wayne contradicts in Roberts/Olson, [Wayne] "claimed Monument Valley was *his* discovery, one he had made in the late 1930's when he was working as a prop man on a George O'Brien film. Duke said that he had told Ford about the location before filming started on *Stagecoach,* and that once the director saw the valley he immediately jumped Wayne's claim of discovery." Roberts/Olson also claim that Ford once gave credit to Harry Goulding, who had a trading post there, and it was Goulding who first suggested Monument Valley as a location. Roberts/Olson cite the following sources: John Ford, *Directors in Action,* Todd McCarthy, *John Ford and Monument Valley,* Ronald L. Davis, *John Ford, Hollywood's Old Master.*

groundbreaking *What Is Cinema?* he wrote that "*Stagecoach* was the ideal example of the maturity of a style brought to classic perfection. John Ford struck the ideal balance among social myth, historical reconstruction, psychological truth and the traditional Western *mise-en-scène. Stagecoach* is like a wheel, so perfectly made that it remains in equilibrium on its axis in any position."

François Truffaut, wearing his critic's hat, recognized the link between *Stagecoach* and Welles's *Citizen Kane*: "Orson Welles has never sought to conceal what he gained from seeing other films brought to him, particularly John Ford's *Stagecoach,* which he says he saw many times before shooting *Kane*. In *Stagecoach,* John Ford systematically showed ceilings each time the characters left the stagecoach to enter a way station. I imagine that John Ford in fact filmed these scenes to create a contrast with the long shots of the stagecoach's journey, where the sky inevitably occupied a large portion of the screen."

In his aptly titled *The John Ford Mystery,* Sarris notes that "*Stagecoach* was more the beginning than the summing up of a tradition, and when we think of the Seventh Cavalry riding to the rescue of white womanhood, we are thinking no further back than *Stagecoach* . . . today [1975] it is surprising how much of *Stagecoach* is conventionally theatrical (*Kane* ceilings and all) and expressionistically shadowy . . . the point is that *Stagecoach* has been clarified and validated by what has followed. Its durability as a classic is attributable not so much to what people thought about it at the time as to what Ford himself spun off from it in his subsequent career . . . thus from a certain point of view, *Stagecoach* is a triumph of classic editing in the Thirties manner, and nothing more . . . It is the economy of expression that makes Ford one of the foremost poets of the screen. It can be argued that *Stagecoach,* even before *Kane,* anticipates the modern cinema's emphasis on personal style as an end to itself. And it can be argued also that, through Ford's style is less visible than Welles' it is eminently more visual, as Welles himself would generally admit."

According to Peter Bogdanovich, Welles watched *Stagecoach* forty times while preparing to make *Citizen Kane,* because of Ford's deceptively simple evocation of a blending of several stories, his cinematography, and the movement of his camera. And Bogdanovich offers this tantalizing revelation of an anecdote, from Wayne himself, about his acting in the film: "When Ford asked him what he thought of his own performance, Wayne just shrugged and said (repeating it to me), 'Oh, well, I'm just playing you—you know what that is.'"

Bogdanovich continues, "When a movie actor says something of that kind, he means that in the picture he is essentially doing what the director has asked for, told or shown him."

Indeed, Ford keeps the actor's laconic character in the forefront throughout by repeatedly cutting to his silent reactions. From Wayne's entrance, Ford is consciously creating a star. The success of *Stagecoach* changed everything for Wayne. "I had never in my life seen anything as exciting . . . the way those [audiences] took to the picture was tremendous. They laughed, clapped, stomped and obviously loved it." He sometimes joked about his good fortune with typical self-deprecation: "When I first got into this business . . . for several years I rode or stumbled, narrow-beamed and flat-bellied, across most of the mountains and deserts of Denver. I was known in those days as a good, grim, rangy type who needed the money and I seldom lacked work .'. . Oh I got a couple of fine breaks. Then, when I made *Stagecoach,* I was a 48-hour wonder."

THE ACADEMY AWARDS FOR THE films of 1939 were presented on February 29, 1940, at the Cocoanut Grove of the Ambassador Hotel in downtown Los Angeles, with the witty Bob Hope presiding over the after-dinner ceremonies. The ten nominations for Best Picture included Edmund Goulding's vehicle for Bette Davis, *Dark Victory*—she was also nominated for her performance in it; Victor Fleming's ode to the burning of Atlanta, *Gone with the Wind;* Hollywood's opaque acknowledgment of the European march of fascism, Sam Wood's *Goodbye, Mr. Chips;* Leo McCarey's celebration of one-night stands, *Love Affair;* Frank Capra's complex pro-American/antigovernment David and Goliath tale, *Mr. Smith Goes to Washington,* set in Congress, starring James Stewart as David and Senator Claude Rains as Goliath; Ernst Lubitsch's *Ninotchka,* Hollywood's attempt to humanize America's about-to-be-Allies, the Russians; Lewis Milestone's *Of Mice and Men;* Fleming's *The Wizard of Oz;* William Wyler's *Wuthering Heights;* and in that elite circle of films, John Ford's complex, majestic, and immensely entertaining *Stagecoach.*

Hope called the night "[a] wonderful thing, this benefit for Selznick." The joke was both funny and to the point. Before the ceremonies ended, the producer's *Gone with the Wind* had won ten Oscars, a record that would last for twenty years. Thomas Mitchell, who that year also gave a superb presentation as Scarlett O'Hara's father in *Gone with the Wind,* walked away with a Best

Supporting Actor Oscar for his nuanced performance as Doc in *Stagecoach*. "I didn't think I was that good," he said as he accepted his award. "I don't have a speech, I'm too incoherent!"

John Ford lost Best Director to Fleming (*Gone with the Wind*), but John Wayne, whose performance was perhaps the best by any actor that year, was not even nominated.* It didn't appear to matter to Wayne. As he later said, *Stagecoach* was nothing short of a rebirth for him as an actor: "At an age when most leading men are starting down the wrong side of the hill, I became a star."

WITH *STAGECOACH*, HIS EIGHTY-SECOND FILM, John Wayne was Hollywood's newest overnight leading man, tougher than Jimmy Stewart, rougher than Clark Gable, more stoic than Henry Fonda. He had pulled off an amazing and nearly impossible feat, coming all the way back from the failure of *The Big Trail,* and the decade-long exile from big pictures that followed, to join the A-list of Hollywood stars. Everybody loved him now, inside the industry and in movie theaters all over the world.

Everybody but Josephine, who had to live with Wayne and not just see him in his glory on the big screen, which is where, she finally began to admit, he really lived. She could no longer stand his carousing, his drinking, his lack of homebound responsibilities, and his apparent love of horses over her. If he wanted it so much, he could have his own life back.

That was why, on what should have been the best time of his life, and despite her religious convictions that did not permit such a thing, she decided she was going to divorce her husband.

* *Stagecoach* also lost Best Editing (Otho Lovering, Dorothy Spencer) to *Gone with the Wind* (Hal C. Kern and James E. Newcom), Art Direction (Alexander Touboff) to *Gone with the Wind* (Lyle Wheeler), and Black and White Cinematography (Bert Glennon) to *Wuthering Heights* (Gregg Toland). It also won Scoring: Original Song Score and/or Adaptation (Richard Hageman, W. Franke Harling, John Leopold, Leo Shuken).

Part Two

War, Hollywood, and Wayne in the Forties

Chapter 7

Josephine's world was one of order, propriety, and self-control, wrapped up neatly with her furniture, her family, and her church. As a Catholic, marriage was sacred, supposed to bring couples together, not push them apart. She talked to her husband about her feelings soon after the success of *Stagecoach,* that it was obvious to her he was no longer willing to play the one role she cared most about, the loving husband. Wayne knew she was right and, for his own reasons, he wouldn't be able tolerate a loveless marriage the way his father had.

Instead, he found the comfort and emotional salve he needed not just from the public's adoration for his on-screen heroics, but in real life in the arms of Claire Trevor, his costar in *Stagecoach,* whose affair with him paralleled both in time and intensity their on-screen romance. Wayne struggled with his guilt about it and shared his feelings with Ford, who had gone through his own extramarital affair with Katharine Hepburn, and it brought the two men closer together. Wayne and Ford took long sailing trips, just the two of them, with few words spoken. Few needed to be.

When Josephine first said she wanted a divorce, Wayne tried, in his guilt-fueled way, to assure her they could still make their marriage work. And they did, for a while, even though Wayne no longer made any excuses for not attending Josie's nightly clerical socials and teas, rarely slept at home, and never in the same bed. He preferred the small place he kept just off the Republic

lot to use as a place of refuge, when he wasn't sailing with Ford or sleeping there with Trevor.

FOLLOWING THE SUCCESS OF *STAGECOACH,* Yates decided to exercise the option he held on the star for westerns, and take advantage of his newfound fame by using him in a few more fifty-minute quickies. Wayne had been through this roller-coaster ride before, after *The Big Trail,* but this time, things were different. *Stagecoach* was everything *The Big Trail* wasn't, and he intended to see to it that it wasn't a one-shot wonder that would lead him straight back to the mediocrity of the Republic Bs. He began by changing agents, or, more accurately, his agent changed him, a move that would prove most auspicious for Wayne. Leo Morrison, as owner of the Morrison Agency, was still, technically speaking, Wayne's agent, not Kingston. But nearly broke, he sold Wayne's contract for cash (Wayne saw none of it) to Charles K. Feldman, a former Los Angeles–based lawyer who had given up his practice to found his own talent agency, Famous Artists Corporation, which had quickly became one of the most powerful in Hollywood. Feldman's roster of clients included Irene Dunne, Claudette Colbert, Tyrone Power, Marlene Dietrich, Fred MacMurray, and George Raft, all heavyweights in the studios' rosters of the late '30s and early '40s. Feldman had what one friend called the soul of a gambler. Another described him as having the biggest brass balls in Hollywood. He did things no one else would dare, like marrying Louis B. Mayer's girlfriend, which resulted in Mayer vowing never to use any of Feldman's clients. (The vow didn't hold. In Hollywood there is only one thing more important than loyalty—money). Feldman was the first agent in Hollywood to put together "package deals." Up until the day he died in 1968 at the relatively young age of sixty-three, he lived it up, with homes in Beverly Hills, the French Riviera, New York, London, and Paris. Despite all the accoutrements of fame, making deals for his clients and making his clients stars (or bigger stars) was what excited him most. He was eager to do the same for Wayne, believing greater things were possible for the actor who was still, essentially, considered a cowboy by the Hollywood studios.

One of the first things Feldman did for Wayne was to meet with Herbert Yates, to have him officially acknowledge the obvious, that Wayne was no longer a B actor.

Yates offered a compromise that Feldman thought he and Wayne could live

with. If Wayne finished out his still active contract at the same salary he was making before *Stagecoach*, Yates would give up all future options he still held on the actor for westerns. The deal was about to make Wayne a very wealthy man.

In the three years following *Stagecoach*, Feldman arranged for Wayne to star in eleven films, only four of which were Republic westerns, none with the impact of his breakthrough performance as the Ringo Kid. Wayne also finished his original obligation to make the last eight episodes of the fifty-one *The Three Mesquiteers* films based on three cowboy buddies invented by the novelist William Colt MacDonald. He had made several before *Stagecoach*, all directed by George Sherman.*

The first film Feldman got for Wayne away from Republic was at RKO, which Yates insisted the studio pay $10,000 to borrow Wayne for. *Allegheny Uprising* was a prerevolutionary drama in which Wayne played a Daniel Boone–type frontiersman. It was made in late 1939, directed by William Seiter and costarring Claire Trevor (who, at Wayne's behind-the-scenes urging, replaced Irene Dunne at the last minute; Trevor again received top billing over Wayne, and $22,500 for her work in the film, to Wayne's $6,000). This repairing of the stars of *Stagecoach* also reignited their off-screen romance, and their sizzling relationship in *Allegheny Uprising* is the best thing in this otherwise unmemorable film. (Its only other importance is that it kick-started the career of George Saunders out of his stock character of the suave, if morally flawed Brit in B movies into his stock character of the suave, if morally flawed Brit in A movies.) Otherwise, *Allegheny Uprising*, which Feldman intended as the follow-up hit to *Stagecoach* that would confirm Wayne's hold on stardom, failed, winding up with a loss of $245,000 from a budget of nearly a million dollars, a huge financial blow for RKO.

Wayne, via Feldman, then returned to Republic to star in *The Dark Command*, to be directed by Raoul Walsh, who had been at the helm of *The Big Trail* and had since landed at Warner's. Walsh's career, like Wayne's, had gone nowhere after the failure of *The Big Trail*. He had made a series of action-oriented features that did nothing until 1939, when producer Hal Wallis hired Walsh to do what would become one of the classics of Warner's crime cycle, *The Roaring Twenties*, notable for pairing two of Warner's biggest "criminals,"

* All are available in DVD. All films going forward have been released on DVD.

James Cagney and Humphrey Bogart. The film elevated the careers of Cagney, Bogart, and Priscilla Lane, the female lead. Walsh then went to Republic to work with one of the biggest cowboy acts not just at Republic but in all of Hollywood—Roy Rogers, in *The Dark Command,* which also starred John Wayne, Trevor, and "Gabby" Hayes.*

The Dark Command, released in 1940 and loosely based on Quantrill's Raiders during the Civil War, is a story of betrayal and rescue, and contains a surprisingly rousing performance by John Wayne. The reviews for the film confirm this, making it clear that Wayne was an actor with staying power to be reckoned with. Bosley Crowther, writing in the *New York Times,* declared, "The most pleasant surprise of the picture is the solid performance of John Wayne as the Marshal . . . Mr. Wayne knows the type; and given a character to build, he does it with vigor, cool confidence and a casual wit." William Everson, in his *A Pictorial History of the Western Film,* said this about Wayne's performance: "Probably the most important commercial element in [*The Dark Command*] is the emergence of John Wayne as an actor of sureness and character. Mr. Wayne, like Gary Cooper before him, has been known through many films as a good-looking man who could ride horseback . . . John Wayne has become more than an action star for little-boy audiences on Saturday afternoons." It was big praise and well deserved. After he had had to temporarily return to B pictures, Wayne's performance for Walsh in *The Dark Command* relit his A-status starlight.

PRIOR TO AMERICA'S ENTRY INTO World War II, Hollywood's feature films increasingly focused on the theme of the coming world war, although, for a number of reasons (including the United States' official position of neutrality), most films that were about America's immediate future were set safely in America's past. *Allegheny Uprising, The Dark Command,* and Wayne's next film for Republic, 1940's *Three Faces West,* were politically motivated, made to justify America's entry into the war.

* Rogers was brought in by Republic to replace Gene Autry, who was serving in the armed forces, and quickly became Republic's biggest star. Autry remained number two, Wayne number three. Yates had suspended Autry's contract during the war and held him to it, and he was never again able to gain his traction at Republic. He eventually left and formed his own film company, which distributed through Columbia.

Three Faces West, directed by Bernard Vorhaus, starred Wayne opposite Sigrid Gurie as Lenchen "Leni" Braun, the daughter of a Viennese refugee, Dr. Karl Braun. Gurie had replaced Trevor after the Wayne/Trevor screen pairing had run its professional and personal courses. Moreover, the role of Leni needed someone who could convincingly play Austrian, and that wasn't Trevor. Small, dark, European, and voluptuous, Gurie more than filled the bill. She was also attracted to Wayne and quickly began an affair with him. According to Zolotow, it was Sigrid who was the aggressor, eager to show the puritanical Wayne the erotic ways of European women. During the three weeks of filming, they carried on an intense sexual affair. Wayne may have thought about extending it, but he was not yet fully willing to let Josephine go, and so, like Trevor, Sigrid Gurie became just one more notch on Wayne's other six-gun.

Three Faces West is a film that Roberts and Olson describe as *Casablanca* meets *The Grapes of Wrath*, although it is nowhere near as good as either, or the other film it most thematically resembles, *Stagecoach*. In *West*, the townspeople of North Dakota, caught in the Dust Bowl drought, are forced to migrate to Oregon, under the guidance of John Phillips (Wayne). Along the way he falls in love with Leni, the refugee doctor's daughter, still mourning the death of her fiancé, Eric (Roland Varno), who apparently gave his life to help her and her father escape from a concentration camp. Eric then reappears in San Francisco, still alive and a bona fide Nazi. Leni and her father rejoin the wagon train. Freed of her longing for Eric, Leni marries Phillips.

The German-born director of the film understood well the machinations of his heavy-handed plot, having himself migrated to the United States via England. He felt a personal connection to the telling of this story of refugees and a charming Nazi who manages to slip into the States with nothing but evil on his mind, only to be rejected in favor of the all-American Phillips. Wartime propaganda abounds in *Three Faces West* as it did in *Casablanca* and *The Grapes of Wrath*.

Three Faces West, made for $140,000, a fortune by Republic's standards, earned Wayne $15,000, a relatively large sum of money for him, thanks to Feldman. The film did fairly well, but Vorhaus's career never lit up in America, and after the House Un-American Activities Committee (HUAC) took a second look at *Three Faces West* and a few of his other efforts, Vorhaus was "outed" as a Communist (films that were properly anti-Nazi before and during the war

were often assumed by HUAC to be too pro-Communist after the war). One of the film's screenwriters, Samuel Ornitz, a founding member of the Screen Writers Guild, gained fame, or infamy, as one of the notorious "Hollywood Ten," a group of writers who refused to name names before the committee and were jailed for contempt. Ornitz spent a year in confinement and never again worked in Hollywood as a screenwriter.

NOT JUST VORHAUS AND ORNITZ, but everyone's career in Hollywood, on-screen and off, was about to feel the heat from HUAC, one way or the other. A year before Pearl Harbor, sides were already being chosen up, and an "us"-or-"them" mentality swept through the studios, based as much on economics as politics. There was resistance from the majors to offend Hitler, because a European market hungry for American movies often made the difference between a film making money or losing it. In *Three Faces West,* the plight of the Dust Bowl refugees trying to flee to California is deepened by the plight of the Europeans trying to escape Hitler by coming to the "New World." Without the fascist elephant in the room, the film loses its emotional impact. With it, it becomes one of dozens of prewar films that carefully pushed back against European fascism by telling stories set in the past that emphasized earning and defending freedom in America.

Wayne's well-known but little-understood activism began in earnest somewhere between *Allegheny Uprising* and *Three Faces West,* both films a reflection of the economic turmoil that had hit the film industry during the Depression. In the years following the 1928 collapse of Wall Street, workers of the world were uniting, at least in theory, and in Hollywood the union movement, which had stagnated in the '20s due to the oppressive domination of the moguls, gained new momentum when those same moguls came up against an enemy they didn't know how to contain, the extreme faction of an organization that attracted many Hollywood workers, the American Communist Party.

It's not clear that the Communist movement would have gained such a strong hold on Hollywood if the economy had been more stable, or if studio heads had been a little less rigid in their attitude toward their workers; from the starlets they regularly forced onto the casting couches to the scene builders, the prop men (of which Wayne had been one), the actors, the writers, and the directors—all were treated as factory workers. Even stars were stars only to the

public. To the studios they still workers who enjoyed the public acclaim that went with the jobs. For the most part, with few exceptions, directors, cinematographers, and writers were unknown entities to a public whose only interest at the time was simply "Who's in it?," not "Who wrote it?" "Who filmed it?" or "Who directed it?"

When the Screen Writers Guild, the Directors Guild, and the Screen Actors Guild were formed (along with dozens of lesser organizations that would soon unite under an umbrella called IATSE—the International Alliance of Theatrical State Employees, which included film workers), the red lines were drawn. The moguls claimed they took great care of the people who worked for them (especially those starlets) and that unionism and Communism were ruining America. In Hollywood, they insisted, its influence on union writers and directors was the source of the subliminal messages contained within the films being made. They weren't completely wrong. In these times of economic discontent and worldwide upheaval and the growing threat of worldwide fascist domination, Communism was for many on the left making movies the only viable alternative to the Fascism of Hitler, Mussolini, and Hirohito.

Most actors, then and now, if the price is right will do almost anything for a paycheck, from fighting space aliens to dressing up as women if they're men, or men if they are women. And if there was a subversive element to the films of the '30s and '40s, it is more than likely the actors who starred in them were either not aware of it, or if they were, simply didn't care one way or the other.

But because few outside the industry knew how films were made, and that most actors were at the bottom of the power ladder, both the public and HUAC saw actors as the real threat. Among the earliest to sense all was not right in La-La Land was John Wayne. During the '30s, Hollywood was a community of sixty thousand working men, women, and children, most connected in one way or the other to the film industry. By 1935, at the height of the Depression, nearly one-quarter of them had become politicized. As the more conservative management and ownership shifted further to the right, the workers, including actors, tended to move to the left. By 1938, there were powerful, if uneasy alliances in Hollywood within these factions, between New Deal Roosevelt liberals, those caught up with the romance of pre–Hitler-Stalin Pact Communism, and those loyal to America but sympathetic to the left's desire to better their day-to-day bottom lines.

Among the most liberal Hollywood players at the time was John Ford, whose 1939–40 post-*Stagecoach* film trilogy were stories of democracy, destiny, and despair, all starring Henry Fonda in the lead. Two of these films were *Young Mr. Lincoln* (1939), with Fonda as the youthful, and mythic, man with morals who, at the end of the film, embarks on a journey to meet his destiny, and *Drums Along the Mohawk,* adapted from the James Fenimore Cooper novel, with Fonda and Claudette Colbert. It was Ford's first film in color and the only one he made set in the Revolutionary War, with emphasis on "Mother America" and "Birth of a Nation." Finally, there was Ford's towering adaptation of John Steinbeck's *The Grapes of Wrath,* which also starred Fonda, this time as Tom Joad in the prototypical leftist Hollywood film prior to America's entrance into the war, the film that of the three most resembled *Stagecoach,* the family car replacing the horse-drawn coach, redemption the ultimate goal in both films of those who made the journey, although in *Wrath* with far different results. Whereas *Stagecoach* brings love, peace, and the opportunity for a new life to the Ringo Kid, *The Grapes of Wrath* turns Tom Joad into a killer and a fugitive.

Wrath is socially significant because it is the first overtly Depression-era left-wing social/political rebel-as-hero movie to emerge out of prewar Hollywood. It was also the Ford film Wayne disliked most. He had no use for Fonda, whose real-life politics seemed, to Wayne, too close to Tom Joad's, more One of Them than One of Us.

For his part, Fonda had little use for Wayne, whom he dismissed as just one more big, dumb actor without a political thought in his head or an ounce of discernible talent: "Duke couldn't even spell politics . . ." Both were wrong and both were right about each other, and both were, at different times in this period, favorite sons of Ford, which may have added an aspect of cinematic sibling rivalry between the two actors, fueled at least in part by the difference in their acting stylistics: Fonda's was driven by aggressive narcissism, Wayne's by soft-spoken stoicism. If Ford leaned toward one over the other, it was Fonda, but it wasn't much of a tilt. He still liked Wayne as the best projection of himself on-screen, but didn't think either actor was that good on his own, and if they gave great performances in his films, it was because of him.

Going into his next project with Wayne, *The Long Voyage Home,* from a screenplay by Dudley Nichols who had last worked with Ford on *Stagecoach,*

the director instructed Nichols to keep Duke's dialogue to a minimum. His acting was better when he had fewer lines. "Count the times Wayne talks," Ford told another coworker when asked how he got such great performances out of the actor. "That's the answer. Don't let him talk unless you have something that needs to be said." To make *The Long Voyage Home,* Ford returned to Walter Wanger and his Argosy unit, this time with cinematographer Gregg Toland, who had shot *The Grapes of Wrath* and whose work on *Stagecoach* had led Orson Welles to hire Toland to help perfect his deep-focus techniques a year later for *Citizen Kane* (Toland's contribution to Ford, Wyler, and Welles reflects some of finest work of each director's respective careers).

Ford's decision to make *Voyage* may have had something to do with his desire to back off from the blatant politics of his Fonda-driven trilogy, for fear they might identify him too strongly with the left. According to McBride, "The American leftists during the Popular Front period emphasized patriotic rhetoric as a way of finding common ground with liberals in defense of basic democratic principles. That urgent patriotic groundswell no doubt influenced Ford's cinematic focus in the trilogy . . . Ford's heartfelt patriotism was expressed in symbolic, almost pop-art terms in *Drums* . . . while his militancy on behalf of the Screen Directors Guild helped ease him into publicly supporting more controversial political causes."

The Long Voyage Home both expanded and diluted Ford's political views by updating some of his good friend Irish-American playwright Eugene O'Neill's early one-act plays, which Nichols ingeniously knitted together into a unified story, pulling it into a more relevant political focus by changing the time from World War I to World War II, while pushing it out by changing the locale from America to England, which was officially at war with Germany.* Most of the action takes place aboard a British merchant ship, the SS *Glencairn.* The crew are really lost souls, made up of Ford regulars, among them Thomas Mitchell, Ian Hunter, Barry Fitzgerald, Ward Bond, and John Wayne, here cast against type as a slightly naive Swedish-born sailor, complete with a singsong accent that Wayne struggled to master. Their ship is on an endless journey to nowhere, their spirits suspended in purgatory as punishment for the human failing of

* The plays, written between 1913 and 1917, include *The Moon of the Caribees, In the Zone, Bound East for Cardiff,* and *The Long Voyage Home.*

the love of war, their final destiny the mythical river Styx. Ford's use of fog gives the film a German expressionistic look that reveals the influence director F. W. Murnau's work had on him and that heavily contrasts stylistically with his previous Fonda trilogy of überrealistic films.

Ford brilliantly sets the tone with his opening scene of the men, a crew without a mission, aboard a vessel without a port, on a journey at sea without an end. They long for the native women they have either left, want to be with, or will never have. It is a moment of unfulfilled sexual desire, unattainable peace. It is the hard price of war. The women represent the warmth of life the men leave behind as they journey into coldness. Ford breaks the mood with a deadly German attack on the ship, killing one of the men. Mankind is its own worst enemy, no matter what colors it flaunts.

Andrew Sarris noted, "The film is suitably moody, shadowy and romantically fatalistic . . . a conscious extension of the foggy expressionism of the Thirties into the programmed heroics of World War II. Producer Walter Wanger, Ford and Nichols were all outspokenly anti-Hitler in this period, and thus *The Long Voyage Home* constitutes a conscious tribute to Britain in its darkest hour . . . Ford and O'Neill are kindred spirits in that they share a tragic vision of life . . . a uniquely American-Irish Catholic vision in which guilt, repression and submission play a large part."

Production on *The Long Voyage Home* began April 18, 1940, the morning after the night Wayne had finished work on *Three Faces West*. The film was shot in two months at the Sam Goldwyn Studios in Hollywood and on location at the Port of Wilmington with a budget of $682,000. It proved a disappointment at the box office, a little too esoteric for audiences who that year could more easily identify with Ford's *The Grapes of Wrath*.

Although *Voyage* did nothing to advance Wayne's career, years later in 1949 he told the *Saturday Evening Post* that it was "[t]he role I liked best [to date] . . . from my point of view, *The Long Voyage Home* could have been titled *Wayne's Long Struggle with a Swedish Accent,* for the role of Oley in this film about the wartime merchant marine . . . Thanks to the coaching of Danish actress Osa Massen and the constructive criticism of director Jack Ford, however, I managed to talk my way out of this hole."*

* During filming Wayne had an intense sexual affair with Osa Massen, a gorgeous Danish actress Feldman had hired to help Wayne learn how to sound Swedish.

After *The Long Voyage Home,* Ford, who had been in the Naval Reserve since 1934, was assigned to make wartime propaganda films for the government. It may have been a blessing in disguise because he was also a founding member of the MPAC (Motion Picture Artists Committee to Aid Republican Spain), an organization that at its peak had fifteen thousand members. In July 1937, the group, including Ford, had hosted Ernest Hemingway and his wife, Florence Eldridge, who made an appearance to raise funds for the Loyalists. Ford donated an ambulance to the cause. In 1938, Ford became vice president, along with Philip Dunne and Miriam Hopkins, of the MPDC (Motion Picture Democratic Committee). Its president was the writer Dashiell Hammett, dedicated to the advancement of liberalism, antifascism, and antiracism. That same year, the first incarnation of HUAC was created in Hollywood, to keep a watchful eye on those who held the reins to the mass medium of film. HUAC's raison d'être was simple: Hollywood had made a hero out of Tom Joad. Washington felt the time had come to keep a closer eye on what was going on in Hollywood, especially Ford, who had glorified Tom Joad on-screen. His increasing involvement in the MPDC, a group that HUAC suspected was a Communist-driven anti-Franco organization, increased their interest in him. Ford's distinguished war service probably saved his Hollywood career.

Politics affected everyone in Hollywood, in one way or another. Wayne became more active as an officer of the Screen Actors Guild. Here is how Wayne put it later on, to friend and future biographer Maurice Zolotow: "I noticed something was going wrong in this business in 1937, 1938 [one of Wayne's most fallow periods, before Ford put him into *Stagecoach*], the Communists were moving in, and under the guise of being anti-fascist. I saw they were hoaxing a lot of decent men and women on humanitarian grounds. I was on the executive board of the Screen Actors Guild and I noticed one or two of my fellow members whose hearts were always bleeding for the little fellow, but they never really helped him. They just talked about it and tried to stir up dissension between extras and producers and directors . . . at parties Russia was the hope of the world."

During the war, Wayne, who did not enlist, made seventeen commercial films. His failure to volunteer for service would become an issue later on his career and leave a scar on his broad-stroke patriotism.

THE TOP-GROSSING FILM OF 1940 was Jack Conway's *Boomtown,* starring Clark Gable and Spencer Tracy, in the midst of their successful run of buddy-buddy films. Other big hits that year included George Cukor's *The Philadelphia Story* starring Jimmy Stewart, Katharine Hepburn, and Cary Grant; Walt Disney's *Pinocchio;* and Chaplin's much-anticipated, controversial *The Great Dictator,* the only studio film that year that dealt overtly with the coming war satirizing Hitler, and a film that got Chaplin in legal trouble with the American government for violating the Neutrality Act, which Washington warned Hollywood to obey. Chaplin owned his own studio and ignored the directive.

The 1940 Academy Awards took place February 27, 1941, at the Biltmore Bowl of the Biltmore Hotel in Los Angeles, its entrance dressed up for the occasion with a fifteen-foot neon outline of Oscar. The host of the proceedings was Walter Wanger, the producer of *The Long Voyage Home,* who was the president of the Academy. That might, with the inevitability of war hanging in the air, Hollywood decided to throw itself, and America, one final peacetime fling. To mark the occasion (both the reality and the unreality), President Roosevelt delivered a radio address, during which he praised Hollywood for its defense fund-raising efforts, put in a plug for Lend-Lease, and thanked Hollywood for being a unified patriotic industry that worked together in harmony for "promoting the American way of life." After, while Judy Garland sang "America," the Republican faction of the Academy, none of whom could stand Roosevelt, pushed their plates away in disgust. Hollywood was anything but unified.

The nominees for Best Actor were Charles Chaplin, Henry Fonda, Laurence Olivier in Alfred Hitchcock's *Rebecca,* Jimmy Stewart in George Cukor's *The Philadelphia Story,* and Raymond Massey for his performance in yet another Lincoln film, John Cromwell's *Abe Lincoln in Illinois.* Although Fonda's performance towered over all the others, the award went to Jimmy Stewart, the result of the Academy splitting its vote between Fonda, Olivier, and Massey (Chaplin, supremely unpopular in Hollywood, didn't have a chance). Best Actress went to Ginger Rogers for her performance in Sam Wood's *Kitty Foyle,* over Katharine Hepburn (*The Philadelphia Story*) in her comeback, Joan Fontaine in *Rebecca,* and Bette Davis in William Wyler's *The Letter.*

For Best Screenplay, Nunnally Johnson and Dudley Nichols both lost, for *The Grapes of Wrath* and *The Long Voyage Home,* respectively, as did Dalton

Trumbo for *Kitty Foyle,* and Robert E. Sherwood and Joan Harrison for *Rebecca.* All fell to Donald Ogden Stewart for *The Philadelphia Story.* Best Picture saw Hitchcock's *Rebecca* walk away with the honors (the award going to producer David O. Selznick rather than the director). Both *The Grapes of Wrath* and *The Long Voyage Home* lost in that category, but John Ford won the Best Director Oscar for *The Grapes of Wrath,* over Sam Wood, Hitchcock, Wyler, and Cukor. Ford's triumphant year could not be denied. "I love making pictures," Ford said later, "but I don't like talking about them." He went fishing with Wayne during the Academy celebrations.

IF HE HAD FELT ADRIFT after the commercial failure of *The Long Voyage Home,* 1940 would not be completely forgettable for Wayne. Among other things, he fell in love with a gorgeous displaced German actress with an insatiable desire for hot sex with American boys and men, even hotter if she could break up their marriages or in some other ways humiliate and disgrace them. Her name was Marlene Dietrich, and when she came into Wayne's life, she juicily sucked every last drop of resistance, loyalty, morality, and guilt out of him. Sex to Dietrich was destructive and debilitating and decadent and debauched. It was the way she liked it, and the way she wanted to make Wayne like it.

It was said by friends of the actress that she would put Wayne on his knees and hold his face close between her thighs and make him recite the Pledge of Allegiance to something even higher than his flag and his government.

Chapter 8

By 1929 the heat had gone out of American film director Josef von Sternberg's silent films, and he accepted an offer from the UFA (Universum Film-Aktien Gesellschaft), Berlin's leading film production house, to make a sound film in Germany simultaneously in German and English. It was *The Blue Angel,* the story of distinguished Professor Unrat, who falls for a gorgeous blond showgirl and prostitute, Lola-Lola, who sexually enslaves and humiliates him, literally turning him into a clown. When she degrades him in front of another man, he returns to the schoolhouse where he once taught and, in the midst of a fit of mad rage, dies.

The film was a huge international hit and made a star out of Marlene Dietrich, a former showgirl and German silent film actress, who then made Sternberg into her real-life Unrat. His love for Dietrich (who was married) turned into a perverse addiction he could feed only by making more films with her. After she came to Hollywood, she made a point of sleeping with every one of her leading men, in films mostly directed by Sternberg, twisting her costars out of sexual shape until they could no longer stand straight. Her so-called victims were all willing and eager for a taste of her luscious exotica (including the young and beautiful and notorious swordsman Gary Cooper, whom she reportedly fell in love with while making Sternberg's 1930 *Morocco*); Sternberg's Unrat-like obsession with Dietrich, and her inability to successfully break away from him, eventually ruined both their careers, as each of the seven films they

made together under contract to Paramount became increasingly fetishistic and overstylized. By 1935, both had become box-office poison.

In 1939, Dietrich's career was revitalized when she managed to land the female lead in George Marshall's western spoof, *Destry Rides Again* (a.k.a. *Justice Rides Again*), produced by Joe Pasternak, a remake of an old Tom Mix silent film, based on a Max Brand novel. This was Jimmy Stewart's fifth and final film of 1939, a very prolific year for the young actor. Even before production began, Dietrich let it be known that she intended to make a full-course meal out of him. Rumors persisted for months after the completion of *Destry* that she had gotten pregnant by the actor and had an abortion, reportedly arranged by her friend Louis B. Mayer.*

She then lost all interest in Stewart and dropped the smitten actor without ever bothering to tell him to his face that his time with her was up. It was a heartbreaking turn of events for the young bachelor, who took a long time to get over it. This was prime Dietrich, whose pattern of hot seduction and cold heartbreak would be put into play again with her next victim, John Wayne.

Tay Garnett, a former naval flying instructor turned gag writer for Hal Roach, Mack Sennett, and Cecil B. DeMille before developing into a solid, if unspectacular film director, was a good friend of Wayne. Both were members of the Emerald Bay Yacht Club. In the fall of 1940, Garnett was assigned to helm *Seven Sinners* for Universal. *Destry* had made Dietrich bankable again, and Universal wanted her immediately for another film produced by Pasternak, this one an updated, (very) loose adaptation of Puccini's *Madame Butterfly*. Garnett knew exactly whom he wanted to play opposite Dietrich. The role called for a rugged tough guy, and he chose Wayne, whose own star had risen after *Stagecoach* before stalling following *The Long Voyage Home*. The only thing standing in the way of Garnett casting Wayne was Dietrich. She now had costar approval, something that came along with her huge $150,000

* "She'd slept with [Jimmy Stewart] from day one. It was a dream: it had been magical. For him, too. Suddenly, she was able to speak about it. It had all been poetic and romantic, hour by hour. That had held her bound to him, making her happy and unhappy . . . She had become pregnant by him the first time they'd slept together . . . she didn't want to abort the child, in order to continue sleeping with him. But she gave in to his wishes."—From the published diaries of German novelist Erich Maria Remarque regarding Marlene Dietrich's affair with Stewart. Remarque and the married Dietrich were romantically involved during this period.

fee to make the movie, a deal Feldman, who had signed her on as a client, had negotiated.

When Garnett first introduced Wayne to Dietrich, she played it cool, but afterward she whispered in the director's ear, "Daddy, buy me *that*!"* According to Pilar Wayne, "A meeting was set up in Dietrich's dressing room at Universal. Duke recalled that day quite vividly. He said that Dietrich invited him inside and then closed the door and locked it. He'd never been in a major star's private dressing room before and stood gawking at the luxurious appointments.

"Dietrich broke the awkward silence. 'I wonder what time it is?' she said, giving him a smoldering look. Before Duke could glance at his watch she lifted her skirt, revealing the world's most famous legs. A black garter circled her upper thigh with a timepiece attached. Dietrich looked at it, dropped her skirt, and sashayed to Duke's side, saying in a husky voice, 'It's very early, darling, we have plenty of time.' "

IN *SEVEN SINNERS,*† DIETRICH'S NAME was billed above the title— "MARLENE DIETRICH IN *SEVEN SINNERS*—and Wayne's was half the size—"With John Wayne." Dietrich plays Bijou Blanche, a South Seas music hall girl (call girl), a variation of the same easy-virtue seductress she had played in every move since *The Blue Angel*. She was so big she was able to demand that no other woman in the film could have blond hair (causing one of her costars, Anna Lee, to have to dye her natural-blond hair dark brown).

For this film, Wayne traded in his cowboy chaps for navy whites, and is stationed at the American air base at Boni-Komba, where Bijou happens to be "appearing" at the Seven Sinners Café, protected by her "bodyguard," the gruff Broderick Crawford. One night she meets U.S. Navy Lieutenant Dan Brent (Wayne), who falls head over heels in love with her, much to the dissatisfaction of his commanding officer. In a statement of defiance, Lieutenant Brent vows

* The anecdote and quote appear in several sources. Bach qualifies it by noting the line is from Somerset Maugham's *The Circle,* a play Dietrich once had performed in early in her career. She was, likely, making fun of Garnett, who had no idea the line wasn't real or original, when she exaggerated her initial attraction to Wayne. Universal had wanted Tyrone Power to costar with Dietrich, but she vetoed the choice. It's also likely that Zanuck wouldn't loan out Power, who was under contract to Twentieth Century–Fox.

† *Seven Sinners* is available on DVD, alone and as part of several different Wayne collections, including one from Turner Classic Movies.

to resign his commission and marry Bijou. Not long after, at the café Brent gets into a rumble with a disgruntled ex-lover of Bijou and is knocked unconscious. He is taken back to the ship, where he slowly regains his senses, while Bijou and her "bodyguard" (and another girlfriend) slip past the authorities and head out for the next port.

The film was released in October 1940 and proved a critical and commercial success, due in large part to Dietrich's drawing power at the box office. As for Wayne, playing opposite a sexual bombshell like Dietrich reminded audiences how little heat he really had as a leading man. Rough and tough was his sweet spot, and *Seven Sinners* is filled with saloon-wrecking fistfights that Wayne felt more at home with.

Off-screen, of course, it was a different story. Wayne was like a sweaty adolescent around Dietrich. He couldn't get enough of her. He had never before had a real whiff of the kind of feral sexuality Dietrich exuded. Certainly there was nothing like that for him at home or with any and all the Claire Trevors of Hollywood. He was crazy for Dietrich from the first time she led him to her bed. He stayed there, at her beck and call, for the next three years and didn't appear to care who knew it. She was the bad girl he'd never had, the forbidden fruit he'd never tasted. She was as free and easy with her body as Josie was uptight and rigid with hers. Dietrich used that to her advantage and made Wayne not just like sex with her, but crave it. The gaggle of gossips that included Louella Parsons, Hedda Hopper, and Jimmie (Jimmy) Fidler all made reference of the affair in their columns and radio broadcasts, with eyebrows raised in surprise and outrage.*

Josephine was not amused. Even in her insulated social world, it was impossible not to hear about her husband's wild romance with his decadent German costar. If her marriage to Wayne had had any chance at all of succeeding, that ended with the arrival into his life, and hers, of *La Dietrich*.

* Dietrich biographer Stephen Bach doubts the veracity of the "love affair" and quotes Dietrich as describing Wayne as "[n]ot a bright or exciting type, not exactly brilliant, but neither was he bad," and he doubts Zolotow's quote by Dietrich that she found Wayne "an actor who was an animal, an animal of honor and dignity." The other thing to consider with Dietrich was that all these affairs coincided with the movies she made and could very well have been orchestrated by the studios. The only problem with that theory is that Dietrich never listened to anything the studios or anyone said when it came to her career or sex life. What cannot be doubted is that Wayne was totally smitten with Dietrich.

He was in love with this glamorous actress, who had shown him her world, and he now wanted to show her his by introducing her to American football. He took her to USC games. He took her fishing and hunting north of Los Angeles, and up to the great Northern California woods and through the vineyards. They were two opposites that seemed strongly attracted to each other. Dietrich lived off her exotic sultriness, her frilly underthings revealed as easily as her smirk, while Wayne epitomized the American male stoic, the strong, silent type who preferred to let his fists do his talking and to keep his lovemaking a private affair. She was his fantasy of Europe, sexually uninhibited and wild; he was hers of America, big, tough, impervious, sexually repressed. Lacking the refinement of his German counterparts but capable of beating them to a pulp, he managed to escape being the next Unrat to her real-life Lola-Lola. Instead she made him her own personal King Kong.

They carried on in public as if they didn't care who saw them kissing in nightclubs over dinner, and that proved the final blow for Josephine, who informed her husband she intended to go through with the divorce after all. Wayne was shocked by her decision. He never thought she would have the courage to actually go through with it, to break up the family and defy her church, but she made it clear to him their marriage was over, and until it became official he was no longer welcome at home.

And if it wasn't enough to make Wayne crazy, there was that other thing going on that was going to affect his and everybody else's life. America was about to enter the war and every able-bodied man was expected to enlist, put on a uniform, and fight. Young boys would lie about their ages to get in; old men would as well because they, too, wanted to fight for their country. Rich men, poor men, men from good families, men with no families, college students, doctors, lawyers, film stars, even directors—everybody would want in on the action.

Except John Wayne.

Chapter 9

In February 1941, ten months before Pearl Harbor, Republic, via Charles Feldman, signed Wayne to two films, the first to be directed by John H. Auer, *A Man Betrayed* (a.k.a. *Wheel of Fortune*, a.k.a. *Citadel of Crime*, a.k.a. *Gangs of Kansas City*), a so-called screwball comedy that had very little screw in its ball. In it, a badly miscast Wayne, whose flair for comedy was never his strongest suit, plays a lawyer investigating the death of a friend, which leads to his uncovering a widespread web of local political corruption. He two-fistedly cleans up the town, and gets the girl while doing so, in this case pretty Frances Dee, married at the time to Joel McCrea. Wayne had no off-screen interest in Dee or any other leading lady, as he was still terribly smitten with Dietrich.

This was a film Yates had pulled from Republic's trunk of recyclables, the studio having made it once before in 1936 (also directed by Auer), with Edward Nugent in the lead. Wayne was paid $18,000 for his services and he asked for and got Ward Bond to be his costar, as the simpleton henchman for the bad guys. *A Man Betrayed* received decent reviews, most critics agreeing it was okay, nothing special.

Two months later the second Republic-produced Wayne feature was released, *Lady from Louisiana*, directed by Bernard Vorhaus (who also coproduced). In the film, which wisely leaned more heavily on action than comedy, Wayne once again plays an attorney, this time on a nineteenth-century Mississippi riverboat. *Modern Screen* described it quite succinctly and accurately as having "a colorful

background, a capable cast, a considerable cast, a considerable amount of action . . . Wayne competently fills the bill." The *Motion Picture Herald* noted the film's "thrilling finale of blood and slugfest." It was shot in twenty-three days in March and Wayne was paid $24,000 for his services. Ona Munson played his female interest. It opened that May nationwide.

Lady from Louisiana completed Wayne's latest commitment to Republic. Free now to accept any and all new offers, Wayne added a key element to his team of business representation, Bö Roos (pronounced *Boo Roos*). For 5 percent, Roos agreed to have his company, Beverly Management, handle Wayne's finances, an assignment he had done for a number of other Hollywood stars including Merle Oberon, Red Skelton, Johnny Weissmuller, Lupe Vélez, Fred MacMurray, Joan Crawford, Ray Milland, and Marlene Dietrich. It was, in fact, Dietrich who first sent Wayne to Roos, assuring him that Roos could take him from being a comfortable actor to a wealthy man. Wayne got the message. Everybody knew he and Josie were headed for divorce and he needed to protect as many of his assets as possible. There was no hidden agenda here on Dietrich's part. She was still married and would remain so for the rest of his life.

Roos's combined portfolios for his clients was about $25 million, an enormous amount for the early 1940s, equivalent to more than a quarter billion dollars today. Tellingly, he was also an expert in managing the finances of divorcing clients and fought for them to keep every last dime they could, no matter how nasty the split.

The first thing he did was put Wayne on a weekly $100 allowance, and he sent an ample amount for household expenses to Josie. He then set up trust accounts for each of their four children. Roos's maneuverings put a strain on Wayne's cash flow; he was not used to someone telling him how and how much to spend of his own money. He had become something of a glad-hander among his friends, and was known in Hollywood as a soft touch. He loved picking up the check whenever he went out, regardless if it was with one woman, or a group of twenty-five pals, and if anyone needed some bridge money, he was always happy to give it to them. This was the way he was brought up—he learned from his father, who was quick to help others even if it meant he didn't have enough for himself. "It was impossible to get Duke to stay on a budget," Roos later told Zolotow. "He just couldn't say no to a guy he liked and, hell, sometimes

he wouldn't tell you, wouldn't tell me, or anybody in the office he was signing a check. However, at least we did get Wayne's capital invested to some extent."

Roos put Wayne's money into a Culver City motel, a yachting marina on Catalina, a beach club, a fleet of shrimp boats, a fast-freeze food-processing plant, a country club, a hotel in Acapulco, some oil wells, and a portfolio of common stocks, while Wayne continued to spend lavishly on his three favorite, if somewhat idiosyncratic hobbies: cowboy suits, comic books, and Kachina dolls. Roos succeeded in stabilizing and maximizing Wayne's income, and protecting as many of his investments as possible from the coming divorce proceedings.

HE MADE HIS NEXT FILM for Paramount, *Shepherd of the Hills,* directed by Henry Hathaway. The film is about a son whose father deserted his mother when the boy, Matt, was young, which led to her death, an emotional context that recalled for Wayne his own problems with his dad. To make the point even more powerful (for him) and to deepen the emotional connections, Wayne insisted that Harry Carey, the actor who had been his role model during the early, formative years, play the father.

After his mother's death, Matt becomes embittered and something of an outcast in the Ozark community in which he lives. He gets involved in moonshining and vows to avenge his mother's death by killing his father, should he ever return. Into this mix comes a stranger who performs what appear to be a series of miracles, including saving the life of Matt's fiancée, Sammy Lane, played by Betty Field. In an interesting twist, this mysterious "Good Shepherd" turns out to be Matt's father. The son forces a confrontation and is shot by the father. He miraculously recovers and becomes a changed man. Matt forgives his father and marries Sammy.

The story plays better than it reads. Filmed near Big Bear Lake, Moon Ridge, and Bartlett Lake in the San Bernardino Mountains, which stood in for the Missouri Ozarks (in the village that is now known as Branson, where a live version of the original novel is still performed nightly in an outdoor arena), the film was an adaptation of a hugely successful 1907 novel by Harold Bell Wright, with a screenplay by Grover Jones and Stewart Anthony. The script simplifies and improves the original novel.

Shepherd of the Hills, Wayne's first film shot in color (Technicolor), opened

July 18, 1941, to great reviews and big box office.* Its neoreligiosity was something of a departure for Wayne and, during production, gave him nightmares. He kept seeing his own father in his dreams; his death still affected Wayne deeply, especially since Wayne had never fully forgiven his father for "abandoning" his mother. Now, in his dreams, he found himself mirroring, or "doubling" the character of Matt, asking the spirit of his father for forgiveness. He also dreamed about being bullied by the other boys at high school, when he was still Marion Morrison, before his father and the father-figure fireman taught him how to fight and defend himself. All this turmoil was not helped by his ongoing feelings of guilt over his romance with Dietrich and the coming divorce from Josephine. Much of this emotional conflict found its way into Wayne's performance, which, under Hathaway's direction, remains one of his most unusual and complex, in an interesting, if offbeat film marred only by its reversion to violence as a resolution.

Americans found reassurance in the film's message of redemption and reconciliation and were moved by Wayne's thoughtful, introspective performance. Critics, too, liked it. Allen Eyles, in his *John Wayne and the Movies,* wrote that the film was "a powerful one on the lines of *Stagecoach* but with a greater depth involving the kind of intense, interior conflict that [Wayne] could register powerfully." The *New York Times* liked it less, while acknowledging Wayne's performance: "Gifted John Wayne and Betty Field do their best against the inanities of their roles."

That fall, Wayne returned to Republic Pictures for one film, lured back by a $24,000 salary and a guarantee of the film's gross, a percentage of the box-office sales before expenses were taken out. This type of deal was usually reserved for only the biggest stars, but Republic needed him and was willing to pay whatever it took to get him.

The film he agreed to make for them was *Lady for a Night* (a.k.a. *Memphis Belle*), directed by Leigh Jason, a bit of fluff that finds Wayne again in the Mississippi riverboat milieu, playing another lawyer, with a plot that could apply to any one of a dozen Wayne movies. Shot in black-and-white, filled with leggy chorines and a tuxedoed Wayne, *Lady* ends in a huge slugfest that resolves all the film's mundane plot twists on Old Man River.

* Zolotow erroneously reported the film being shot "in beautiful black and white." He may have confused it with *The Big Trail,* which was shot in black-and-white.

Scheduled for a holiday release, the opening had to be pushed back several weeks, to December 29, because earlier that month, on the seventh, the Japanese attacked Pearl Harbor and the next day Roosevelt declared war. The country changed overnight, united in patriot-driven rage and eager for revenge against the Japanese. Suddenly, Hollywood found itself with dozens of unreleased films that looked and sounded like they were made a hundred years ago, of which *Lady for a Night* was one.

John Wayne had completed one more film before December 7, this one for Cecil B. DeMille, one of the earliest pioneers of Hollywood, best known for the kitschy, expensive movies he produced and directed. He wanted Wayne to play the second lead in a $2 million extravaganza called *Reap the Wild Wind*. DeMille, via Feldman, agreed to pay Wayne $35,000 to costar with Ray Milland, a sophisticated, handsome British Hollywood transplant. Wayne and Milland formed the two male corners of a love triangle, with Paulette Goddard as the woman they both lust after. The film is set in the Florida Keys in 1840, against a special-effects-riddled background of storms, fogs, sinking and sunken ships and the salvagers who live off them, pirates, kidnappings, crooked lawyers, and a sea monster that conveniently kills off Wayne. It was a kind of *Gone with the Wind* lite, with Goddard and Susan Hayward (two stars who tried and failed to land the role of Scarlett O'Hara), and Wayne miscast as an adventure-seeking salvager, the type of expansive but hollow spectacle that DeMille loved to make, complete with his own stentorian voice-over prologue narration, his auteurist signature.

When the film finally opened, in March 1942, with the country deep into the war, the women left behind flocked to see the romantic spectacle and it enjoyed a five-week run at Radio City Music Hall, where it broke all previous attendance records. It proved a huge moneymaker then, and again in 1954 when it was rereleased.

Before America entered World War II, Wayne's career had fully regained the momentum it had lost after *The Big Trail* and he had become a legitimate Hollywood star. He had paid more than his fair share of dues both before and after *The Big Trail*, and struggled for years until *Stagecoach* had made him bankable. He was thirty-four when the bombing of Pearl Harbor happened on December 7, 1941, and he feared having to give it all up now by going into the army, which might put a permanent halt to his career. If the war dragged on another

five or six years, he would likely be too old to still be an action-oriented leading man, and older character actors didn't make the same kind of money as young ones. Besides, he had four young children to support. Who would look after them while he was gone? Josephine?

Because he chose not to enlist, he became an even more valuable commodity because of the sudden lack of leading men. Henry Fonda, a Naval reservist, who was thirty-seven, married with three children, was called to active duty. Thirty-three-year-old Jimmy Stewart, whose family had a proud military tradition, had been rejected when he tried to enlist because he didn't weigh enough. He then went on a diet of candy, beer, and bananas until he was able to make the minimum weight, putting his Academy Award–winning career on hold while he flew dozens of missions over Germany. Thirty-four-year-old Gene Autry joined the Army Air Corps. Tyrone Power enlisted in the Marines. Robert Montgomery joined the army. William Holden joined the army. Following the death of his wife, Carole Lombard, in a plane crash during a tour selling war bonds, a distraught Clark Gable also joined the army. Ronald Reagan was the right age to be drafted and had to give up a career that was finally about to break—Jack Warner was considering him for *Casablanca,* a role that went instead to World War I veteran Humphrey Bogart. The list goes on and on, and it should be noted that not everybody went easily. Many celebrities were forced to join because of the pressure of patriotism, and the promise they would never see action. Others, like Laurence Olivier, a member of the expat group of "Beverly Hills Brits," were threatened by their government with extradition and imprisonment if they didn't immediately return home to do their duty.

John Ford reported for active duty in September 1941. On June 8, 1943, he was assigned to the Office of Strategic Services, Washington, DC, as Officer in Charge, Field Photographic Division, with additional duty as Director of Motion Pictures. The following August he had temporary additional duty as Technical Observer in the China-Burma-India theater. In April 1944 he would serve as Technical Observer with the Branch Office, Office of Strategic Services, London, England, in connection with the accomplishment of various reconnaissance flights in combat areas in preparation of strategic motion picture sequences from air.

Ford was wounded filming the Battle of Midway, and for the invasion of Nor-

mandy, June 1944, he would organize the seaborne Allied photographic effort in the invasion and was the Commanding Officer of the United States Navy and Coast Guard, and the Polish, French, and Dutch camera crews. In November 1944, after his return to the United States, he was temporarily released from active duty to return to Hollywood to work with Metro-Goldwyn-Mayer on production and direction of the motion picture *They Were Expendable*, which portrayed PT boat activity in the United States Navy.

In July 1945 he returned to active status in the U.S. Naval Reserve and served again with the Office of Strategic Services, Washington, DC, until October 1945, when he was released to inactive duty. For his four years of outstanding services rendered the government of the United States, John Ford would be awarded the Legion of Merit.

WHILE OTHER ABLE-BODIED STARS WERE fighting for their country, Wayne was making movies. In his biography, Maurice Zolotow wrote: "Wayne had tried to enlist as soon as the war was declared. He was rejected because he was thirty-four years old, married, had four children, and a defective shoulder. He attempted to enlist twice more and once he flew to Washington to plead with [John] Ford, by now a lieutenant commander in the Navy, to help him get a post in the navy. He failed. This was a bitter disappointment to Wayne."

The story was a complete fabrication, the product of Zolotow's uncomfortably close relationship with his biographical subject. Wayne never tried to enlist and never "pleaded" with John Ford to get him into the navy. It is, however, a bit of a stretch to describe Wayne as a draft dodger, as Gary Wills did in his book *John Wayne's America: The Politics of Celebrity*. Five months after war was officially declared and the United States joined the Allies in the European and Asian theaters, Wayne turned thirty-five. At this early stage of the war he was at the high end of the age range for eligibility. Most draftees were closer to twenty years old. His local board did call him in, and he claimed he was exempt because he was the sole supporter of his family, even though he was about to be divorced, which he didn't mention. He also told the board that his old shoulder injury made him ineligible (although it didn't seem to bother him much when he was working as a stuntman or riding horses or throwing punches). He was granted his first provisional 3-A classification "for family dependency reasons."

Herbert Yates of Republic Pictures had a strong hand in keeping Wayne out

of the army. His continual requests for extensions of his deferment were not filed by Wayne himself, but an unnamed "other," who was, in fact, Yates. According to Ford biographer Dan Ford, Wayne claimed the studio head threatened to sue him if he let himself be drafted, as preposterous an excuse imaginable (The government at war's end destroyed most of Wayne's and Yates's service-related papers).

One of the few revelations about Wayne's war involvement (or resistance to it) was his supposed willingness to join the OSS (Office of Strategic Services), the agency that later became the CIA, arranged by John Ford, who made one last attempt to get Wayne to commit to the war effort. According to Glenn Frankel, "The office sent Wayne a letter saying they were running out of places and urging him to sign on without delay, but Wayne claimed that Josephine hid it from him. 'I never got it,' he later told [Ford biographer and grandson] Dan Ford."

Wayne then changed his story, revealing to Dan Ford more than he ever had before about why he didn't serve. "I didn't feel I could go in as a private, I felt I could do more good going around on tours and things . . . I was America [to the young guys] in the front lines . . . they had taken their sweethearts to that Saturday matinee and held hands over a Wayne Western. So I wore a big hat and I thought it was better." Years later, according to Pilar, his third wife, his decision not to serve was the real reason he became, after the war, a "superpatriot for the rest of his life trying to atone for staying at home." Whatever his true motivations, not serving in the military was a subject he was always reluctant to discuss in detail.

There were some things and people Wayne was eager to be a part of. He was still clinging to his relationship with Marlene Dietrich, whom he once described to Pilar, as "the most intriguing woman I've ever known." To one close male friend he put it a little differently, describing Dietrich as "the best lay I've ever had." He wasn't quite ready to give her up for anything, even, perhaps, his country, although Dietrich had already tired of him and begun an affair with George Raft.

Wayne's next picture was with Dietrich, a fourth remake of *The Spoilers,* directed by Ray Enright, about claim jumpers in Alaska, costarring Randolph Scott. In the film, Scott's character has designs on a gold mine owned by Wayne

and his partner, played by Harry Carey. Scott is also Wayne's character's rival for the affections of Marlene Dietrich, the owner of the local saloon. Things get more complicated, until, at the end, Wayne and Scott fight it out in one of the best, and longest, screen fistfights of Wayne's career, something the film is most remembered for.

The Spoilers, made in 1942, was produced by Charles Feldman, who was behind this Wayne/Dietrich film reunion, despite the fact that Dietrich had tried to persuade Feldman not to use Wayne. It was not just that their relationship had cooled. She was, in addition to seeing Raft, also having an intense affair with France's biggest movie star, Jean Gabin, who had fled to America to escape the Nazi occupation of his country. Being an outspoken anti-German, Dietrich did not want to be so closely associated with Wayne, whom she feared might be seen as a Nazi sympathizer for his reluctance to join the armed forces. It was an opinion others shared about Wayne and gave her one more excuse to stop seeing him.

The film was a huge hit, grossing over two million dollars in its initial domestic release (there was little in the way of foreign rentals until after the war, when it was rereleased in 1948 and again in 1949). For the six-week shoot, Dietrich received $100,000, Wayne $42,000, and Scott $40,000. A case could be made for the idea that defending one's mine was a metaphor for defending one's country.

IN 1942, A BROKENHEARTED WAYNE finally got the message from Dietrich herself that it was over between them. He then made another movie for Republic, William McGann's 1942 *In Old California* (a.k.a. *War of the Wildcats*), about the California gold rush of 1848. Wayne received $43,229 to appear in the film, which co-starred Broadway actress Binnie Barnes, and Albert Dekker, assigned to play the heavy. In the film, Tom Craig (Wayne) is a pharmacist from Boston who heads west to go into business in Sacramento (a journey and a profession that evoked his father's early life). On the way he meets a dance-hall singer named Lacey Miller (Barnes), who is engaged to Britt Dawson (Albert Dekker), the corrupt head of Sacramento politics. Dawson tries to keep Craig from leasing space for his pharmacy. The pharmacist is able to make a deal anyway and sets up shop in anticipation of the gold rush. A se-

ries of events follows and by the end of the film, Craig has Lacey, Britt is dead, and everyone lives happily ever after. It was a typical John Wayne western, lots of shooting, scenes of scantily clad women in saloons, fistfights, with a distinctive musical score (by David Buttolph and Cy Feurer). The *New York Times* called it a film with a "[g]ood story, excellent acting and fine photography that make this horse opry playable anywhere. The film hasn't a dull moment. Wayne's acting is tops throughout."

His next film, the low-budget *Flying Tigers,* made for Republic, was his first in a contemporary wartime setting, but not as an enlisted man. Instead, he plays a volunteer member of the famed group of mercenaries that went to China to help fight against the Japanese invaders. (Interestingly, there was very little outcry about American volunteers going to China the way there had been a few years earlier when the Lincoln Brigade had been formed to fight against Franco in Spain. Many Lincoln Brigadiers were later accused of being Communist sympathizers. The members of the Flying Tigers did not suffer the same fate.)

In the film, directed by David Miller, squadron leader Jim Gordon (Wayne), understaffed and greatly outnumbered by the Japanese, leads his men in air strikes against the enemy. Gordon is tough, hard-edged, and suffers stoically when a new recruit steals Gordon's girlfriend (Anna Lee). Even in the remoteness of China, American-style romance was a necessity in a Republic film. Wayne was paid only $8,400 for the production, with China approximated by Republic's Russell Ranch in Chatsworth, California, and aerial footage shot over the Arizona desert. The film, seen by some as a cheap rip-off of Howard Hawks's 1939 *Only Angels Have Wings,* was not only a huge success, but also the perfect vehicle to enhance Wayne's image of the tough American who will fight for justice anywhere in the world. It was released in September 1942 and quadrupled its one-million-dollar negative cost in its first domestic release. In England it became the third highest-grossing film of all time, just behind *Gone with the Wind* and Noel Coward's *In Which We Serve.* It was rereleased after the war in 1948, in 1949 on a double bill with *The Spoilers* that played around the world, and again as a single feature in 1954.

During its initial run, the Japanese were making strong advances in the Pacific, and were the enemy Americans hated most, because of Pearl Harbor. The film played liberally with the facts, but Yates was not interested in giving

history lessons, only in making an action war film that was entertaining and uplifting to American audiences, and on that level he succeeded, due in no small measure to Wayne's gutsy performance. The *Hollywood Reporter* raved that "Wayne is at his peak" in this film.

After its release, the film's producer, Edmund Grainger, and director David Miller enlisted in the military. Wayne later claimed he toyed with the idea as well, but insisted Yates wouldn't let him do it.

Instead, he signed on to star in Jules Dassin's *Reunion in France,* a drama about occupied Paris in which Wayne plays a wounded RAF pilot who escapes from a prison camp and is rescued by a beautiful Frenchwoman (Joan Crawford), who falls in love with him and helps plan his escape out of Paris to unoccupied France. Unfortunately, there was zero chemistry between Wayne and Crawford; audiences sensed it and the film barely earned back its production costs.

Wayne's seventh and final film of 1942 reunited him one last time with Dietrich, something he was very much looking forward to, far more than she was. Made at Universal, *Pittsburgh* was produced by Feldman and directed by Lewis Seiler. Randolph Scott was back as a character called Cash, and Dietrich's was tellingly named Josie. Wayne's name in the film is "Pittsburgh." The story begins on the eve of Pearl Harbor, after which the two iron men forget their jealousy over Josie and devote themselves to turning out steel for the war effort. The film was pure propaganda and played like it, and this time the chemistry between Dietrich and Wayne was nonexistent. They barely talked to each other during production, and Gabin showed up frequently on-set. Marlene openly displayed her affection for the French actor in front of Wayne and frequently took Gabin into her dressing room and locked the door behind her. It drove Wayne crazy.

Dietrich made one more Hollywood film during the war years, *Kismet,* co-starring Ronald Coleman, which didn't do well, after which she relocated to New York. Some believe that after she lost her box-office appeal, Feldman was responsible for studios turning cold on Dietrich so that Wayne wouldn't have to see her around town or at premieres he had to attend.

UPON COMPLETION OF *PITTSBURGH,* WAYNE took a trip to Mexico, at the time Hollywood's favorite sex playground for male stars, where life

was cheap, and women cheaper. Bö Roos suggested the idea to Wayne hoping it would help him get over Dietrich. A number of Roos's clients came along for the cheer-up ride, including Ward Bond, Fred MacMurray, and Ray Milland.

One night while out with the others in Mexico City, Milland introduced his Mexican "girlfriend" to Wayne: call girl to the stars and Mexican film bit player Esperanza Baur Diaz Ceballos, Chata for short ("pug nose" or "sweetie" in Mexican slang). Chata was a statuesque beauty with a come-hither smile. She then decided she preferred Wayne to Milland (he never talked to or worked with Wayne again). As Chata would later tell her friend Ruth Waterbury, her attraction to Wayne was immediate and visceral: "When I first see Duke in Mexico, where most of the men they are so short, I know it is good for me. I know that, when I, who am not so long, dance with him, his head will be above me which never happened to me before."

Chata had an initial erotic attraction for Wayne similar to Dietrich's, although that was where the resemblance between the two women ended. Dietrich was German, blond, with flawless skin and the slim body and long legs of a model. Chata was Hispanic and short, with dark hair and bad skin. The only other thing the two women had in common was their high-octane sexuality, and the fact that both had worked, at one time or another, as professional "escorts."* Chata was married to and separated at the time from Mexico's biggest star, the ironically named Eugenio Morrison.

After that first trip, Wayne returned to Mexico every chance he got, using Chata to ease himself out of the pain he felt over losing Dietrich. Exhausted from his 1942 seven-pictures-in-a-single-year burst, he found warm relief in her comforting arms.

In May 1943, after nine years, eleven days, and two months of marriage, Josephine made good on her threat to go through with her divorce from Wayne, but then couldn't quite take that final step. At the last minute, she petitioned the Superior Court of the County of Los Angeles for a legal separation, which it granted.

* In her memoir, Pilar Wayne writes that Chata "claimed to be an actress. In fact she was a high-class call girl . . . and Milland was one of her [regular] clients . . . Chata was the exact opposite of church-going, ladylike Josephine. Duke . . . lusted for Chata. She was vivacious, blatantly sexual and voluptuous, a combination that was guaranteed to make her a perfect companion for an emotionally repressed man."—from *John Wayne: My Life with the Duke*, p. 45.

When he received the legal notice from Josephine's lawyers, Wayne was filled with a combination of guilt, remorse, and relief. He understood now what a failure he had been as a husband. Josephine made arrangements for him to see the children on Sundays, and he was grateful for that much. They were delivered to him once a week and, when the visit was over, returned to her by chauffeur.

According to Wayne, "Whenever I've been in trouble, [John Ford] has always been there . . . That's what I call a friend." Ford had gone through something similar with his wife but had managed to hold his marriage together. He wanted to be there for Wayne during his time of need. On Ford's advice, Wayne made it his business to stay active in the lives of his children. "I've shared Josie's anxieties when they needed their tonsils out, worried about the braces for Melinda's teeth or glasses for Toni. I've taken Mike on hunting trips with me and on explorations into the desert. And Pat and I have gone away on fishing trips and scouted the coast of Catalina Island."

AFTER HAVING HIS HAND HELD for him by Ford, Wayne was relieved that all the charades could now be over. He didn't have to pretend to be a bachelor anymore; he could be one. He started hanging out again every night with Ward Bond, who encouraged Wayne to enjoy his newfound and hard-fought-for freedom.

One evening, while dining at Chasen's with friends, the green-and-white restaurant that catered to the golden age crowd, Wayne, with more than a few drinks in him, began to whine again, this time to the tall, dark, handsome billionaire playboy and already slightly eccentric filmmaker Howard Hughes, who was sitting next to him. Hughes liked Wayne, but he couldn't stand hearing him piss and moan about how upset he was over his failure as a husband in one breath and in the next how he missed this woman in Mexico, and how he wished there was some way he could just sneak away from everything and everyone and go to be with her.

Hughes then told him he had a private plane at his disposal and suggested that they take a midnight flight to Mexico City. They left Chasen's together after dinner and were in Mexico before daylight.

Chata was thrilled at the flourish of his sudden appearance, and even more so when he promised her that he would find a way to bring her to America. He

meant it. When he got back to Hollywood, he worked out a plan with Yates to do just that. Yates was understandably reluctant but wanted to keep Wayne happy and continuing to make movies for Republic. He arranged for Chata to get a visa to come to Hollywood and put her under contract at $150 a week, just enough to get her a permanent resident card. She never made a single movie for the $80,000 the studio wound up paying her over the next decade.

Soon enough, Wayne was talking about marrying her, and Yates and others warned him that he should slow down, that he was still not legally divorced, and how much he disliked the restrictive married life. Yates was playing up his concern for Wayne's welfare but he was also worried about his own, meaning the money Wayne made for him. He was already walking a professional tightrope over his military service, or lack of it; that kind of behavior had nearly killed the career of Lew Ayres, who had, ironically enough, become a star in 1930 for his performance in Lewis Milestone's *All Quiet on the Western Front*. Because of his conscientious objector status, Ayres's career was nearly ruined, and he never recovered the star status he had enjoyed before World War II. A divorce, an interracial marriage, and no service in the armed forces, Yates feared, could mean professional suicide for Wayne, and conceivably bring down Republic Pictures as well. Wayne felt the pressure from Yates, but he was determined to marry Chata and also to take some of the heat off himself by at least making a real attempt to serve in the military, in some capacity short of actual enlistment. He wrote to John Ford to see if there was any room left in Ford's naval field photographic unit and was told via return registered mail that that unit was full but that the army's similar unit had room; he included the forms necessary to get him in. Wayne never filled them out.

His next picture was Albert S. Rogell's 1943 *In Old Oklahoma* (a.k.a. *War of the Wildcats*) opposite Martha Scott and costarring Albert Dekker, a standard '40s romantic triangle set against the booming Oklahoma oil business. It was a huge popular success, and the only film Republic produced that year that was among the top ten grossers, due mainly to Wayne's ongoing popularity in a Hollywood where there were very few leading men left for him to compete with.

Yates offered Wayne a new five-picture contract, with a starting salary of $3,125 a week, to increase with each picture. Yates then announced to the press that "John Wayne will soon be a triple-threat man in the industry. Already a top star, he will prove himself a capable producer and will eventually move into

directing." But even before he made his first film for Republic under his new deal, Yates loaned him out to RKO to make William Seiter's *A Lady Takes a Chance* (a.k.a. *The Cowboy and the Girl*), a vehicle for Jean Arthur, produced by her husband, Frank Ross. The film was a bit of fluff about a young New York girl bored with her job who takes a fourteen-day vacation to "the West," where she meets Wayne, who is working in a rodeo. They "meet cute" when he is bucked from his bronco and lands in her lap. Arthur had been a star since the silent era and had made some notable films in the '30s, including appearing back-to-back in Howard Hawks's 1939's *Only Angels Have Wings* opposite Cary Grant, and Frank Capra's *Mr. Smith Goes to Washington* opposite Jimmy Stewart. The film was a bit of a departure for Wayne, and he was paid $55,000 directly by Universal (Yates was paid separately). It was made on a budget of $664,000 and grossed over $6 million in its initial North American release, and was a solid hit for both stars.

Then, in June 1944, a week after D-Day, the Allied invasion of France, all 3-A deferments were changed to 1-A, including Wayne's, which meant he was immediately eligible for the draft. Yates once again stepped in and instructed Republic's attorneys to file a new series of appeals, arguing that Wayne's work in film was more important to the country than his actual service, and not long after, Wayne's draft status was changed to 2-A "in support of the national interest." He was able to maintain a 2-A status for the remainder of the war.

That same year, Wayne joined the Motion Picture Alliance for the Preservation of American Ideals (MPA), an organization formed by director Sam Wood, who was its first president, and Walt Disney, one of its vice presidents. This was the organization's credo: "In our special field of motion pictures, we resent the growing impression that this industry is made up of, and dominated by, Communists, radicals and crack-pots . . . We pledge to fight, with every means at our organized command, any effort of any group or individual, to divert the loyalty of the screen from the free America that gave it birth," and to "turn off the faucets which dripped red water into film scripts."

Wayne's membership in the MPA erased all notions anyone might have had that he was soft on Nazism. For the moment, at least, Wayne had managed to affirm his patriotism while avoiding service in the military, and he continued to make movies.

YATES THEN CAME UP WITH a new script for Wayne that would allow him to fight for his country—on-screen at least. Edward Ludwig's *The Fighting Seabees* (a.k.a. *Donovan's Army;* Robert Florey was the unaccredited codirector; he worked for one week on the picture). In the film, Wayne plays construction chief Wedge Donovan, who together with Lieutenant Commander Bob Yarrow (played by Dennis O'Keefe, another actor who benefited from the lack of available Hollywood leading men) creates a new branch of service, the Seabees, because civilian workers in the Pacific are not allowed to carry firearms. It was a standard formula picture loosely based on the adventures of the first group of Seabees, in the film a politically correct, ethnically balanced group of civilian fighters.

Yates had several reasons to make this movie. The army division that approved military pictures was cracking down on films that were not accurate, or depicted the military as anything less than heroic. Yates wanted to make something unabashedly patriotic, not just to satisfy the army, but to cash in on the wave of patriotism that turned these films into big moneymakers.

During the making of the film, Wayne made several appearances in USO shows in the South Pacific and Australia, his version of military service. According to press releases generated by Yates to publicize Wayne's visits, "The boys are starved for news from home and that the biggest day in their lives over there is when the mailman hands them an envelope postmarked 'United States.'" Wayne made it a point to deliver sacks of mail wherever he appeared, and he visited hospitals. "The kids are not thinking about any trouble at home because they are too busy fighting a war but they do want to be sure they have something to say when they get back," Wayne told one reporter. "What the guys down there need are letters and cigars, more snapshots, phonograph needles, and radios . . . the G.I. bands need reeds, strings, and orchestrations . . . and if you have any cigarette lighters, send 'em along." In addition to playing two shows a day and visiting out-of-the-way camps in New Guinea and New Britain, Wayne told the press he felt he belonged at the fronts, with the boys. He had a few picture commitments, after which, he assured everyone, he would head straight back to Burma and China. *Screen Guide* magazine ran a story about his "extended" USO tour and showed him with pictures of his four children.

He never went back, partly because he didn't have the time and partly because he had not been warmly welcomed by the enlisted men, most of whom

had seen hard combat, and did not appreciate these visits by Wayne or any of the Hollywood entertainers who had not enlisted. The soldiers considered them coddled, spoiled, and looking for some good P.R. to promote their own careers and couldn't care less about G.I.'s. Among those they treated similarly were Bing Crosby, Bob Hope, and Al Jolson, although these raucous booing sessions were not reported in the press. Wayne wasn't the only one who got "the treatment" from soldiers.

And there was another reason he did the USO shows; William J. "Wild Bill" Donovan, the head of the OSS, needed a liaison to collect information from General Douglas MacArthur about how the war was proceeding. Wayne never met with MacArthur (who did not like Donovan) but upon his return from one tour of his poorly received USO shows he received a large, fancy plaque congratulating him for his service to the OSS. The plaque was sent to John Ford's home. Wayne never picked it up.

BY THE TIME *THE FIGHTING Seabees* opened in March 1944, Wayne was openly living with Chata in a penthouse apartment at the Chateau Marmont hotel, overlooking the Sunset Strip. The few nights he didn't spend with her, Wayne and his pal Ward Bond roamed the bars of the Strip, at the time a relatively lawless, unincorporated literal strip of land, a mile-and-a-half-long stretch on Sunset Boulevard between the end of West Hollywood and the start of Beverly Hills that fell under no specific police jurisdiction. It was an anything-goes playground for Hollywood, a place where everybody could let off a little steam after a hard day's work. Stars and crews openly mingled in the many storefront bars that dotted the Strip. Bond, who had recently left his wife, was living alone at the Beverly Hills Hotel. Unlike his pal, Bond was in no hurry to return to married life. He wanted to dip into Hollywood's pool of the best-looking women in America, and Wayne sometimes accompanied him. If Chata let Wayne have his freedom, it was because there was little she could do about it. She was in America by the good graces of Duke and Herb Yates, and she knew that all Wayne had to do was pull the trigger and she would be back home in a Mexican minute.

On nights Wayne was out on the town with Bond, Chata stayed in their suite at the hotel and lit candles for both their souls. And for her mother. And for Yates to make her a star.

Chapter 10

On November 25, 1944, thirty-five-year-old Josie sued for divorce, charging her husband with repeated acts of "cruel and inhuman treatment, and grievous physical and mental suffering . . . absenting himself from home several nights a week, refusing to explain his activities" and "daring" his wife to check on his movements. Testifying before Superior Judge Jess E. Stephens, Josephine said she had found a "lady's coat," not her own, in the actor's car upon his return from a trip to a resort. Wayne's lawyer cross-examined her and asked if she had gone through his pockets at a nightclub party. Josephine replied, "I told him he would have to mend his ways or I'd have to do something. He said, 'Hurry up and get it over with.'" Judge Stephens granted Josephine an interlocutory decree of divorce, to be made final after one year, and she got sole custody of their four children, Michael, ten; Toni, eight; Patrick, five; and Melinda, four.*

Wayne later told one interviewer, "When we split up [were divorced], I

* No evidence was ever presented that Wayne had physically abused his wife, nor was that implied by her testimony. This was standard operating procedure for California divorce hearings. After, to make sure there was no misunderstanding that would give the Hollywood gossip press corps a chance to damage Wayne's career (and her continued alimony), Josie issued this statement: "Because of my religion, I regard divorce as a purely civil action in no way affecting the moral status of a marriage, I am, however reluctantly, accepting the advice of counsel, and am seeking a civil divorce from my husband. I have received permission to do this from the proper authorities of my church. It is the only means of clarifying the position of my children, whose interests are of paramount importance."—From the *Citizen News*, October 31, 1944, and the *Herald Examiner*, November 1, 1944.

took just one car and my clothes and Josie got all the rest of it, including every cent I saved." In addition to the $75,000 Wayne had in the bank, Josephine got the house and everything in it. Wayne also agreed to turn over 20 percent of the next hundred thousand dollars he earned, and 10 percent of everything after that, for as long as he lived, or until Josephine remarried, which he knew was out of the question. He also set up separate individual trust funds for his children.

It would take years for Josie to get beyond the acrimony, but eventually she and Wayne would become friends. Then he would often come by the house, the same one they'd lived in as husband and wife, to talk to her about his career, spend time with the kids, or just to relax in familiar surroundings. Twenty years after his divorce, Wayne acknowledged he and Josie were much closer and better friends after their marriage than during it.

THROUGHOUT THE REMAINDER OF THE war years, Wayne continued to turn out movies. In 1944, he made *Tall in the Saddle,* a frontier western directed by Edwin L. Marin, in which he was loaned out by Yates to RKO. This was a western, costarring the beautiful Ella Raines, Ward Bond, and "Gabby" Hayes. The story concerns Wayne, a ranch foreman who reluctantly goes to work for the female heir to the land and livestock of the KC Ranch. Through a series of adventures, he winds up falling in love with a competing female ranch owner. Much of this is resolved with fistfights and horse chases. The film received high praise from the critics. *Variety* compared it to *Stagecoach* for its "gutsy approach and spirit."

It was followed by Joseph Cane's *Flame of Barbary Coast,* filmed in July 1944 but not released until May 1945, because Yates wanted to hold it until Wayne's divorce became final. It was touted as the crowning achievement of Republic's first ten years. It costarred Virginia Grey (after Wayne once again vetoed Claire Trevor). The story concerns the romantic adventures of a cattleman who comes to San Francisco to collect the fee for delivering his herd and is filled with gambling, fights, shoot-outs, and showgirls, which all comes to a climax as the famed earthquake of 1906 hits.

IN MAY 1945, THE WAR ended in the European Theater but continued on for another three months, until America dropped two nuclear bombs on Japan.

During that time, at RKO, Wayne was drafted for one more wartime propaganda film, Edward Dmytryk's *Back to Bataan* (a.k.a. *The Invisible Army*), which was filmed at RKO's studios in Arcadia, which doubled as Bataan, and at the Baldwin Estate.* Wayne received $87,500 for working on the film, while Anthony Quinn, his co-star on loan from Fox, earned $15,500.

The story concerns the plight of a group of officers and men on Corregidor, trapped by the Japanese and unable to be rescued. Madden (Wayne) orders his troops and the Filipino soldiers to resort to guerrilla resistance. When the Japanese arrive, they hang the Filipino school's principal for refusing to lower the American flag. Eventually Madden's guerrilla forces hang the Japanese officer responsible. Meanwhile, Corregidor is surrendered by General MacArthur and the Filipino men revolt, strong enough to make the Japanese reconsider taking the island, and eventually give it back to the Filipinos. However, before that happens, Madden and his men make a daring attack on the Japanese and wipe out the remaining forces.

Wayne is particularly good in this film, despite the fact that he had no use for Dmytryk, a former Communist who would later be blacklisted, with Wayne's enthusiastic support. The screenwriter, Ben Barzman (who wrote the film with Richard Landau), would also later be blacklisted. During production, both Dmytryk and Barzman were verbally bullied by Wayne, and they retaliated by writing into the script increasingly difficult stunts they knew their star would insist on doing himself.

Wayne liked to be up at 4 A.M., have a light breakfast, usually two eggs, two pieces of toast, and black coffee, read the papers, then go over his lines and be in makeup by six, ready to shoot at first light. However, he wanted to put it to Dmytryk every opportunity he could, even shit on him, which, in effect is what he did. As Richard Fleischer recalled in his memoir, when he was given a tour of the RKO lot during the filming of *Back to Bataan* by his friend Sid Rogell he noticed something peculiar about the set. Fleischer remembered it was already 10:30 in the morning, a half day's worth of potential sunlight shooting time, "And nothing was happening. The crew, and it was a large one, was lounging. Small groups were sitting around, talking in subdued tones, and playing cards."

* This film is not a sequel to Tay Garnett's 1943 *Bataan* (MGM, executive produced by Dore Schary), but it does bring the story of the fierce battle to defend the Pacific from the advancing Japanese forces up to date.

The problem? John Wayne hadn't taken a shit yet. When he emerged from his trailer, it was signal for everyone to get ready to shoot, that Wayne had moved his bowels and was ready to do some acting. He usually worked until 12:30, broke for lunch, returned at 2:00, and worked straight through to 6:30, after which he would go home, and have a big steak dinner, with potatoes and a side dish of Mexican food.

Later, Wayne had this to say about the production: "Many of us were being invited to supposed social functions or house parties . . . that turned out to be Communist recruitment meetings . . . Take this colonel I knew, the last man to leave the Philippines on a submarine in 1942. He came back here and went to work sending food and gifts to U.S. prisoners on Bataan [when] the State Department pulled him off of it and sent the poor bastard out to be the technical director on my picture *Back to Bataan,* which was being made by Eddie Dmytryk. I knew that he and a whole group of actors in the picture were pro-Reds, and when I wasn't there, these pro-Reds went to work on the colonel. He was a Catholic, so they kidded him about his religion. They even sang the *Internationale* at lunchtime. He finally came to me and said, 'Mr. Wayne, I haven't anybody to turn to. These people are doing everything in their power to belittle me.' So I went to Dmytryk and said, 'Hey, are you a Commie?' He said, 'No, I'm not a Commie. My father was a Russian. I was born in Canada. But if the masses of the American people want Communism, I think it'd be good for our country.' When he used the word 'masses,' he exposed himself. That word is not a part of Western terminology. So I knew he was a Commie. Well, it later came out that he was."

Dmytryk, who died in 1970 at the age of ninety, never hid the fact that he had in his youth been a member of the Communist Party. When he was first subpoenaed to appear before the House Committee on Un-American Activities (HUAC) in the late '40s, he refused to cooperate and was sent to jail. After spending several months behind bars, Dmytryk gave them what they wanted, not just his admission that he was once a Communist—that was already well known—but the names of his fellow members in the American Communist Party; he tried to minimize his own guilt by claiming that John Howard Lawson, Adrian Scott, Albert Maltz, and others had pressured him to include Communist propaganda in his films. He didn't work again in Hollywood for several years, but eventually returned to America and directed a hit movie,

1954's *The Caine Mutiny,* about a fictional revolt aboard a naval vessel in which the men overthrow the captain.

RKO RELEASED *BACK TO BATAAN* on May 31, 1945, when America's attention had turned completely to the hated Japanese. The film tripled its negative cost of $187,000 in domestic ticket sales and broke all existing records in Manila, where it was released that same month.

Wayne followed *Back to Bataan* with Joseph Kane's *Dakota,* costarring Vera Hruba Ralston, a Czech-born actress and former Olympic ice skater. Yates had had Ralston under exclusive contract since 1941, after she came to America to escape the Nazis and starred in a number of ridiculous ice-skating-themed films (Yates eventually married her). *Dakota* also featured Ward Bond. At first Wayne resisted working with Ralston, whose English was poor and acting even worse, but agreed to do it if his pal Bond could also be in the film. *Dakota* is a typical Republic western, filled with bad guys, complicated plots, and a fistfight resolution; it earned $145,000 for Wayne (including a piece of the back end), opened in November 1945, and was a big hit with audiences. With the war over, Americans wanted to be entertained by Wayne in his familiar guise as a cowboy, not, as his next picture would prove, a soldier. *Dakota* also marked the end of Wayne's latest contract with Republic.

Between December 1941 and the war's end in 1945, civilian John Wayne made sixteen films. *Back to Bataan* was the 107th film of his career, and the 13th he made during the wars years. Of those, three were about World War II, and one about enlisted soldiers. *Flying Tigers* told the story of American volunteers in China to fight the Japanese, and *The Fighting Seabees* civilian construction workers volunteering to fight the Japanese. Only in *Back to Bataan* did Wayne play an American enlisted man. And yet, during those years, he become Hollywood's reigning symbol of the American fighting soldier.

AFTER THE OBLIGATORY ONE-YEAR WAIT, Wayne's divorce became final December 26, 1945. Exactly three weeks later he married Chata, in the Unity Presbyterian Church of Long Beach, the same church where his mother had married her second husband, Sidney Preen, a sewer inspector for the city of Long Beach, not long after Clyde's death. The Reverend Johnson Calhoun performed the ceremony. Herb Yates gave the bride away. Harry Carey's wife,

Olive, was the matron of honor. John Wayne's best man was Ward Bond, still on crutches after being hit by a car in Hollywood in July 1944, shortly after filming was completed on *Tall in the Saddle*. His leg had been so badly mangled it was about to be amputated, prevented by Wayne's and MGM's intervention, both insisting Bond be allowed to heal, no matter how long it might take. The hospital could not guarantee Ward would ever walk normally again. Noticeably absent from the wedding was John Ford.

The reception was held at the California Country Club in Long Beach. Yates then paid for the newlyweds' three-week honeymoon in Waikiki. Howard Hughes personally flew them there, the first civilian flight to Hawaii since the war ended. Perhaps as an omen of things to come, it rained every day they were in Oahu. That left them largely confined to their suite at the Royal Hawaiian Hotel.

Upon their return to Los Angeles, Wayne bought a beautiful, and expensive, two-story Colonial ranch house in Van Nuys (4735 Tyrone Street), north of Hollywood, with a separate room for Chata's mother. Soon after they moved in, Chata, frustrated by her meaningless contract with Republic, began pestering Wayne to use his influence to get her a real role in a movie. Wayne was reluctant to do so. He didn't want his wife to become a Hollywood movie star. He knew too well what they were like and insisted her place was in the home.

Her reaction to his refusal to help her career was to begin drinking excessively, and for all intents and purposes, before too long she was a functioning alcoholic. Wayne began complaining to Bond that all Chata did at home was talk to her mother in Spanish. When he complained to Chata about it, his wife said, "Why don't you buy me a bigger house?"

She and her mother often drank together and always slept curled in each other's arms in the same bed, and on those nights, when Wayne came home late he would sleep on the oversized sofa in the downstairs living room. Wayne was a physically big man who took pride in keeping himself in condition to look good in front of a camera. But whereas Josephine had been, like him, bodily immaculate, Chata made no attempt to remove her facial hair (she had a bit of a mustache), bathed not nearly as frequently as Wayne would have liked, and refused to shave her legs, which drove him crazy. Whenever

he asked her to do it, an argument would inevitably follow. They soon began arguing about everything. One time he complained to Bond, "Our marriage was like shaking two volatile chemicals in a jar." Soon enough, Wayne confessed to his friend that marrying Chata was "the stupidest damn thing I ever did in my life!"

Chapter 11

During the war, John Ford was making documentary films for the government. He shot 1942's *The Battle of Midway* by hand, with one camera, while in the middle of the action, and it won him a special Academy Award.* At one point Ford offered Wayne a chance to help make these movies. British sound director Robert Parrish later learned how Wayne had turned down the chance by not following through on joining Ford's naval Field Photographic Reserve unit, and later remembered that "Ford remained furious at Wayne for years." When the director heard that Wayne had divorced his wife and was marrying Chata, he couldn't resist writing the actor a letter that mocked both him and his decision. It said, in part, "If you can take enough time from playing with those Mexican jumping beans, I would be very much interested in knowing what's cooking, good looking!" Ford ended it by calling Wayne a "damn fool."

AS THE WAR WOUND DOWN, Ford was eager to get back to commercial filmmaking. In 1942, MGM had purchased the rights to W. L. White's best-

* *The Battle of Midway* is in the public domain and is available for viewing in the United States in its entirety on YouTube, and it is also on DVD. Ford's *The Battle of Midway* and *December 7* both received Academy Awards, *Battle* for Best Documentary, a film that FDR declared that he wanted "every mother in America to see." Ford was wounded at Midway, shot in both legs, and lost the use of one eye. He also participated in the China-Burma-India theater and witnessed firsthand the invasion of Normandy. By the end of the war he was promoted to Lieutenant Commander Ford.

seller, the nonfiction military story *They Were Expendable,* about a squadron of PT boats in the early months of the Pacific Theater, intended as a populist war vehicle for Spencer Tracy. A year later Mervyn LeRoy was assigned to direct it. When that deal fell through, MGM assigned Frank "Spig" Wead to rewrite the script and when it was finished placed the newly-returned-from-action John Ford in charge of the production. Wead was fifty years old, a World War I veteran who in 1926 had fallen down a flight of stairs at his home and was partially paralyzed.

Ford decided the film should, at least in part, glorify Douglas MacArthur, one of his heroes. In the film, the squadron leaders are ordered to evacuate by MacArthur, as the Japanese step up their attacks and force the retreat. Ford also wanted Ward Bond to be in it, even though he was still seriously impaired from his car crash and barely able to walk. After Robert Taylor turned down the role of the hot-headed Rusty Ryan, the director reluctantly decided to offer it to the last name on his possibles list, John Wayne, who quickly and eagerly accepted the assignment. It was the first film they would work on together since 1940's *The Long Voyage Home.*

At the initial production meeting, Wayne sat uncomfortably in his civilian clothes—gray flannel slacks, brown sports shirt, houndstooth sports jacket—while Wead, Ford, and Robert Montgomery all wore their military uniforms. With the war still officially on, this was the mandatory dress for all soldiers, abroad or at home. Montgomery, three years older than Wayne, had been a popular movie actor before the war, then went into the navy and was part of the D-Day landing at Normandy. He eventually rose to the rank of lieutenant commander and won a Bronze Star for his service. Before he entered the military his acting specialty had been light romantic comedy, on ample display in Alexander Hall's 1941 release *Here Comes Mr. Jordan.* With the war ending, Hollywood wanted to continue to glorify its heroes and their heroics; these films were popular and profitable.

They Were Expendable, set early in the war, has an undeniable darkness to it, a film that anticipates the long and drawn-out affair World War II would become before it ended in atomic fury, and like all American war movies made during this period, it had an inevitability to it that Andrew Sarris later described: "less history than mythology, the film can now be viewed as an elegy to doomed individuals in a common cause . . . Montgomery a wary Odysseus, as it were, to Wayne's excitable Achilles."

When the meeting ended, and Montgomery and Wead stood up and left, Wayne went into the bathroom and began to cry. Ford, who could hear Wayne's sobs, decided to go in and comfort him, and it was then that all the animosity between the two over Wayne's decision not to serve was finally resolved. Ford held Wayne in his arms and let him get it all out. For these two, the war ended here.

WITH EXTENSIVE COOPERATION FROM THE U.S. Navy, production began on *They Were Expendable* on February 11, 1945, in South Florida, near Miami and Key Biscayne. Donna Reed, a popular and savvy beauty who projected an interesting combination of come-hither/girl next door, and who was fourteen years Wayne's junior, played a naval nurse in a Manila hospital and his love interest in the otherwise mostly all-male script. She was paid $300,000 for her services, while Wayne got $75,000.

During production, Ford quickly reverted to form and continually needled Wayne about his acting. Ford was relentless, and one day it got so bad that Montgomery had to intervene and physically pull the ferocious Ford away from the much bigger but passive Wayne, who would not raise his fists against Ford.

The film was the big Christmas picture at New York's Capitol Theater, with a live stage show featuring Tommy Dorscy and his orchestra. It received generally good reviews, but lost money in its initial domestic release.

By the time *They Were Expendable* opened, the thirty-eight-year-old newly divorced Wayne was rapidly losing his youthful appeal; his face was weathered and puffy and he had become noticeably heavier, partly due to his excessive drinking, and his hair was rapidly thinning. Knowing he could no longer play the young hero, he was hoping to phase out of acting in front of the camera and make the transition to directing. He had talked about it a lot with Ford. However, when the director became temporarily ill during the making of *They Were Expendable*, he chose Montgomery, who would go on to become a respectable Hollywood director, to take over the production while Wayne did not even appear in another movie directed by John Ford for nearly two more years. Perhaps Ford hadn't fully forgiven Wayne after all.

They Were Expendable's disappointing box office was a good indicator of the subtle shift that had taken place in American audiences' attitude toward pictures being made about the war. The gung-ho spirit of inevitable victory had

given way to an uneasiness about what we had been fighting for. Was Soviet domination of Eastern Europe all that much better than Hitler's? Was Mao's surging forces and China's rich oil supplies really what the Allied war against Japan was all about?

The next year, Hollywood's big "war" film would be William Wyler's post-war *The Best Years of Our Lives,* a realistic film about the problems that faced veterans returning to civilian life. It was the most successful Hollywood film of the '40s. Ford had always sought to sentimentalize the past, even when it produced films like *They Were Expendable* that audiences weren't always able or willing to identify with. He described his own philosophy of making war films in Hollywood this way: "Any war *I* was in we always *won* . . . of course [the soldiers] *were* glorious in defeat in the Philippines, they kept on fighting." Wyler's film saw things differently (both thematically and stylistically). His film looked at the very real consequences of the war on American everyday life, and what it did to the individual G.I.'s who fought it.

Now that Hitler and Hirohito were gone and the Soviet Union had devoured much of Eastern Europe, and Mao was making advances in China, the Specter That Haunted the Continent soon began to hover over Hollywood, or at least it appeared that way to those who sought to stop it before it spread any further. Wayne regarded *The Best Years of Our Lives* as frankly anti-American, the public's embrace of it disturbing, while the box-office sales of *They Were Expendable* were surprisingly disappointing. He believed the reason for the success of the former and the failure of the latter was a rising postwar disillusionment fueled by American Communism. He determined to play a larger role in the quickly polarizing politics of Hollywood and the nation, and he wanted everyone to know for certain which side he was on.

This was a war in which John Wayne was more than happy to serve.

HE QUICKLY SIGNED A NEW seven-picture, nonexclusive contract with Yates at Republic. Upon their return, many of the actors who had left Hollywood to fight in the war were having more than a little difficulty finding work. Five years away from the camera was a lifetime in the film business. Most had aged out of the new youth market and missed the cultural postwar shift from the just-ended hot war to the beginning of the cold one. Younger audiences now wanted younger stars, like John Garfield and the newest and hottest kid

on the block, Montgomery Clift, who'd made a big splash on Broadway before moving to the big screen. Wayne was one of the few able to age gradually (if not totally gracefully) because he did it in front of the camera rather than fighting on the front, and his continual presence in movies made during the war served as something of a security blanket for Americans. The new deal with Republic guaranteed steady work and income he would need following his divorce.

Wayne now wanted to make one film a year for Yates that he could also produce, a step toward directing. The real money in films, Wayne had learned, was in producing. He set up his own production company with a writer friend Robert Fellows, Wayne-Fellows, and as part of his new deal at Republic got Yates to agree to let Wayne-Fellows make films on a nonexclusive basis, whenever the opportunity presented itself. To help run Wayne-Fellows, Duke hired someone he knew he could trust, his brother, Robert.

Wayne then signed a similar deal with RKO Radio Pictures, a move Howard Hughes encouraged him to make. Hughes was planning to take over RKO and wanted to ensure the studio would have at least one legitimate star in its stable. To induce Wayne to sign with the troubled studio, Hughes promised him he would have greater control and bigger budgets than he had ever had before.

The first postwar film Wayne-Fellows produced at Republic was 1946's *Angel and the Badman* (a.k.a. *The Gun* and *Angel and the Outlaw*), a western written and directed by James Edward Grant, a writer Wayne favored, who had scripted several of Wayne's earlier B movies. *Angel* costarred the twenty-two-year-old raven-haired Gail Russell. During production, Russell developed a crush on Wayne, who, with his relationship at home with Chata not going well, reciprocated and began an intense physical relationship with the actress.

Angel and the Badman was shot in black-and-white in Monument Valley, Wayne's professional nod to *Stagecoach* and personal tribute to John Ford. The film tells the story of "the badman," Quirt Evans (Wayne), who is wounded and nursed back to health by the granddaughter of a Quaker family, the aptly named Prudence, the "Angel" of the title, played by Russell. Also in the film is Harry Carey, who plays the marshal and ultimately saves Wayne from the other "badman" in the film, Bruce Cabot. Carey's presence, Monument Valley, and Wayne's better-than-usual performance in a western that was grittier than many of his recent previous ones led some to suspect that perhaps Ford had something to do with the direction, which was not true. It did, however, mark

Wayne's return to classic western form. It was, also, without question, the best work of Russell's twenty-five-film career.*

In an interview Wayne gave to Louella Parsons to promote the film he talked about the professional struggles he had gone through and the strong influence Ford had had on him, perhaps sending a message to Ford that he wanted to work with him again: "I started in three-day productions. I went in and out of those so fast that half the time I didn't know their titles. I'll bet I've survived more bad pictures than any other actor onscreen, but I was so disgusted with the lot of them that I would have gone back to being a prop man if it hadn't been for Jack [John] Ford . . . Well, every time I'd get completely discouraged, Jack would insist that I hang on—that he'd yet find the right part and put me across."

Parsons asked him what it was like to be both producer and star, as he was on *Angel:* "It sure changes you when you're the producer as well as the star. I used to be a little vague about when I reported to the studio mornings—but now I'm ahead of time. I know all my lines. I love all the other actors in the troupe, who don't blow scenes . . . as a producer I want to give new people chances. If they click, I'll feel that will be a sort of repayment for the brand of friendship and trust that Jack Ford has given me."

At the end of filming, Wayne threw a cast and crew party. According to Gail Russell, "Earlier in the day, James Brandt, director and writer, and John Wayne, producer and star of the picture, had surprised me by telling me they were presenting me with approximately $500 because they believed my salary had not been in keeping with the caliber of my work as feminine lead . . . John [Wayne] took me home after the party. He had celebrated too much and apologized to my mother for his condition. He called a taxi. My brother helped him into the taxi and he left about 1:00 a.m. The next morning he sent my mother a box of flowers with a note of apology for any inconvenience he might have

* Wayne was not satisfied with any of Republic's female contract players and personally paid Paramount $125,000 for Russell's loan-out (she received $125 a week from Paramount). He considered the twenty-two-year-old the most beautiful actress in Hollywood. According to Hedda Hopper, Wayne became something of a father figure to Russell and had a heavy crush on her even before he cast her. Russell later married actor Guy Madison, became an alcoholic, and drank herself to death in 1961 at the age of 36. Some information about Gail Russell is from Hedda Hopper's column of January 29, 1956. *Variety* reported the details of Russell's death October 26, 1982.

caused her. I was contemplating marriage to Guy Madison at the time and was living with my family."

Chata, meanwhile, whose Hollywood film career had gone nowhere, began to suspect, along with and encouraged by her *mamacita,* that her husband was spending entirely too much time with Russell. One night during filming he didn't come home at all, and she suspected her husband was at a hotel in Studio City with the actress.* When he finally did come home the next night, after spending a few hours drinking with the boys, he discovered he was locked out of his house. He broke a glass pane of the front door with his fist, let himself in, and, still drunk, lay down on the sofa. A few minutes later, an inebriated Chata came running into the living room holding a loaded gun. Her mother grabbed it and prevented her daughter from killing John Wayne.

The next day she apologized and promised Wayne she would stop drinking and be a better wife to him. To do so, Wayne said, his mother-in-law would have to go back to Mexico, and Chata would have to share her bed every night with him. She agreed, but they soon fell back into a familiar pattern of arguing, drinking, arguing some more, fighting (sometimes physically), breaking up, and then entering a brief "honeymoon phase" before it all started again. It would be that way for the rest of their marriage.

IN 1947, WAYNE APPEARED IN the first film under his new contract with RKO, although he did not produce it (Stephen Ames did). He was given $101,000 to star in Richard Wallace's *Tycoon,* with a screenplay by Borden Chase and John Twist, adapted from the novel by C. E. Scoggins. The film is about the adventures of a couple of railroad tunnel-building engineers in Peru (Wayne and James Gleason), working for the film's tycoon (Sir Cedric Hardwicke). During their off-hours, Wayne falls for his daughter (Laraine Day, a last-minute replacement for Maureen O'Hara) and marries her, while he continues to have problems with her father.

At the time, Day, who was a Mormon, had just married baseball manager Leo Durocher, known to have a nasty jealous streak in him. The film was supposed to be shot in Mexico, but due to budget problems was made in California. Durocher often visited the set of *Tycoon* and became enraged whenever

* Chata later claimed she called Russell's mother's home and was told by a servant that because of the late schedule Russell was staying at a motel.

he saw Day embracing Wayne during a scene. Wayne reacted good-naturedly. "Every time I kiss Laraine, that guy's face looks as if somebody on the other team had just stolen home."

The film went seriously over budget, with a final negative cost of $3.2 million, and when it was released, it failed to earn back its cost at the box office. Wayne was convinced it would have done better if he had produced. Here is his first explanation of why it failed, in what amounts to an early vision of what would, years later, be labeled auteurism: "I do believe that one man should serve as producer and director. Making a film is like painting a picture. If you were having your portrait painted, you wouldn't have one artist do your eyes, another your nose, and still a third your mouth. That's why I think, as nearly as possible, production control should be centered in the talents of a single individual."

But after repeated viewings of the film, something Wayne liked to do with all his pictures, he began to change his mind. It wasn't the way the film was produced or directed that was the problem. It was the content. *Tycoon* was a sucker punch; it played right into the hands of those who believed that capitalism—the tycoon—exploited workers, with a love story as the sugarcoating meant to sell it. It had, Wayne believed, an anti-American message. The fault was not in the stars, Wayne was now convinced, but in the films they made.

He decided he had to do something about it, to clean up Hollywood and rid it of his subversive element. To do so, he strapped on his symbolic six-guns and set about to shoot it out with those he believed hated America and were bent on destroying it.

This town wasn't big enough for both John Wayne and Communists.

Chapter 12

He may have arrived relatively late to the lynching party, but when he did, John Wayne aimed to be its head executioner. In 1948, the year that Wayne officially enlisted in the war against Communism, the Motion Picture Alliance for the Preservation of American Ideals (MPA) was steadily gaining membership and determined to root out the Communists who had made significant gains in the industry's unions and guilds. The Screen Actors Guild especially had a large number of members who were also members of the American Communist Party (CPUSA), the latter having regained its lost popularity in Hollywood after the Hitler-Stalin Pact, when the United States and the Soviet Union became allies against the war on fascism in Europe. In 1944, the same year the MPA came into existence, so did the Communist Political Association, the Communist Party's new name, to separate it from the prewar CP. It was led by Earl Browder and had a growing following. Some of it was due to the feeling of friendship toward the Soviet Union, America's ally during the war, and some of it was because the old problems between management and labor that had been there long before the war continued after it with little progress.

The MPA, draped in patriotic slogans, attracted the cream of the Hollywood conservative right, a membership that included Clark Gable, Robert Montgomery, Morrie Ryskin, Ward Bond, Donald Crisp, Gary Cooper, King Vidor, Norman Taurog, Victor Fleming, Ginger Rogers, Barbara Stanwyck, John Ford, Pat O'Brien, Robert Taylor, Irene Dunne, Dmitri Tiomkin, Cecil B.

DeMille, union leaders Ben Martinez and Roy Brewer . . . and John Wayne, who had become a member in 1944. His enemy even then was Communism, and his army was the MPA.

SUBVERSIVE BEHAVIOR IN HOLLYWOOD WAS nothing new. In 1936, the first stirrings of recognition and concern in Hollywood had come when *Variety* published an article that declared that "Communism is getting a toehold in the picture industry . . . among a crowd of pinks listed on studio payrolls as writers, authors, scenarists and adapters . . . most of the leaders of the literary-communist movement are easterners who have hit Hollywood during the past two years."

Variety had identified the link between the eastern, theater-based left and the growing liberalism in Hollywood, or as *Variety* identified it, Communism. The CP had always appealed to young performing artists and writers in New York and now in Hollywood because it seemed to be the best way for workers who felt exploited and believed in the right to organize its protests. According to Larry Ceplair and Steven Englund, in their book *The Inquisition in Hollywood,* this organized opposition was something that infuriated Hollywood's producers, who believed the industry's trade unions were welcome harbors for the growing unrest for disgruntled workers, from writers to actors to scenery movers. The contradictory dualism of '30s Communists was that they loved fighting for their rights and wanted to make as much money as they could doing it; to a certain, weird extent, these self-appointed heroes of the working class looked to get wealthy by exercising dialectic materialism.

Some elements of the industry workers' social discontent appeared in many of the biggest Hollywood movies of the 1930s and 1940s, most prevalent in films like Mervyn LeRoy's *I Am a Fugitive from a Chain Gang* (1932), starring Paul Muni; William Dieterle's *The Life of Emile Zola* (1937), with Muni again; and John Ford's *The Grapes of Wrath* (1940), starring Henry Fonda. Even Victor Fleming's *Gone with the Wind,* made in the run-up to World War II but set safely back in the Civil War, had elements of social unrest and political dissatisfaction.

Ceplair and Englund: "Hollywood screenwriters and the American Communist Party were wedded in a marriage of convenience. The [Screen Writers Guild] union lasted because the party did not push the writer to jeopardize

his position and the writer did not push the party into cinematic sophistication." In other words, '30s Communists in Hollywood were interested in intellectual ideology and economic equality. The same contradictory existence of the desire for both equality and privilege was what united the unions and the Communists.

And it was part of what drove Wayne to want to join management, as a producer. His goal was to make entertaining and profitable movies that promoted a fair and positive image of America, to transfer his patriotic zeal to the characters he portrayed, while separating them, and him, from activism.

Unions were, from the very beginning in Hollywood, and elsewhere in America, filled with ideologues and the CP encouraged them. However, it appeared they could have relatively little impact on the content of the films they wrote because screenwriters simply didn't have that freedom, due to the strictly moral and patriotic story lines imposed on the studios by the Motion Picture Production Code—popularly known as the Hays Code, which was adopted in 1930 by Hollywood's self-regulating organization, the Motion Picture Producers and Distributors of America (MPPDA). The MPPDA closely monitored everything that came out of the studios, and although it was created to keep censorship a private operation rather than one controlled by the government, the effect of the code was the opposite of what it was intended to be. The production guidelines that both limited what writers could write and what directors could direct ironically helped the development of the sophisticated language of visual suggestion and the power of cinematic metaphor that not only allowed more subversive messages to be delivered, but by doing so elevated film to a higher form of art.

The conflict between workers and management continued to deepen. In May 1940, Walt Disney's studio suffered one of the largest and most contentious strikes in the history of Hollywood. The CSU (Conference of Studio Unions), led by Herb Sorrell, was well organized, Communist infiltrated, and meant business.* The strike lasted until the end of June, and when it was finally settled, Disney blamed the whole thing on the Communists; not long after, he began to plan the formation of the MPA. Disney's group quickly aligned with the House Un-American Activities Committee, formed in 1938 to investigate

* The CSU was made up of five member unions—the Cartoonists Guild, the Screen Office Employees Guild, the Film Technicians, the Machinists, and the Motion Picture Painters.

Communist and fascist organizations that had become active during the Great Depression. Disney and the other organizers of the MPA wanted HUAC to focus part of its investigation on Hollywood. There was a brief set of hearings that took place in Washington during the war that touched upon the problem of Communist subversion in Hollywood, but little interest could be generated while the United States was still officially allied with the Soviet Union.

In 1947, the MPA once again urged HUAC to return to Hollywood to conduct a second, and more potent, investigation of Communism in film. On October 20, 1947, HUAC issued forty-three subpoenas, nineteen to suspected Communists, the rest to those who would become known as "friendly" witnesses. The hearings that took place in Hollywood quickly turned into a public kangaroo court, likened by some in the liberal national press to the Soviet hearings that prompted Arthur Koestler's *Darkness at Noon;* others, in the conservative press, saw it as long overdue, a much-needed step in the eradication of Communists from Hollywood.

That same year, Wayne, who had not been subpoenaed to testify before HUAC, was approached by the MPA to run for president of the organization. It was an offer he had turned down before, begging off and claiming he didn't have the time to devote to such an important and demanding position because he was too often away on location, and anyway, he claimed, he was not a very good public speaker, surely nowhere as effective as the organization's two previous presidents, Clark Gable and Robert Montgomery.

Many of the MPA's members were angry at what they saw as Wayne's shirking of his responsibility—something he had done before—and talk began that perhaps he, too, was too soft on Communism or too far to the left, and they let him know it. Wayne later recalled his reaction to these personal attacks and political suspicions from the MPA that quickly spread throughout Hollywood and resulted in conservative columnist Hedda Hopper publicly denouncing him as "a damn fool" for not accepting the presidency of the MPA: "I was the victim of a mud-slinging campaign like you wouldn't believe," Wayne said in his own defense. "I was called a drunk, a pervert, a woman-chaser, a lousy 'B' picture western bit player, an unfaithful husband, an uneducated jerk, a tool of the studio heads. Well, that just made me determined to become the president of MPA if the members [still] wanted me."

Then he heard from the other side. "Charlie Feldman advised me not to stick my neck out, Bö Roos told me to stay out of it, and Herbert Yates told me, 'Duke, you're a goddam [*sic*] fool. You are crazy to get mixed up in this. It'll put you on the skids in Hollywood.'"

So he was a damn fool for joining and a damn fool for not, but Feldman, Roos, and Yates knew what they were talking about. Wayne was already not that well liked in Hollywood, due to his military service, or lack of it—both the Communists and the anti-Communists agreed that service in the military, especially in the anti-Fascist European Theater, was mandatory, and conservatives were outraged that he had divorced his American Catholic wife to marry a Mexican. They felt that sort of thing was not just un-Christian but un-American, the kind of sin only a Communist would commit.

ON DECEMBER 3, 1947, AT a closed-door meeting held in New York's Waldorf-Astoria, the studio heads decided they had to take a position once and for all on the problem of Communism in Hollywood before the government did it for them and issued what would come to be known as the Waldorf Statement, a capitulation to the pressure on them brought by HUAC and the Supreme Court to get the studios to clean up their act, meaning to get rid of the Communists in their midst or else face the consequences. The Waldorf Statement declared that no major studio would knowingly hire anyone who its executives believed was a Communist.

Thus was born the notorious blacklist that destroyed the careers not only of Communists in Hollywood, but of anyone *suspected* of being a Communist. Magazines were started solely to publish the names of "Communists." The appearance in these magazines, whether or not there was evidence to back up the accusation, was enough to get that person blacklisted. Fear and paranoia ran rampant throughout Hollywood, as some of the best and brightest, Communists or suspected Communists, overnight saw their livelihoods taken from them.

No one was immune from it. Wayne, weary and frightened of the suspicions from both sides of the political division, chose one, joined the MPA, and became one of the most outspoken anti-Communists in Hollywood. Not long after, Adolphe Menjou, a longstanding member of the MPA, praised the "eternal

vigilance" of HUAC, and assured the MPA's members, including Wayne and now Ford, they would henceforth be given a free pass through HUAC.

Wayne downplayed the importance and power of the MPA and denied it was even a political group. This is how he described his involvement with the organization, in an interview with *Playboy* in 1971, what became one of his most controversial (and final) extended interviews. On the Motion Picture Alliance and his association with it: "Our organization was just a group of motion-picture people on the right side, not leftists and communists. There was no blacklist at that time, as some people said. That was a lot of horseshit. Later on, when Congress passed some laws making it possible to take a stand against these people, we were asked about Communists in the industry. So we gave them the facts as we knew them. That's all. The only thing that our side did that was anywhere near blacklisting was just running a lot of people out of the business."*

The interview made some of his friends laugh, and others who had been blacklisted furious. "Hell," one of them said, "Duke didn't know anything about the menace of Communism! All he knew was that some of his friends were against them!"

With the Cold War in full operational mode, and the impending "fall" of China, HUAC proceeded to disregard the civil rights of those who had at one time or another chosen to be a member of the Communist Party, and during its hearings, it denied those who testified as "unfriendly" witnesses their constitutional rights against self-incrimination.

Eventually, in need of the best and the brightest that they had vanquished, the studios, old and tired and making mediocre films that reflected nothing so much as the fact that they had blacklisted some of their best talent, after a decade, for reasons of necessity rather than policy were willing to forgive and forget.

But not John Wayne. Being the head of the MPA restored the political-correctness credibility he had damaged by not serving in the military. Here is part of a 1947 speech he gave at a rally shortly after becoming president of the MPA: "The past ten years the disciples of dictatorship have had the

* The facts are these: Congress passed no laws regarding Communists in Hollywood. The Waldorf Statement was instituted by the studio heads, as noted above, on December 3, 1947.

most to say and said it louder and more often. All over the world they pour their mouthings into the ears of the people, wearing down their resistance by repeating hammerings of half-truths. That's where our crusade for freedom comes in."

As a crusader for freedom, he loved beating up on bad guys. He was, after all, the king of the cowboys.

Chapter 13

By the end of the 1940s, the now-right-wing-conservative John Wayne's film career began to soar into the stratosphere, even as the liberal/centrist John Ford's started to decline. Wayne had become the most popular box-office actor in Hollywood, while Ford's career had taken a downturn from which it would never fully recover. Ford's first film after *They Were Expendable* was 1946's *My Darling Clementine*, a western he made the same year as Wyler's *The Best Years of Our Lives*.

After *They Were Expendable*'s relative failure at the box office, Ford decided to step back from making anything that had to do with the war, and chose instead to make movies drenched in the sentimentality and safety of the past, beginning with *Clementine*. It was the first western Ford had made since *Stagecoach*, seven years earlier, a reworking of the famous gunfight at the OK Corral. A band of brothers, the Earps and Doc Holliday (the Allies), devote themselves to cleaning up Dodge and disarming Billy Claiborne, Ike and Billy Clanton, and Tom and Frank McLaury (the Fascists), who want the town to stay in their total and lawless control. If moviegoers looked hard enough, they might see a contemporary metaphor lurking in Ford's retelling of the story, but he always denied it.

My Darling Clementine starred Henry Fonda as Wyatt Earp. Ford may have thought Wayne was better suited to play Earp, but he and Wayne had not gotten along all that well after the verbal (and nearly physical) beating Wayne had taken during the making of *They Were Expendable*. Like a parent putting his

two sons through a tormented sibling rivalry, Ford went instead with Fonda, the actor's first film after returning from his active duty in the navy. Fonda had served for three years as a quartermaster third class aboard the destroyer USS *Satterlee,* later as a lieutenant junior class for Air Combat Intelligence in the Pacific Theater, and was awarded the Naval Presidential Unit citation and the Bronze Star. Ford loved servicemen, especially those who did their service in the navy.

And yet, a gray cloud hung over Fonda after the war for his lifelong liberalism, and his too-real and impassioned portrayal of Tom Joad in *The Grapes of Wrath.* Zanuck, the head of Twentieth Century–Fox, who had agreed to distribute *Clementine,* objected to Ford's choice of Fonda, claiming the actor had been away from films for too long, and instead wanted Wayne to play the role. That was, if Ford insisted on making a western at all rather than a war film. When Ford went ahead with *Clementine* and Fonda, an angry Zanuck recut the completed negative to make it shorter, and, he insisted, more commercial.* The film barely made back its production costs—lavish sets were built for it, including an entire western "town" on Fox's back lot. It grossed only two million dollars at the box office and marked the end of the Zanuck/Ford professional relationship. He still owed Zanuck one more movie, but it would be years before he would make it.

Instead, Ford revived his dormant production company, the Argosy Corporation (now Argosy Pictures), with his partner Merian C. Cooper, and six of their former navy colleagues as investors.† The new Argosy's initial foray was Ford's 1947 *The Fugitive,* based on Graham Greene's *The Power and the Glory,* a curious art film starring Henry Fonda and Delores Del Rio, about a Jesus-like priest who takes on the Specter Hanging Over Europe. It was well received by critics but flopped at the box office. As Andrew Sarris later correctly observed, "*The Fugitive* marked the last occasion on which the great

* Zanuck cut about ten minutes from the film, mostly the comic relief sequences. A 1946 prestudio edited version has been preserved by the UCLA Film and Television Archive in cooperation with the Museum of Modern Art.

† Argosy is derived from the Italian, loosely translated to mean "a large merchant ship," or "a fleet of ships," or "a rich supply." The other investors included former OSS colleagues Wild Bill Donovan, David Bruce, William Vanderbilt, and Donovan's law partner and OSS right-hand man, Otto C. "Ole" Doering Jr. The original Argosy Corporation had been formed in 1940 for *The Long Voyage Home,* the only picture it produced.

majority of American critics made the slightest effort to confront Ford as a contemporary artist. After . . . he was widely regarded as a voice from the past, as an eccentric antique dealer with a good eye for vintage Americana."

In 1948, Ford made *Fort Apache,* set safely in the past and the first of what would come to be known as his cavalry trilogy, three films that take place in the years following the Civil War when the quest to settle the West was at its peak. The uneasy wisdom of the three films, beginning with *Fort Apache,* powerfully mirror through the reflection of time American audiences' uneasiness following World War II. The film remains a milestone for both Ford and the stars, John Wayne, the story's true hero, and Fonda, who played the film's fatally flawed Martinet, Colonel Owen Thursday. After the commercial failure of *The Fugitive,* at first, Argosy Pictures would not get a decent distribution deal and completion funding to make *Fort Apache* from its new studio, RKO, if Fonda was the star, Howard Hughes, the new head of the studio, insisted. Hughes pressured Ford to use Wayne instead. The director eventually reached a compromise with Hughes to use both—Fonda playing the villain, Wayne playing as the hero. The film signaled the start of Fonda's sharp decline from cinematic superstardom.*

Fort Apache, written by Frank Nugent, was adapted from James Warner Bellah's *Saturday Evening Post* short story, which was (very) loosely based on the infamous 1876 defeat of George Custer by Sitting Bull's Lakota tribe, better known as Custer's Last Stand or the Battle of Little Bighorn. It was shot mostly in Monument Valley, on the Valley Navajo Indian reservations, with interiors done at Selznick Studios in Culver City, and in Simi Valley, California, where an entire fort was built for it at Corriganville.† Production lasted seven weeks in the desertlike heat, with six-day workweeks and eighteen-hour workdays. Nugent always tried to write to Wayne's strength, not as an emo-

* There is some question as to whether Fonda was blacklisted. According to his son, Peter Fonda, in his autobiography, *Don't Tell Dad: A Memoir* (1999), Henry's liberalism caused him to be gray-listed during the early 1950s, when he experienced a six-year layoff from films. After *Fort Apache,* he made one film in 1949, *Jigsaw,* and one in 1951, *Benjy,* which he narrated. Between 1949 and 1955, when he starred in *Mr. Roberts,* directed by John Ford, he was absent from the screen for nearly six years. During that time he appeared in the stage version of *Mr. Roberts.* Broadway was a dependable refuge from those who suffered blacklisting, and many who did left Hollywood for the bright lights of the Great White Way.
† The set remained standing after the completion of the film and was later used as the main setting for the early '50s TV series *The Adventures of Rin Tin Tin.*

tional actor but as a physical one. "Having Wayne put his arm on your shoulder," he once remarked good-naturedly, "is like having somebody dump a telephone pole on you."

In the film, John Wayne plays Captain York, a wizened, if grizzled, telephone pole of a commander of the fort, who has come to know and respect the Navajo reservation, while he has been stationed there to help defeat them. York favors peace and, if possible, reconciliation with the people he has had a hand in conquering. Into the fort rides the martinet Colonel Thursday, with his daughter, a grown-up Shirley Temple, who is soon romanced by a West Point–educated officer, Michael Shannon O'Rouke (played by John Agar, making his film debut; he was Temple's real-life husband, a clever piece of casting by Ford, who had worked with Temple when she was a child-star sensation), the son of one of the enlisted men at the fort (Ward Bond). Henry Fonda plays not just a bad man but an evil one. His performance was so strikingly good, so fearsomely believable it actually turned audiences against Fonda and may have further damaged his career.*

Colonel Thursday has been sent from the East to Arizona to help fight the war against the Indians. He is bitter and out for blood, having been demoted after the end of the Civil War, and looking to reestablish his glory and his rank by pulling off a massacre against the Indians. The tension in the film comes from the clash of the experienced and wise York and the ambitious and bloodthirsty Thursday.

Thursday sets up a meeting with the Apaches, who are distrustful of the Americans because so many previous treaties have been broken or ignored. The Indian chief agrees to lead his tribe back to the reservation, knowing it is a trap set up by Thursday. The film's tremendous climax, the confrontation of the cavalry and the Apaches, ends with only a few surviving soldiers, one of them York, as he was assigned to the rear guard by Thursday, humiliation for his insubordination when he tried to convince Thursday not to go through with the ambush.

Back at the fort, York defends the late Thursday as having been a great soldier, declares him a hero, and hangs his picture on the wall, a lifeless portrait

* Wayne was paid $100,000 up front and deferred half of it of it for a percentage of the net profits. Fonda received the same salary without the deferment. Temple received $100,000 with no deferment. Bond received $35,000, no percentage, no deferment.

that at once celebrates a lie and glorifies a myth. This is a theme that would be repeated again and again by Ford, nowhere better than in 1961's *The Man Who Shot Liberty Valance*—"When the legend becomes fact, print the legend."

Fort Apache was the film that marks Wayne's move into cinematic middle age. In the film, he does not lead the climactic battle, defeat the "bad guys," or win the heart of the leading lady, but he still manages to steal the picture from Fonda.

Wayne's performance ranks among his best and he should have been nominated for an Academy Award for it. However, despite money reviews—the *New York Times*' film critic Bosley Crowther raved about the film: "A rootin', tootin' Wild West show, full of Indians and the United States Calvary . . . Henry Fonda is withering as the colonel, fiercely stubborn and stiff with gallantry, and John Wayne is powerful as his captain, forthright and exquisitely brave"; and Howard Barnes at the *New York Herald Tribune* did as well: "*Fort Apache* is a visually absorbing celebration of violent deeds. John Wayne is excellent as a captain who escapes the slaughter and protects his superior's name for the sake of the service"—at Oscar time, Wayne, Fonda, and Ford and the film were all ignored. The winners that year were Laurence Olivier's star turn in his self-directed *Hamlet*, Anatole Litvak's *The Snake Pit*, a star showcase for Olivia de Havilland, John Huston's glorious *The Treasure of the Sierra Madre*, which showed off Bogart at his darkest and Huston at his cleverest, and Jean Negulesco's *Johnny Belinda*, starring Jane Wyman and her real-live lover, Lew Ayres, for whom she had left her first husband, Ronald Reagan.

WAYNE THEN RETURNED TO FINISH Howard Hawks's monumental *Red River*, which had begun production before *Fort Apache* but had been delayed several times because Hawks's independent production company, Monterey Productions, had continued to have trouble over financing with its distributor, United Artists (*Red River* was Monterey's only production before it was dissolved).

It was Wayne's first film for Howard Hawks, Ford's cinematic antithesis, whose films had no room for teary sentimentalism. Hawks's pacing was too fast and his camera too objective to allow for expressive emotionalism in his mise-en-scène. Whereas Ford's films dwell in the soulful melancholia of the American past, Hawks's films speed forward unafraid of anything

that might get in the way of the fast lane. In Hawks's world, men romance strong, modern, and racy women, while Ford's prudent affectations offer visions of chaste love. Hawks's films are energized by the physical movement of its characters through space, while Ford's are enriched by their emotional passage through time.

What Hawks's and Ford's films share is a fondness for heroes who are "real men," two-fisted tough guys not afraid to stand up for what they believe in. Ironically, it was *Red River* that gave Wayne the opportunity to play a deeper, more complex version of that character than he ever had with Ford. It is arguably Hawks's greatest film and certainly his best western, as it explores the Freudian nature of conflict and competition between father and son without the restrictive safety of orderly civilization.

There is little doubt that Hawks had Ford in mind when he made *Red River*. He admired Ford's expansive view of the West, and Hawks wanted to get that into his film. Ford had helped elevate westerns to a higher level of acceptance with *Stagecoach*, and Hawks wanted to make a film at least as good as that one. When he was asked one time to name his three favorite directors by film critic and historian Richard Schickel, Hawks unhesitatingly answered, "John Ford, John Ford, John Ford."

Hawks's Monterey Pictures had purchased the rights to Borden Chase's novel *The Chisholm Trail*, serialized in the *Saturday Evening Post* in late 1946 and early 1947. The director then hired Charles Schnee to write the picture screenplay. Hawks had originally wanted Gary Cooper to play the story's dark lead, Tom Dunson. Cooper had won an Oscar in 1941 for his performance in Hawks's *Sergeant York*, for which Hawks was nominated as Best Director, and the actor was nominated twice more for Best Actor in each of following years, although he didn't win either (Sam Wood's 1942 *Pride of the Yankees* and Wood's 1943 *For Whom the Bells Toll*). He was eager to work with Hawks again, but when the director offered him the role of Dunson, Cooper turned it down, believing the character was too dark and it might hurt his all-American good-guy image, especially after his recent and odd turn in *For Whom the Bells Toll*.

Hawks also thought about casting Cary Grant in the supporting role of cowhand Cherry Valance. Grant was one of Hawks's favorite actors (he had used him in 1938's *Bringing Up Baby*, 1939's *Only Angels Have Wings*, and 1940's *His Girl Friday*), but he, too, begged off because he had never made a western and

also refused to play any role but the starring one. Valance's role eventually went to John Ireland, a handsome tough-guy character actor.

Only then did Hawks decide on Wayne for Dunson and, to get him, he smartly made Charles Feldman the film's executive producer. Feldman would be instrumental in getting Wayne to agree to do the film. He was hesitant, at first, to accept the role, as he had just a played an older character in *Fort Apache*. Dunson is essentially a father figure in the film and ages during it to older than Wayne's real-life forty-one years, and there was no real romantic interest for him in the script. The extent of Wayne's reluctance is debatable, but he eventually agreed to take the role.*

Despite gray powder in his hair and lines added to his face, at first Wayne still had trouble projecting the physical movement of an older man. To help him with his performance, Hawks assigned Walter Brennan, also in the film as Groot, Dunson's sidekick, to teach Wayne how to "act older." Rounding out the cast was Harry Carey Sr., and his son, Harry Carey Jr. (Everyone called Carey Jr. Dobie so he wouldn't be confused with his father, whom he strongly resembled. Carey Jr.'s hair was the color of the brick used to make adobe houses.)† *Red River* was the senior Carey's penultimate screen appearance. He died in 1947 of cancer at the age of sixty-nine, before the delayed 1948 release of the film, and shortly after appearing in a Walt Disney movie, Harold D. Schuster and Hamilton Lake's part live-action, part animated *So Dear to My Heart,* a vehicle for Disney child star Bobby Driscoll. "God, it was a terrible day," Carey Jr. recalled. Wayne was at the hospital when it happened. "Duke brought me a tumbler of whiskey. I think it was the first time I ever turned down a drink."

THE MOST INTERESTING TURN OF casting for *Red River* was Hawks's choice of the young and diminutive Montgomery Clift in the role of Matt Garth. Clift had caused a sensation on Broadway as one of the new "Method

* Zolotow claims Wayne was eager to do it, that he wanted to play another hard character (Zolotow, pp. 219–20), while Roberts and Olson report on his reluctance to do so, claiming, "When Hawks talked to him about the part, Duke said he was not sure he wanted to play an 'old man,' to which Hawks was said to have replied, 'Duke, you're going to be one pretty soon, why don't you get some practice?'"

† *Red River* "introduces" Harry Carey Jr., the fifth time he had been billed that way in a movie. Supposedly, Ford didn't want him to use the "junior" in any of his films, but Wayne convinced Carey Jr. that there was nothing wrong with honoring his father that way.

actors." The notion of making a Hollywood movie, with John Wayne no less, was not something that interested him at all. Hawks, who could be both convincing and persistent, flew Clift out to L.A., wined and dined him, and further sweetened the pot by offering the young, inexperienced film actor a fee of $60,000. Clift asked for time to think it over, flew back to New York, and a few days later called Hawks to tell him he was accepting his offer.

Not that Clift, who was gay, felt simpatico with Hawks or Wayne; he was an easterner through and through. He was from the New York theater community, where sensitivity reigned over machismo. In her biography of Clift, Patricia Bosworth described Clift's uneasiness around these "real men": "Clift respected Wayne's and Hawks' professional abilities but disliked them on a personal level. He told a friend about Duke and Hawks' nightly card games. 'They laughed and drank and told dirty jokes and slapped each other on the back. They tried to draw me into their circle but I couldn't go along with them. The machismo thing repelled me because it seemed so forced and unnecessary.'"

Hawks set up an initial meeting between the two stars of his film. Wayne was a little bit surprised at how small Clift was and told at least one interviewer his initial reaction to the New York actor was that he was "a little queer . . ."* Wayne was skeptical that someone as small and "sensitive" as Clift could make the film's climactic fistfight look at all believable, but Hawks assured him of the young actor's abilities. Wayne reluctantly agreed to try to work with the young Method man.

Hawks's version of that first meeting is a little different: "When [Wayne] saw Clift for the first time, he said, 'Howard, think we can get anything going between that kid and myself?' I said, 'I think you can.' After two scenes, he said, 'You're right. He can hold his own anyway, but I don't think we can make a fight.' I said, 'Duke, if you fall down and I kick you in the jaw, that could be quite a fight, don't you think so?' And that was all there was to it." It eventually took three days to film the climactic fistfight, to make Clift look believable against Wayne. Hawks himself taught Clift how to throw a punch and move the way fistfighters did.

As it turned out, Clift was more than just a brilliant casting coup on Hawks's part. He represented the passing of a generational torch, from the actors of

* According to Roberts and Olson, from an interview with Wayne's personal secretary, Mary St. John, p. 299.

Wayne's generation, who learned their craft on the job, who grew up with the industry from the days of silent films, to the new youth-oriented crop of actors weaned on "the Method." Clift was the first of a trio of young men who would, in the '50s, redefine what screen acting was—Clift, Marlon Brando, and James Dean. This great acting transformation begins in Hawks's *Red River*.

Tom Dunson is an aging Texas cattle baron after the end of the Civil War; in order to survive in business, he decides to move his herd over the Chisholm Trail, beyond the Red River into Missouri, where the railroads can transport his cattle west. The journey is fraught with obstacles—the elements, Comanches, and dissension among the hired hands, led by Cherry Valance, who, finding Dunson's leadership too harsh, threatens to lead a revolt. Matt, Dunson's grown-up foster son, stops it, and takes over the drive himself. He also finds love along the way when he helps rescue Tess Millay's wagon train from a Comanche attack. (Broadway actress Joanne Dru replaced Hawks's first choice for the role, Maggie Sheridan, when she became pregnant before filming began. A year after the film's completion, Dru married John Ireland. The marriage lasted eight years.)* Tess's talky presence later on in the film ignites a Freudian rivalry between Dunson and Garth. Tess is a typical Hawks woman, rough, tough, and not just able to run with the boys but also to fire a rifle with the best of them.

During production, Clift grew into his character, to the point where during the climactic fight, he looked quite believable against Wayne, not because of Hawks's off-screen fighting lessons but because both men played their characters so well; Dunson is older and wearier than Garth, and his surrogate son is filled with a rage of his own. It is to Hawks's credit that he could tie together all the complex psychological ends of the film into one immensely entertaining picture, one of the gems of 1948. It is also among the most indirectly political films of its time, with Dunson the dictator brought down by his brave, rebellious, and ultimately heroic foster son, Matthew Garth, the proto workingman's hero.

Red River was shot on location in seventy-six days in Elgin Rain Valley, Arizona, with the additional scenes filmed after the completion of *Fort Apache*, in the Goldwyn studios in Hollywood. To make these scenes match the earlier locations, twenty tons of sand and mesquite were imported from Arizona.

* Dru was on loan from Fox. The studio initially refused to let her make the film, until she personally appealed to Darryl F. Zanuck.

Wayne received $165,000 and 10 percent of the net profits to appear in the film, renegotiated by Feldman from his original $125,000 because of the film's extended production time, which caused Wayne to leave the film before it was finished, to work on *Fort Apache.**

When Hawks ran into some editing problems, he called Ford and asked him for help. Ford graciously agreed and convinced Hawks to eliminate some of the dialogue sequences that slowed the action and have Walter Brennan narrate them instead. It cut nearly eight minutes of film and increased its pacing. Ford's influence extended into the actual shooting, as Hawks consciously tried to emulate the vistas that made Ford's pictures so visually beautiful. Hawks: "I made a very good burial scene [in *Red River*] . . . I saw a cloud coming and I knew it was going to pass over the hill behind and I said to Wayne, 'Now get ready and no matter whether you make a muff, just keep on going, we can dub it in easy.' And he did, and he went on with some other things and he said, 'What was happening?' I said, 'The cloud went right over as you were reading this thing—that made it very good.' Ford fills his pictures with stuff like that."†

One of the most curious prerelease moments happened when Howard Hughes, of all people, saw a screening and objected to the use of "Draw your gun," a line of dialogue in the film. Hughes then insisted that the end of *Red River* had been wholly lifted from his 1943 *The Outlaw*'s quirky retelling of the saga of Billy the Kid, as seen through the point of view of Jane Russell's chest. In that film, there is a sequence in which, according to Hedda Hopper, "Billy the Kid resists the efforts of his erstwhile friend Doc to draw him into a duel. Billy refuses to go for his guns even though Doc shoots a few rounds in his ears. The two are reconciled during the film." Hawks couldn't believe it, but the lawsuit threatened to hold up the film's already long-delayed release, so, despite his insistence the line be left in the film, he finally agreed to delete it.

That still didn't satisfy Hughes, who insisted on suing Hawks for copyright infringement and went to court, where it appeared he was going to win, until Gradwell Sears and Edward Small, two executives from United Artists, agreed to give Hughes the right to edit out the entire scene. An exasperated Hawks

* Wayne eventually earned a total of $375,000.

† For years after, Hawks would laugh when people would come up to congratulate Ford on directing *Red River,* especially when Ford always said, "Thank you."

went to Wayne and asked him to intervene with his friend. Wayne then met with Hughes and asked him to please leave the scene in, saying it meant a lot to him personally. The perverse billionaire then smiled and asked Wayne why it took him so long. Wayne laughed, as did Hughes, who then dropped his lawsuit, and the scene was left in the film.

Red River opened September 30, 1948, six months after *Fort Apache,* and of the two films, it was *Red River* that proved the career turning point for Wayne. Even with Clift's impressive debut, the film belongs to Wayne, who gives not just a bravura performance, but the best of his career to date. In the midst of his polarizing political activities, an unstable second marriage, financial problems, and a postwar Hollywood increasingly populated with bunch of newer and younger angst-filled actors, like Clift, Wayne was able to rise above it all to deliver a performance that was at once physically coarse and emotionally strong.

The reviews rightly hailed both the film and Wayne's soaring performance in it. The *New York Times'* Bosley Crowther called it a film with a "solidly masculine cast, topped off by a withering job of acting a boss-wrangler done by Mr. Wayne. This consistently able portrayer of two-fisted, two-gunned outdoor men surpasses himself in this picture . . . on the way to becoming one of the best cowboy pictures ever made . . . sixteen hands above the level of routine horse opera these days." *Time* magazine called it "[a] rattling good outdoor adventure movie" and singled out Wayne's performance: "Wayne's consistently able portrayal of a two-fisted, two-gunned outdoor man surpasses himself in this picture . . ." that would "take its place among the other big, box-office important western epics that have come from Hollywood over the years . . . a spectacle of sweeping grandeur." And from *Variety* came this: "[a] film which is spectacle at its best although spectacle is by no means all of it . . . it is epic in its sweep and size of its canvas but the canvas is packed with hard-bitten detail rather than romantic flourishes." Later on, Andrew Sarris, in the *New York Film Bulletin* wrote, "What is most impressive about *Red River* is Hawks' concentration on character relationships and the swirling dust of horses and cattle."

The film still impresses today. Andy Webster, writing about a 2013 Hawks revival, said that "Wayne plays Tom Dunson, an obsessed boss placing unreasonable demands on his crew, including his compassionate but defiant

surrogate son, [played by] Montgomery Clift, every inch a star in his screen debut . . . Wayne may play a domineering father figure, but in conceding the spotlight to the ascendant Clift, he displays perhaps the highest virtue of all: humility."

But it was John Ford's "critique" that meant the most to Wayne. After seeing the complete version in a screening room, Ford turned to Hawks and said, "I never knew the big son-of-a-bitch could act!"*

* In 1990, *Red River* was selected for preservation in the United States National Film Registry by the Library of Congress for being "culturally, historically, or aesthetically significant." In June 2008, AFI listed *Red River* as the fifth-best film in the western genre.

Chapter 14

After his double Academy snub for *Fort Apache* and *Red River,* Wayne was convinced the Communist members of the Academy would fight to prevent him from ever winning. It was following the Awards ceremony in 1949 that Wayne finally decided to accept the presidency of the MPA.

Charles Feldman then sent him the script to *All the King's Men,* loosely based on Robert Penn Warren's novel of the same name that focused on the political career of Huey Long, the demagogic, charismatic governor and then senator of Louisiana who had his eyes on a run for the White House before he was assassinated in 1935. Wayne told Feldman he could take the script and "shove it up [director] Robert Rossen's ass." He believed that the producer/writer/director was trying to make a film to illustrate the failings of the democratic system. Wayne never regretted his decision to turn down the role, even though it went to Broderick Crawford and he won an Oscar for his performance, and the film (Rossen and Columbia Pictures) Best Picture. Wayne was so enraged by the script he wrote a letter to the MPA excoriating Rossen for trying to destroy the fabric of American life. A year later, Rossen was called before HUAC and his career in Hollywood was shut down for more than a decade.

After rejecting *All the King's Men,* Wayne also passed on Henry King's *The Gunfighter* (he had wanted to play the role of the aging gunfighter but the film was being made at Columbia, and he still held a grudge against Harry Cohn). The studio then sold the project to Twentieth Century–Fox, where Gregory

Peck eventually got the role. Wayne also said no to Michael Curtiz's *The Breaking Point.* The starring role in that went to John Garfield, his penultimate film before being blacklisted. Wayne also turned down *White Native*, a jungle script for RKO that eventually went to Johnny Weissmuller but was never made. John Ford and Merian Cooper then offered Wayne one of the three starring roles in *3 Godfathers*, which, of course he accepted.*

McBride posits that Ford sensed which way the political wind in Hollywood was blowing and wanted to make an unabashedly pro-Christian movie (even more so than his others) that in no way disrespected the birth of Christ. *3 God-fathers* is a John Wayne western-style parable (rather than a true western) of the story of the Three Wise Men and the birth of baby Jesus. It is one of the most overlooked films in Ford's canon. (Andrew Sarris barely mentions it in his Ford book and marks it as one of Ford's lesser achievements in *The American Cinema*. Bogdanovich also neglects it; McBride pays scant more attention to it.)

Even though they hadn't worked together for years, and their relationship never recovered from their professional and personal schism, Ford dedicated *3 Godfathers* on-screen "To the memory of Harry Carey—bright star of the western sky." Carey's son, Harry Carey Jr., making his first appearance in a John Ford film (after his "debut" in *Red River*), played one of the three godfathers, all bank robbers, Wayne and Pedro Armendáriz the other two. Ward Bond played the marshal looking for the three bank robbers. Running from him, they come across an expectant mother in a covered wagon in the desert, dying of thirst. They deliver the baby, a girl, and the mother's dying wish is that they care for her. They are deeply moved by this, find religion, so to speak, and take the baby to New Jerusalem, Arizona. It is the hokiest, rather than the holiest of Ford films, perhaps rightly neglected by his best critics. If it served any purpose other than "remembering" Harry Carey, it reaffirmed Ford's moral standing among the political commandants of Hollywood. It also reaffirmed Wayne's Christian ethics after his divorce. Filmed in Death Valley in thirty-two days, between the end of May and the middle of June, with interiors shot at RKO-Pathé in Culver City, *3 Godfathers* opened December 1, 1948, in time to catch the Christmas crowd. Critics were generally kind to both the film and Wayne. The *New York*

* A.k.a. *Chistmas at Mojave Tank.* Ford had made a silent version in 1919, starring Harry Carey, titled *Marked Man.* Ford often said it was his favorite of all the silent films he had made. No existing print of *Marked Man* is known to exist.

Times' Bosley Crowther wrote, "It is Mr. Ford's wonderful style in picturing a frontier fable that has the classic mold. John Wayne . . . is wonderfully raw and ructious . . . There are humor and honest tear-jerking in this visually beautiful film." Audiences loved it as well. Made on a budget of $1.2 million, it doubled that in its initial domestic release and added another $750,00 in foreign. Wayne earned $207,000 from his salary and percentage of the profits (Bond was paid a straight $2,500 a week, Harry Carey Jr., $350 a week).

That same year Wayne had also agreed to make *Wake of the Red Witch* for Republic, a sunken-treasure melodrama based on a forgotten bestseller by Garland Roark. It was directed by Edward Ludwig and bore more than a passing resemblance to *Reap the Wild Wind,* reteaming Wayne with his costar from *Angel and the Badman,* Gail Russell.* The film, told in a series of flashbacks-within-flashbacks, was written by Harry Brown and Kenneth Gamet and filmed at Republic Studios and on location in Arcadia, California.

According to Dave Kehr, an astute film critic writing in the *New York Times,* "*Red Witch* is a film that courts the ridiculous, with its potted-palm islands populated by ethnographically unlikely natives . . . but the film finds something dreamlike and beautiful in all this artifice, largely by refusing any overtly poetic efforts and allowing the slow rhythms and circular patterns of the narrative to reveal the unexpected scale of the characters' emotions . . . *Wake* [along with *Red River,* helped] reveal a new, middle-aged gravity in Wayne and a dormant ability to play distant, troubled men . . . an eccentric, haunting work that made a contribution to Wayne's transformation, but which traffics in elements of gothic fantasy and lyricism not often associated with Wayne's personality."

Made for $1.2 million, *Red Witch* grossed $2.8 million in its initial domestic release, a tribute to Wayne's post-war popularity. The best sequence is his battle against a rubber octopus that took six puppeteers to control. For the film, Wayne earned $283,000, Gail Russell $35,000, and Luther Adler, who played the villain, $10,000.

IT HAD BEEN A BUSY period for Wayne. As Gladwin Hill noted that year in the *New York Times,* "Even the home-bound little-old-lady-in-Pasadena . . . can hardly peek out the door these days without coming into figurative combat

* The rights were originally owned by MGM, which purchased it for a Clark Gable feature. When Gable turned the film down, the studio sold its option on the Roark novel to Republic.

with that amiable, shambling, six-foot-five pillar of the Hollywood community Marion Michael Morrison, alias, John Wayne, alias 'Duke.'" Hill then quoted Ford's reply as to the reason for Wayne's popularity. " 'He's the best actor in Hollywood, that's all.'"

Certainly one of the most popular. In March 1949, the influential poll of exhibitors that appeared annually in the *Motion Picture Herald* had Wayne in fourth place, up from thirty-three the year before (behind Bob Hope, Bing Crosby, and Abbott and Costello).* The honor was announced by Louella Parsons on her ABC radio program. She had reconciled her differences with Wayne when he became the president of the MPA.

By the fall, it was possible to choose from eight John Wayne pictures playing at the same time new or in rerelease in various theaters in Los Angeles, a time when Hollywood's output was at an all-time low, due to its political infighting and the new popularity of television. Playing at the same time were *Red River, Stagecoach, 3 Godfathers, The Long Voyage Home, Wake of the Red Witch, Fort Apache, The Spoilers, Seven Sinners, Pittsburgh, I Cover the War, The Sea Spoilers, Fighting Seabees,* and *Flying Tigers.*

He was also on TV every day on *Frontier Playhouse* or *Six-Gun Cinema,* a syndicated series of replays of some his old B movies. A spokesman for *Frontier Playhouse* said at the time, "We regard our Hopalong Cassidy, Tim McCoy and John Wayne westerns as our quality shows. Don't make the mistake of thinking that only kids watch them. Our surveys show that while fathers and mothers may say they're just looking at them to keep the children company, they outnumber the juveniles in our audiences, sixty-two percent to thirty-eight percent."

According to one publication, the reason for his surge in popularity was that he "carries dynamite in his large fists. This, and the charm in his crinkly eyes, gives him tremendous pull at the box-office all over the country. His drawing power is especially potent in the small towns, where any John Wayne picture, whether it is new or 10 years old, will pack the house . . . working with a steady, unnervous strength for four different studios—Republic, RKO, Argosy [John Ford] and Warner Bros—he shifts back and forth between Westerns, sea-epics, and war pictures . . . one female fan summed up his appeal for women this way: 'He doesn't look like an actor—he looks like a real man.'"

* He was number 2 according to *The Showman's Trade Review,* ahead of Crosby, behind Hope.

Because of this newly elevated popularity, in April 1949, one month after his ascendancy in the popularity polls and two months after being elected as president of the MPA, Wayne was offered and signed a precedent-setting deal with Warner Bros to do one picture a year for the studio for seven years, in return for 10 percent of the gross when and if any of them were reissued. No other actor had ever received this type of residual deal, and it initiated a long fight between the studios and the guilds over the question of reissues. Wayne had insisted on including it because so many of his films were being perpetually rereleased, with no additional pay for him. He justified his position as an unselfish move: "I'm looking for some security for my kids. Don't forget I didn't start making big money until the era of high taxes. Right now, I get to keep six cents out of every dollar I make. That's why I have to get the residual rights of some of my pictures so the money will keep coming in." The Screen Actors Guild was against reissues without repayment as well, because it claimed it kept members from making new pictures while getting nothing for the ones they already made.

How did he get the deal? There is no question he was hot, at the top of his game, and that his pictures, good or bad, were making money. But there was something else. Simply put, popularity meant power in Hollywood. No studio wanted to come up against Wayne over the question of residuals. His strong anti-Communist stance and his new position as the head of the MPA was a strong one-two punch. And yet, as much as he fought for the additional money, he also worried that all this exposure would make audiences tire of him and lower the demand for new John Wayne movies, reducing his price. "That finishes me," Wayne told Ward Bond one night not long after, over drinks at the Formosa, a small Polynesian-style bar across from Warner's Hollywood studios. "No actor can have that many pictures showing at one time and not be finished."

When asked by the press how he felt about all the exposure he was getting that year, Wayne again expressed his concern over making too many movies: "I think four [pictures] a year, which due to delays probably means about three and a half, is about right. I don't want to saturate the market with my pictures, and I hope it doesn't turn out that the reissues have done so. I've got three [unmade] pictures coming up—*She Wore a Yellow Ribbon* [Ford/Argosy], *The Sands of Iwo Jima* [Republic] and *The Fighting Kentuckian* [Republic]—and if they don't go aground on the rock of too much Wayne, I suggest a case will have been made for the saturation-booking idea."

But when another reporter suggested he was a shrewd businessman, perhaps better at making money than movies, he just grinned, put his head down, moved his boot in the dust, and, with, his eyes still looking forward, said, "I'm just a guy trying to make a living in the movies." He was even more insistent about his financial needs when he was interviewed about his exposure by Hedda Hopper, claiming he wasn't just cashing in on his fame, but struggling to make ends meet, that that was the reason he was working so hard. "I have to make $2,600 a month to take care of my two families. I just have to keep jumping around . . . to make it."

DURING THIS PERIOD OF NONSTOP filmmaking, the newly-empowered Wayne stepped up his campaign to clean up Hollywood, to rid it once and for all of those he perceived were the bad guys. In 1949, his single-minded battle against Communist infiltration led him to publicly declare that, much to his dismay, the blacklist was ineffective because blacklisted writers were being hired without hesitation by the studios under assumed names. Wayne believed the Communists were a talented and powerful bloc in Hollywood and that the studios needed their talent to make movies, regardless of whom or what they believed in. Whether it was true—a case could be made for both sides—what's important is that Wayne *believed* it was true and began to wonder if the studios he was so determined to protect were just as corrupt as those he was trying to protect them from.

WAYNE'S NEXT RELEASE WAS *SHE Wore a Yellow Ribbon,* made for John Ford at his Argosy Pictures, on location in Monument Valley. The second in the Cavalry trilogy, it was written by Frank S. Nugent and Laurence Stallings, adapted from two short stories by James Warner Bellah, who had also provided the original source material for *Fort Apache.* Wayne had brought the Argosy project to his friend Howard Hughes's RKO for funding and distribution.

She Wore a Yellow Ribbon opens with a shot of the flag of the Seventh Cavalry and the words "Custer Is Dead" splashed across the screen. This informs the audience it is a follow-up to *Fort Apache.* When Ford suggested the Indian chief leader of the Kiowas, played by Noble Johnson, an African American actor, wear a bright red shirt, Hughes went ballistic. Ford said it was simply

because the film was being shot in color, but Hughes insisted that somehow it meant that Ford was sympathetic to both the Indians in the film and the Communists in Hollywood. Wayne, who didn't want to go against Ford, did believe he was pushing the limits with his red-shirted Indian. Ford was openly mocked for it later on by the hard right, who called his film *He Wore a Deep Red Ribbon.*

The film produced another kind of excitement. Wayne was nearly killed during production when the cinch belt on his saddle loosened and he was thrown from his horse while filming a sequence in which he waves his blue coat at the Indians. "I hit the ground. Hit my head. Blacked out. Now there's about fifty horses tear-assing at me. I came out of the blackout to hear the Old Man, Mr. Ford, yelling and there was general hysteria, but a wrangler with guts, he ran out and headed off the stampeding horses, which were within about a few feet of stomping me to death."

In the film Wayne plays the reluctant retiree, aptly named Captain Brittles, supported by a strong star-studded cast that included Ben Johnson, Victor McLaglen, Joanne Dru, Harry Carey Jr., Mildred Natwick, and Wayne's old friend Paul Fix. Wayne's performance smartly emphasizes the emotional pain the aging Brittles feels at the announcement of his reluctant retirement. Wayne was forty-three at the time the film was made, and once again willing to age himself, as he had in *Red River,* to give his character an even deeper and more complex gravitas.*

The speech he gives at the end of the retirement ceremony, in which his troopers give him a silver watch and chain and he responds with his moving, humble, brink-of-tears farewell, is all the more impressive because it was not in the original screenplay, but entirely improvised during the shooting of the scene. It's memorable "I'll be back" recalled the famous "I shall return" of Douglas MacArthur, one of Ford's heroes. (It also anticipates Kazan and screenwriter Schulberg's "I'll be back" at the end of Kazan's 1954 *On the Waterfront.* Kazan idolized Ford, and many of his films echo Ford's stylistic touches.) "It was an emotional reaction rather than a studied response," Wayne said, later. "Pappy was very conscious of each actor that he had, their sensitivity, he knew the paint

* In *Ribbon,* Wayne played even older than he had in *Red River.* There are some, like Peter Bogdanovich, who feel that Ford was jealous of Wayne's performance for Hawks in *Red River* and thus made him even older in *She Wore a Yellow Ribbon.*

he was using when he put me in that scene. So he knew my reaction would be simplistic and deeply moving, which I think it was."

It was.

AFTER FINISHING THE PICTURE, WAYNE finally allowed himself a brief respite, during which he claimed in the press to have gone hunting and fishing with Chata. In fact, he went sailing with Ford. He was depressed about the state of his second marriage and once again sought comfort from Ford aboard *The Araner*. The hard truth for Wayne was that he could no longer pretend it could be saved.

The real trouble between him and Chata had increased during the filming of *Fort Apache*, shot on location in Monument Valley, Utah, and California. Instead of accompanying him, which she usually did, Chata traveled with her mother to Mexico, where they both went on an extended drinking binge. She later claimed she was lonely whenever her husband was away on location, but even though Wayne had told her she was welcome to come along, she preferred the company of *mama*. She didn't return to L.A. until Wayne had finished the picture, and as soon as they were together they began to fight, or more accurately, to resume the one long, continuous fight they had been having since the day they were married. She never liked his long absences on the shoots and although Wayne could drink with the best of them, he didn't like it when Chata drank. He didn't think it was proper behavior for a wife, especially when he wasn't with her. They were barely talking to each other by the time he finished *She Wore a Yellow Ribbon*.

THE FILM GROSSED NEARLY $10 million in its combined initial domestic and international releases. It was another huge hit for Wayne, and for RKO, and signaled a strong comeback for Ford. Despite his well-received performance, Wayne now felt he had played too many older characters in overly complex films and wanted to make a simpler picture as someone closer to his own age, a rough, smack-in-the-face film that underscored his patriotic verve. That turned out to be *The Fighting Kentuckian* (a.k.a. *Eagles in Exile* and *A Strange Caravan*), a coonskin-cap romantic adventure that he produced through Wayne-Fellows for Republic. It was written and directed by George Waggner, an old and dear friend of Wayne's, and costarred the blond and beau-

tiful Vera Ralston, a Republic regular. Oliver Hardy was also in it, a rare solo turn for the rotund comic without his partner Stan Laurel, here playing Willie Paine, the usual Andy Devine sidekick role. Also in it was the Grand Ole Opry's famed Roy Acuff. Republic claimed the film failed to make back its $1.3 million cost, one of the few failures Wayne had in this period, and the film is today considered one of the lesser films in his canon.*

Undaunted, Wayne pushed ahead with his plan to make a film version of the story of the Alamo, the Texas mission near San Antonio where a relatively small group of heroic military men and civilians defended Texas in 1836 against a thousand Mexican soldiers ordered to reclaim the territory. Wayne wanted to produce the film and star in it as the then little-remembered Davy Crockett, five years before Walt Disney turned the political frontiersman into a TV folk hero, media sensation, and marketing phenomenon. Disney, like Wayne, had hit upon the notion that Crockett embodied the patriotic essence of the true American, and made his original 1954 TV series (and several sequels/prequels) to cash in on the popularity of the folk hero, and turned unknown Fess Parker, who played Crockett, into a national "hero."

Wayne wanted to produce his film about Crockett at Republic, but Yates had other ideas. He insisted that *The Fighting Kentuckian* had been a failure and wanted to take his studio in a different direction. Wayne blamed Yates's obsession with Vera Ralston for the so-called failure of the film and believed that the real reason Yates wouldn't agree to make *The Alamo* was that there wasn't a starring role in it for her: "Yates was one of the smartest businessmen I ever met. I respected him in many ways, and he liked me. But when it came to the woman he loved—his business brains just went flyin' out the window."

Yates's refusal to make *The Alamo,* even though he was making a fortune on TV syndicating old Wayne westerns, infuriated him. "[He] will have to make me a damn good offer to get me to do another movie with him. I'm fed up to the teeth with him. I wanted to do *The Alamo* under my own company, Wayne-Fellows, and just release it through Republic. Yates said I would have to [give up producing it with my own company and] make the picture for Republic.

* Profit numbers are always suspect. In 1950, *Variety*'s annual roundup of the previous year's films claimed *The Fighting Kentuckian* had made money. It was not unusual for studios to try to minimize profits for a number of reasons, including but not limited to profit participation and taxes.

He said to me, 'You owe it to Republic. We made you.' How do you like that? I don't owe them one thing. I've made plenty of money for Republic."

Wayne wanted to produce *The Alamo* through Wayne-Fellows not only so he could maintain creative control but also to be able to keep a closer eye on the money. Even with Bö Roos riding shotgun on his income, with all the alimony he was paying from his first marriage and Chata's expensive spending habits, he still needed more than he was making. He never seemed to have enough, despite the large number of movies he was making. Yates had a barrel of it, told Wayne to forget about *The Alamo,* and instead came up with a script idea he knew he wouldn't be able to resist. Yates was right. Wayne agreed to make *Sands of Iwo Jima,* a World War II film that turned into one of the most memorable movies of his career. It was directed by veteran Allen Dwan (his eighty-fourth film, forty-eight of which he made in the silent era, when John Ford was his prop man) and coproduced by Edmund Grainger, from a screenplay by Harry Brown and Wayne favorite James Edward Grant.*

The film is an unabashedly patriotic depiction of heroism that ran against the grain of all the angst and self-doubt of many of the majors' postwar films. Wayne wanted to remind American audiences of the heroics of the U.S. Marines during World War II, and the steep price they paid defending freedom.

The idea for the movie began after Grainger saw the historic Joe Rosenthal photograph of the planting of the flag on Mount Suribachi. He immediately bought the rights to it and set about building a film that would climax with a reenactment of that famous shot. The story couldn't have been simpler—grizzled Sergeant John Stryker (Wayne) has to turn a bunch of soft young boys into tough marines. Although they hate him at first, by the time he dies at the end of the film, they idolize him and recognize the heroism of his ultimate sacrifice.

The Marine Corps agreed to cooperate with the filming, despite some initial hesitation about Republic's ability to make a film good enough to properly express the pride of the Corps. John Wayne's late commitment to the project

* "I used to work for Wayne for nothing, because he wanted his pictures to be right. He would come to me with a script for a film long before he was famous and ask me if something couldn't be done with it. We evolved a system of making him a sort of bystander in situations, instead of actively taking part in them. He would avoid acting. This pleased the other actors who worked with him, because they had every chance to ham it up with big scenes, while Wayne would just take his in stride."—James Edward Grant, quoted by Edwin Schallert, *The Los Angeles Times,* March 4, 1951.

was the turning point, and the marines allowed much of the film to be shot at Camp Pendleton, a hundred miles south of Hollywood.*

With a budget of a million dollars, Dwan was charged with bringing the story of Sergeant John Stryker to life, using as the backdrop the battles of Tarawa and Iwo Jima, and the final assault on Suribachi. Even with the full cooperation of the marines, the film's budget inflated to nearly $1.4 million, making it the most expensive picture Yates and Republic had ever produced.

Iwo Jima premiered December 14, 1949, and received rave reviews. Thomas M. Pryor wrote in the *New York Times* that "Wayne is especially honest and convincing, for he manages to dominate a screenplay which is crowded with exciting, sweeping battle scenes . . . the film has undeniable moments of greatness" and there was this from the then highly influential right-wing columnist Walter Winchell: "The original story was written in blood by the glorious United States Marines! John Wayne must be everybody's idea of a good actor! He's immense in *Iwo Jima,* the best of the war pictures!"

Yates began an all-out campaign to get the film nominated for Best Picture (an award that would go to himself as executive producer) and Wayne for Best Actor, something Yates felt was long overdue, even in the divided and hostile political atmosphere of the polarized Academy.

He pulled it off. The film grossed just under $11 million in its initial domestic release and managed to get into "prestige" first-run houses that Republic's films were rarely able to do. *Sands of Iwo Jima* was the fourth-highest-grossing film of 1949, and earned the forty-two-year-old Wayne his first Academy Award nomination, for Best Actor.†

The nomination caught Wayne off guard, but it was no surprise to Dwan,

* Some reports claim Dwan wanted Kirk Douglas for the role. Others report that Wayne was Dwan's first choice. Dwan: "I didn't ask about Wayne—because I thought there were three or four actors who could play it: there's no part in the world that only one actor can play. But Eddie [Grant] wanted Wayne, so I said, 'Go ahead and get him—fight for him.' But it was hard to get him to go to Yates . . . he didn't feel secure enough. But he did and it worked. After the picture, Wayne was a kingpin—he'd go and tell him, 'Mr. Yates, I like your office better than I do my dressing room. *You* go over to the dressing room, I'll take the office.' He became a big shot, because the picture was a big success for him, and I don't think anyone could have been any better . . . but up until the day we started the picture, we weren't sure we had Wayne."—Dwan, quoted by Peter Bogdanovich, *Who the Devil Made It,* p. 114.
† The top-five-grossing films of 1949 were Cecil B. DeMille's *Samson and Delilah,* $25 million; William Wellman's *Battleground,* $11 million; Henry Levin's *Jolson Sings Again,* $10.9 million; *Sands of Iwo Jima;* Howard Hawks's *I Was a Male War Bride,* $8.9 million.

who later gave a one-minute analysis of why: "The great movie stars learned the technique and a few mannerisms and a few moves and become sort of public idols. They couldn't do anything wrong if you liked them—no matter what they did; it wasn't what they played. A fellow like John Wayne is the same in every picture, but you like him because it's Wayne. And you like to see that strange walk of his and you're satisfied. He can play certain scenes very well, his way, and you accept them his way. And if there are scenes he can't play well, he just won't do them."

THE AWARDS WERE PRESENTED MARCH 23, 1950, at the RKO Pantages Theater in Hollywood, hosted by actor Paul Douglas. Wayne showed up smiling and compliant, with Chata on his arm, the two appearing very much the happily married couple. When asked by a reporter that night about his nomination, Wayne was effusive. "It was a beautiful personal story . . . 'Mr. Chips' put in the military."

He was up against some tough competition. Broderick Crawford was nominated for his performance in Rossen's *All the King's Men,* the role that Wayne had turned down; Kirk Douglas for his star-turn performance in Mark Robson's fight picture, *Champion;* Gregory Peck in Henry King's *Twelve O'Clock High,* another solid World War II movie; and Richard Todd for *The Hasty Heart,* which featured future president Ronald Reagan, then president of the Screen Actors Guild, in a supporting role. It was a look at the war and its aftermath from the British point of view.*

Wayne lost Best Actor to Crawford. After the ceremonies, Wayne said, with a hint of bitterness, "After twenty-five years in the business, this does not keep me tossing in my bed at night." When one reporter pressed him on whether he

* Neither John Ford (*She Wore a Yellow Ribbon*) nor Allan Dwan was nominated for Best Director, and Yates was shut out for Best Picture. The five films nominated were *All the King's Men,* William Wyler's *The Heiress,* Joseph Mankiewicz's *A Letter to Three Wives, Twelve O'Clock High,* and William Wellman's *Battleground. All the King's Men* won Best Picture, Mankiewicz Best Director. *She Wore a Yellow Ribbon* was nominated and won for Best Color Cinematography (Winton Hoch). *Sands of Iwo Jima* was also nominated but didn't win for Sound Recording (Republic Sound Department) and was nominated but didn't win for Film Editing (Richard L. Van Enger). Among the films that weren't nominated for Best Picture that year, besides *Ribbon* and *Sands,* were Gene Kelly and Stanley Donen's *On the Town,* and arguably Raoul Walsh's best film, *White Heat.*

was disappointed, he said, "I worry about it the way Aga Khan worried where his next meal is coming from. What'd *I* want with an Oscar, anyhow? It'd just clutter up the mantel."

When the dust cleared, at the top of the box-office heap that year was not Todd, or Crawford, or Douglas, or Peck. It was John Wayne.

Part Three

Searching Through the Fifties

Chapter 15

As the new decade began, John Wayne was not just one of the biggest movie stars in the world, he had evolved into a real actor who could play complex roles in A movies made by great directors. He had also gone from being a supporter of FDR to one of the toughest and most unforgiving political soldiers in Hollywood's war on Communism. Wayne had turned into something of a real-life version of Tom Dunson, from *Red River*, unyielding to the reality of the changing times, willing to throw out the baby, or the cream of Hollywood's talent, with the bathwater of their perceived politics. At the age of forty-two, he was, more than ever, wanting to rid Hollywood of the Communist menace once and for all, and hopefully by doing so win the respect of the Academy, if, indeed, these were two separate goals. Despite what he told the press, friends knew, it continued to rankle Wayne not just that he hadn't won the Oscar for *Sands of Iwo Jima*, but that he had not even been nominated for *Stagecoach*, *They Were Expendable*, *Fort Apache*, or *Red River*. He was convinced more than ever it was the Communist faction in Hollywood that had prevented him from getting the gold statuette he deserved.

His unforgiving battle against subversives was deeply affected by a confrontation that took place between John Ford, who never completely trusted the tactics of those who forced others to testify, to name names, and then have to suffer the punishment of blacklisting, and Cecil B. DeMille, Hollywood's self-appointed demagogic anti-Communist enforcer. Wayne had been a big sup-

porter of DeMille's, admired his guts, and was inspired by his example to do his part to help the industry-wide purge in any way he could.

The hunt for Communists in Hollywood had taken on a life of its own and had increasingly become a regular part of doing business. Wayne understood that, but he was, nonetheless, surprised and disturbed when DeMille set his sights on John Ford and publicly questioned his loyalty. Even if it was only for the liberalism in his films, DeMille's public distrust of Ford could prove extremely damaging. Careers were being routinely destroyed by innuendo. Nobody was safe, not even Ford, and it was something Wayne didn't like.

The incident that finally moved Wayne to some degree of compassion for those accused of being Party members was one that pitted Ford directly against DeMille over the question of the MPA's right to demand that every member of the Screen Directors Guild sign an anti-Communist loyalty oath or else be barred from working in Hollywood. DeMille, a high-ranking member on the Motion Picture Industry Council, urged the members of the SDG to sign it to prove their allegiance to America, this despite a non-Communist affidavit that was already a requirement of all guild officers. DeMille wanted every member to sign this new oath.

The guild was split over it. SDG president Joseph Mankiewicz refused to sign (even though he had already signed the officers' special requisite oath), a push-back that raised eyebrows all over Hollywood. Merian C. Cooper also refused, and Ford backed both of them. The guild's infighting made it to the front page of *Variety,* and DeMille felt he had to call for Mankiewicz's resignation. At a general meeting of the SDG that October 1950, DeMille, who had assumed the mantle of anti-Communist spokesperson for Hollywood, complete with halo above his head, read the names of all those who refused to sign the oath. When he got to Billy Wilder, a Jewish German refugee who had fled Hitler, William Wyler, born in Alsace to Jewish parents who fled the country after World War I, and Fred Zinnemann, a German Jew who had studied alongside Wilder in Germany before coming to America, DeMille pronounced their names "Billy *Vilder,*" "William *Vyler,*" and "*Tzinnemann.*" Much to Saint DeMille's surprise, his toxic mockery drew loud boos from the membership.

A slew of directors then made impassioned speeches, many pointing out De-Mille's alleged anti-Semitism, the great unspoken by-product of the blacklist. DeMille, like so many non-Jews in Hollywood at the time, believed that all

union Jews in Hollywood were Communists, if for no other reason than they were so antifascist (not everyone in Hollywood had opposed Hitler prior to World War II).

Finally, it was Ford's turn to have his say. He served on the SDG's Veterans Committee, along with Frank Capra, Wyler, and George Stevens, and was adamantly against the proposal. He stood up, and all eyes went to him. After taking a deep breath, the room went silent as he stared directly at DeMille and after a long pause said, "My name is John Ford. I'm a director of westerns . . . we organized this guild to protect ourselves against producers . . . now somebody wants to throw ourselves . . . in a position of putting out derogatory information about a director, whether he is a Communist, beats his mother-in-law, or beats dogs . . . I admire [C. B. DeMille] but I don't *like* him . . . I think Joe [Mankiewicz] needs an apology." The board then resigned in unison. Manciewicz was elected the new president, and Ford vice president.

The next day he privately apologized to DeMille, but the taint was already on Ford. For whatever reason, his films never again reached the popularity they had enjoyed for nearly two decades.

Ford's standing up to DeMille at whatever professional cost had a deep personal effect on Wayne. Now he began to question DeMille's real motivations and the fact that he was a big supporter of the first-term senator from Wisconsin (Republican, 1947), Joseph McCarthy, whose rising star would soon provide the rocket fuel for the '50s witch hunts and whose name would come to define an era in America of hate, paranoia, and self-aggrandizement.

Unlike the doctrinaire DeMille, Wayne knew Ford was a humanist, in his films and in his life, and he had no use for DeMille's or McCarthy's tactics. At a party given by Ward Bond, one of the more doctrinaire anti-Communists in Hollywood, to honor the senator, in front of Wayne Ford told Bond, "You can take your party and shove it. I wouldn't meet that guy in a whorehouse. He's a disgrace and a danger to our country." Thereafter, Ford, who continued to use Bond in movies, routinely and lovingly referred to Bond as "a shit, but he's our favorite shit." And when not long after, Ford was casting a new movie, he was told by an executive at Republic that he couldn't use a certain actor because of the blacklist, Ford reportedly told him, "Send the Commie bastard to me, I'll hire him right now . . ." and then threw the studio rep out of his office.

Ford's and Wayne's next picture was 1950's *Rio Grande*, produced by Argosy

and distributed by Yates's Republic (a.k.a. *Rio Grande Command*, the Mexican name for the river marking its border with the United States). For this third film in the trilogy, Ford had to work with a $1.2 million budget, half as much as *Fort Apache* and barely enough to get the film made within its thirty-two-day shooting schedule. Because of the pressure from it and the continuing negative fallout from his confrontation with DeMille, he nearly had a nervous breakdown, having increasingly contentious battles with Yates over production costs. He had to forgo shooting in his beloved Monument Valley and filmed instead in Moab, Utah. Moreover, Yates rejected Frank Nugent, Ford's chosen writer, because Yates considered him too liberal to make the film. His place was taken by archconservative screenwriter James Kevin McGuiness, who turned the focus of the film away from its central relationship between Colonel Yorke (Wayne) and his estranged wife (Maureen O'Hara) and into to an allegory about Korea, with angry Apaches substituting for the Asian enemy.

It was the least impressive of the three films in Ford's cavalry trilogy and after all of Yates's interference, he lost interest in it. Instead, he'd wanted to make *The Quiet Man*, but Yates hated the project and insisted that Ford make *Rio Grande* first, and if the picture was a hit, Yates promised he would green-light *The Quiet Man*.

Rio Grande, as were the first two films in the trilogy, was based on a short story by James Wayne Bellah, this one "Mission With No Record," which had appeared in the *Saturday Evening Post*. Although it was directed by Ford, it was dominated by Yates. Ford agreed on condition that Yates would then green-light *The Quiet Man*.

Ford had taken a ten-dollar option on a Maurice Walsh short story, "The Quiet Man," which had first appeared in the *Saturday Evening Post* as part of a collection of related short stories released together in book form as *Green Rushes*, which became a bestseller. The stories were about the adventures of Paddy Brawn Enright, who was born in Kerry, spent his life in the United States, and returned to Ireland to live in retirement.[*]

In *Rio Grande*, O'Hara plays Kathleen Yorke, Lieutenant Yorke's estranged wife, who shows up after fifteen years to retrieve her son Jeff from what she sees

[*] Walsh was paid another $2,500 when Ford sold the idea to Republic in 1951, and $3,750 when the film finished production. Perhaps because he feared making a film that was too political, Ford eventually eliminated much of the part of the story that deals with the IRA's struggles.

as a certain early death at the hands of his father, Yorke, who had caused their breakup when, in anger, he burned their plantation down. As O'Hara later remembered, "For me, the most special part about making *Rio Grande* was that it was the first time that Duke and I worked together. We were very friendly, but not the closest of friends. The seeds of that deep friendship were planted on *Rio Grande* and grew naturally over time . . . we loved working with each other. From our very first scenes together, working with John Wayne was comfortable for me. We looked like a couple who belonged together. We both had an inner core of strength, and were both gutsy! Did I know we had that special erotic chemistry together that would be so magical on-screen while filming? No, I did not; neither of us did. There were no kinetic sparks from which to duck. But when we saw ourselves together on-screen for the first time—oh yes, we knew."

But what struck O'Hara most was the darkened mood that had overtaken Ford during production of the film. At least part of his frustration was vented on Wayne, in front of O'Hara, which embarrassed both of them. "Mr. Ford's vicious treatment of John Wayne . . . was extremely severe and cruel. It was horrible treatment, unlike anything I had ever seen. He repeatedly belittled and insulted him in front of the entire cast and crew. Duke would just stand there with his head lowered, hat in hand, while Mr. Ford tried to reduce Duke to a miniature version of the man he was. I kept silent . . . and had to excuse myself from the set so I could go to the bathroom and vomit . . . to me there was something noticeably different on this set, as compared to when I had made *How Green Was My Valley* ten years earlier. I could see that Mr. Ford himself had changed. While we were shooting *Rio Grande,* I clearly saw the darker side of John Ford, the mean and abusive side."

Ford's anger with Wayne may have been less about politics, Yates, and his acting than Ford's own attraction to O'Hara, for whom Ford had sexual feelings. As Wayne's son, Patrick, who had a small part in the film, later told Ron Davis, in his biography of the director, "Ford saw himself as my father. He saw himself as a Western character and identified strongly with that. Maureen O'Hara was the perfect mate for John Wayne and so was the perfect mate for John Ford." (Wayne, meanwhile, continued to have financial problems due to Chata's uncontrollable spending and under Bö Roos's guidance he had suffered a series of losing investments, including "John Wayne" comic books, a line of outdoor outfits for children, and oil wells in Kansas, Texas, Oklahoma, and Nebraska.)

RIO GRANDE RETURNED WAYNE TO the role of a romantic hero, something he hadn't played for several pictures, by pairing him with the woman who would become the most familiar female costar of his career, the beautiful red-haired Irish beauty Maureen O'Hara. She had been a member of the Ford acting company since her moving performance in Ford's towering *How Green Was My Valley* (1941), her eighth film and her first for Ford, for which he won an Oscar for Best Director, the film Best Picture (for Darryl Zanuck). As O'Hara later remembered, "It was to be the beginning of a deep and enduring friendship. We had such respect and love for one another and that continued to build throughout the years."*

Rio Grande was the only film Wayne made in 1951. And he had done it only as a favor to Ford, even though Wayne didn't want to work for Yates again. To get the film made, Wayne, strapped for cash, gave up his guaranteed $150,000 fee and 10 percent of the gross for a flat $100,000, and his costar, Maureen O'Hara, agreed to a $75,000 salary. It was the only way Yates would greenlight the film and Wayne wanted to help out Ford by getting it made.

Even though *Rio Grande* was a hit, Yates stalled on going ahead with *The Quiet Man*. The reason may have been that soon after *Rio Grande* opened, Ford's name and loyalty came under a deeper cloud of suspicion when the House Un-American Activities Committee members held a public debate about whether or not it had been the right thing for John Ford to have made such a leftist film as *The Grapes of Wrath*. Among those who most vociferously questioned the filmmaker's "loyalty" was a young congressman from California and HUAC member named Richard Milhous Nixon. Afterward, the imperious chairman of the HUAC, Parnell Thomas, said, "We'll take care of [all of] them when their turn comes."

Ford took that as a threat aimed directly at him. In response, the SDG's Veterans Committee wasted no time sending a stinging letter to Thomas and everyone on the committee, which said, in part,

* Wayne and O'Hara made five films together: *Rio Grande,* Ford's *The Quiet Man* (1952), Ford's *The Wings of Eagles* (1957), Andrew McLaglen's *McClintock!* (1963), and George Sherman's *Big Jake* (1971). O'Hara: "Once in a while a great thing happens in the film industry. A special chemistry between an actor and actress develops and 'it is magic.' Ginger Rogers and Fred Astaire, Myrna Loy and William Powell, Katharine Hepburn and Spencer Tracy, Julia Roberts and Richard Gere, and Maureen O'Hara and John Wayne . . ."—"Remembrance," *John Wayne, the Legend and the Man,* p. 122.

EVERY SIGNATORY OF THIS TELEGRAM IS AN AMERICAN
CITIZEN, OPPOSED TO COMMUNISM. MAKING MOTION
PICTURES IS OUR BUSINESS . . . WE DO NOT BELIEVE THE
CONSTITUTION INTENDED TO GIVE ANY EXECUTIVE,
LEGISLATIVE OR JUDICIAL BODY OF OUR GOVERNMENT
THE RIGHT TO SUBJECT THE GOOD NAME OF ANY CITIZEN
TO ATTACK WITHOUT PERMITTING HIM FULLY AND
FREELY TO DEFEND HIMSELF . . . IF THERE ARE TRAITORS
IN HOLLYWOOD OR ANYWHERE ELSE, LET THE FEDERAL
BUREAU OF INVESTIGATION POINT THEM OUT. LET THE
ATTORNEY GENERAL BRING THEM BEFORE THE COURTS.
BUT AS CITIZENS, LET THEM HAVE A FAIR TRIAL, PROTECTED
BY THE GUARANTEES OF THE CONSTITUTION. SUCH IS THE
BILL OF RIGHTS.

It was the strongest statement yet any organization in Hollywood had dared
to make against HUAC, and it challenged the very authority of the committee
and the Waldorf Statement.

At the same time, the FBI began what would become its phone-book-sized
secret file on Ford, noting his participation in "Communist Party front groups,"
including the Motion Picture Artists Committee and the John Steinbeck Com-
mittee for Agricultural Workers, and Ford's support of the Lincoln Brigade, all
of which took place prior to America's involvement in World War II. Notes in
his file also questioned the motives of his wartime documentaries, which some
in the bureau thought made America look less than fully prepared, and several
pages were dedicated to the making of *The Grapes of Wrath*. Even *Fort Apache*
came under scrutiny for its unflattering portrayal of a U.S. military officer. It
was Ford's membership in the MPA that likely saved him from having to come
before the wrath of the House Un-American Activities Committee.

On March 21, 1951, HUAC did call actor Larry Parks as an "unfriendly wit-
ness." Parks had shot to stardom in the '40s with his charming and immensely
popular portraits of singer and Broadway and movie star Al Jolson in Columbia
Pictures' 1946 musical (and fanciful) biopic, Alfred E. Green's *The Jolson Story*,
and its sequel, Henry Levin's 1949 *Jolson Sings Again,* both films released in
that brief postwar window when Jews could be portrayed as popular American

folk heroes. Curiously, despite the large number of studio heads who were Jewish, Jews were rarely portrayed on-screen. Parks's performances were considered breakthroughs. (Both James Cagney and Danny Thomas, two non-Jews, had turned down the role before it went to Parks.)

Parks was riding high until he was subpoenaed in 1951 (some speculated he was called because he had popularized a Jew on-screen). The committee loved going after big fish, because they were the names that brought the most attention and publicity to HUAC and fueled its self-importance. During his hearing, Parks tearfully pleaded with committee members not to make him testify, but when he was asked that most feared question, "Are you now or have you ever been a member of the Communist Party?" through his tears he answered yes, and then once again begged not to have to name the names of others who were fellow members. The committee forced him to, and he went into detail, naming names of other members who were there during his four-year membership.

His testimony took away his livelihood. He didn't work in film again for a decade, even though he was commended by HUAC for having been "very cooperative." Columbia Pictures canceled his contract and, except for a very few one-offs in TV series, he didn't make another movie until 1962, after the blacklist ended, when he played Dr. Breuer in John Huston's *Freud*.*

Wayne knew all about Parks and had personal reasons to celebrate the actor's unfortunate fate; *Jolson Sings Again* had edged out *Sands of Iwo Jima* at the box office, and *Jolson* was the second-highest-grossing film of 1949, *Iwo Jima* third. However, he had been uneasy about what was happening in Hollywood after what Ford had gone through post-DeMille, and did not like what had taken place with Parks. At a SAG meeting shortly afterward, when Parks begged the membership to let him keep working, Wayne said that it was "too bad that Larry had been a Communist, but damn courageous of him to admit it," and urged the thousand-plus members assembled at the Hollywood American Legion Hall to forgive the actor and let him go on earning his living: "Young Parks needs our moral support. He should be commended for being a good

* Parks starred in Stanley Donen's *Love Is Better Than Ever* in 1950, at MGM, opposite Elizabeth Taylor. The film was held back from release for three years, until Taylor used her star power to force them put it out. It had a very limited release and grossed under a million dollars. Parks returned to the big screen in John Huston's *Freud: The Secret Passion*, in 1962. He died in 1975 of a heart attack at the age of sixty, never able to regain the momentum or the stardom of his pre-HUAC-testimony years.

patriotic American," for doing his duty and ratting out his associates. "When any member of the Party breaks with them, we must welcome him back into American society. We should give him friendship and help him find work again in our industry."

And then Hedda Hopper spoke and crucified Parks, and Wayne too, indirectly, for having asked for forgiveness for the broken actor, by attacking Wayne's nonservice in the military. "I have read the papers," she told the assembly. "I have listened to the radio. And then I was shocked as I read the statement of our president, John Wayne . . . Parks read the best script of his career [before HUAC . . . Wayne] says he felt he'd done nothing wrong. I feel sorry for [the both of them]. And I'm wondering if the mothers and families of those who've died and the wounded who are still living will be happy to know their money at the box office has supported and may continue to support those who have been so late in the defense of their country." The audience leapt to its feet and enthusiastically applauded the columnist's speech.

Not long after Hopper's denouncement, Wayne issued a written statement that included the following: "It gives me a genuine feeling of satisfaction to have played a part in the tremendous job this industry does in creating entertainment on a scale no other medium can attempt. I like my job. I like the people I work with, and I have the highest respect for what the screen accomplishes, and what it stands for . . . We should express that pride in giving our best in the way of acting and technical performances, and in conducting ourselves as self-respecting members of a highly-respected industry. And if I sound like I'm on a soapbox, that's the way I feel about the movies."

Nonetheless, after Hopper's diatribe, Wayne's position as a leader of the conservative right was diminished. He was, thereafter, more of a figurehead than a player and as an act of self-preservation, every film he made now had a purposeful undertow that pulled the film's themes into the deep waters of patriotism and allegiance.

WAYNE REFUSED TO FACE THE fact that his marriage was all over but the very loud shouting that was still to come. Not long after *Rio Grande*'s release, when Louella O. Parsons interviewed him for her syndicated column he commented on Chata and her constant visits with her mother to Mexico, something Parsons and everyone else in Hollywood knew about, since Chata

was never with Wayne when he appeared at a function, and his excuse was always the same: she was in Mexico. "Esperanza is like every other person—man or woman. She thinks the doctors in her hometown are better," he told Parsons when she asked where Mrs. Wayne was. "She is highly nervous, and she needs medical attention, so she goes home to Mexico . . . she knows that John Ford and I enjoy discussing our pictures and that I love to hunt and fish . . . you know, that's a great woman. She understands me better than I understand myself. She knows that I am miserable when I am not working, and she never complains when I spend most of my time at the studio."

Chata, meanwhile, had a few gems of her own she wanted to share with the world. To *Time* magazine, she complained about her husband's single-mindedness, that he was "[o]ne of the few persons who is always interested in his business. He talks of it constantly. When he reads, it's scripts. Our dinner guests always talk business. And he spends all his time working, discussing work, or planning work." That much was true. Wayne got up at seven every day, had breakfast by himself, and left for the studio where he was working. Chata never arose before eleven.

The fact they didn't have children was something else that troubled her greatly. With a film career that never materialized, not being a mother left her without any real purpose in her life. Because of it whenever they did spend any significant time together, the tension between them was always high and aggravated her chronic case of hives and psoriasis.

They were on a collision course that would prove impossible for either of them to escape.

Chapter 16

In 1950, Wayne began work on Howard Hughes's *Jet Pilot,* a combination of a (very) loose adaptation of *Ninotchka*—the West seduces the East—and Hughes's far superior 1930 *Hell's Angels.* Josef von Sternberg, who had not made a film in over a decade, directed *Jet Pilot.*

The film starred Janet Leigh as a Russian pilot who lands in Alaska seeking asylum. Hughes, one of Hollywood's legendary womanizers, had a scene added to the Jules Furthman script (Furthman also produced) that had Lieutenant Anna Marladovna (Leigh) strip off her clothes and reveal her shapely body while being searched for concealed weapons, after which the reluctant Colonel Shannon (Wayne) is assigned to be her guardian. Somehow they wind up in Palm Springs, and Leigh is subsequently filmed in very Western-style negligees. She falls in love with Shannon and sheds her allegiance to Communism.

The only production problem with the film was the same old problem for Hughes: he couldn't finish. It was not a financial problem (obviously) but a psychological one; *Jet Pilot* had become his latest neurotic fetish, an anti-Communist piece of political propaganda, costarring Leigh's body and equally great aviation footage. He would to continue to play with this toy for years, until, with several additional aerial sequences shot and added, he eventually released it in 1957.

After filming the bulk of his scenes, Wayne returned to filming more Cold War propaganda, where the characters he played were less material and more

message-bearing. The opening credits to *Operation Pacific* included this line: "When the Pacific Fleet was destroyed by the Japanese sneak attack on Pearl Harbor, it remained for the submarines to carry the war to the enemy. In the four years that followed, our undersea craft sank six million tons of Japanese shipping including some of the proudest ships of the Imperial Navy. Fifty-two of our submarines and thirty-five hundred officers and men were lost. It is to these men and the entire silent service that this picture is humbly dedicated."

Operation Pacific is a World War II Pearl Harbor vengeance submarine drama, filmed on location in Hawaii and at the Warner Bros studio in Burbank, where a full-size replica of the submarine *Thunder* was reconstructed. The film was written and directed by George Waggner, produced by Louis Edelman, and costarred Wayne's buddy Ward Bond and the lovely Patricia Neal. The sophisticated Neal was, in real life, deeply in love with Gary Cooper, and perhaps that was one reason she did not get along at all with Wayne during production of a war picture in which Wayne gets to play action hero and broad-shouldered lover.

The film was made under the personal supervision of Jack Warner, with technical adviser Admiral Charles A. Lockwood, who had been the commander of submarine forces in the Pacific during World War II. With Korea heating up, World War II pictures once more became less complicated and more patriotic, the perfect propaganda machine, to stir up support for America's next conflict in Asia. With *Operation Pacific* Wayne began a new seven-year nonexclusive contract with Warner Bros at a minimum base salary of $175,000 per picture and an automatic $50,000 payment each time it was rereleased.

Released in January 1951, *Operation Pacific* was not well received by critics. *Time* magazine called it "[a] tiresome love versus duty romance . . . Actor Wayne's flinty authority as a man of action crumbles under the trite situations and dialogue ashore . . . what should be *Operation Pacific*'s strongest point proves its major disappointment: the action at sea." *Variety* liked it better, but not by much: "Marquee weight of John Wayne's name in the action field and other good selling points offset the rather formula conception and give it sturdy chances . . . Wayne registers with his usual punch." Audiences disagreed. Made for $1,465,000, the film grossed just under $9 million worldwide. Even with less than great material, Wayne was still box-office boffo, as *Variety* would say.

He then went directly into RKO Radio Pictures' *Flying Leathernecks*, pro-

duced by Howard Hughes and finished reasonably on time. It was shot in glorious Technicolor and released, while *Jet Pilot* remained trapped in the sociopathology of Hughes completion issues for another six years. *Flying Leathernecks* was directed by the very un-Hughes-like Nicholas Ray, the second of five straight films he'd make for Hughes, and who would, a few years later, gain new fame as the director of James Dean in 1955's *Rebel Without a Cause*.

Flying Leathernecks was shot at Camp Pendleton Marine Base and at the RKO-Pathé studios at a negative cost of just under $1.2 million and grossed nearly six times that. It was another financial hit in this burst of Wayne films that continued to feature him as a mythic military World War II hero who floats through them like a revisionist apparition, reinforcing his good-guy soldier image (in this film he is in charge of the battle against the Japanese at Guadalcanal). In 1951, for the second consecutive year, Wayne was voted the most popular star in Hollywood, according to the all-important *Motion Picture Herald* annual poll of exhibitors.

To get him to make this film, Hughes renegotiated Wayne's nonexclusive contract with RKO. Wayne asked for and received $300,000 (paid out at $1,000 a week) because Hughes wanted to keep making movies for him.* He was willing to do anything for him except produce Wayne's long-standing pet project, a film about the Alamo. In fact, not just RKO but no studio in Hollywood showed any interest in Wayne's pet project, even with him producing and directing as well as starring in it.

JOHN FORD, MEANWHILE, HAD MADE *Wagon Master* (1950) with Ward Bond and Ben Johnson, which failed at the box office and ended Argosy's relationship with RKO. Ford had wanted Wayne for the film, but knew that he was not eager to return to the fold after the throttling he had taken from the director during *She Wore a Yellow Ribbon*. Even when Ford managed to sign Maureen O'Hara to be in it, Wayne wouldn't bite.

Ford then set out on a public path of reconciliation. He wrote an usually laudatory piece about Wayne for the popular movie magazine *Photoplay,* after he'd agreed to accompany him to Reno, Nevada, to take part in the festivities for "John Wayne Day," during which the star received that city's annual award—

* The salary was actually $301,000, the extra dollar insisted upon by the eccentric Howard Hughes and which made it Wayne's highest salary for a picture.

"Best Western Performance of the Year"—for *She Wore a Yellow Ribbon*. Ford's piece for *Photoplay* amounted to nothing less than a public apology, in the form of a ghostwritten love letter that appeared in the magazine that March, in which "Ford" declared: "I can't think of a better time than now—when Duke Wayne is sitting on the top of the heap—to say that he's my boy. Always has been; always will be." After recapping his own (rightful) importance in Wayne's career, Ford then declared, "In all of the adventure films which he has made for me . . . Duke's power as a man has contributed immeasurably to the integrity of those films . . . I don't believe there is an honor, a testimonial, or an award which Duke cannot bear in good grace, and like the true gentleman that he is beneath the roughneck exterior. Years ago, just before we made *Stagecoach*, I told Duke that he had a great future ahead of him. If it were not already so obvious, I would tell him the same thing today."

Much to Ford's relief, after the article appeared, Wayne agreed to work with him again, and, in 1952, Republic resurrected the "Irish" project that had sat it felt like forever on Ford's desk. Yates was looking for a sophisticated script that would help save his studio from being forced out of business by the TV monster that was slowly devouring viewers' attention and money. Yates was now open to making *The Quiet Man* because he believed there was nothing else like it on the *I Love Lucy*–dominated airwaves, and thought it might attract a large theatrical audience.

TO MAKE *THE QUIET MAN*, the 123rd film of Wayne's career, Yates gave Ford a $1.4 million budget (Ford had wanted $1.75 million, but Yates would not go that high).* Wayne agreed to make the picture to help out Ford's career. Even if it failed, which everyone associated with it except Ford expected it to do, Wayne believed it wouldn't hurt his career. As Ward Bond, also in the movie, put it, "There is no other actor than Duke who ever survived so many bad pictures."

Production began in June 1951, on location in Ireland, and after six weeks

* To get the picture made, Wayne had to take a pay cut and accept $100,000 and no percentages. Yates was hoping he could get Robert Ryan, a former boxer, to play the lead in the film for less money than he would have to pay Wayne. Ford, however, wanted only Wayne, whose star power, he believed, was far stronger than Ryan's and would help fill seats in theaters. Maureen O'Hara, the female lead, was paid $75,000.

filming was completed in July in Hollywood, nearly half the film made on Republic Studios' main lot. This was the only Republic picture ever shot in Technicolor (rather than the studio's own Trucolor, which did not compare in quality, and whose prints tended to quickly fade to a purple tint).

Yates, who was present for the duration, often and loudly complained to Ford about every aspect of the production, beginning with its title. He wanted Ford to change it to *The Fighter and the Colleen*. Ford said no. Yates complained after viewing the dailies that the film looked too "green." Ford ignored him. The location cinematographer, Winton C. Hoch, would go on to win an Oscar.

IT WASN'T ONLY AS A favor to Ford that Wayne agreed to make the picture. He was desperate to get out of town. The tension between him and Chata had become unbearable and he also wanted to be away from horses and uniforms for a while and give himself time to formulate a new plan of attack for his stalled Alamo project. As he told one interviewer: "I want to get out of the saddle and away from the uniform. When I do *The Quiet Man* for John Ford in Ireland that will be different. I [will] play a prize-fighter who has killed a man in the ring and doesn't want to fight anymore. He becomes involved in a fight when he goes to Ireland, a fight that goes on in field, town, pub, and everywhere else. The fighters go in and have drinks and start fighting all over again. That should be a riot, as Ford will do it. I like the idea of the comedy possibilities." It also gave him opportunity to work again with his favorite co-star, Maureen O'Hara.

At the last minute, Chata—who was jealous of all Wayne's leading ladies, but especially O'Hara, who she believed wanted to steal Wayne away from her—decided to take herself and Wayne's four kids, Michael, Patrick, Toni, and Melinda, to Ireland for the duration of the shoot. She knew he wouldn't say no to her if his children came along (they appear in one scene sitting in a car during the Innisfree horse race). She was right, he couldn't, but he was not at all happy about the situation.

The Quiet Man, with all its boozy Irish sentimentality, was about aging. Ford was fifty-five when he made it; Wayne, forty-four. Both looked older than their years, prematurely aged by sailing in the sun, alcohol, the pressures of the film business, and difficult marriages. *The Quiet Man* was certainly Ford's most personal, if not the best film of his career. Wayne's character's name is Sean

Thornton (Sean is the Irish version of John). The action is set in the fictitious village of Innisfree, the name inspired by a Yeats poem.

The Quiet Man, despite its comic fistfight climax, is not a violent film, or a somber one. It is, essentially, a love story between Sean, who has come home to the land where he was born, and Mary Kate (O'Hara), whom he falls in love with. Sean soon runs into trouble with her brother, Red Will (Victor McLaglen), when he refuses to pay his sister's dowry. Mary Kate takes her anger out on Sean—no dowry means no lovemaking. Sean is humiliated by Kate's refusal to let him sleep in her bed and the whole town knowing it, and that leads to the big fistfight, the "final shoot-out" that settles everything.

During production, it was widely rumored that Ford and O'Hara were continuing their supposed love affair that had begun during *She Wore a Yellow Ribbon,* and that when they had a lovers' quarrel it interrupted shooting for a few days. O'Hara disputes this in her memoir, saying that Ford had lapsed into a depression during the film and that was the real reason the production stalled. Her version sounds truer. Ford stayed in bed during the stoppage, surrounded by O'Hara, Wayne, and Bond, begging them to not let him get drunk again.

She also denies another, more prevalent rumor that had spread throughout Hollywood, that despite the presence of his wife and children, she was having an affair with Wayne: "Duke and I were never involved romantically. We were never lovers . . . I never saw the Duke with his boots off . . . while we were shooting *The Quiet Man,* a story was released in the United States that Duke and I were fooling around on the set . . . the article said an anonymous source present on the set provided the details. I was furious and stormed into John Ford's office, demanding to know, 'Who would do such a terrible thing?' The old man answered without a blink, 'I did. It'll sell more tickets.'"

AFTER A SLOW START, THE film began to gather steam toward its two most famous love scenes, the first of which was shot in the rain in the cemetery. Thunder frightens Mary Kate and she runs under an arch. Sean takes off his coat and wraps it around her. Then they kiss. O'Hara: "I was the only leading lady big enough and tough enough for John Wayne. Duke's presence was so strong that when audiences saw him finally meet a woman of equal hell and fire, it was exciting and thrilling . . . so during those moments of tenderness,

when the lovemaking was about to begin, audiences saw for a half second that he had finally tamed me—but only for that half second."

The second was the windblown embrace during which Wayne passionately kisses O'Hara after which she slaps him (it was actually filmed on a soundstage in Hollywood using two airplane propellers to create the dramatic wind that blows open the door). It was the most romantic scene Wayne ever filmed.

When Ford delivered his final cut of 129 minutes, Yates blew a gasket. He had instructed Ford to keep it under two hours, to ensure two showings a night in theaters. At one of the first screenings of the film, just as the fistfight was about to begin, the screen went white. Yates jumped up and ran to the projection room to see what the problem was. No problem, Ford said, who was standing next to the projector with a pair of scissors. Ford told Yates he had cut the last twenty-nine minutes to bring the film down to the studio head's limit.

The fight footage was restored, and the film released at 129 minutes.

BACK HOME, WAYNE TOOK CHATA away for a quick vacation to Acapulco, and as soon as they unpacked their bags, they began to fight. Chata left before Wayne did, and when he returned to Los Angeles, Chata told him she wanted a divorce. An angry Wayne agreed to a first-step formal separation. They chose their sixth anniversary to make the announcement to the public. "We had a disagreement," Wayne told reporters. "She consulted well-known divorce-attorney-to-the-stars Jerry Giesler, but after when I came home and talked to her, I thought everything would be straightened out. I still hope and believe that it will be." A contrite Wayne added, "I blame myself for our troubles. I devoted too much time to business and not enough to making a home for Esperanza and me."

But everyone close to the couple knew the real reason the marriage was failing was the constant and, to Wayne, unbearable presence of Chata's mother, who was once again living with them. He was fed up with having her around the house. Not long after they announced their separation, trying to reconcile, Wayne met with Chata and told her, "Choose between your mother and me." This time Chata chose her mother.

A month later, Wayne announced that he and Chata had reconciled. It happened when Wayne had gone to San Francisco on business and injured his left

ear. He claimed he had fallen off a chair. Wayne came home and into Chata's bed. He forgave her, she forgave him, she cared for his ear, he nibbled hers, and all was peaceful again, but only for a few days. They erupted over something neither one could remember, and within days both consulted their lawyers.

That same week in January 1952, Wayne was again named as the most popular actor in movies.

ON MARCH 3, 1952, *TIME* magazine put him on the cover, in suit and tie, floating around his head drawings of cowboys, Monument Valley, and a giant cash register. The headline under Wayne's image had a double meaning, the conservative weekly acknowledging Wayne's abilities as an actor, and his reputation as a force behind the ongoing blacklist: *Let the bad 'uns beware.*

Inside, the writing could not have been more effusive: "To millions of moviegoers and televiewers, in whose private lives good & evil often were dreary, inconclusive little wars, John Wayne is as reassuring as George Washington's face on a series E bond . . ." To explain this, the magazine coyly critiqued what it was about Wayne that made him such a granite symbol of America by pointing out what he wasn't: "Why does the U.S. public like him better than Betty Grable, Bing Crosby or Martin and Lewis? His legs are not as pretty as Betty's; his voice is not as sweet as Bing's; he is nowhere near as funny as Martin & Lewis. And he is not the best of Hollywood's actors. In fact, it is an open question whether he can act at all."

After, when asked about *Time's* description of his abilities, Wayne repeated his familiar refrain: "How often do I gotta tell you guys that I don't act at all—I re-act." He insisted that was what always saved him: "If it's a bad scene, the loudmouth gets the blame. I like basic emotion stuff. Nuances are out of my line. If I start acting phony on the screen, you start looking at me instead of feeling with me. When I do a scene, I want to react as John Wayne." Later on, he added sincerity as a reason for his success as an actor: "I got nothin' to sell but sincerity, and I been sellin' it like the blazes ever since I started."

THE QUIET MAN PREMIERED ON July 21, 1952, to mixed reviews—the *New York Times* dismissed it as a "carefree fable of Irish charm and perversity." *The New Yorker,* which had never had much use for Ford's films, said it

looked as if the director "had fallen into a vat of treacle"—and great box-office sales, grossing $3.2 million in its initial domestic release, and nearly twice that internationally. It undersored Wayne's enduring popularity with the public and helped remove some but not all of the political tarnish that had settled on Ford's once golden career.

THE 1952 ACADEMY AWARDS CEREMONY was held March 19, 1953, at the RKO Pantages Theater in Hollywood and at NBC's Century Theatre in New York City, where part of the NBC telecast came from. Bob Hope was the host in Los Angeles, Conrad Nagel in New York. *The Quiet Man* was nominated for seven Oscars, including John Ford (Best Director), Best Picture—John Ford, Merian C. Cooper, and Republic, the first Best Picture nomination in Republic's history—Hoch and Archie Stout for Best Cinematography, Victor McLaglen (Best Supporting Actor), Best Art Direction (Frank Hotaling, John McCarthy Jr., Charles S. Thompson), Best Sound (Republic Sound/Daniel Bloomberg), and Best Adapted Screenplay (Frank Nugent). Notably absent from the list were John Wayne for Best Actor and Maureen O'Hara for Best Actress.*

That made it an especially galling night for Wayne, who had agreed to accept either or both the awards for John Ford if he won, after he told Wayne he either didn't feel well enough to attend (or simply couldn't stand to sit through the ceremonies; he never liked the idea of competitive awards for films). Wayne had been incensed over the Best Actor nominations, not just because he wasn't included in the list, but because Gary Cooper was, for *High Noon,* a film Wayne detested on every level—cinematic, political, script, story, theme, direction. What made it worse was that it was a role Wayne had turned down before it went to Cooper, the other tall, strong, good-looking, conservative Hollywood all-American screen hero who spoke softly in his movies and carried a big gun.

* Best Picture went to *The Greatest Show on Earth,* produced and directed by Cecil B. DeMille. Gary Cooper won Best Actor for Fred Zinnemann's *High Noon.* Shirley Booth won Best Actress for Daniel Mann's *Come Back, Little Sheba.* Best Supporting Actor went to Anthony Quinn in Elia Kazan's *Viva Zapata!* Best Screenplay went to Charles Schnee for Vincente Minnelli's *The Bad and the Beautiful.* Best Color Art Direction to Paul Sheriff and Marcel Vertes for John Huston's *Moulin Rouge.* Best Sound Recording to London Films Sound Department for David Lean's *Breaking the Sound Barrier.* Best Director went to Ford.

COOPER'S NOMINATION WAS THE CULMINATION of their long-time professional rivalry, which through the years had included women (Dietrich) and films (*The Virginian, The Big Trail,* and especially *High Noon*). Wayne was plainly furious that this film was so lauded by audiences and critics alike. Here is what Wayne said about *High Noon* (and *All the King's Men*), two decades after the fact, the smoke still visible coming off his heated words: "I knew two fellas who really did things that were detrimental to our way of life. One of them was Carl Foreman, the guy who wrote the screenplay for *High Noon,* and the other was Robert Rossen, the one who made the picture about Huey Long, *All the King's Men* . . . *High Noon* was even worse. Everybody says *High Noon* is a great picture because [Dmitri] Tiomkin wrote some great music for it and because Gary Cooper and Grace Kelly were in it. So it's got everything going for it. In that picture, four guys come in to gun down the sheriff. He goes to the church and asks for help and the guys go, 'Oh well, oh gee.' And the women stand up and say, 'You're rats. You're rats.' So Cooper goes out alone. It's the most un-American thing I've ever seen in my whole life. That last thing in the picture is ole Coop putting the United States marshal's badge under his foot and stepping on it. I'll never regret having helped run Foreman out of this country . . ."*

* According to Foreman, he fled to England before the film came out, because he was afraid of being sent to jail, like the other writers, the infamous "Hollywood Ten," when he could find no support for Stanley Kramer's leaving off Foreman's name as one of the producers and thereby denying him his Best Picture Oscar: "My associates were afraid for themselves—I don't blame them—and tried to get me off the film, unsuccessfully. They went to Gary Cooper and he refused [to go along with them] . . . There are scenes in the film that are taken from life. The scene in the church is a distillation of meetings I had with partners, associates and lawyers. And there's the scene with the man who offers to help and comes back with his gun and asks, 'Where are the others?' and Cooper says, 'There are no others . . . I became the Cooper character.'" Cooper was not Kramer's original choice to play Will Kane. He wanted Brando or Clift, but they turned him down and he went to Cooper. "When Foreman, a former member of the Communist Party, was called before HUAC in 1951 while still writing the script for *High Noon,* he declined to name names and was thereafter considered an 'uncooperative witness' by the HUAC, despite Kramer's urging him to do so. Kramer then tried to have the studio remove Foreman from the production until Zinnemann, Cooper, and others stepped in and insisted Foreman's name be retained as writer. He was eventually blacklisted after Harry Cohn of Columbia, the studio that made the film, refused to stand by Foreman. John Wayne's only direct involvement was that he was the head of the MPA, which chose not to defend Foreman after he was blacklisted."—Anthony Holden's *Behind the Oscar,* p. 201.

However, three years later, in 1974, in an interview he gave to BBC4, when asked about his participation in the blacklist, Wayne said this: "We were not blacklisting . . . we didn't name anybody. We stayed completely out of it and said 'We are Americans. If anybody wants to join us, that's fine. We gave no names out to anybody at any time, ever . . . the radical Liberals were going to take over our industry . . . Larry Parks admitted to being a Commie and went on working."

Either way, no one ever said *High Noon* was great only because of the Tiomkin score (which *was* great) and the catchy, compelling plotline theme song sung by Tex Ritter, the winner of the Oscar for Best Song, any more than they praised John Ford's stylish use of American western folk music and the Sons of the Pioneers, who sang many of them in his films. The "guys" in the church don't go "Oh well, oh gee." What they do debate is whether or not a gunfight will be good for the town's future, while the "folks up north" were watching. As for Cooper stepping on the badge, no one, including Wayne, objected when Clint Eastwood did it at the end of Don Siegel's 1971 *Dirty Harry*. Callahan was hailed as a hero for rejecting the hypocrisy of the system, essentially the same hypocrisy that prevents the town from helping Will Kane.

Wayne's vision was clearly blinded as much by professional jealousy as personal politics. Besides, the film shared several storytelling aspects with *Stagecoach*. Both the Ringo Kid and Kane are tall, lean, tough, and as soft-spoken. Both come up against ruthless villains to settle old debts. Both have women who try to stop them from going through with the showdown—Claire Trevor the reformed prostitute in *Stagecoach*, Grace Kelly the virginal Quaker in *High Noon*. And both end the movie on a horse and buggy to ride their way into a future made better by having settled the moral bills of their past. And, oddly enough, both Wayne and Cooper were real-life lovers of Marlene Dietrich (which might account for some of Wayne's fury at losing out to Cooper).

The differences between the two films are mostly stylistic. Ben Hecht and Dudley Nichols's script is every bit as good as Carl Foreman's, perhaps better, certainly with a greater scope. And Ford's direction of Wayne charges the performance as he surrounds his actor with the grandeur of the Old West, often putting his camera at eye level or above Wayne, to place him in the context of the film's mise-en-scène, and to underscore Ford's invisible godlike supe-

riority over his visible, mortal star. Ford's camera looks down on Wayne, in a sense, diminishing him, keeping him human. Wayne's youth is what makes his performance so poignant against the backdrop of the millennia of Monument Valley. Zinnemann shot Cooper mostly from below, to give him a stature that strengthens him and evens the playing field against the Miller gang. Youth is Ford's strength in *Stagecoach*; age drives the tension in Zinnemann's *High Noon*.

Finally, *High Noon*'s lasting popularity is because of its cinematic qualities, not its political ones. It is a statement of personal bravery, a man defending himself against a gang of vengeful killers. It is, at its core, a conventional, if complex love story that ties together Kane, his wife (Grace Kelly, making a showing in her second film), his former lover Helen Ramirez (Katy Jurado), the leader of the gang looking for revenge, Frank Miller (Ian Macdonald), and Kane's deputy (Lloyd Bridges). The concept of shooting the film in 124 continuous minutes of so-called real time, to increase the drama leading up to the climactic shootout, the editing techniques—all those clocks ticking as time runs out, the arrival of the train, one woman staying on it, one getting off, the action of the Miller gang, and the final, nearly silent twenty-minute final shootout—were all held together by Foreman's original script.

There was a reason *High Noon* was so popular; it was a great film.

LATE INTO THE EVENING OF the awards, presenter Olivia de Havilland presented the Best Director Oscar. John Ford won it and an elated John Wayne accepted it for him. He concluded his brief statement by reminding the audience that Ford was still, in his opinion, the best director in Hollywood and fully deserved the award: "Ford will place this Oscar on his mantel with his five other Academy Awards."

Not long after, Janet Gaynor presented the Best Actor Award to . . . Gary Cooper. Showing a bit of humor and looking to mete out a fair dose of humility, when Cooper knew he couldn't be there he, too, had asked Wayne to accept for him. Wayne graciously agreed. Now, holding Cooper's Oscar in his hand, said into the microphone, "I'm glad to see they're giving this to a man who has conducted himself throughout his years in this business in a manner that we can all be proud of him." After the applause died down, he good-naturedly ribbed the film's success: "And now, I'm going to go back and find my business manager, agent, producer . . . and find out why I didn't get *High*

Noon . . . since I can't fire any of these very expensive fellas, I can at least run my 1930 Chevrolet into one of their big black new Cadillacs."

Wayne left the stage to easy laughter and loud applause. Bob Hope, who had been displaced by Wayne as the most popular actor in America, came out and commented, in his typically dry pseudo-ironic and self-deprecating fashion, "He gets pretty big laughs for a leading man!"

ON JUNE 18, 1952, THE same week that a smiling Wayne appeared on the cover of *Newsweek* with an equally radiant Betty Grable, the top male and female movie stars in Hollywood, the next fragile reconciliation that had held together his marriage to Chata collapsed once again. Not long after Chata let herself be seen having dinner and drinks in nightclubs all along Sunset Boulevard with Palm Spring native Quay Sergeant, who she always maintained was just a friend, Chata and her mother returned to Mexico and refused to have any further contact with Wayne.

Louella Parsons broke the story of the Waynes' latest split in her nationally syndicated column and gave this rather incoherent reason for the breakup: "I happen to know the real reason behind the rift. Mrs. Wayne is desperately jealous of John's devotion to his four children by a previous marriage. Chata's first annoyance started when John wanted to fly home from Honolulu [where they were on vacation] for [his son] Michael's graduation from Loyola High School." Without a shred of evidence or affirming comment from Josephine, Parsons then suggested that Wayne's first wife, Josephine, who had never remarried, was looking to get back together with her ex-husband.

Wayne then heard that Chata was in the hospital to treat a minor respiratory ailment and he thought it might be a good idea to visit her and see if they could reconcile. Accompanied by Beverly Barnett, his press agent, Wayne flew down to Mexico.

According to one eyewitness, "Wayne went into his wife's room and Barnett remained outside the door. Wayne was inside for a long time. Barnett then opened the door to remind his boss of another appointment. Wayne went crazy. It seems he'd almost talked his wife into a reconciliation, which he badly wanted, but when she saw Barnett she concluded Wayne had been so sure of success that he'd stationed his press agent outside so as to lose no time in announcing the reconciliation to the columnists."

According to another witness, "Mrs. Wayne declared there was no chance of getting back together. Outside the room, Wayne behaved like a wild man. He flailed his arms and shouted for Barnett to keep his distance . . . Barnett went to a telephone booth to call a cab. Wayne went on raving."

THAT AUGUST 1952, JUST BEFORE the preliminary hearing for their divorce trial was scheduled to begin, the forty-five-year-old Wayne returned to filmmaking, to put some cash in his pocket to pay his legal fees and to reinforce his image as the nation's number-one Commie fighter. The first project was one he had wanted to do for a while, *Big Jim McLain,* directed by Edwin Ludwig (*The Fighting Seabees*), produced by Wayne-Fellows, and distributed by Warner Bros.

In this quickie, along with James Arness, a Wayne discovery, two enforcers track down "Operation Pineapple" in Hawaii, where "Commies" are up to no good, in league with some local doctors. One of them, Dr. Gelster, happens to have a young and beautiful assistant, played by Nancy Olsen, who provides whatever romantic subplot may be uncovered by viewers (more hidden than the actions the Commies are plotting). At the film's climax, there is a knock-down, drag-out fistfight, after which Wayne and Arness watch helplessly as the suspects invoke "The Fifth," a not-so-subtle reference to the HUAC hearings, making the dubious point that anyone who refused to cooperate on constitutional grounds was a Communist. The film was a hack production with a political message audiences were growing weary of being hit over the head with. Its characters, both good and bad, were clichés, with lots of name-calling, and no real assessment of a conflict, or solution. It is one of the more ludicrous films made about one of the darkest periods in American history.

Big Jim McLain did just okay at the box office, while being savaged by the critics. Bosley Crowther in the *New York Times* wrote, "Mr. Wayne is rugged and genial . . . but the over-all mixing of cheap fiction with contemporary crisis in American life is irresponsible and unforgivable. No one deserves credit for this film." *Time* magazine said, "the film has some pleasingly authentic Hawaiian background, but the action in the foreground is implausible and fumblingly filmed. Leathery John Wayne lopes through all the mayhem with the expression of a sad and friendly hound."

Wayne as usual had no comment about the critics' opinions of his film,

except to say: "I have been described by newspaper writers as a man with a leathery skin and blue eyes, like a sad and friendly hound. I do not know if this is a compliment. I am fond of dogs."

Wayne was paid $150,000 for *Big Jim McLain* from Wayne-Fellows, which had spent $826,000 to make it. To finance the film, Warner Bros got 30 percent of the gross before anything went to Wayne-Fellows, which meant that the studio made its money back first. The film grossed about $2.5 million in its first international release, and after promotion, fees, and other costs, it barely made its money back. It ranked twenty-seventh on the list of top moneymakers of 1952, a year that saw fewer studio films made than any other since the end of World War II. It did provide a valuable lesson to Wayne about this new decade of moviemaking: films that overtly preached politics were less effective than those that entertainingly illustrated the American way of life. Americana trumped American. It was a lesson he would not forget.

His next film, *Trouble Along the Way* (a.k.a. *Alma Mater*), had no political message, either explicit or implied. Warner's best resident director, Michael Curtiz, helmed it. Yet another college football saga, this one concerned the fate of St. Anthony's, in dire financial straits when it hires ex-college coach Steve Williams (Wayne), whose career has been ruined by gambling, to put together a winning team for the school. Williams reluctantly takes the position to show he has a steady job and sufficient income to retain custody of his eleven-year-old daughter. Donna Reed played the sympathetic caseworker who helps Wayne get the job. When the film was released in 1953, it did fairly well at the box office, but no one mistook it for Academy Award material. It was commercial product, pure and simple. There is one bit of trivia about this film that makes it memorable for reasons having nothing to do with the production. A new young actor out of New York live TV has a small, uncredited role, an extra in a scene that takes place in a chapel. His name was James Dean.

TROUBLE HAD WRAPPED IN 1952, and anticipating a difficult divorce trial, on the advice of friends, the forty-five-year-old Wayne decided to take a break from everything, to clear his head and recharge his batteries. He turned down John Ford, who wanted him to star in *The Long Gray Line* opposite Maureen O'Hara. The role went to Tyrone Power. Instead, Wayne flew down to Peru, the trip paid for by Howard Hughes under the guise of a working

vacation. Hughes supplied his personal plane for transportation and a hotel room for Wayne and one for Hughes's friend and adviser, Ernie Saftig, his job to make sure Wayne had everything on the trip he needed. Hughes, who never did anything without some sort of string attached, wanted Wayne to star in *The Conquerors* for RKO. He hinted at the possibility of producing *The Alamo* as part of a special two-picture deal. Hughes told Wayne that if he was up to it he should scout some locations for *The Alamo* while in Peru, even though there was no actual deal set for the film.

WAYNE AND SAFTIG WERE MET at the airport by Richard Weldy, an Irishman who occasionally conducted safaris up the Amazon. Hughes had hired him to accompany the two and to see to it they both had a good time.

During dinner one night at the 91 club, a popular local restaurant, Wayne, Saftig, and Weldy got into a fight with a couple of locals who had been drinking and began making loud, unpleasant comments about Wayne, that he was "an *Americano*" and *Americanos* were not welcome in Peru. Just like in one of his movies, chairs flew, tables were overturned, and the three visitors got away just before the police arrived. On the way out the door, Wayne threw some cash at the owner to cover any damages. Weldy then suggested they all get out of town for a while. He knew of a film shooting in the jungle near Tingo Maria and volunteered to fly them all there.

The film was *Green Hell,* which happened to be starring Weldy's estranged wife, twenty-three-year-old actress Pilar Pallete, a popular Peruvian movie actress. Weldy was hoping his wife seeing him with John Wayne might somehow make her want to rethink their separation. The Peruvian movie star wondered what all the fuss was about when it was announced he was visiting the set. That afternoon, after filming a particularly sensual dance scene, she was formally introduced to the American movie star. As she later wrote in her memoir, "I was making a movie in the beautiful jungles in the Amazon, and the director told me John Wayne was here and he wanted to see us work. Well, I'd heard the name, and knew that he was a big movie star, but I couldn't quite place him. Trying to be very sophisticated, I told him that he was wonderful in *For Whom the Bells Toll.* He said, you have me completely confused. You're thinking of my friend Gary Cooper. I started laughing, so did he and that broke the ice . . . I had never been so immediately and powerfully affected by a casual meeting

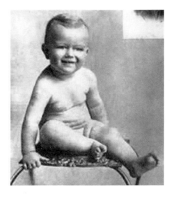

Marion Morrison as a baby.

Marion Morrison, USC football star.

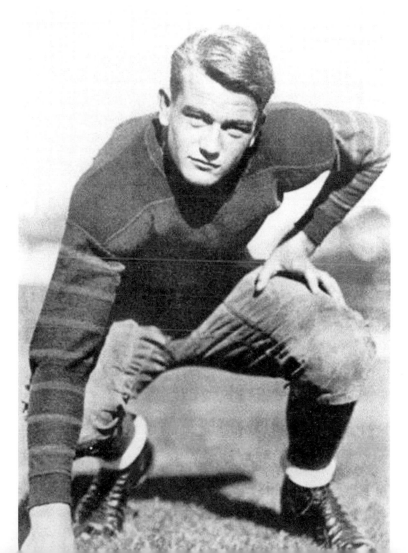

Two early studio publicity photos of young Marion Morrison (one autographed as
"John Wayne"—the autograph added later by Wayne), star of a series of "B" college-
football films, a popular genre at the time. Morrison failed to connect with the public
through these films, most of them made before he changed to a "B" "cowboy."

(Rebel Road Archives)

Morrison's "B" cowboy
movie character, whom
audiences would more
readily accept.

(Rebel Road Archives)

A rare studio PR photo as a generic cowboy good guy, before he had his teeth fixed by the studio.

(Rebel Road Archives)

Harry Carey, John Ford's silent-film cowboy star, after whom Wayne modeled his own cowboy screen image. Wayne paid tribute to Carey at the end of *The Searchers* by grabbing one arm with the other hand, a familiar Carey gesture.

John Wayne marries the Catholic Josephine Alicia Saenz, June 24, 1933, despite the strong reservations of her father about Wayne's being a Presbyterian and a struggling actor. They were married in Wayne's actress friend Loretta Young's garden (Young is standing next to Josephine).

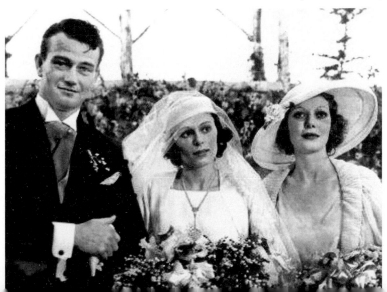

Wayne's first film after *The Big Trail*, Seymour Felix's collegiate comedy, *Girls Demand Excitement*, co-starring Virginia Cherrill (in his arms).

(Rebel Road Archives)

Wayne was in all twelve chapters of *The Three Musketeers* serial. It was released in 1933, along with eleven other "B" features in which he appeared.

(Rebel Road Archives)

Mack V. Wright's *Haunted Gold*, co-starring Wayne and Sheila Terry (Wright also acted in it) was a remake of Ken Maynard's 1926 silent *The Phantom City*. It was Wayne's thirty-sixth film, the seventh of seven films he made in 1932.

(Rebel Road Archives)

The Man from Monterey, Wayne's forty-fourth feature, directed by Mack V. Wright. A Warner Production, it proved a big hit. It was made for $28,000 and earned $175,000 in worldwide profits. It even had a one-day run at the then prestigious Loew's New York theater in 1933.

(Rebel Road Archives)

John Ford's 1939 *Stagecoach*, Wayne's eighty-second feature, similar in plot to *The Big Trail* but vastly superior. It was the picture that finally made Wayne a star.

(Rebel Road Archives)

With Claire Trevor, the Ringo Kid's love interest. Her name appears above Wayne's (first position) in the ensemble cast credit role that followed the opening title.

(Rebel Road Archives)

Wayne as the iconic Ringo Kid.

(Rebel Road Archives)

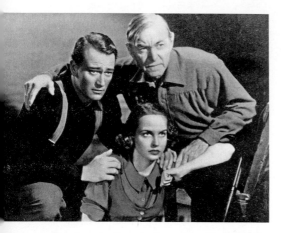

Based on the immensely popular Harold Bell Wright novel, the film, Wayne's ninety-fourth, made at Paramount, marked Harry Carey's thirty-third year making movies, and the first time Wayne appeared together with his idol on camera. Wayne with Carey, and Betty Field.

(Rebel Road Archives)

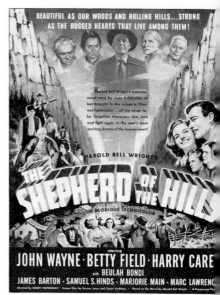

1941's *The Shepherd of the Hills*—the first of six films Wayne starred in that were directed by Henry Hathaway, and his first in color. He was cast as Matt Matthews after the studio tried and failed to get Tyrone Power, John Garfield, Robert Preston, Burgess Meredith, and Lynne Overman to play it.

Pittsburgh, a 1942 Universal Picture directed by Lewis Seiler, veteran of silent films and "B" westerns. The film was produced by Wayne's close friend and longtime agent Charles K. Feldman. It was Wayne's hundredth feature, for which he was paid $50,000. His co-star, Marlene Dietrich, was top-billed and received twice that amount. She also began a blazing sexual affair with Wayne that lasted for more than two years before she coldly dumped him.

(Rebel Road Archives)

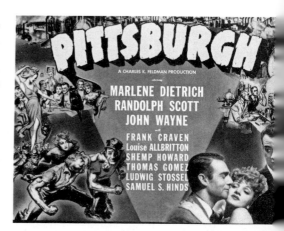

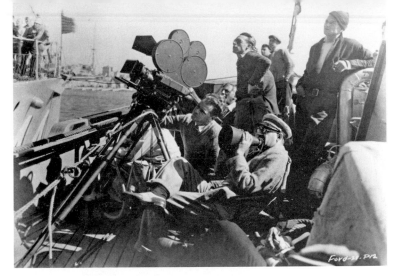

Wayne on set, standing behind mentor John Ford during the making of *They Were Expendable*, Wayne's 108th film. Ford had recently returned from service in the war, while Wayne stayed behind and made movies. Ford gave Wayne's co-star, Robert Montgomery, an MGM star, first position in the credits (the film was made for MGM, where he was one of their biggest stars, while Wayne was on loan-out from Republic).

Wayne's 111th feature, 1947's *Angel and the Badman*, was produced by Wayne himself and co-starred Gail Russell. Wayne had wanted Gary Cooper to play the lead. When Cooper turned it down, Wayne offered it to Randolph Scott, who also declined. He then took the role himself and it proved a big hit for him at the box office.

(Rebel Road Archives)

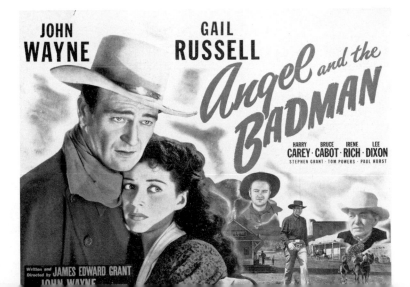

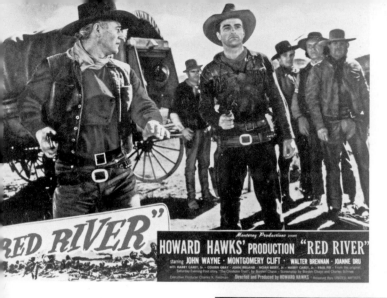

Hawks's classic *Red River* deepened Wayne's appeal by allowing him to play an older character and a villain. It was Wayne's 114th released film, made in 1946 but not released until 1948. Before production began, Wayne was concerned his co-star, Montgomery Clift, was too small for the climactic fistfight between the two.

A publicity photo released by Paramount Pictures after *Red River* to remind people Wayne was not really old. This is an image Wayne rarely projected onscreen—urban, intellectual, thoughtful.

Wayne's 114th release, *Fort Apache*, co-starred Henry Fonda in John Ford's fictionalized version of the battle at Little Big Horn. Ford liked Wayne's performance in *Red River* and wanted him to "age" in this film as well. *Fort Apache* (made two years after *Red River*, but released before it) was a massive box-office hit, despite war veteran Fonda's emerging "gray-listing" that would keep him out of features for several years.

Wayne with his second wife, Esperanza Baur. They had a tumultuous marriage that began in 1946 and ended in 1954 with a front-page scandal of a divorce.

Wayne and his wife Peruvian actress Pilar Pallete, leaving for Los Angeles just after being married in Hawaii. It was Wayne's third marriage, Pallete's second. Wayne, at forty-seven, was twenty-nine years older than his bride. They married November 4, 1954, the same day his divorce became final from his second wife. All three of Wayne's wives were Latin.

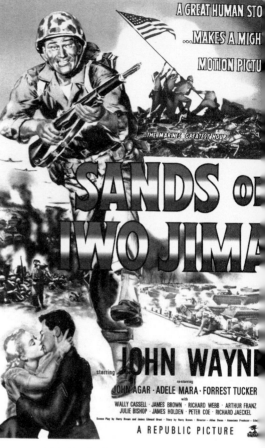

1949's *Sands of Iwo Jima*, directed by Allan Dwan. It was Wayne's 119th film, and earned him his first Best Actor Oscar nomination. His lack of military service and politically divisive anti-Communist activities may have cost him the win. The Oscar went instead to Broderick Crawford for his performance in Robert Rossen's *All the King's Men*, a role Wayne had turned down because of its negative view of American politics. Rossen was later blacklisted.

William Wellman's 1955 *Blood Alley*, shot in CinemaScope, was Wayne's 130th feature. He was on his honeymoon when Robert Mitchum, the star of the Batjac-produced film, had an onset fight with Wellman and quit. Unable to find anyone else to play the role of the riverboat captain in this anti-Communist propaganda film, Wayne stepped into it himself.

Wayne, with Lana Turner, one of the many top female leading ladies he starred with. John Farrow's 1955 *The Sea Chase* was Wayne's 129th film, a top-grossing movie. Filmed in Hawaii, it completed just before Wayne married Pilar Pallete there.

Wayne may be seen smoking cigarettes in virtually every film he made up until 1964, when he was diagonosed with lung cancer. These are two commercial stills that show Wayne posing for cigarette ads and endorsements.

John Ford's masterpiece, 1956's *The Searchers*,
Wayne's 132nd feature.

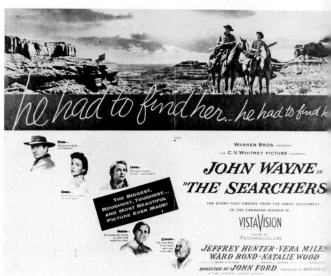

John Wayne in his
greatest role, the
existential wanderer
Ethan Edwards.

A French poster for *The Searchers*. An
international hit, the film was ignored
by the Academy, dismissed by most
critics as just another Western, despite
the fact that many consider it the best
Western ever made.

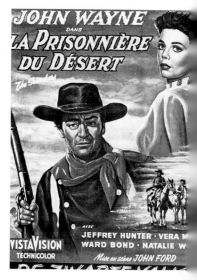

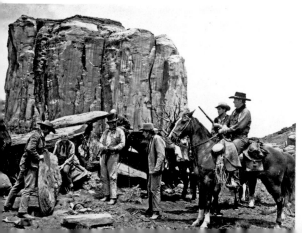

With the backdrop of
Monument Valley, the Ford
company stands over the
body of a dead Comanche.

Wayne's spectacular acting misfire as Genghis Kahn in Howard Hughes's production of Dick Powell's 1956 *The Conqueror* (with Susan Hayward). Rumors persisted for years that nearby earlier nuclear testing was responsible for the large number of cancer-related deaths suffered by those associated with the film, including, eventually, Wayne and Powell. Hughes pulled the film after a strong initial run and kept it out of circulation for years due to the cancer rumors. He didn't want to be blamed for all the illnesses and deaths.

(Rebel Road Archives)

Reteaming with Ford for the director's 1959 *The Horse Soldiers*, Wayne's 139th film. Clark Gable had been Ford's original choice for the role that eventually went to Wayne. The director had also wanted James Stewart for the role of the doctor that went instead to William Holden.

(Rebel Road Archives)

Wayne reteamed with Howard Hawks for 1962's *Hatari!*, Wayne's 144th feature. The film was shot mostly in Tanganyika. Hawks originally wanted Clark Gable and Gary Cooper for the leads that eventually went to Wayne and Hardy Kruger. Paramount released it again in 1967 on a double bill with Ford's lesser hit, *The Man Who Shot Liberty Valance*.

(Rebel Road Archives)

Wayne and a small circle of friends, 1971. Left to right: Bob Hope, Wayne, Ronald Reagan, Dean Martin, Frank Sinatra.

(Rebel Road Archives)

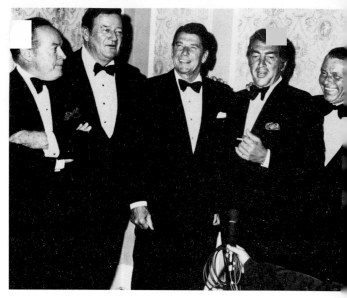

Publicity photo of an aging and ailing Wayne on the set of his 163rd film, Mark Rydell's *The Cowboys*, 1972.

(Rebel Road Archives)

Backstage at the 1975 Academy Awards, Wayne and Howard Hawks celebrating his Honorary Oscar for "A master American filmmaker whose creative efforts hold a distinguished place in world cinema."

(Rebel Road Archives)

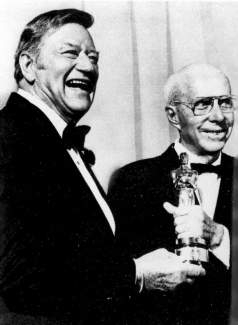

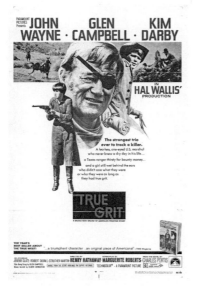

The film that finally won Wayne his only Oscar (and a Golden Globe) for Best Actor. Henry Hathaway's 1969 *True Grit* was Wayne's 158th film.

Backstage, Wayne holding the Oscar just presented to him by Barbra Streisand.
(Rebel Road Archives)

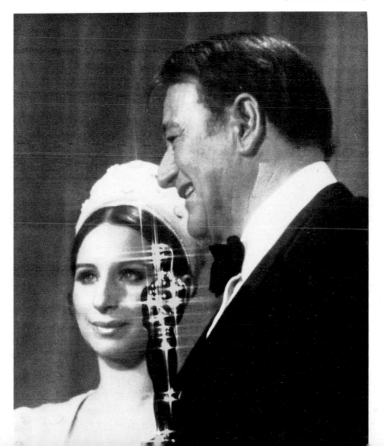

Wayne at home proudly standing in front of a small part of his vast collection of awards and honors.

(Rebel Road Archives)

with a man the way I was by my meeting with John Wayne. It was much more than sex appeal or good looks, both of which he had in abundance, or his success and fame, of which I had been told. Something elemental about the man, a sense of great strength, appealed to me."

Pilar had separated from Weldy after she caught him cheating, but had hesitated to divorce him because in the male-dominated world of Peru, she feared it might adversely affect her status as a popular movie star. Now, however, after meeting Wayne, she decided to get her marriage to Weldy annulled.

And marry John Wayne.

Not long after his vacation ended, Pilar flew to Hollywood to do some dubbing on her film *Green Hell,* in preparation for its U.S. release. She was determined while she was there to meet up with Wayne. It happened while she was on the Warner Bros lot in Burbank. He was surprised and delighted to see her again and asked if she would join him for dinner that night.

EVEN BEFORE *TROUBLE* HAD COMPLETED production, Frank Belcher, Wayne's lawyer, had filed for divorce in Los Angeles for Marion Morrison, accusing Chata of "mental cruelty." Giesler, in turn, filed for divorce on behalf of Chata on the same grounds. On September 11, 1952, Giesler announced, "We are now in the process of a discussion stage and look forward to an amiable settlement." In his interim complaint, Giesler indicated that Chata wanted a sizable chunk of Wayne's estimated yearly salary of $500,000, and that his net worth was in excess of $1 million. She also wanted $40,000 for legal fees and $50,000 for auditors, appraisers, and private detectives, $12,571 in monthly expenses to be paid in perpetuity—$1,245 for household maintenance, $1,938 for household expenses, $3,654 for personal expenses and entertainment, $948 for auto upkeep and traveling, $1,518 for health and auto insurance, $650 for her mother's allowance, $499 for furs, jewelry, personal effects, $1,023 for charities, $795 for travel fares, $301 for telephone.

He also named sixty witnesses that included businesspeople, associates, Warner Bros, RKO, and others for the purpose of establishing Wayne's income and financial status. She wanted the deed to the house in the Valley Wayne had rented out and all the accumulated proceeds from the rentals.

Judge Orlando Rhodes, of the Santa Monica Superior Court, ordered Wayne to appear September 26 to show cause why a temporary restraining order to

prevent him from molesting or annoying his wife should not be issued against him. He was also enjoined him from disposing of any property. Belcher managed to get that order thrown out, and trial was set for September 1953, Jude Allen W. Ashburn presiding.

Belcher indicated that at trial his client would challenge Chata's "mental cruelty" accusation and counter with an offer of $40,000 for two years, and $35,000 for the next seven years. When Wayne was asked by one reporter why he was contesting a divorce that both sides so obviously wanted, he said, softly, staring straight ahead, "A man has to have some self-respect. I've taken all I can take. I refuse to be a doormat any longer."

Wayne did not contest the year-long wait for the trial to begin. Pilar was pregnant and he needed to solve that "problem" first. If somehow Chata found out about it, she could cause serious damage to his case. After much reluctance, because she wasn't married to Wayne, Pilar finally agreed to have a secret and illegal abortion.

WHILE WAITING FOR HIS DIVORCE trial to begin, he openly dated Pilar, who remained in Hollywood. She had managed to have her marriage to Weldy annulled, and Wayne went back to work nonstop, mainly to replenish his bank account.* Wayne starred in *Island in the Sky* for Warner Bros, produced by Wayne-Fellows and directed by William Wellman (Andrew Mclaglen, Victor's son, was the assistant director). *Island* is a plane crash survival melodrama in which Wayne plays the pilot charged with keeping his crew and passengers alive until they can be rescued. It filmed from February to April 1953 near Donner Lake, in Northern California. (Big Bear, the original location, was scrapped due to an unusually light winter that year that left it without the sufficient amount of snowfall the script required.) The film also featured Fess Parker, still unknown before he created a phenomenon playing Davy Crockett in Walt Disney's TV series, and Mike Conners (then called "Touch" Conners), who would later become famous as the TV detective *Mannix,* a character he played for eight seasons on CBS.

And Wayne-Fellows went immediately into their next John Wayne film, *Hondo,* a western directed by John Farrow, a veteran Warner helmsman, who

* Her annulment was granted by the Catholic Church because she was able to prove that Weldy had not been officially divorced from his first wife.

shot it on location in Mexico at Jack Warner's directive in the newest film fad, 3-D. When it opened a year later, November 27, 1953, a month after his divorce trial began, *Life* magazine called it "[t]he best 3-D movie to come out so far. The film is beautifully photographed [by Robert Burks and Archie Stout] and with the added feature of depth will have theater audiences dodging spears, knives, horses, hatchets and Indians for whatever their lives are worth." The film pitted Wayne, as Hondo Lane, against the Apaches. He only intended to produce the film through Wayne-Fellows, but audiences wanted to see Wayne in a western; he hadn't made one since *Rio Grande,* but when Glenn Ford dropped out at the last minute Wayne agreed to replace him.

Hondo proved an enormous hit, grossing more than $4 million off its shooting budget of $1.3 million. Wayne received a salary of $175,000, and Wayne-Fellows earned a hefty percent of the profits. Ford directed two scenes in 3-D for the film, uncredited at Wayne's insistence. He didn't want the the director's name to overtake the production and turn it into a "John Ford Production." According to Ford, "I went down to Mexico to visit Duke, so immediately he sent me out to do some trivial second-unit stuff, a few stunts." Even with Ford downplaying his involvement with the film, when Wayne refused to officially list him in the credits, Ford replied, "Jesus Christ, don't you people ever give me credit for *anything?*"

WAYNE'S DIVORCE TRIAL BEGAN IN October 1953 and quickly turned into kind of Hollywood media circus that captures the attention and fuels the imagination of the entire country. Following the previous sensational filmland trials of Errol Flynn (for statutory rape) and Robert Mitchum (for smoking pot), Wayne's promised to have a fair share of scandal, too.

The first day, thousands crowded the courthouse, straining for a glimpse of their favorite movie star. Everybody showed up on time except Chata. The trial was set to begin at nine, but when she hadn't shown up by ten thirty, the judge retired to his chambers to figure out what to do next. Chata finally appeared at eleven o'clock, and the judge demanded to know why she was late. She produced a speeding ticket she had gotten after being stopped by a highway patrolman, the reason, she said, for her missing the start of the proceedings. The judge shrugged and accepted her excuse, and the proceedings began.

Chata was the first to take the stand, looking quite glamorous. Either her

psoriasis had been expertly covered up by makeup, or its seriousness exaggerated. She wore an expensive dark blue tailored suit, pinstriped blouse, and white gloves. Her hair was pulled back in a bun. After she was sworn in, she began her testimony. She talked about her life before she had met Wayne, what it was like after, and said that she had indeed lived with Wayne for two years before his divorce from Josie was finalized.

Under oath she testified about twenty-two specific acts of cruelty on her husband's part, that Wayne was an alcoholic and got violent when he was drunk, which he was more often than he was sober, and that he had, on several occasions, slapped her and kicked her, trampled on her clothes and scarves, dragged her by the legs and the roots of her hair, and "clobbered" her many times, in Encino, Hawaii, Mexico City, Acapulco, Dublin, London, and New York. She testified that once, on Waikiki Beach, she had discovered Wayne having an orgy with other naked men and women, and when she asked her husband why she hadn't been invited, he told her to go away and stop spoiling his fun, and that a similar incident had happened at a pool in Acapulco, that she had shown up with a bathing suit and been bawled out by Wayne because she wasn't naked like the others. She had several witnesses, all friends or Mexican servants who worked for her mother, who corroborated her accusations.

Wayne's face visibly reddened when she told the court that a "strip-tease girl" once bit him on the neck during a stag party he had gone to and when he came home he had "a big black bite on his neck" (on cross-examination Wayne admitted he had been bitten but insisted it happened without his consent). And Chata told the story of how she had almost shot him that night when he broke into the home because he couldn't find the key. She said she took a gun from a bedside table drawer and went to investigate the noise, accompanied by her mother, and was just about to shoot "the intruder" when her mother told her, "Don't shoot, it's your husband."

As Wayne told Hedda Hopper, "We had pretty good times except when she tried to kill me."

Chata also testified that Wayne had committed adultery with actress Gail Russell, that the time she almost shot him, he'd stayed out the night before at Russell's home, and that a friend of hers had told her that her husband had

bought Russell a car. Wayne stared out the large courtroom windows during this part of the testimony.

After a conference in chambers, the judge ordered Wayne to pay an additional $2,000 to Chata for her court costs after she complained she couldn't afford her attorney fees. When court was dismissed that day, Russell immediately retained counsel and threatened to sue Chata for libel, insisting that Wayne had not bought her a car, only given her a loan of $500 during the making of *The Angel and the Badman* because she wasn't making enough money to get by.*

After court that day, Wayne looked visibly angry that Russell was being "dragged into this" and bemoaned the fact to reporters the fact that he would "[h]ave to earn $20,000 [more] to pay that $2,000."

Walking into the courthouse the next morning, he stopped to sign autographs, mostly for squealing young girls who rushed at him waving pens and autograph books and pads. One carried a large sign on a stick that said: JOHN WAYNE, YOU CAN CLOBBER ME ANY TIME YOU WANT.

Now it was Wayne's turn to testify. The night before he had come down with the flu and was running a 102-degree temperature when he took the stand. Under oath, he testified that it was Chata who was the out-of-control drinker, not him, and he denied ever having sex with Russell. He denied every accusation that he had ever physically abused his wife. He claimed she was "reckless" with his money, giving expensive gifts to other men, lost thousands of dollars at the tables in Las Vegas, and that she had been carrying on an affair with hotel heir millionaire Nicky Hilton, the son of Conrad Hilton, and that Hilton had spent a week at the Wayne home while he was away on location. To back up his story, he had Hilton subpoenaed to testify under oath.

On recross, Chata denied the affair with Hilton.† Once again, she talked

* Gail Russell told Louella Parsons during the trial's run that she was considering bringing a lawsuit against Chata: "All day yesterday Gail Russell was in conference with her attorney about what action to take in regard to what she claims are false representations made concerning her in the John Wayne divorce trial. Gail, who was shocked at the bitterness of the attack, gave me an exclusive interview . . . 'There was absolutely nothing between us.' "—Louella O. Parsons, *Los Angeles Examiner* and syndication, October 1, 1953.

† Hilton's girlfriend at the time was actress Betsy von Furstenberg; she publicly denied there was an affair, saying that she had asked Chata to put Hilton up "as a favor" that week, to let him recover from an auto accident. Left unanswered was why Hilton couldn't stay at Furstenberg's home, or at one of the several Hilton hotels in Los Angeles.

about Wayne's physical brutality. One time in Acapulco, they'd had a fight and "he threw a glass of water in my face. I grabbed a bucket of water and sloshed it at him. He then threw rubbing alcohol into my eyes and it burned and blinded me for a moment. I told Mr. Wayne that I was absolutely through with him."

When it was Wayne's turn again, he said he had "swished" the alcohol at Chata to repel an attack—"she tore my neck open!"—and that for the last three years of their marriage, his wife found "every possible excuse to stay away from me."

During a recess the afternoon of October 21, 1953, Frank Belcher suddenly announced a possible settlement, telling reporters, "We are very close, but nothing has been signed yet. It's like working a cross-word puzzle."

Both sides met for an hour in the judge's chambers, and when they emerged, it was officially announced that a settlement was reached, ending the lurid, national headline-grabbing trial, and the marriage.

The front page of the *New York Daily News* screamed: **WAYNE, WIFE END SIZZLING TRIAL; SETTLEMENT REACHED.**

The following week, both Chata and Wayne testified on matters relating only to the financial settlement, but it quickly turned into more of the same. While he was on the stand, Wayne testified he had found doodles on a napkin in his house that his wife had scribbled: " 'Chata Hilton,' 'Mrs. Nick Hilton,' and 'Esperanza Hilton.' " And with his voice trembling, again he hotly denied any hint of misconduct with Gail Russell and finished by calling his wife a "heavy drinker," possessing a "fishwife temper," and being the instigator of "various acts of violence."

On October 29, 1953, Judge Rhodes granted a divorce on the grounds of cruelty (the rough equivalent of today's no-fault divorce; this was more accurately a both-fault divorce). Wayne agreed to pay his wife $50,000 for six years, take care of all her current debts (about $20,000), and make a onetime cash payment of $150,000.

Outside the courtroom, Wayne told reporters that despite the $502,891 his wife had testified he had in the bank, he was now broke (he actually had about $60,000 in cash) and had had to borrow money to pay his taxes, all because of the extravagances of his wife. Some of it was true—he was in bad financial straits—but not all of it was Chata's fault. Wayne had continued to make bad investments, remained an easy touch to friends, and still loved to pick up the tab no matter how many people in the party. And he did go out with other

women and liked to lavish them with cash and gifts. Here is Wayne complaining about how taxes kept him broke: "The minute I became a success, the government began auditing my income tax returns . . . I wanted desperately to be rich, but like the fellow who mistook the hen house for the privy in the dark of the night, I never quite achieved my intended goal."

After the settlement, Chata hired a new lawyer, S. S. Hahn, who threatened to reopen the case if he could find any discrepancies. He couldn't; Chata insisted they appeal anyway and it was thrown out, after which she left Los Angeles for good, moving in with her mother in her house in Mexico City. Very quickly, she ran out of all the money from the settlement. After her mother died, Chata sold the house and moved to a Mexico City hotel. She rarely left her room, barely ate, and subsisted mostly on brandy. She eventually died of a heart attack at the age of thirty-five in the winter of 1961.

JUST BEFORE THE START OF the divorce hearings, Wayne had been voted the most popular overseas male film star for 1952 by the Foreign Press Association (Susan Hayward was the number one female star), but he now feared that after all the bad press from the divorce, nobody would want to see him again in the movies.

He was also suffering from stomach ulcers.

He needn't have worried. Shortly after the trial ended, Wayne filmed *The High and the Mighty*. It was shot in Warner Color and CinemaScope. The film reteamed Wayne and director William Wellman (*Island in the Sky*) in another flight drama. Wayne was offered the part of the pilot after Spencer Tracy, Wellman's first choice for the role, quit the film. *The High and the Mighty* revitalized the emergency-landing genre and set the standard for such ensemble-cast air disaster films, each character played by a (usually) late-in-the-day star with a story of their own who learn a few "life-lessons" after their near brush with death. Robert Aldrich's 1965 James Stewart vehicle, *The Flight of the Phoenix*, was one. The most enduring of the lot was George Seaton's 1970 *Airport*, based on the novel of the same name by Arthur Hailey, which starred Burt Lancaster and Dean Martin, and a host of famous-face cameos.

The High and the Mighty premiered May 17, 1954, with a gala, red carpet, klieg light affair at the Egyptian Theater in Hollywood, and went into national release the next day. It became the biggest hit yet for Wayne-Fellows and one of

the highest-earning films of Wayne's career. It grossed over $100 million from a $10 million budget and was nominated for five Academy Awards, including Best Score for Dmitri Tiomkin's whistly theme that floats through the entire film. Dan Roman (Wayne) whistles it one last time after he lands the plane and walks off into the sunset. His costars in this ensemble drama were Robert Stack, Claire Trevor, Laraine Day, Jan Sterling, Phil Harris, Robert Newton, and longtime friend Paul Fix. At Oscar time the following winter, Wayne was once again overlooked as Best Actor.*

Despite its success, *The High and the Mighty* was the last film produced by Wayne-Fellows. In January 1954, shortly after completing production on the film, Wayne was forced to end his partnership with Robert Fellows, when Fellows fell in love with one of the company's secretaries and asked his wife for a divorce. The distraught Mrs. Fellows went to Wayne and pleaded with him to talk her husband out of ending their marriage over some meaningless affair. Wayne politely refused, claiming Fellows's private life was nobody's business but his own. Not long after, when it became clear Fellows intended to go through with the divorce, he needed to liquidate as many of his assets as he could and offered to sell his half of the company to Wayne, who quickly agreed to the deal.

Wayne then formed a new company, "Batjac," named after the fictitious Dutch shipping company in one of his own favorite films, *Wake of the Red Witch*. It was his eldest son, Michael, who suggested the name. Wayne liked the way it sounded like bat crap. It was originally supposed to be "Batjak," as it is spelled in the movie, but a typographical error put into the incorporation papers substituted a "c" for the "k," thus "Batjac." On June 1, 1954, the incorporation was complete, Batjac opened new offices on Hollywood and Beverly Boulevards and immediately began work on several unmade Wayne-Fellows properties included in the buyout.

WAYNE AND PILAR MOVED INTO a new house in Encino, which quickly became a never-ending salon for Wayne's friends, including Bond,

* The film won Best Music Score—Dmitri Tiomkin; Tiomkin and Ned Washington won Best Song for the Title Song. Jan Sterling, and Claire Trevor, two of the passengers, were nominated for Best Actress; both lost to Eva Marie Saint for her performance in *On the Waterfront*. Wellman was nominated as Best Director but lost to Kazan for *On the Waterfront*. Ralph Dawson was nominated for Best Editing but lost to Gene Milford for *On the Waterfront*.

Ford, McLaglen, and Feldman. For them, especially, the door was always open and Ford showed up at all hours of the day and night, usually drunk, the only friend of Wayne's whom Pilar disliked, but she wisely decided not to make an issue of it. For his part, Wayne always welcomed Ford, no matter what time and now matter what condition he was in. If Ford was drunker than Wayne, he was always ready to drink a few to catch up with Pappy.

When the house wasn't filled with his friends, Pilar and Wayne often went out by themselves for dinner and entertainment, most often at Charlie Morrison's and Felix Young's West Hollywood South American–styled Mocambo, where his favorite maroon leather banquette was always ready for him.* One time the house reporter asked if he could take their picture together. It was before the divorce had been finalized. When he asked Wayne what the occasion was, he replied, "We're celebrating the fact that it's a great world!"

Late into the night, Wayne loved to snuggle with Pilar on the sofa, use his custom remote controls to lower the TV from the ceiling, snack on salami sandwiches Pilar would make, chain-smoke his beloved Camels (he went through four packs a day and did print and TV ads for the brand), and watch TV shows or old movies until he fell asleep. On weekends, they would relocate to Wayne's boat, *The Nor'wester*. It was a form of at-home happiness Wayne had never had before, and he cherished it, as well as Pilar for giving it to him.

But her friends cautioned he would never marry again. "Duke's too much of a man's man," one friend told her. "He's too fond of his freedom. He likes to carouse too much." Another talked of how he had trouble playing the role of a husband. "When he takes off his clothes, he will throw his shirt and pants on a chair and his socks on the floor. He is constitutionally opposed to ashtrays. He hates [domestic] schedules. He likes to eat when he feels like it, drink when he wants to, and stay up until he can't keep his eyes open any longer." They slept in a specially made king-size bed to accommodate his size and both loved the luxury of the roominess. He always wore only bottoms at night.

* Mocambo catered to the Hollywood movie set. There was always top talent playing there, including Ella Fitzgerald and Edith Piaf. The restaurant was also a favorite night spot for Humphrey Bogart and Lauren Bacall, Charlie Chaplin, Henry Fonda, and dozens of others. Its décor was copied for several episodes of the *I Love Lucy* show, where Desi Arnaz's Ricky Ricardo was the house band.

FOR THE LONGEST TIME, HOWARD Hughes had wanted Wayne to make a film about Genghis Khan. Two years earlier, Dick Powell, the former film juvenile who had grown up and into rough-and-tough guy roles and become a savvy producer, had been hired by Hughes to direct the film. Hughes, never a speedboat, was finally ready to make it, which meant everybody had to be ready.

Given the green light, Powell's first choice to play the lead had been Marlon Brando, and when he told Hughes, he did not say no. As it turned out, Brando was under contract to Warner at the time, and they wouldn't loan him out. Hughes was convinced he could get them to change their mind, no matter how much he had to pay. He hired British-born screenwriter Oscar Millard, who had relocated to Hollywood after World War II, to custom-fit a script for the actor. The screenwriter, however, ignored Hughes and wrote it his own way, without considering Brando at all. According to Millard, "I decided to write it in stylized, slightly archaic English, mindful of the fact that my story was nothing more than a tarted-up Western. I thought this would give it a certain cachet and I left no lily unpainted. It was a mistake I never repeated."

Not long after, Powell received word that Brando was beginning production work on Joseph L. Mankiewicz's film version of the Frank Loesser musical smash *Guys and Dolls*. The truth was, that film was still in preproduction and had no start date; it was just an excuse Brando came up with because the young Method actor hated Millard's stilted old-style fake-historical script. The bald and at the time immensely popular Yul Brynner also turned it down. With a shooting script ready and a director in place, a desperate Hughes called up Wayne, who had always been his first choice, and asked him to take the part as a personal favor. Wayne didn't want to say no to Hughes, hoping he could still get him to produce *The Alamo*.

WAYNE RECEIVED $250,000 (PAID AT a $1,000 weekly salary) to make *The Conqueror*, good money that he sorely needed. It was directed by Powell with all the subtlety of a sledgehammer, not entirely Powell's fault as he had Hughes hovering over him dictating every shot. Millard's faux twelfth-century Far Eastern dialogue sounded as if Shakespeare had suffered a stroke just before writing it, with acting that made starch seem a softener (some actors' dialects appeared to come and go without any reason), and throughout, Wayne

sounded like someone reading aloud an instruction manual with some of its words missing.

The very idea of Mr. Americana as an Oriental warrior might be laughable if the film weren't so pathetic. *The Conqueror* is not one of those films that turns out not just as bad as one might imagine, a good piece of camp, but worse, plainly dreadful, a bad tooth of a movie that keeps throbbing with pain from start to finish. Wayne knew he had a dog on his hands, and to get through filming he popped Dexedrine pills four times a day, to help keep him awake and to prevent his weight from ballooning beyond his already brawny forty-six-inch chest, thirty-seven-inch waist, and seventeen-inch biceps. For the five long months it took to make the film, from March to August 1954, he kept to a strict diet of hard-boiled eggs, spinach, green salad, cottage cheese, and one steak or lamb chop a day and washed it all down with as much high-test champagne as he could pump into himself.

The Conqueror became the last film Hughes ever produced. By 1953, RKO was hemorrhaging cash, and in late 1954, Hughes reluctantly sold out to General Teleradio for $25 million, a deal that included the rights to all of RKO's negatives, not just the two dozen or so movies made during his tenure.

The sale also meant the end of Hughes's soft commitment to Wayne to make *The Alamo*. Soon after General Teleradio took over the studio, all productions were shut down and the physical lots were sold to Desilu Productions (Lucille Ball and Desi Arnaz) for $6.1 million. With that sale, RKO, one of the "Big Five" studios of Hollywood's golden age, ceased to exist.*

One of the more interesting side stories to the making of *The Conqueror* that continues to haunt this cursed film is the large number of cancer deaths among the cast and crew. Of the 220 persons who worked on it, 91 had contracted cancer by the early 1980s and 46 died from it, including Wayne, who died from stomach cancer, not lung cancer as is popularly believed (he first contracted lung cancer in 1964, claimed to have beaten "the big C," and lived another fifteen years); his costar Susan Hayward; popular character

* Hughes bought back two negatives from General Teleradio—*Jet Pilot* and *The Conqueror,* for $12 million ($8 million up front, $4 million deferred). After their initial theatrical releases, he never allowed either to be shown or distributed during his lifetime. Both eventually appeared on television and are now available on DVD. The "Big Five" were MGM, Paramount, Twentieth Century–Fox, Warner, and RKO, the latter considered the least successful of these. The "Little Three" were Universal, United Artists, and Columbia.

actress Agnes Moorhead; and Dick Powell. It has never been proven (and probably never will be), but many attribute the source of the outbreak of cancer among the participants of the production to radioactive fallout from U.S. atom bomb tests in nearby Nevada. What clouds the facts are the other variables, such as the lifestyle of most Hollywood workers, both in front of and behind the camera. They lived hard, including heavy drinking and cigarette smoking (Wayne was a four-pack-a-day man). Most involved in the production apparently knew about the radiation and none took the threat that seriously (there's a photo in existence of Wayne smiling and operating a Geiger counter during the filming).

Ultimately, although researchers have failed to make any connection to the tests and the high rate of those who worked on the film, Hughes believed there was. He felt guilty about having caused the death of so many of his friends, which might have been one of the factors in his decision to withdraw *The Conqueror* from circulation after its initial run. It is said that during the last crazy years of his life, lived as a recluse on the top floor of the Desert Inn in Las Vegas, he often screened it with a 16 mm projector and a portable screen for himself while lying propped up in bed.

The film's initial release itself was delayed two years because of postproduction problems—much of the desert sand had to be relocated to the RKO studios to try to make some scenes match the location shooting—because of the sale of the studio, and because of Hughes's plain weirdness. He didn't release *The Conqueror* until February 1956 (and *Jet Pilot,* which had wrapped in 1951, didn't come out until fall of 1957).

IN OCTOBER 1954 WAYNE AND Pilar traveled to Honolulu, sparking rumors they were about to be married there. Wayne denied all of them. He said, "Unless there is some delay in *The Sea Chase* [his new movie, the official reason they were there] I won't be free to marry before my return. I certainly hope to marry Pilar when I am free—that is, if she will have me. There are two sides to this, you know."

The Sea Chase was made for Warner, shot in Warner Color and CinemaScope, and produced and directed by John Farrow. Jack Warner, the film's executive producer, eager to sign Wayne to a new long-term contract, threw a huge, star-

studded welcoming party on the beach, highlighted by an appearance of MGM star Elizabeth Taylor and her then-husband, British actor Michael Wilding.

THE SEA CHASE IS A World War II at-sea drama based on a 1948 novel by Andrew Clare Geer that Warner Bros had bought the rights to in 1950. In it Wayne plays the captain of a ship hunted by the Nazis, with Lana Turner as a German spy somehow on board and undetected as the enemy, to supply some much-needed, if highly improbable, sexiness to the story. Warner had to pay MGM $300,000, to borrow Turner. Before they signed her, at Wayne's suggestion they tried to get Virginia Mayo or Susan Hayward for the role. When they couldn't get either, they signed Turner and paid MGM. Wayne hadn't wanted her because he couldn't stand her and she abhorred him. Wayne thought she was cheap-looking, and she considered him Hollywood's biggest hick. The two didn't say a word to each other off-camera the entire shoot. The cast also included Wayne's good friends James Arness, Paul Fix, and Alan Hale Jr. *The Sea Chase* was a familiar genre for Wayne and gave his audience what it wanted, a simple, nonpolitical action thriller with Wayne the larger-than-life if two-dimensional movie hero.

WAYNE AND PILAR TIED THE knot on November 1, 1954, in Kailua, before they left Hawaii after Wayne received the phone call he had been waiting for, from Frank Belcher, informing him that the final divorce papers had been delivered to him that morning. "You're a free man," Belcher told Wayne, laughing as he did. Wayne put the phone down, turned to Pilar and said, "How would you like to get married today?" Pilar scurried to find a wedding dress, aided by Wayne's longtime personal assistant, Mary, while Wayne used his influence to bypass all the necessary papers and blood tests. District Magistrate Norman Olds agreed to waive the mandatory three-day waiting period.

The wedding took place at sunset, a civil ceremony held in the palatial former home of King Kamehameha III. Mary was the maid of honor, and Francis Li Brown, a wealthy sportsman and former Republican senator from Oahu, the best man. Director John Farrow, who had just wound up production on *The Sea Chase,* gave away the bride. Also in attendance were three of Wayne's chil-

dren, Patrick, Toni, and Melinda, who had come to Hawaii while their father was making the film.

Pilar, twenty-six, wore a pink organza dress with matching hat, orange blossoms in her hair, and held a bouquet of native flowers as the two exchanged vows.* Wayne, forty-seven, wore a dark suit, white shirt, black tie. The ceremony lasted ninety seconds. The word *Obey* was omitted by mutual agreement. After he kissed the bride, Wayne said, "This is the greatest thing that ever happened to me. I've had a lot of wonderful things happen, but this is the best."

A crowd of native Hawaiians in traditional hula dress dancing to *pila ho'okani* played for family, friends, and about 150 members of the cast and crew of *The Sea Chase* at a reception in the garden of the house the studio had rented for Wayne for the duration of filming. To a friend, Wayne quipped, "I was married in the morning, divorced at lunch, and married at sunset."

The next morning they flew via private plane chartered by Warner Bros back to Honolulu, where they were met by a mob of reporters. When asked where they were going to spend his honeymoon, Wayne graciously replied that having just finished *The Sea Chase,* he wanted to go home to Encino with his lovely bride and take it easy at home.

They were about to board a commercial Pan American flight to Los Angeles when gossip columnist Sheilah Graham managed to get Wayne on the phone at the airport. She asked him if he noticed anything unusual about the fact that this was his third marriage, and that all three of his wives were Latin American. Wayne said, "Some men collect stamps. I go for Latin Americans."

FOR THE SECOND TIME, HE had rebuilt his family. He had made a successful transition to his new production company. He was one of the biggest movie stars in the world. He should have been content, but he wasn't. There was still something missing.

He hadn't yet been given a part that required more than his ability to throw a punch, or his squinting into the camera and reciting his lines in that familiar halting nasal rhythm. He wanted to make a movie with a role that would come from the inside. How he could express it before the camera, he had no idea.

Wayne was filled with self-doubt about his professional future and on a per-

* According to some records, Pilar may have been twenty-nine when she married Wayne.

sonal level, being able to fulfill his role as husband to his third wife, who was three decades younger than him. As he wrote in an article for the *Hollywood Reporter* in April 1954 in which he paid indirect homage to John Ford for discovering him (the piece was ghosted by Zolotow for "The Rambling Reporter"), "Once in a while I look into a mirror and wonder how long I'll be an actor. I suppose for a few years yet. But one day I know my hair will abandon me completely. The wrinkles in my face will hold water when it rains. And I won't be able to pucker up for the last reel. I may not have my poke, but I'll be around. I'm looking forward to it. I'll be telling some youngster, still unknown, with a belly big as a mail sack that he can't be a stunt man—and what time to come to work in the morning."

He may have felt uncertain about where his career was going, but one thing he was sure of, Hollywood hadn't seen the last of him.

He still had some bullets left in his gun.

Chapter 17

On December 30, 1954, Wayne was once more ranked as the number-one box-office star in America, according to the *Motion Picture Herald* poll. It was the third time he had reached the top spot, after falling out of it for two years, and the first time any star had ever regained the top spot—he held it in 1950 and 1951. This time Wayne bested Martin and Lewis, Gary Cooper, James Stewart, Marilyn Monroe, Alan Ladd, William Holden, Bing Crosby, Jane Wyman, and Marlon Brando for the coveted number-one position, thanks in large part to the huge box-office successes of *Hondo* and *The High and the Mighty*.

ON MARCH 15, 1955, BATJAC went into production on *Blood Alley*, directed by William Wellman, from a script A. S. Fleischman adapted from his novel of the same name. The story concerns merchant marine ship captain Tom Wilder, who has escaped from a "Red" Chinese prison and then agrees to help take the 180 villagers of Chiku Shan through the Formosa Straits—"Blood Alley"—to Hong Kong and freedom, via a stolen flat-bottomed stern-wheeler. The plot is less doctrinaire than *Big Jim McLain* (and therefore more entertaining) but no less anti-Communist. The story line is further complicated by the unlikely presence of Cathy Grainger (Lauren Bacall), whom Wilder reluctantly agrees to take along on the dangerous voyage to Hong Kong after her father, a doctor, is taken by the Communists and forced to operate on a party official and then killed. During the hazardous journey, filled with near calamities at

every turn, Wilder falls in love with Cathy (the real reason her character exists is to add some romantic relief for the women in the audience taken by their ticket-buying men looking to see Wayne beat up some Commies).

The film was a difficult one to make, not just physically, but also for the chaos that took place behind the scenes. Wayne had wanted to take Pilar on the honeymoon he already had to postpone several times, and planned only to executive produce *Blood Alley,* not star in it. It was originally intended as a vehicle for Robert Mitchum, who had turned down the lead in George Stevens's *Giant* to be in it. (That role went instead to Rock Hudson, who was nominated for an Oscar for his performance.)

However, three days into the shoot, on location in San Rafael, California, Mitchum abruptly quit the picture after a falling-out with the always short-fused Wellman. It began when Mitchum shoved assistant director George Coleman into the ice-cold San Rafael Bay after he had refused to provide a bus to take Mitchum and his friends on the crew to San Francisco for a party. They went anyway and five of them, including Wayne's frequent traveling companion Ernie Saftig, were arrested later that night in a bar for being a little too rowdy. They all had to be bailed out by Batjac.* Mitchum (who had not been arrested) then refused to return to the film, despite the fact that Wellman had given him his first starring role in 1945's *The Story of G.I. Joe.*

Wellman had to call Wayne, who was honeymooning in Manhattan with Pilar, to tell him the news. Wayne desperately tried to get another star to replace Mitchum, but after being turned down by Gregory Peck, who said he had other commitments, and Humphrey Bogart, who wanted $500,000 to take over the role, Wayne flew back to the coast and took Mitchum's part himself. It was a replay of what that had happened with *The High and the Mighty,* when Wayne had to step in for Tracy. He hoped it was an auspicious turn of events, that *Blood Alley* would turn out to be as big a hit as *Mighty.*

It wasn't. It opened in June 1955 and barely broke even. *Newsweek*'s film critic summed it up best when he wrote, "Good ship, shallow draft." Wellman defended his star's performance by saying, "Wayne is a nice guy with a special touch of nastiness."

The year was saved for Wayne by the release of *The Sea Chase* a month earlier,

* The others arrested were John True and A. P. Settle, both deep-sea divers, and Donald McClean and Gass Gidley, marine workers. Gidley was seriously injured in the melee.

in May. It would go on to be the tenth-highest-grossing film of 1955, earning just under $7 million (international) off a budget of $3 million.*

WITH BOTH FILMS OPENED AND his promotional commitments to them finally done, the forty-eight-year-old Wayne, his face puffy from drink, his hair thinner, his back perennially sore, his belly starting to sag, and his throat dry from the hundred Camels he smoked each day, didn't want to even look at another script. He only wanted to complete his honeymoon, That is, until Pappy called. He had a new project he wanted Wayne to star in.

As tired as he was from making *Blood Alley,* and fed up from all the abuse he had taken over the years from Ford, when the director told him Kirk Douglas was lobbying heavily to play the lead role of Ethan Edwards in a new western written by Frank Nugent, Wayne agreed to meet with Pappy and at least talk about it.

The Searchers was to be his twelfth collaboration with Ford, in what would become not just the best western ever made, but the greatest role of John Wayne's career, the one he would most be remembered for.

* The top-ten-grossing films of 1955 were, in descending order, Clyde Geronimi's *Lady and the Tramp,* $100,249,000; John Ford, Joshua Logan, and Mervyn LeRoy's *Mister Roberts,* $9,900,000; Joseph L. Mankiewicz's *Guys and Dolls,* $8,075,000; Billy Wilder's *The Seven Year Itch,* $7,875,000; Nicholas Ray's *Rebel Without a Cause,* $7,100,000; Joshua Logan's *Picnic,* $6,350,000; Jesse Hibbs's *To Hell and Back,* $6,500,000; Fred Zinnemann's *Oklahoma!,* $6,275,000; Charles Vidor's *Love Me or Leave Me,* $6,150,000; and John Farrow's *The Sea Chase,* $6,000,000.

Chapter 18

After 1952's *The Quiet Man*, Ford had moved to Twentieth Century–Fox to direct a proposed musical remake of Raoul Walsh's 1928 silent World War I melodrama *What Price Glory?* Ford used Jimmy Cagney in the original Victor McLaglen role. It did just all right at the box office as audiences showed little interest in it or the war it takes place in. Flag-waving World War II films were on the decline and Hollywood's prolonged victory cry was somewhat muted by the new and dreary Korean conflict, about which far fewer war films were being made. Wars without happy endings tended to do less well at the box office, and World War I films were considered no longer viable in Hollywood, a fact *What Price Glory?* underscored.

Ford then returned to Republic to make a comedy from a script he liked, called *The Sun Shines Bright*, even as his company, Argosy Pictures, was embroiled in an ongoing financial dispute with Yates. Ford had accused Republic of cooking the foreign books on *The Quiet Man*, believing the film had earned more money than was reported. After he won the Best Director Oscar for the film, Ford tried to settle with Yates, because he had wanted do a new picture for Republic, *Three Leaves of Shamrock*. When that didn't happen, he made *What Price Glory?* at Fox instead, and then, after some sort of a settlement was reached, returned to Republic to film *The Sun Shines Bright*. Yates made peace with Ford because he hoped the director's new film would help turn his failing studio around. In the spring of 1953, Republic entered *Bright* in the Cannes

Film Festival, where it wasn't well received; Yates then cut ten minutes from the original 100-minute running length. Ford was furious and vowed never to work for Yates again.*

With Argosy mired in financial troubles, Ford engaged talent agency MCA's Lew Wasserman to represent him. Wasserman quickly made a deal with MGM to have Ford remake Victor Fleming's 1932 *Red Dust,* a property the studio already owned. The remake was called *Mogambo* and starred some of MGM's biggest stars, Clark Gable, Ava Gardner, and Grace Kelly, hot off the success of *High Noon.* (Gable had starred in the original as well, with Jean Harlow and Mary Astor.) Ford had wanted Maureen O'Hara for the Gardner role, but she turned him down. For now, she had had enough of Ford's nastiness, drinking, and jealous rages.

Mogambo proved a major box-office success, and Ford followed it with *The Long Gray Line* for Columbia, during which he became romantically involved with the star of the film, his new discovery, Betsy Palmer; it was an affair that infuriated Maureen O'Hara, who had reluctantly agreed to be in the film. She hated Ford going behind his wife's back, and Ford was angry at her as well because he believed she was having an affair with one of the other stars of the film.

The Long Gray Line was a commercial hit, and Ford then made *Mister Roberts* in 1954 for Warner Bros, as a favor to help Henry Fonda make a return to major studio filmmaking. Working again in CinemaScope, Ford produced another success and the film made a star out of newcomer Jack Lemmon, who won a Best Supporting Actor for his performance.

During production, at the U.S. Navy base on Midway Island in the Pacific Ocean in September 1954, producer Leland Hayward arranged a meeting between Fonda and Ford to discuss changes Ford wanted to make in the original play to make it more cinematic. Ford, who was sprawled out on the sofa with a drink in his hand, sprang up and punched Fonda in the face. Ford's drinking and generally hostile attitude, topped off by his punching Fonda, quickly became the talk of Hollywood. Their relationship was never the same after

* Ford's original version was only released in theaters overseas. It was not seen in America until Ford's cut was used for a 1990 VHS release of the film. To date, it has not been made available on DVD.

that and Ford left the film before it was finished. It was completed by Mervyn LeRoy, who shared screen credit with Ford, and Logan, who did not.

Despite this good run, stories of Ford's increasing hostile behavior spread throughout Hollywood and as a result, few new offers came his way. At sixty-one, an alcoholic, in fragile health, half blind, and recovering from gall bladder surgery, he feared his long career might be over. Just to keep working, he agreed to direct two one-hour episodes of the TV anthology series *Studio Directors Playhouse,* the contents of which are better left forgotten (one featured Wayne).

And then he got a call from Merian Cooper, saying he was restructuring Argosy and partnering with "Sonny" Whitney's production company.

IN LATE 1954 MERIAN COOPER had accepted the offer from his good friend Cornelius Vanderbilt "Sonny" Whitney, heir to both the Vanderbilt and Whitney fortunes and the owner of a stable of Thoroughbred horses. Whitney had long been involved in the motion picture business. While still in his teens, with his cousin John Hay Whitney he became a major investor in the development of the original Technicolor process and then a majority stockholder in the Technicolor Corporation. They later had a hand in perfecting the technology of CinemaScope. The two Whitneys also provided much of the $3.5 million production money to David O. Selznick's company to make his 1939 film classic *Gone with the Wind,* after every major studio had turned it down (it was distributed by MGM). The success of that film, shot in Technicolor, made the Whitneys major players in Hollywood.

Seventeen years later, in 1954, C. V. Whitney formed "C. V. Whitney Pictures" and offered both Ford and Cooper a stake in the company and a five-year deal to serve as its vice president and executive producer. Cooper had accepted the deal, but Ford turned it down. After all the problems he had had with Argosy, he said he preferred to just make movies freelance.

Whitney, who always loved westerns, then bought the film rights to two novels. One was a Civil War saga called *The Valiant Virginians,* by James Warner Bellah, who had written the short stories that Ford had used as the basis for his cavalry trilogy. The other was Alan LeMay's 1954 western saga *The Searchers,* which had been serialized in the *Saturday Evening Post.*

Whitney decided to go with *The Searchers*—"The biggest, roughest, tough-

est and most beautiful picture ever made in America!"—over *The Valiant Virginians,* believing that the Civil War film would be too expensive a picture to launch the new company. Whitney, via Cooper, then offered Ford the chance to direct *The Searchers* as the first picture of a three-picture deal that would pay him $175,000 each and 10 percent of the profits. Ford signed on.

Whitney and Cooper took the package to MGM to sell distribution rights in return for a 50/50 split of the gross. However, before the deal could be finalized, Columbia's Harry Cohn made a counteroffer of a 65-35 split in Whitney's favor. Warner Bros then came in to what had become an auction, willing to advance fully one-third of the projected $1.5 million production budget and distribute the movie. Despite the bad feelings between Ford and Warner over what had gone down during the making of *Mr. Roberts,* Ford okayed the deal. He hadn't done a western in five years, since 1950's *Rio Grande,* and was eager to return to the genre and to his beloved Monument Valley.

And he wanted Wayne to star in it.

Wayne, however, was hesitant to work with Ford again. Besides all the industry buzz about Ford's drinking and his infamous on-set punch-out of Fonda, none of which came as a surprise to Wayne, he was well familiar with Ford's methods and temperament. According to Patrick Wayne, his eldest child and an associate producer on *The Searchers,* "I can't say whether my father wanted to do the film or not."

He finally did, because there was something gnawing at him ever since *High Noon* had been hailed by critics as "the greatest western ever made." Every major male star now wanted to be in a so-called adult western, including Clark Gable (Raoul Walsh's 1955 *The Tall Men*), Gregory Peck (William Wyler's 1958 *The Big Sky*), Henry Fonda (Anthony Mann's 1958 *The Tin Star*), Robert Taylor (Robert Parrish's 1958 *Saddle the Wind*), and Jimmy Stewart (Anthony Mann's 1954 *The Far Country*), to name a few; and Joel McCrea and Randolph Scott *only* made westerns now.

TV, too, had fallen in love with the genre. In 1955, Bill Paley of CBS decided to move his network's long-running radio series *Gunsmoke* to TV, and he approached Wayne about starring in it. He said had no interest in TV series work and suggested, instead, his friend James Arness. Arness was given the role

and wound up playing it for two decades. Wayne agreed to introduce the first episode to personally endorse Arness and give the series a leg up.*

TV westerns were cheap and easy to make, especially since they could use the ready-made permanent sets of the movie studios. After the ratings success of *Gunsmoke,* westerns popped up on every network. By 1959, they reached their peak with twenty-eight different prime-time weekly series on the air with a crop of newcomers who made their names on the little box, including Clint Eastwood, Steve McQueen, Burt Reynolds, and Michael Landon. These shows became the new B westerns with "adult westerns" now reserved for the big screen.

Wayne always became visibly rankled whenever he heard the phrase "adult western." He thought he and Ford had been making them since *Stagecoach.* Now, it seemed to him, every studio in Hollywood wanted another *High Noon.* Wayne was determined not just to make a better western; he wanted to give a performance so powerful and moving it would remind audiences that he, not Cooper, was Hollywood's greatest cowboy actor. That's why, after reading Frank Nugent and John Ford's script, even though it meant going back to work for Ford, he agreed to make the film. Wayne believed *The Searchers* was that good.

HE SIGNED ON WITH C. V. Whitney Pictures for $125,000 up front (paid out in weekly $1,000 installments), against 10 percent of the film's profits, payable after it earned back its production costs. Ford's deal was $175,000 and 10 percent of the profits for directing and cowriting the screenplay with Nugent.

The original Alan Le May novel was loosely based on a true-life incident that occurred in 1836, when a nine-year-old white girl by the name of Cynthia Ann

* "Good evening. My name's Wayne. Some of you may have seen me before; I hope so. I've been kicking around Hollywood a long time. I've made a lot of pictures out here, all kinds, and some of them have been westerns. And that's what I'm here to tell you about tonight: a western—a new TV show called *Gunsmoke.* No, I'm not in it. I wish I were, though, because I think it's the best thing of its kind that's come along, and I hope you'll agree with me; it's honest, it's adult, it's realistic. When I first heard about the show *Gunsmoke,* I knew there was only one man to play in it: James Arness, who is actually my friend. He's a young fellow, and maybe new to some of you, but I've worked with him and I predict he'll be a big star. So you might as well get used to him, like you've had to get used to me! And now I'm proud to present my friend Jim Arness in *Gunsmoke*"—John Wayne, *Gunsmoke,* TV episode one, first broadcast September 10, 1955.

Parker was kidnapped by the Comanches, Kiowas, and Caddoes at Parker's Fort on the Navasota River. They renamed her Naduah and she became the wife of Peta Oconoa, war chief of the Nocomi band. She was freed in 1860. Some accountings, including Le May's fictional adaptation, claim it was a "recapture," and after, when she tried to return to her tribe, she was held under guard until she starved herself to death. Her son, Quanah Parker, was the last free war chief of the Comanches.*

Ford and Nugent made one crucial change from the novel. They shifted the story from the girl's being the primary character, to her rescuer, Ethan Edwards, to accommodate Wayne's star power (Ethan was named Amos Edwards in the novel, changed for the film because of the popularity of the *Amos 'n' Andy* comedy radio and TV shows). Ford loved the idea of following Ethan, the existential wanderer, searching for the kidnapped Debbie, and her abductor, Scar, so he can kill them both. Ethan's sidekick for much of the pursuit is Martin Pawley, the part-Cherokee seventeen-year-old adopted child of Aaron and Martha Edwards, Ethan's brother and sister-in-law, a character whose presence allows Ethan to verbalize his feelings during their ten-year search for Debbie.

To find the right actor to play Martin, Ford tested many of the new crop of studio-contract pretty boys. At first he'd wanted Fess Parker, Disney's TV Davey Crockett, but "Uncle Walt" had Parker under contract and wouldn't lend him out, intending to use him in additional episodes as the character who set off the çoonskin hat craze among the children of '50s America. John Agar, who had appeared in two of the three parts of the cavalry trilogy, and whose career had since begun to fade, desperately wanted the part, but Ford no longer had any interest in him. He also briefly considered Robert Wagner, but Ford really wanted one of Wagner's best friends, the up-and-coming Jeffrey Hunter.†

* Le May's novel, in fact, may not have been entirely based on Parker's life. She was only one of sixty-four real-life cases of nineteenth-century child abductions in Texas he researched for his book. His notes suggest that Amos was likely based on Brit Johnson, a black man who ransomed his captured wife and children from the Comanches in 1865. Afterward, Johnson made at least three trips to Indian Territory and Kansas relentlessly searching for another kidnapped girl until Kiowa raiders killed him in 1871.

† Ford was also considering Robert Francis, who had shot to fame as Ensign Willie Keith in Edward Dmytryk's 1954 *The Caine Mutiny*, and played a leading role in Ford's *The Long Gray Line*. Not long after Ford chose Hunter, Francis was en route to promote the release of *The Long Gray Line* when on July 1, 1955, the plane he was on went down and he and the other two people aboard were killed.

Hunter was a handsome, strong young actor with a face as pretty as a studio starlet. He had signed a two-year contract with Twentieth Century–Fox in 1950 after the studio's talent scouts spotted him while he was still an undergraduate, in a play at UCLA (the contract would be extended every two years for the rest of the decade). Ford asked Zanuck for a loan-out of Hunter, the studio head agreed. However, smelling fresh meat, he couldn't resist giving Hunt the Ford "treatment." At the audition, after making him read scene after scene, and filming him, he made him take his shirt off and turn slowly around while flexing his muscles. Only then did he tell him he had the part. (Hunter became a favorite of Ford's and would go on to make two other films for the director: *The Last Hurrah* in 1958 and *Sergeant Rutledge* in 1960.)

To fill out the cast, Ford used many of his stock company regulars, including Ward Bond, Olive Carey (Harry Carey's widow), Harry Carey Jr., Ford's son-in-law Ken Curtis, and the young and beautiful Natalie Wood, who was already under contract to Warner Bros as the grown-up Debbie. For the child Debbie, Ford used her younger sister, Lana Wood. Pippa Scott played Lucy, Debbie's older sister. Vera Miles played Laurie Jorgensen, the daughter of the Edwardses' neighbors. She becomes entangled in a love triangle with Charlie McCorry (Curtis), who is available but without passion, and Martin, who is absent but filled with it. This subplot does not merely supply some romance and comic relief from Ethan's decade-long hunt for Debbie; it also serves as a warning of sorts to Martin, that he may turn into another Ethan, a lonely, bitter wanderer, if he doesn't settle down and marry Laurie. The relationship between Ethan and Martin also reflects (and inverts) the one between Ford and Wayne, with Wayne/Ethan the paternal, if tough Ford, and Hunter/Pawley the younger, greener Wayne.

The Searchers is immeasurably enriched by Wayne's extraordinary performance, filled with deep passion, a strong, if repressed sense of humanity, great physical strength and endurance, weariness, courage, and an eerie coldness, all wrapped up and held together by a controlled rage that is a window into Ford's personality and moral complexities.

The Searchers begins in the middle of the story, as Ethan arrives on horseback at his brother's home, his sagging body evidence of a complicated, dark life lived hard and tough. The audience soon learns he is a wanderer, but unsure from what or to where, whether he is running from something he did or

running to something he wants to do, a character Andrew Sarris described as "representative of a peculiarly American wanderlust."

Ford gives Wayne his best star entrance since the zoom-in of Ringo in *Stagecoach*. He is beautifully captured in deep focus by Ford's brilliant cinematographer, Winton C. Hoch. We discover Martha from behind as she opens the door of her dark house to see who is coming. There is a degree of fear in her manner as she walks outside. The frame of the door expands as if by magic until it disappears and the camera follows her out. Ford has taken us from the dark, close confines of Martha's home to the brightness of the wide-open plains (a scene reminiscent of Dorothy's stepping into Oz). Over her shoulder, we then see what she sees, her brother-in-law, Ethan, in the distance. He seems to have appeared out of nowhere riding slowly and deliberately into the center of the frame, toward Martha, and the audience. As Martin Scorsese remembers from the first time he saw the film as a boy, during its initial theatrical run, "Suddenly, this character, this lonely character, comes out of the desert or something, and he's absolutely terrifying."

Terrifying and, as we soon learn, an obsessive bordering on and frequently crossing the fragile boundary between sanity and insanity. Sarris satirized Ethan's character by borrowing from Shakespeare's *Twelfth Night*: "Some [characters] start out mad, some achieve madness, and some have madness thrust upon them." Ethan is not unlike Jimmy Stewart's Scottie in Hitchcock's 1958 *Vertigo*, a '50s film with distinct echoes of *The Searchers*. Both films are focused on characters obsessed with retrieving their past. Both are wanderers, whose searchings make their lives deeper and darker. Both are trapped in their own self-imposed emotional prisons. Both are figures of authority. Scottie is a retired police detective, Ethan a former Civil War soldier. And each causes the deaths of other men. The primary difference between the two characters and the films in which they appear is essentially stylistic; each reflects the personality of their respective directors. Hitchcock's Scottie is an innocent wanderer drawn into a complex scheme of stolen identities from which he seeks his liberation, while Ford's Ethan is a wanderer similarly obsessed by a crime of stolen identity but is by no means innocent. Scottie seeks his redemption through lost love regained; Ethan seeks his by killing lost love.

Ford reveals early on what has brought Ethan back home, when his sister-in-law Martha, played by Dorothy Jordan, is caught by the camera, and we see the

visiting Texas Ranger/clergyman Reverend Samuel Johnston Clayton, played by Ward Bond, who is having coffee in the kitchen. He is both an authority figure and a religious one, a character filled with the self-righteous entitlement that justified the great and violent expansion west. While Johnston is at the table, Ford's camera glimpses Martha caressing Ethan's cape as she stands alone in her bedroom, a telling moment so subtle it was missed by most viewers in 1956.

Nonetheless, as we will soon discover, it is the key to Ethan's character and explains all that follows. Peter Bogdanovich asked Ford about that moment: "Was the scene, toward the beginning, during which Wayne's sister-in-law gets his coat for him meant to convey silently a past love between them?" Ford: "Well, I thought it was pretty obvious—that his brother's wife was in love with Wayne . . . you could tell by the way she picked up his cape and I think you could tell from Ward Bond's expression and from his exit—as though he hadn't noticed anything." In the novel, their relationship is even more ambiguous. It is Amos who loves Martha but never confronts or expresses those feelings. We understand better now one reason for Ethan's wandering.

He has returned from a three-year absence, the war over and reconstruction the order of the day. He brings with him a considerable amount of gold pieces and a fancy Mexican Revolution medallion in his possession. During his visit, Ethan gives Debbie, his young niece, the medallion, a talisman of Ethan's prideful paternalism. It may be that Debbie, is, in fact, his own unacknowledged child, perhaps the real reason he left the homestead. Debbie's coming fate may be seen, at least in part, as Ethan's punishment for his forbidden love for Martha.

Not long after, Ethan, Martin, and a small party are lured away from the house by the Comanche, only to return to find everyone murdered and the house burned down to the ground. The Comanche have left behind a message, of sorts, Debbie's doll. They have taken Debbie and her older sister, Lucy. The moment Ethan realizes the girls are still alive, it ignites his obsessive desire to retrieve them. He vows he will bring both back. He sets out with Martin, the girls' half-Indian adopted brother, and Lucy's fiancé, Brad Jorgensen (played by Harry Carey Jr.). When Ethan eventually discovers Lucy's dead body (off-screen), an enraged Brad makes a suicidal attack on the camp of the Comanches (also off-screen) and is killed, suicide by Indian. Death stalks Ethan wherever he goes.

A decade-long Ahab-like pursuit on Ethan's part ensues. As the seasons change, and others' lives go on, Ethan's chances of finding Debbie alive grow slimmer. He learns that Debbie was taken by Scar (played by Henry Brandon, a European), the great white whale chief of the Nawyecka band of Comanches, and that he has made her one of his wives. There is a measure of vengeance working through Scar as well. The "white man" has taken his land, and he will take their women. Scar reflects the darker side of (the already dark) Ethan, and Debbie is reflected in Martin, Debbie's half-Indian stepbrother. Ethan reveals to Martin that he intends to kill Debbie when he finds her because Scar has made her his wife; he has violated her in a way that can never be taken back. The film then becomes a personal battle between Ethan and Scar as much for Debbie's soul as it is for her flesh. In the film's shockingly brutal climax, Ethan scalps an already dead Scar shot to death by Martin (Scar, we know, scalped both Martha and Lucy), and then goes after Debbie, to kill her. A desperate Martin tries and fails to stop him. When Ethan has Debbie cornered, he gets off his horse, twirls his six-gun, his signature move, and, in a transformative and redemptive instant, he swoops her up in his arms with the same majestic Fordian swoop Wayne used with O'Hara in *The Quiet Man*.*

After he delivers Debbie back to the Jorgensens, we glimpse Ethan one last time, through the same open door from the film's first shot, as he puts his left arm over his stomach and grabs his right elbow, before turning away and walking in that familiar John Wayne way. As the door closes, *The Searchers* ends as it began, in blackness, with Ethan still the outsider, unwilling or unable to rejoin society. With that arm-grabbing gesture (a move he suggested to Ford), Wayne became the Harry Carey of his generation.

Ethan Edwards is the most complex character Wayne had ever played, and it is without question the most internal performance of his career. His Ethan is at

* Wayne was, by now, suffering from a chronic bad back that made it difficult for him to lift Natalie Wood. In an earlier scene he also lifted Lana Wood, Debbie as a young girl. As Lana Wood remembered: "He was always very sweet to me. When I first met him, his concern was could he lift me . . . every day on the set he would come with his little box of Allenbury's Black Currant Pastilles for his throat . . . he was always ruffling my hair and giving me a hug . . . I was eight years old . . . Jeffrey Hunter was a beautiful, wonderful kind man . . . John Ford loathed children. He was not fond of me at all."—Lana Wood, interviewed by Red Carpet News TV, March 2013.

once manly and frightening, manly *because* he is frightening, one of the many uneasy truths of this performance and Ford's film, an ultimately uplifting story filled with murder, hatred, racism, vengeance, rape, and rage. While Wayne claimed never to be much of an actor, and certainly not a Method-style one, his performance has all the earmarks of an actor "living" his character. Here is Harry Carey Jr. recalling his reaction to watching Wayne play Ethan during filming: "The first scene I was in with Duke was the one where I discover that my family's prize bull has been slaughtered. When I looked up at him in rehearsal, it was into the meanest, coldest eyes I had ever seen. I don't know how he molded that character . . . He was even Ethan at dinnertime. He didn't kid around on *The Searchers* like he had done on other shows. Ethan was always in his eyes."

Wayne had played a simpler version of Ethan Edwards before, in Hawks's *Red River*. Both Ethan Edwards and Thomas Dunson are older, embittered men (Wayne had to look older for both roles). Each is a loner who reluctantly takes on younger partners. In *Red River* it is Montgomery Clift's Matt Garth; in *The Searchers* it is Jeffrey Hunter's Martin Pawley. Both films are centered around an obsessive journey. The main difference between the films is once again stylistic. Hawks's is externally motored; it races through its multigenerational story, pulsating toward its happy reconciliatory conclusion. Ford's is internal; it moves slowly, with a meditative drive that focuses on the interior journeys of its characters. In *Red River,* Tess Millay (Joanne Dru) is the key female love interest. She is loose, spirited, sexual, and aggressive. In *The Searchers,* the key love interest (besides Debbie) is Martin's Laurie, tight, spiritual, and aggressive. Both films share Wayne's brilliant, multidimensional performance of essentially the same character, differentiated and deepened by the stylistics of these two very distinct directorial masters.

When he first saw *The Searchers,* Hawks, with tongue firmly planted in cheek, flatly declared it "[t]he best color film I've ever seen!"

THE SEARCHERS WAS FILMED IN two stretches, one in June 1955, the second that August, to capture the winters and the summers that pass during the telling of the story. One part was shot in Monument Valley, the fifth John Ford production to be set there, and one part in Gunnison, Colorado, with

nine days of interior work at RKO-Pathé Studios, with a total budget of $2.5 million that Ford was able to meet almost to the dollar, the actual negative cost coming in at $2.502 million.

The scene where Ethan sweeps Debbie up in his arms was shot near Griffith Park in Los Angeles at midday on August 12, the next-to-last day of filming. That same afternoon everyone returned to the studio to shoot the winter scene, against artificial snow, during which Ethan promises Martin, "Injuns'll chase a thing till he thinks he's chased it enough. Then he quits. Same way when he runs. Seems like he never learns there's such a thing as a critter'll just keep comin' on. So we'll find 'em in the end, I promise you. We'll find 'em—just as sure as the turnin' o' the earth." It is to Wayne's everlasting credit that he could make this emotional shift from one scene to another in a single day, on cue at Ford's direction.

During the shoot, Ford's health was still frail, which may partly explain why he was less vitriolic than usual with Wayne. He was awed by the level of Wayne's performance and prudently decided it was best to leave him alone lest he upset his delicate balance of emotions Wayne was drawing up from inside himself to inhabit the character of Ethan Edwards. Ford wasn't going to go near that. Wayne was no Fonda; Duke might kill Ford if he tried anything funny with him.

Like *The Big Trail* a quarter of a century earlier, *The Searchers* was filmed in a new process intended to emphasize the expansive reach of the story and the glorious Monument Valley. Cinematographer Winton C. Hoch shot it in VistaVision, which yielded an exceptionally sharp image and allowed for greater depth of field, one of Ford's favored techniques. As with *The Big Trail,* there were only a few theaters equipped to show it in this format, one in New York and one in Hollywood. Most people saw *The Searchers* in standard 35 mm. The reduction of the print reduced the glory of Ford's vision, even as it sharpened and brightened the film's visuals.*

The Searchers opened March 28, 1956, after four months of delays due

* VistaVision (1:66 to one screen ratio) was different from CinemaScope in that it did not use an anamorphic lens that CinemaScope (2:66 to one) did, but turned the 35 mm negative horizontally in the camera gate, allowing it to shoot a single frame in a larger area. Special equipment was required to run the prints. That, and finer-grained film stocks that were developed, made VistaVision obsolete after only seven years, although it is still used by some filmmakers to produce a sharper image when necessarily reduced to 35 mm.

mainly to the difficulty of editing the VistaVision negative, to decidedly mixed reviews. *Variety* called it "overlong and repetitious." Bosley Crowther, writing in the *New York Times,* called it "a rip-snorting Western as brashly entertaining as they come . . . [it boasts] a wealth of Western action that has the toughness and leather and sting of a whip." In the June 6, 1956, issue of *The New Yorker,* John McCarten wrote, in part, that "*The Searchers,* John Ford and his celebrated road company, headed by fearless John Wayne, are back, chasing around Texas, fighting Indians, fighting each other and fighting time . . . the thing has to do with the search for a couple of maidens some nasty Comanches have abducted shortly after the Civil War, and it certainly has plenty of action." Robert Ardrey, in *The Hollywood Reporter,* was even less impressed than McCarten: "The same John Ford who once gave adults *The Informer* must now give children *The Searchers.*"

Audiences loved it even if the critics didn't, and it earned $8.5 million U.S. and Canada in its first year of release, making it the sixth-highest-grossing film of 1956. Wayne eventually earned $350,000 from his deal (his estate continues to earn revenue from the film).*

Although popular with audiences, Ford and Wayne's collaborative masterpiece did not impress the Academy, and it received no Oscar nominations. The favorites for Best Picture that went instead to overlong, huge, and hollow "epics" *Around the World in Eighty Days, The Ten Commandments, War and Peace, Giant,* and the winner, *The King and I.* Best Actor went to Yul Brynner for his signature portrayal of the King of Siam. Rock Hudson, the star of two of the top ten films of the year, was nominated for his role in the best of the nominated films, *Giant* (James Dean's last movie before he died; his performance was also overlooked by the Academy).† Best Director went to George Stevens for *Giant.* In these last-gasp years of the studios, "big" rather than better was the hoped-for antidote against the disease called television.

* The year's top-ten-grossing films, in descending order: Cecil B. DeMille's *The Ten Commandments* ($43 million); Michael Anderson's *Around the World in Eighty Days* ($23 million); George Stevens's *Giant* ($14 million); King Vidor's *War and Peace* ($12.5 million); Walter Lang's *The King and I* ($9 million); *The Searchers;* Joshua Logan's *Bus Stop* ($7.2 million); Frank Tashlin's *The Girl Can't Help It* ($6.2 million); Charles Walters's *High Society* ($5.9 million); and Douglas Sirk's *Written on the Wind* ($5.7 million).

† Dean was nominated for Best Actor twice, for Elia Kazan's 1955 *East of Eden* and *Giant.* He lost both times.

It wasn't until years later that *The Searchers'* greatness began to be recognized. Ironically, it was the French Marxist filmmaker Jean-Luc Godard, in the vanguard of the French New Wave, who was among the first to recognize the film's cinematic power, in the pages of the French bible of auteurism, *Cahiers du Cinéma*: "How can I hate John Wayne upholding Goldwater and yet love him tenderly when abruptly he takes Natalie Wood into his arms in the last reel of *The Searchers?*" After seeing the film for the first time in a Paris theater, Godard claimed he was so moved by Wayne's performance that he openly wept. In August 1999, Peter Bogdanovich in *The Observer* wrote that *The Searchers* was "a vivid and beautiful piece of Americana; it is certainly among Ford's greatest achievements—as entertainment, as art, as personal statement . . . an unqualified masterpiece." In a 1971 essay by Joseph McBride and Michael Wilmington in *Sight and Sound*, "Prisoner of the Desert," they wrote that "*The Searchers* has that clear yet intangible quality which characterizes an artist's masterpiece—the sense that he has gone beyond his customary limits, submitted his deepest tenets to the test, and dared to exceed even what we might have expected of him." In 1972, the highly respected *Sight and Sound* listed *The Searchers* as one of the "greatest films ever made." In 1992, it ranked it fifth; in 2002, eleventh; and in 2012, seventh. In 2008, the American Film Institute named *The Searchers* as the greatest western of all time. How much satisfaction it would have given Wayne to know that at long last, his film was considered better than *High Noon*!

The next generation of filmmakers lauded the film as an inspiration for their own filmmaking. Scorsese, discussing *The Searchers* for the American Film Institute, said: "The dialogue is like poetry, and the changes of expression are so subtle, so magnificent. I see it once or twice a year." In his early masterpiece *Taxi Driver,* Scorsese contemporizes Ford and Wayne's notion of the antihero as a wanderer, searching for and running from something he, and we, aren't quite sure of.

Director John Milius (who wrote *Taxi Driver*) called *The Searchers* "[t]he best American movie—and its protagonist Ethan Edwards is one classic character in films . . . I've seen it sixty times."

Steven Spielberg noted: "It has so many superlatives. It's John Wayne's best performance . . . it's a study in dramatic framing and composition. It contains the single most harrowing moment in any film I've ever seen."

George Lucas's massacre at the beginning of *Star Wars* is a direct homage to

The Searchers. And 1969's *Easy Rider,* directed by Dennis Hopper, the journey of the two motorcyclists updates the existential wandering of Ethan's and Martin's souls in *The Searchers*.

The film influenced the world of pop music as well. A year after it was released, the late Buddy Holly wrote "That'll Be the Day," after hearing Wayne repeat the line several times in the film. And in the '60s, a British band named itself "The Searchers."

Finally, years later, here is what Wayne himself said about the film and its lack of immediate recognition as a classic, either by the critics or the Academy: "You know I just don't understand why that film wasn't better received. I think it's Ford's best western . . . Ethan Edwards was probably the most fascinating character I ever played in a John Ford western."

In any western, or in any film by any director. Wayne, who always expressed himself best with a script in his hand and a director calling the shots, said little more about the film until twenty-five years later, when he was interviewed by *Playboy* magazine not long after winning the Best Actor Oscar for his performance in *True Grit*. When asked if he thought *The Searchers* was the best film he'd ever made, he bristled as he told the interviewer, "No, I don't. Two classic westerns were better—*Stagecoach* and *Red River*—[although I thought] *The Searchers* . . . deserved more praise than it got."

TWO DAYS AFTER *THE SEARCHERS* opened, Pilar gave birth to a seven-pound, eight-ounce baby girl they named Aissa. Wayne was ecstatic. Pilar describes him as behaving like a "blithering idiot" at the moment of their daughter's birth. Breathing life into a character on-screen was one thing; bringing life into the world was quite another. He was proud of *The Searchers,* but he loved Aissa. There were tears in his eyes when here affirmed his devotion to Pilar: "This is my second chance in life. This time, Pilar, I swear I'll do it right."

Chapter 19

The Academy's snubbing of *The Searchers* reconfirmed Wayne's long-standing belief that it would not let him win an Oscar. He never openly complained about it—he didn't want to give them that satisfaction—but it helped diminish whatever compassion he may have had for both the studios and the victims of the blacklist.

There was another reason he didn't make any noise about *The Searchers*: despite the public's acceptance of him in the film, and the solid box office, it was still a critical flop. Whenever a film of his opened that audiences loved and critics dismissed, he would tell friends that he laughed all the way to the bank. That was Wayne the actor talking; Wayne the producer understood that while he was at the moment the most popular star in Hollywood, it didn't always translate into automatic funding.

Thanks to the large financial successes of *Hondo, The High and the Mighty, Blood Alley,* and *The Sea Chase,* most times a nod from his leathery face was all that was needed to raise the money to make any movie he wanted. He had hoped to cash in on his popularity to produce *The Alamo,* but even he wasn't able to overcome the culture-defining popularity of Disney's Davy Crockett series, whose third episode of the original TV three-hour weekly series was called "Davy Crockett at the Alamo." Fess Parker, as Davy Crockett, was as popular in 1954–55 with preteens in America as Elvis Presley would be for their older

brothers and sisters a year later. Even for Wayne it was too difficult a cultural mountain to climb over.

The Searchers barely made money at the box office, but Wayne realized all his recent movies weren't breaking any records. *Blood Alley* managed to break even in its initial theatrical run. *The Conqueror,* released domestically a few months before *The Searchers,* had proved the disaster he knew it would be. It failed to turn a profit (not including the millions Hughes spent after it had finished its run to buy back the negative). *The Searchers* did okay, but it was not by any means a blockbuster. Suddenly, Duke the indestructible couldn't buy a hit.

After *The Searchers'* critical failure, Sonny Whitney decided to get out of the film business. Whitney was a wealthy kid who treated movies the same way Howard Hughes did, like a toy. After *The Searchers* opened, Whitney was already in preproduction on *The Valiant Virginians,* with Ford in place to direct, when he suddenly pulled the plug on the project. He met personally with Ford to assure him it had nothing to do with the success or failure of *The Searchers.* He now wanted to buy a chain of television stations, a medium in which be believed it would be much easier to make a lot of money.

C. V. Pictures made only two more films, both in production and hard to pull the plug on without taking a financial bath. One was Jerry Hopper's 1958 *The Missouri Traveler,* a turn-of-the-twentieth-century coming-of-age story starring Brandon deWilde (the towhead from *Shane*), Lee Marvin, a Ford stock company member, Gary Merrill, and Ken Curtis. The other was Ted Tetzlaff's 1959 *The Young Land,* starring six-foot-one Patrick Wayne, who bore a remarkable resemblance to his father but was only seventeen years old and needed both his and Josephine Saenz's written approval to work full-time (Wayne's only condition was that his boy work as an actor in the summer and agree to return to school in the fall). Whitney had signed Patrick to a $200-a-week contract for forty weeks, or $450 a week if the picture took less time, whichever was the larger amount. *The Young Land* also featured Dennis Hopper, Yvonne Craig, and Dan Dailey. When the two pictures wrapped, C. V. Pictures was history.

Ford suffered a period of severe depression after the cancellation of *The Valiant Virginians,* during which time he wrote a letter to Wayne, saying the pleasure of making movies had left him. The business was changing, Ford said, and he felt lost in this new world of independent-driven moviemaking.

CHARLES FELDMAN QUIETLY NEGOTIATED WITH Twentieth Century–Fox's production head, Buddy Adler, to secure Wayne a ten-year, minimum three-picture nonexclusive deal that would pay him $200,000 each year, with Feldman's commission to be paid by the studio and Batjac having the option to produce any or all of the movies.

It was a big score for Wayne in an industry that was rapidly shrinking. When asked by one reporter how he had landed such a great deal, he turned back to the past as a way of explaining the future: "There are only a handful of big stars left . . . They won't spend any money to make stars. They won't take a chance on kids. And the new ones who have come along all go in for that mannered [Method] acting. They won't take any direction." It was Wayne's defensive explanation of his own success; there was nobody left from the old days who was any good, and the new actors weren't his, and presumably his audience's, cup of tea. Wayne appeared to disregard his rather formidable contemporaries, including Robert Mitchum, Cary Grant, Jimmy Stewart, Burt Lancaster, Robert Taylor, Kirk Douglas, William Holden, Rock Hudson, and others who had come out of the system, as he had, and the younger crop of all studio-developed talent, including Clint Eastwood and Burt Reynolds, and all of whom were turning out quality movies.

And there was something else. The power of the notorious blacklist was at last beginning to fade after the 1954 censure of Senator McCarthy, and over the next several years the majors began to relax their official ban on "Communists." In addition, television was based on the East Coast and with close physical proximity to the theater, which was not vulnerable to Hollywood's blacklist. The medium still suffered, mostly because the revived postwar foreign markets wanted films that ignored the blacklist on actors, writers, and directors and gave a lot of the best exiled American talent, names like Robert Rossen, John Berry, and Bernard Gordon, among them, a second chance overseas.

At the same time, Wayne, who had once felt compassion for those he felt victimized by the blacklist and the HUAC hearings—which he pulled back from when he feared becoming a victim himself—now began once more to harden his stand against the left, a form of self-enshrinement he felt he deserved for all he had done on the front lines of the war on Communists. While more and more blacklisted actors began to find work, and writers and directors had kept working under assumed names, and those who had instigated or supported

the blacklist were either dying off or fading from power, Wayne remained uncompromising in his anti-Communism (some of his criticism of the new crop of talented youth who wouldn't "take orders" was Wayne's veiled accusation of their lack of respect for the industry, to him a step below a lack of respect for the country). His resistance to change was granite hard and the more doctrinaire he became, the more out of fashion he appeared. While the rest of the industry looked to survive by moving forward and changing with the times, to Wayne, the future was the enemy of the past.

ADLER HAD FULLY EXPECTED WAYNE to start immediately producing motion pictures for Twentieth Century-Fox. Wayne, however, demurred, telling Adler he needed a break. He said he had just become a new father and wanted to spend some quality time at home. Adler said he understood how Wayne felt, and that he should do what he needed to do.

He did—and decided to go out on tour to promote the long-delayed overseas opening of *The Conqueror* at the personal request of his good friend Howard Hughes.

Wayne had reasons to want to go. He had never been a doting father type, and the shift in dynamic from romance to rock-a-bye just wasn't doing it for him. And there was other family trouble. It began before *The Searchers* ended, when Mary Antonia "Toni" Wayne, his nineteen-year-old daughter from his first wife, learned her father's new wife was going having a baby just three weeks before she, Toni, was to marry twenty-seven-year-old law student Donald La Cava. Toni asked Wayne to walk down the aisle and give her away, and after, sit next to Josie at the church. To make things worse, Pilar was not invited.

Wayne had tried to reason with Toni. He asked her to change her mind about excluding Pilar, saying that she was his wife, but Toni absolutely refused. And then Pilar insisted he not go without her. He went to the wedding over Pilar's objections, and threw a reception for 750 invited guests at the Beverly Hills Hotel's Crystal Room. Among his friends there to celebrate the occasion were Ward Bond, Ann Blyth, Bob Hope, Ray Milland, and Loretta Young.

WAYNE FLEW WITH HUGHES ON his private plane to Paris, Rome, Italy, and Berlin for the premieres of *The Conqueror*. He loved the overflowing crowds of screaming fans fighting each other to get a glimpse of him. And he loved

running around Europe with Hughes, whose taste for women was almost as strong as his taste for money. Together, they made a formidable team, a pair of modern-day conquerors. On the way back to L.A. they stayed in New York for a week before Hughes convinced Wayne not to go home but instead to fly with him to Africa, ostensibly to scout locations for the next run of Batjac films.

Despite his promise to Pilar that this time he would get it right, the new John Wayne behaved a lot like the old John Wayne.

WAYNE'S FIRST FILM AFTER *THE Searchers* was made at MGM rather than for Fox, where his new deal was nonexclusive. It was a film biography of Ford's good friend, screenwriter Frank W. "Spig" Wead. Ford was reluctant at first to do *The Wings of Eagles*. As he told Peter Bogdanovich, "I didn't want to do the picture because Spig was a great pal of mine. But I didn't want anyone *else* to do it. I knew him first when he was deck officer, black shoe, with the old Mississippi—before he went into flying. I was out of the Navy then and I used to go out and see him and some of the other officers. Spig was always interested in writing and I helped him a bit and encouraged him. We did a couple of pictures together. He died in my arms . . . Everything in the picture was true. The fight in the club—throwing the cake . . . when they all fell into the pool . . . and the plane landing in the swimming pool—right in the middle of the Admiral's tea—that really happened."

The film follows as closely as possible (as close as Hollywood film biographies do) the life of Spig Wead, who, along with his friend Lieutenant John Price, played by Ken Curtis in the film, helped to take the navy airborne. In the picture, Spig marries Millie, played by Maureen O'Hara. They suffer the death of their infant son, which changes the dynamic of their relationship. Spig's constant traveling for the navy puts a further strain on their marriage. Millie pointedly stays behind with the children when he is sent to Washington. Upon his return, he tries to effect a reconciliation but suffers a horrible tragedy one night when he falls down a flight of stairs and breaks his neck. Diagnosed as paraplegic, Spig forces his wife and daughters out of his life and begins a long, difficult rehabilitation supervised by former navy mechanic "Jughead" Carson, played by Dan Dailey. Attempting to start a career as a writer, "Spig" teams up with a Hollywood director, based on Ford, played by Ward Bond, and gains some professional success and also regains limited use

of his legs. He reunites with his wife, and at the film's end is paid tribute by a crew line on a carrier deck. The film is filled with classic Ford sentimentality, the male heroes almost always in his film much more memorable than his female ones. According to O'Hara, "Despite all the horrible things John Ford had done to me, I reported happily to the set of *The Wings of Eagles* in August 1956 . . . it was good to be home again . . . I played 'Spig's' wife, Millie . . . the picture gave Duke and me some wonderful dramatic scenes, although much of my best work was left on the cutting-room floor. Millie Wead had slipped into alcoholism later in life, but, at the request of her children, Mr. Ford cut that wonderfully dramatic footage out of the picture. The edited picture was good, but not vintage Ford. Something was missing. Perhaps that old magic—the Ford-Wayne-O'Hara fire—had waned . . . I never worked with John Ford again."

THIS TENTH COLLABORATION BETWEEN FORD and Wayne was filmed in forty-seven days, from July to October 1956 on location in Pensacola, Florida, and finished at the MGM Studios in Hollywood. The finale was filmed on the aircraft carrier USS *Philippine Sea*. Pilar came along to the location with Aissa and remained with her husband for the entire shoot, except when he left for a few days to do an uncredited cameo in Hal Kanter's *I Married a Woman* (a.k.a. *So There You Are*), a goofy comedy starring George Gobel, a TV comic hot at the time, and the voluptuous Diana Dors, England's answer to Jayne Mansfield. Wayne had befriended Gobel and did the two-day shoot as a favor to him. In it, only Wayne is in color, the rest of the film remains in black-and-white.

The original budget for *The Wings of Eagles* was $2.79 million, but Ford was able to bring it in for a hundred thousand dollars less. It opened in 1957, and proved disappointing at the box office. MGM took a million-dollar loss. Audiences were not interested in a static story about a physically impaired hero and with a lot of overly narcisstic navel-gazing on Ford's part. If David Lean's *Bridge on the River Kwai* was the audience's favorite war film that year, it was because audiences preferred their heroes young, physically active and handsome, and could forgive their moral imperfections. William Holden's reluctant warrior would rather sleep with nurses than save the world, but in the final reel

makes the ultimate sacrifice. Holden's moral uplift at the end of *Kwai* was far more appealing than Wayne's being physically lifted up at the end of *Eagles.**

The commercial failure of the film confirmed to Ford that his times was over. The dialogue by Frank Fenton and William Wister Haines, based on the life and writings of Commander Frank W. Wead, had none of the snap and spark of Frank Nugent's classic Ford screenplays. Ford's filming of Spig's true story of loss, deprivation, struggle, and redemption lacked any true diamond writing or directional wit.

IN FEBRUARY 1957, WAYNE BEGAN production on Batjac's *The Legend of the Lost,* coproduced by Panama, Inc. Knowing he was going to be away overseas on location for at least three months, he asked Pilar to come with him. When she told him the baby was too young to be inoculated and therefore couldn't make the trip, Wayne suggested Pilar leave the baby in the care of a nurse. She refused, and Wayne reluctantly took off for Libya without her; they agreed to meet in Rome after the picture finished production at the famed Cinecittà Studios. He was gone less than a week when he sent her a telegram that he was sick, imploring her to come join him in Libya. She decided she had better go after all. After hiring a nurse, as Wayne had suggested, Pilar took off for North Africa. When she arrived, she found him in perfect health. He said he just wanted to share the glorious sunsets with her. The sunsets were great, but the accommodations were awful. Pilar was forced to share a mud hut with her husband (everyone involved with the production lived that way) and one communal toilet used by all.

The Legend of the Lost costarred Italian sex symbol Sophia Loren and Rossano Brazzi, both noticeably younger looking than Wayne; nevertheless he played the love interest to Loren, while Brazzi acted the villain. The story is centered around a hunt for a lost treasure that takes place largely in the blistering desert. While she was waiting for her husband, Carlo Ponti, to arrive, Sophia carried on an affair with Brazzi. Wayne didn't approve (maybe he was jealous) and neither did Pilar, who thought it unseemly for the international beauty to be so

* *Bridge on the River Kwai* won seven of eight Academy Awards, including Best Picture, Best Actor, Best Director, Best Screenplay. *The Wings of Eagles* wasn't nominated for any Academy Awards.

obviously disrespectful to Ponti. It created extra tension between Wayne and Pilar, perhaps because Loren showed her more clearly what goes on between married costars on location when they are away from their spouses.

When Wayne was ready to move the production to Rome, hoping that would make things easier for Pilar, she told him she had had enough, that she missed their child and needed to go home. After arriving back in Los Angeles, she confessed to a friend the trip had left her an emotional mess. He sent her to a Beverly Hills doctor who prescribed tranquilizers to ease her anxieties. She started taking them and quickly became dependent, and by the time Wayne returned home, she was like a zombie. Don't worry, Wayne reassured her, he was going to be home and for a long time and everything would to be better now.

WHEN *THE LEGEND OF THE Lost* was released in December 1957, it proved another box-office disappointment and Wayne believed his career might be in serious trouble. Not long after the opening, despite his promise to Pilar, he left by himself for Japan to make his first feature for Adler and Fox, the jingoistic *The Barbarian and the Geisha* (a.k.a. *The Townshend Harris Story,* a.k.a. *The Barbarian*). Directed by John Huston, it is the story of the first American diplomat in Japan, sent by President Pierce, who arrives in "the forbidden empire" in 1856 to a hostile reception. A cholera outbreak occurs, and a love story is worked in between Harris and a geisha, Okichi, played by Eiko Ando, a twenty-three-year-old local burlesque dancer who Huston felt was perfect for the part. She has been hired to kill Harris but falls in love with him instead. The romance fails and the film ends with Harris marching triumphantly through the streets to the Imperial Palace, with Okichi watching mournfully from afar.

The fourteen-week location shoot in Kyoto and Kawana produced a lot of friction between Huston and Wayne. They had never worked together before, and despite their perfect fit on paper, they proved not a good creative match. Huston did not appreciate Wayne's constant and unasked-for suggestions about directing, and Wayne felt that Huston's choices of shots, cuts, and camera placement were all wrong (it was something Wayne never tried with Ford). Moreover, as he always did, Wayne depended on guidance for his acting from his director, but Huston offered him none. Wayne felt that Huston was more interested in how a shot looked than the performance of the actors in it. Moreover, Wayne wasn't a regular part of the Huston "gang" of regulars, like Humphrey Bogart,

whose rapport with Huston made it easier for both to "understand" each other. Moreover, Wayne felt out of place in this historical romance drama. If Huston knew it, he didn't appear to care, about Wayne or the movie. He did care about Eiko, though.

During this production, Hughes decided it was finally the right time to release *Jet Pilot*. Wayne felt the film might make him look ridiculous costarring with Janet Leigh, especially since most people wouldn't know the film was seven years old. He reacted to the film's release this way: "My problem is I'm not a handsome man like Cary Grant, who will still be handsome at sixty-five . . . I may be able to do a few more man-woman things before it's too late . . . [and I'll look like a] silly old man chasing young girls, as some of the stars are doing."

Pilar decided to fly to Japan for the duration of the shoot, and it gave Wayne a chance to confide his frustrations over this film and *Jet Pilot* to her, which made her feel important and needed in his life. Not long after she arrived, Wayne brightened considerably at the news that his good friend Elizabeth Taylor and her husband, producer Mike Todd, were going to be passing through Japan and would like to stop by to visit. Wayne found Taylor down-to-earth, fun, with a salty tongue and that singular beauty highlighted by those famous dollar-coin-sized violet eyes. Wayne was less well acquainted with Todd but sensed they were kindred spirits of a sort, men's men, and he was eager to get to know him better. They instantly bonded and while Wayne chain-smoked and drank scotch, Todd puffed on the big cigars he loved; they spent hours swapping Hollywood stories, while Liz talked away the time with Pilar. It was a visit Wayne would not forget, for its ease, bonding, and relief, for both him and Pilar. He told Todd he hoped to see him back in the States and maybe work out a plan to make some movies together.

It never happened. Todd was killed four months later in a plane crash.

In February 1958, with only two weeks left to shoot, the excitement and relief of Pilar's visit had evaporated, and the tension between them became palpable, until Wayne suggested she go home and let him finish the film by himself. Pilar quickly agreed. One night, shortly after she arrived back in Encino, she was deeply asleep when the pet dog, Blackie, barked her awake. The house was on fire. She rushed down to the main floor, opened all the windows, got a fire extinguisher, went back upstairs to grab Aissa, wrapped her in a blanket, and then made a run for it back down the stairs and out the front door.

When Wayne found out, he promised to come home as soon as possible, and had Bö Roos send over a blank check to her to cover any immediate expenses. Pilar appreciated the gesture but wished Wayne had delivered it in person. She took the fire as an omen and wondered what would have happened to Aissa if she hadn't flown home earlier to be with her when the fire broke out.

THE BARBARIAN AND THE GEISHA was due to be released in the fall, and Wayne had hoped it would break his four-film slide, but he wouldn't bet on it.

His instincts were correct. The film opened September 30, 1958, to mostly negative reviews—Variety's expressed what Wayne had feld during filming. It praised the visuals but concluded that "the human story it tries to tell has been all but swallowed up by the weight of its production." The picture failed to make back its $4 million negative cost. When Wayne complained to Hedda Hopper that Huston was the reason for the film's failure, and she printed it, Huston returned the favor by publicly blaming Wayne for using his influence at the studio to make changes in postproduction that he, Huston, did not approve of.

It was the oldest story in Hollywood. Everyone takes credit when a film is a success, and everyone blames the other guy when it fails. In this case, whoever was right or wrong, the film flopped, and Wayne feared his career may have passed the point of no return.

He needed a hit, and he needed it fast.

Chapter 20

He got it with his next film, Howard Hawks's *Rio Bravo*. Hawks had last directed Wayne in *Red River,* and continued to have a string of hits, until 1955, when he directed and produced *Land of the Pharaohs* for Warner Bros, a sandals-and-robes epic that, despite the popularity of Henry Koster's 1953 *The Robe*, laid an atomic bomb. Warner Bros had advanced Hawks $2.9 million for the production and was not at all pleased the film failed to make back its investment, due mostly to the lack of star power, crucial in this genre. Jack Hawkins, a major star in England, voted its sixth-most-popular star in 1955, remained a familiar face without a real name or box-office draw in America.

Hawks was looking to return to form and decided the best way to do so was to make another western with John Wayne: "I came in and said to Jack Warner, I want to do *Rio Bravo . . .* and it started a whole cycle of [studio big screen] Westerns going again."

As it happened, Wayne and Hawks had each sought out the other to use as a way to return to the top of their respective games. Separately, they had both agreed about how much they had disliked *High Noon*. Wayne had told Hawks on more than one occasion how much he hated the film, and Hawks promised him they would make a film to "correct" *High Noon*'s misleading image of Americans. He later talked a lot about how disappointed he was with Hollywood after *High Noon* and another western, Delmer Daves's 1957 *3:10 to Yuma,* not for their politics—*High Noon* had plenty, *Yuma* had little, if any—

but for their "warped" portrayal of bravery. In Hawks's words, "I don't like *High Noon*. It's phony. The fellow's supposed to be good. He's supposed to be good with a gun. He runs around like a wet chicken trying to get people to help him. Eventually his Quaker wife saves his guts."

Putting aside the dramatic impact of that last act, it is interesting to see how long *High Noon* remained in the consciousness of Hollywood's premier filmmakers, and how little of what was supposed to be its antithesis really appears in *Rio Bravo*. It would be surprising if it did, as Hawks's films were never explicitly political, unless one may infer from his love of action a reverence for freedom, but either way he was not considered one of Hollywood's polarizing politicos. In *Rio Bravo* audiences simply wanted to see Wayne back in action in a western and in *Rio Bravo* they did.

In truth, *Rio Bravo* resembles nothing so much as a dry run of Wayne's vision of *The Alamo*—plenty of action based upon a premise that a small, tough, and dedicated group can hold off a much larger band of evil attackers.

Wayne left Encino on May 4, 1958, to begin filming *Rio Bravo* on location in Old Tucson, Arizona, leaving Pilar behind to "redecorate," or more accurately, clean up the mess left behind from the fire and supervise the construction crews. It was not a chore she wanted, and it left her with the feeling that she might be able to rebuild the house, but not so easily her relationship with her husband. She could not escape the sense of having been abandoned once again. Wayne made no pretense about what he wanted and needed to do; the unreal excitement of filmmaking was where he lived, not in a home with a moody wife and a crying baby.

As soon as he left, she began taking pills again.

RIO BRAVO WAS STUDDED WITH costars. Besides Wayne, the film had adult idol Dean Martin, teen idol Ricky Nelson, Wayne's pal Ward Bond, Walter Brennan, who had been Wayne's sidekick in *Red River*, and newcomer Angie Dickinson to provide some female heat.* According to Dickinson, "The

* Dean Martin wasn't Hawks's first choice for the role; Frank Sinatra was. Hanks wanted Montgomery Clift in the part that went to Ricky Nelson. For the villain, played in the film by John Russell, Hawks had wanted James Cagney, Richard Widmark, Rod Steiger, or Edmund O'Brien. In the film, for good luck Wayne wore the same tattered cowboy hat he'd worn in westerns since *Stagecoach*. After *Rio Bravo*, he finally retired it.

scenes we were in were long and complex and Duke was used to 'All right, get up, and I'll hit you again . . .' Usually, he had very short, tough [action] scenes in his movies. Ours went on for pages, for minutes, and they were very difficult. They ended up great, but it was hard work."

Wayne was paid $750,000 to appear in the picture, while Hawks only received $100,000 to direct.

Rio Bravo was released February 17, 1959, and played to sold-out audiences everywhere. Audiences loved it and so did critics, from its opening, wordless action sequence, which sets the tone and the pace for the rest of the film. *Variety* called it "[a] top-notch western . . . Wayne delivers a faithful portrayal of the peace officer." Andrew Sarris was among the first American critics to acknowledge the importance of Wayne's body of work to American movies. In his paper "The World of Howard Hawks" for the *New York Bulletin* in 1961, Sarris wrote, "[Wayne] has always been an underrated screen personality, and if one does not accept the preeminence of Wayne as the incarnation of the Western hero, one will have difficulty in fully appreciating the stature of Ford and Hawks' westerns."

Godard's critical love affair with all things Wayne continued with this movie: "*Rio Bravo* is a work of extraordinary psychological insight and aesthetic perception, but Hawks has made his film so that the insight can pass unnoticed without disturbing the audience that has come to see a Western."

Dave Kehr, writing about the revival of the film and its DCP (digital cinema package) release in the *New York Times,* said "the interaction among these characters [Dean Martin a drunk, Ricky Nelson a punk, Walter Brennan a grouch, Angie Dickson a lady gambler, and the local sheriff, John Wayne], as they come to form the group of people central to all of Hawks' work, is so vivid and alive and fraught with moral purpose that this supremely relaxed film is completely gripping."

From a final negative cost of just over $3 million, *Rio Bravo* grossed an impressive $30 million worldwide. It is still a favorite today, considered one of Hawks's better westerns. However, it does not compare to *High Noon* on almost every level and should not be measured against it. Hawks's and Wayne's private war with the Zinnemann film neither helped nor hurt *Rio Bravo,* but it did inspire it, and that is where any comparative discussions should end.

BY THE TIME WAYNE RETURNED to L.A. in mid-July 1958, he barely had time to unpack before preparing for his next film, a Civil War drama to be shot on location in Arizona and directed by John Ford, called *The Horse Soldiers*. To get it made, Wayne had signed a complicated three-picture non-exclusive deal with United Artists (UA), which guaranteed what he was really after, part funding and distribution of *The Alamo*.

This time, Pilar insisted she was going with him, and bringing Aissa. Wayne had no choice but to agree. Production on *The Horse Soldiers* was scheduled to begin that October, and Wayne was eager to keep in motion his newly ener-gized career. He didn't want any distractions and knew it would be easier to take Pilar and Aissa along than to have to go through all the pre- and post-drama that would take place if he didn't.

However, by late September, just before they were preparing to leave for Arizona, Pilar's pill addiction had gotten out of hand. It came to a climax one night when she ran out of her supply of tranquilizers and couldn't fight off the symptoms of withdrawal. When Wayne realized what was going on, rather than get her the refills she begged him for from the Beverly Hills doctor who had prescribed the pills, he threw away the empty bottles and insisted they could get through it together.

At least, as it turned out, until it was time for him to leave for Arizona, which he did and by himself. Two days later, against her doctor's advice, an insistent Pilar showed up, with Aissa, and without pills. Two days later she began to have hallucinations. Reportedly, she tried to slit her wrists. Wayne immediately sent her back to Los Angeles in a private plane and had her admitted to a hospital in Encino. Pilar's father came up from South America to care for the baby while Pilar stayed in recovery.

His wife's problems weren't the only ones that plagued Wayne during the making of *The Horse Soldiers,* one of his most beautiful and overlooked collab-orations with Ford. The director was unhappy with the script by John Lee and Martin Rackin and rightfully so. Few who have seen the film remember many of the plot's details, but no one can never forget Ford's beautiful visual of sol-diers riding their horses in single file and in shadows across the skyline horizon.

In *The Horse Soldiers,* Wayne plays Colonel John Marlowe, assigned to lead his Union soldiers on a mission of serial terrorism in the heart of Confederate

land. To play Major Henry Kendall, a doctor assigned to accompany the band of soldiers on their mission, Ford wanted Jimmy Stewart, but he had other commitments, and the director instead got William Holden, one of the most popular actors of the '50s, whose career had peaked with *Bridge on the River Kwai* and was now beginning its slow slide into decline. Ford charitably gave "Hoot" Gibson, the great film cowboy, a small part. Gibson was broke, in bad health, and needed money. Ford had a small part written into the script for him.

Unfortunately, the chemistry between Wayne and Holden was nonexistent ("Two Hellions" as the film's coming attractions described them, something neither one came close to playing on-screen; their real-life differences were mostly philosophical). They didn't work well together on-screen, nor did the mandatory love interest, played with sophistication by the gorgeous Constance Towers as a captured southern belle forced to accompany Colonel Marlowe on his mission until he can deliver her safely into the enemy's hands somewhere near Louisiana. The film's implied triangle between Wayne/Holden/Towers also doesn't work, and the film feels at least a half hour longer than its 119 minutes.

Some of the film's problems were the result of Ford's heavy drinking. Holden, who was a degenerate alcoholic, and Wayne needed little encouragement to join him in what became a booze-drenched set. Because of it, the film lacks Ford's usual precise timing and the much-needed sexual spark between Marlowe (Wayne) and Hunter (Towers). He is a gentleman, she is a southern woman of means. Their attraction is complicated by her repressed feelings for Kendall (Holden), and his for her. There should have been more dramatic tension and the lack of it leaves *The Horse Soldiers* an action picture without much action. What real drama there was occurred off-screen, when Ford hired Fred Kennedy as a stuntman. Kennedy was out of shape and, tragically, was killed falling off a horse as he doubled a shot for Holden. After that, Ford's already heavy drinking increased, so did Holden's and Wayne's, and they all lost any real interest in finishing the film.

Wayne and Holden each received a hefty $750,000 for being in the film, while Ford received $200,000 for directing and a percentage of the profits that never materialized. Its negative cost was just under $4 million and the film's net just matched it, off a gross of $10,200,000.

AS THE DECADE DREW TO a close, Wayne wanted more than ever to make his cherished film about the Alamo. He had already begun preproduction back in the mid-1950s by personally paying for the writing of a script by James Grant, his favorite screenwriter, whom Wayne also made a coproducer on the film. He had then taken it to Yates, who optioned it but was no longer in a position to finance anything. Yates told Wayne at that time no studio would back the film. The script as written was too long, had no sexual heat, and an ending that, even though it was based on historical fact, was too downbeat for Hollywood. In 1955, about a year after he turned down Wayne, Yates released his own version of the Davy Crockett Alamo saga, *The Last Command*, directed by Frank Lloyd, and starring Sterling Hayden as Jim Bowie. This incensed Wayne, who felt that he had been stabbed in the back by Yates, and perhaps worst of all, that Hayden was in the film despite his having confessed to being a Communist in front of HUAC. Because he had named names he was able to continue working, although his career never regained the level of stardom it once had.

Wayne then lost any shred of sympathy he had left for anyone caught in HUAC's career-killing web. And he had no forgiveness in him for Yates, who he rightly believed had stolen his movie and given it to a Commie. Wayne never worked for Yates again.

Wayne went to Jack Warner in 1959 hoping he would agree to make it to fulfill part of his multiple-picture deal contract with the studio, but Warner was not at all enthusiastic about the project, and advised Wayne to let the whole thing go, that it was too expensive for any studio to make, and that the days of the western epic had gone out of fashion. Besides, Warner told him, he was too old to play Crockett. Wayne disagreed. He said at fifty-two, he was only two years older than Crockett was when he died at the Alamo. Maybe so, Warner told him, but Disney's TV bio had officially lowered Crockett's age to make it possible for Fess Parker to play him. Besides, Warner said, heroes in film were always portrayed younger than they were in real life, to bring in the youth market that did most of the buying of tickets these days.

A disappointed and increasingly desperate Wayne then went to John Ford, who echoed Warner's (and Yates's) comments. When Wayne insisted he was not only going to get it made, but he was going to direct, produce, and star in it, Ford told him he was flat-out crazy. He had no experience as a director

and an epic like this, if he somehow did manage to get it funded, was not the project to start learning how to do it. The film, Ford concluded, had failure written all over it.

Wayne next took the script to UA and asked for a budget and for $7.5 million to make it. The studio agreed to give him $1.5 million up front and a commitment to distribute. That meant he would have to find $6 million dollars elsewhere. He went immediately to Howard Hughes, who turned him down. The increasingly reclusive billionaire said he was out of the movie business for good.

Furious, Wayne decided to put up the balance of the money needed himself and then hope to make his investment back by selling the negative to the highest bidder.

There was only one problem. By the end of the 1950s, after thirty-four years in the business and 139 feature films, the man at the top of the popularity charts, whose name was synonymous with Hollywood heroes, was flat broke.

Part Four

From the Ashes of *The Alamo*
to the Fires of Vietnam

Chapter 21

Wayne was shocked when he went to Roos to get the funds for *The Alamo* only to discover his financial manager had left him cash poor, and with almost no liquid assets. Wayne had never been very good at handling money, had showed no interest in what happened to his earnings, and trusted Roos, as long as Duke had enough cash in his pocket to pick up all the tabs and he could stay in the best hotels when he traveled with Pilar and Aissa. He believed that Roos had done a great job of watching his money.

The first sign of real trouble began shortly after he visited Roos to arrange to move some money from his individual investment company into Batjac to make *The Alamo*. Roos then explained that some of Wayne's investments had not made money, like the deal to raise cotton in Arizona that was currently bleeding dollars. And it wasn't the only problem. Wayne had recently written a check on his private account that the bank had returned unpaid. Why, he asked Roos, would a check with John Wayne's name on it be no good? That was when Roos finally told Wayne that he was broke. Besides the Arizona deal, Roos said, the substantial investment Wayne had made with the Arias family in Panama that dragged him unknowingly into the turbulent political scene there had resulted in the loss of nearly three-quarters of a million dollars and that Wayne was now being investigated by J. Edgar Hoover for possible criminal activities. (He was eventually cleared of all charges.) The Acapulco hotel Wayne owned had been badly mismanaged, a situation made worse by Wayne's open offer to all his friends that

they could stay for free whenever they wanted. A lot of them did just that. He would eventually give the building away to the YMCA, for the tax write-off.

The list went on and on. One bad investment after another, while Roos had treated himself to a lavish lifestyle paid for by his clients. For instance, when Wayne was on location in Japan for *The Barbarian and the Geisha,* Roos had joined him for a month, lived in an expensive penthouse, and spent thousands on food and geisha girls, all paid for out of Wayne's funds. Now Wayne pressed Roos to tell him exactly how much he had left, and Roos replied, "It's all gone. You've got the house, your personal possessions, and Batjac [without funds]. That's all I could save."*

Wayne fired Roos on the spot and replaced him with someone he was sure he could trust, his own son-in-law Don LaCava, Toni's husband.†

Nonetheless, he somehow managed to raise the $5 million to put *The Alamo* into production. Where it came from nobody is certain, although speculation has always pointed to Hughes, who became a silent partner in the project. There was, however, another investor who likely put up at least part of the money. That investor was John Ford. McBride says Wayne raised the money "from Texas millionaires," who wanted the story of what happened at the famous fort told again, but other sources point to Hughes and Ford as being Wayne's primary silent-partner investors.‡

PRODUCTION BEGAN ON *THE ALAMO* September 22, 1959, blessed the first day by a Catholic priest at the film's chosen location, Brackettville,

* Batjac's value was its negatives. It had no available cash. In order to raise money from it, the company would have to sell off its library, something Wayne refused to do. Roos handled the finances of several other major Hollywood stars, many of whom had similar catastrophic experiences. Red Skelton was one who lost a fortune and only found out when he discovered he didn't have enough money to pay for his child's hospital care. Others, like Fred MacMurray, held the reins tight on Roos and allowed him only to invest in blue-chip stocks. He, too, was ultimately dissatisfied with Roos's management techniques and fired him in 1956. When MacMurray died in 1990, he was worth a half-billion dollars.

† LaCava had no previous training as an accounted or investment manager. His only qualification was that he was a member of the family. He eventually formed Markland Management Associates. Wayne fired him in 1965 when Wayne, as had happened with Roos, went looking for immediate cash, and there wasn't enough money to pay bills. LaCava's inexperience had led him to put Wayne's money into dry oil wells and bad real estate deals, while operational costs for Markland Management and exhorbitant management fees drained whatever was left.

‡ Some of the other investors were Texas oilmen O. J. and I. J. McCullough ($2.5 million), and Texas businessmen Clinton and John Dabney Murchison ($1 million).

Texas, where an exact duplicate of the original Alamo was built at a cost of $1.5 million. The company was huge, over two thousand actors, extras, and crew people. John Ford was there and ready for the first setup, a presence that confused everybody and upset Wayne, who felt that Ford was trying to take over and turn *The Alamo* into a John Ford film.

Wayne wanted to ask Ford to leave, but couldn't. Besides the director's (probable) financial interest in the film, Wayne could never forget what Ford had done for him. But he had waited a long time to make this film, and he intended to make it his way. After conferring with his cinematographer, Bill Clothier, his son, Michael Wayne, the "assistant to the producer" on the film, and Cliff Lyons, the second-unit director, Wayne agreed to offer Ford the second unit by telling him that Lyons couldn't handle the job by himself. Ford took the assignment, for a fee of $200,000, a big bite out of Wayne's own pocket, money he really didn't have. Ford was hedging his own investment and gaining more influence on the making of the film.

While directing, Wayne began to take on Ford's more obnoxious characteristics, barking at his actors, belittling his stars, remaining distant and unapproachable. And his drinking increased.

Exactly how much of *The Alamo* Ford directed remains open to question. According to Wayne, none of the Old Man's footage made it into the final cut. According to Ford's own notes, however, he directed several key scenes, including some with Wayne that were definitely not second-unit stuff. When the film eventually opened, Ford called it "[t]he greatest picture I've ever seen."

Whatever Ford's contribution really was, the film that resulted was the one Wayne wanted to put in movie theaters. Throughout the '50s, Wayne's films— and the characters he played—had become more political, or patriotic, with *The Searchers* being the major exception. Although they were made in a different order than they were released, *Jet Pilot, Big Jim McLain, The High and the Mighty, Blood Alley, The Conqueror, The Wings of Eagles, The Barbarian and the Geisha, Rio Bravo,* and *The Horse Soldiers* all contained elements that not just promoted, but glorified "the American way." *Big Jim McLain* is certainly the most obvious, followed by *Blood Alley* and *The Wings of Eagles,* but even films like *The High and the Mighty* may be seen as parables demonstrating the might and right of the Christian American way of life; Dan Roman's quiet courage

and low-key profile bring him miraculously to the landing strip that looks like a giant cross. In *The Horse Soldiers,* Wayne's portrayal of Colonel John Marlowe is a display of courage combined with reverence that was a pre-*Alamo* culmination of Wayne's carefully cultivated image of the American hero. Dave Kehr, writing about *The Alamo*'s DVD release in the *New York Times,* called it "an important, personal film . . . in the context of Wayne's career . . . By the time of *The Alamo,* John Wayne didn't play Davy Crockett, Davey Crockett played John Wayne."

WAYNE HAD PROBLEMS CASTING THE film's other key roles. He had originally wanted Clark Gable to play William Travis, but Gable, who had no love for Wayne ever since the time years earlier that Wayne had made a mean-spirited comment about Gable's ears being bigger than his brain, claimed he had to turn the role down because he was already committed to *The Misfits* for John Huston. The role of Travis went instead to British actor Laurence Harvey, a choice that didn't sit well with some of Wayne's Texan investor friends, but Wayne assured them Harvey could bring something valuable to the role, a sense of dignity that would elevate the heroic element of the story of the men of the Alamo. Burt Lancaster was Wayne's first choice to play Jim Bowie, but Lancaster was already committed to Richard Brooks's *Elmer Gantry.* The role went instead to Richard Widmark, a committed liberal Wayne personally disliked but who, with time running out, he figured was the best screen tough-guy actor available.

When Widmark was cast, Wayne couldn't resist taking out a full-page ad in the trades that shouted, "Welcome aboard, Dick." The double-entendre jab wasn't lost on Widmark, who made it a point of telling Wayne the first day on-set, in front of everybody, that he was nobody's "Dick," that his first name was Richard. A few days into production, Widmark threatened to quit the film if Wayne continued to ride him. Because of the size of his part, Widmark's departure would likely have shut down the entire production. Wayne knew it and tried to bite the bullet but eventually during one scene the two went after each other. Widmark was strong, and it would have been an interesting brawl, but it never happened. The two men were quickly separated, sent to their neutral corners, and the shoot continued with no further clashes between them. Neither

talked directly to the other for the remainder of filming, but the damage was done. On-screen, their characters' friendship has zero chemistry.

Wayne wanted Sammy Davis Jr. for the role of Jim Bowie's slave, but Davis, extremely popular at the time as a nightclub performer and a member of Frank Sinatra's swaggering "Rat Pack," was embroiled in a controversy that had arisen over his relationship with Swedish blond actress May Britt. Davis's penchant for beautiful white movie-star blondes, a no-no at the time, was well known in Hollywood. He had been romantically linked a few years earlier with Kim Novak, Harry Cohn's and Columbia's answer to Marilyn Monroe (with whom Davis was also said to have had an affair). The Novak situation had led to Davis being physically threatened by Cohn, who had her under contract at Columbia and feared she would not be able to make films releasable in the South if she continued to see Davis. The versatile performer, who had lost one eye in a car crash a few years earlier, was told by Cohn he would lose the other if he continued to see Novak. Davis ended it but his next relationship, with Britt, cost her any chance of having a sustained film career in America, and Davis a role in *The Alamo*. The tabloid hysterics over Davis's relationship with Britt, especially when he announced they were planning to be married that November, was too much for Wayne to overcome, especially with his investors still upset over the Harvey casting. The part of Bowie's slave went instead to Jester Hairston.

Wayne, as Ford had always done, cast many of his friends and family. Ken Curtis was in the film; so was Patrick Wayne, Duke's son. Aissa, four years old now, played a small part as one of the children living at the fort. Even Pilar had some camera time. Her addictions behind her, she had agreed to accompany Wayne to Texas and stayed for most of the eighty-three-day location shoot. To add some youthful allure to the cast, Wayne, taking his cue from Hawks's successful casting of pop singer Ricky Nelson in *Rio Bravo,* found a part for teen idol Frankie Avalon.

Wayne hired cinematographer William Clothier to film *The Alamo*. The two had first worked together on *The Sea Chase,* after which Wayne signed him to a long-term contract with Batjac. Wayne had originally wanted to shoot *The Alamo* in Cinerama, the wide-screen process that used three synchronized projectors to show one gigantic image on specially made screens, but Clothier convinced him

not to, because so few theaters were equipped to play the film in that format. Instead, Wayne went with Todd-AO, a 70 mm film 2:220:1 aspect ratio process that required no special equipment for the film to be played in theaters.

That bit of practical thinking on Clothier's part saved Batjac a lot of money, but Wayne was not into counting pennies on this film. The payroll included four thousand extras and fifteen hundred horses, and Wayne upgraded the portable toilets and insisted every actor and crew member could have access to them. The lengthy shoot—from mid-September to mid-December—inflated the production cost to $17 million, or $90,000 a day. Wayne was desperate to find the extra money he needed to finish the film and at one point was about to announce the suspension of production when he managed to secure a considerable pledge from, of all places, the Yale Foundation.

It was still not enough. He gave up his salary, took out a second mortgage on the house in Encino, a second mortgage on an apartment he owned at the Hampshire House in Manhattan, sold off whatever property he still had in Mexico, and took out bank loans using his cars and *The Nor'wester* for collateral. *The Alamo* would now have to gross $4 million for him to recoup his personal investment in it. At one point during production, Wayne commented wryly, "I have everything I own in this picture—except my necktie."

He had to walk a fine line between politics and entertainment making *The Alamo*, and it wasn't easy, with his political vision all over the script, threatening to smother the film's dramatic action in a sea of verbal polemics. The Mexicans in the film represent the Communist threat that Wayne felt was still very real, the nineteenth-century Alamo a metaphor for the United States of 1960. The fierce, climactic battle in the film of the Texans fighting and defending their fortress against Generalissimo Santa Anna's forces was Wayne's metaphor, as he saw it, for America's ongoing battle against the subversive forces that wanted to destroy the country's way of life. Santa Anna's soldiers are costumed in Communist gray uniforms decorated with red epaulets, resembling nothing so much as Mao's Korean War "Volunteers." The film's opening narrative tells audiences that "Generalissimo Santa Anna was sweeping north across Mexico toward them, crushing all who opposed his tyrannical rule . . . The [men of *The Alamo*] now faced the decision that all men in all times must face . . . to endure oppression or to resist."

Crockett's love interest in the film is Mexican, Graciela Carmela Maria

"Flaca" de López y Vejar, a direct reference and a further blurring of the lines of between Wayne and Crockett. All three of Wayne's wife had been of Latin heritage. Fifty-three years old during the making of the film in 1960, Wayne cast twenty-six-year-old Argentinean-born Linda Cristal to play Graciela (Crockett was married twice; neither wife was Latin).

All during production, Crockett espouses "the American way." At one point, he says to Lopez, as he tries to explain why he's come to defend the Alamo: "I'm gonna tell you something, and I want you to listen tight. May sound like I'm talkin' about me. But I'm not. I'm talkin' about you. As a matter of fact, I'm talkin' about all people everywhere. When I come down here to Texas, I was lookin' for somethin'. I didn't know what. Seems like you added up my life and I spent it all either stompin' other men or, in some cases, gettin' stomped. Had me some money and had me some medals. But none of it seemed a lifetime worth of the pain of the mother that bore me. It was like I was empty. Well, I'm not empty anymore. That's what's important, to feel useful in this old world, to hit a lick against what's wrong or to say a word for what's right even though you get walloped for sayin' that word . . . here's right and there's wrong. You got to do one or the other. You do the one and you're livin'. You do the other and you may be walkin' around, but you're dead as a beaver hat."

During production, when he heard about it, Wayne publicly criticized Frank Sinatra for having hired Albert Maltz, one of the original Hollywood Ten, jailed for contempt in 1950 and subsequently blacklisted for years, to write the screenplay for a film about Eddie Slovik, the only American soldier executed by the U.S. military, for desertion during World War II. Wayne was outraged that Sinatra had hired a blacklisted writer without forcing him to use a pseudonym (the standard practice of the day). Not long after the completion of *The Alamo*, Wayne and Sinatra happened to be at the same restaurant shortly after Wayne returned from location, and the two men had to be separated before coming to blows.*

* Sinatra was never able to get the film made. A different TV version written by Richard Levinson and William Link, directed by Lamont Johnson, was made and shown on NBC in March 1974. The part of Slovik that Sinatra had originally wanted to play went to Martin Sheen. The blacklist was officially broken in 1960 when Kirk Douglas, the star and producer of Stanley Kubrick's *Spartacus,* adapted from the Howard Fast novel by Dalton Trumbo, insisted that Trumbo use his own name; he agreed, and that ended the blacklist. John Wayne and Kirk Douglas were friends, but Wayne was also furious at Douglas for using and crediting Trumbo.

Wayne wanted *The Alamo* to be a testament to America, to his America, how he wanted to define it and how he thought it should be. Davy Crockett died fighting to defend freedom from any and all enemies. That freedom was something Wayne was determined not to let anybody take away. His battlefield was as much Hollywood and the rest of America as it was San Antonio, Texas.

Not long after wrapping production on *The Alamo*, Wayne had received a phone call from Charles Feldman with the news that the film they had done some scouting for in Alaska during the making of *The Alamo* had finally gotten a green light. Wayne was practically packing his bags before he hung up the phone. As it happened, *North to Alaska* was to be his next film for Fox, not *McLintock!* at UA. Wayne would still make *McClintock!*, they assured Feldman, just not right away.

Buddy Adler at Fox had had no such qualms when he was first approached by Feldman during the making of *The Alamo*. Alaska had just become the forty-ninth state and Adler thought the tie-in would assure the film's success. As it happened, Feldman also represented Buddy Adler as well as two writers on *North to Alaska* (a.k.a. *Go North*, a.k.a. *Port Fury*), John Lee Mahin and Martin Rackin. Adler was recently divorced from actress Anita Louise and living with the French beauty Capucine, a discovery of Feldman. She was an actress whose career Feldman was not having much luck getting off the ground in America, and to do so he had introduced her to the head of Fox. American audiences usually wanted American actresses in their films. Few foreigners, except for the British, made the crossover easily. Dietrich was the big exception, but even she, at the height of her popularity, had to play either Nazis (Billy Wilder's 1948 *A Foreign Affair*) or Nazi sympathizers (Stanley Kramer's 1961 *Judgment at Nuremberg*), or exotic showgirls cast as some echo of Lola-Lola (George Marshall's 1939 *Destry Rides Again*). Language was the killer for most foreign actresses, no matter how beautiful they were. It was why Brigitte Bardot never made a successful American film. Feldman had assured Adler that Capucine could star in *North to Alaska,* and that Richard Fleischer, a veteran director whose career had taken off after Disney's 1954 *20,000 Leagues Under the Sea* and 1959's feature *Compulsion* for Buddy Adler at Fox, a fictionalized account of the Leopold-Loeb murders, was eager to direct. Adler was confident this project had all the right components to make a big hit.

And then a series of disasters struck. Before the film could begin produc-

tion, Adler died from lung cancer at the age of fifty-one and Fox was taken over by Spyros Skouras, who was less than thrilled with the project. Fleischer then had second thoughts and for the first time said he wanted to see a script, but Mahin and Rackin had nothing ready. Fleischer had also had reservations about being able to direct Capucine as a prostitute. To him, she did not project a lot of heat. He wanted off the film now but didn't want to offend Feldman. He consulted with a friend who told him the easiest way out was to simply call Feldman and tell him Fleischer didn't think Capucine was right for the role.

Feldman released him and hired Henry Hathaway, another client, and more important, a director Wayne was comfortable with. Hathaway had already made a couple of films with Wayne, including 1941's *The Shepherd of the Hills,* a film Wayne had liked, and 1957's *Legend of the Lost,* and he was eager to work with him again.

And then the Screen Writers Guild went out on strike and Hathaway and company had to make the movie without a finished script. The SWG had been the hardest hit during the height of the blacklisting. The strike proved just how dead blacklisting really was, if the writers were willing to risk staging a walkout to protest wages, residuals, credits, and other things they felt they deserved.

EARLY IN MAY 1960, JUST two months after completing *The Alamo,* Wayne found himself back in front of a camera, where he stayed for the rest of the summer, filming the lightweight *North to Alaska,* his second film for Fox, costarring Capucine, Stewart Granger, Fabian (another teen idol inserted into a movie to attract younger audiences), Mickey Shaughnessy, a character actor who could also throw a convincing screen punch, and Ernie Kovacs as Wayne's rival for the gold, an extremely popular actor and comedian and early TV pioneer, who would be killed a year later in a car crash. The film is also notable for its theme song, "North to Alaska," which became an enormous hit for Johnny Horton, killed not long after in a car crash.

Making the film, being back in the saddle as it were, lifted Wayne's spirits. He had had nothing to do with producing it and after *The Alamo,* to chase Capucine around in her bustier and throw a few fists at Granger and Kovacs was not the worst job in the world.

He was surprised and delighted when both he and *North to Alaska* received

positive reviews. Eugene Archer, in the *New York Times,* wrote: "Mr. Kovacs is droll as the would-be nemesis and Mickey Shaughnessy brightens a moment or two as his drunken stooge, but the proceedings are easily dominated by the indefatigable Mr. Wayne. Straddling the muddy terrain without benefit of his customary six-gun, he proves that he can carry his tongue in his cheek with the same impregnable aplomb."

As much fun as he had making the film, it also helped ease a lot of financial woes for Wayne. He received $666,666.67 to star in what was Fox's most expensive film that year. The gamble paid off. *North to Alaska* proved a big hit, earning a domestic gross of over $12 million in its initial domestic release, from a budget of $5 million. And there was not even a whiff of stale politicking anywhere to be found in it. The film's numbers were great for Wayne. He was back in the money, and back in the big show.

FOURTEEN YEARS AFTER HE FIRST thought of making a film commemorating and re-creating the famous Texas battle, *The Alamo* opened October 24, 1960, with a gala tent-pole premiere held in San Antonio, paid for by Wayne, to offset "[o]ne smart-aleck remark from a newspaperman on opening day that could cost us plenty." The road to San Antonio turned out to be another battle for Wayne, this one behind the scenes to ensure the film received ample publicity in its buildup. Batjac originally hired Jim Heneghan to promote the film, with one eye on a rollout that would build to a climax with a klieg light "event" premiere, and the other on making *The Alamo* a certain contender for that year's Oscar race.

Heneghan's strategy was to wine and dine critics, features writers, radio and TV talk-show hosts, anyone he felt could help promote the film. However, when too many women's names showed up on Heneghan's expense accounts who did not make their livings by writing and not enough writers who did, Wayne angrily fired him. Heneghan immediately sued, and to avoid any unwanted negative publicity, Wayne paid him his full fee of $100,000, and all the questionable expenses he claimed he had accrued.

With no one to promote the film and the clock ticking, Batjac then hired Russell Birdwell, who had golden credentials; he had been in charge of the great publicity campaign for *Gone with the Wind,* which had climaxed with the star-studded Atlanta premiere. It didn't get any better than that. Wayne

agreed to pay him $125,000, plus all expenses, and provide office space for the duration both in New York and Beverly Hills. Batjac allotted $1 million for Birdwell to spend on media advertising, one-eighth of the film's original budget, one-twelfth of what it actually cost to make.

Birdwell immediately issued a 183-page press release and arranged for ABC to air a network special the night before the film's opening, called *The Spirit of the Alamo,* in which Wayne appeared and read a letter out loud written by the real Davy Crockett. After, Wayne looked with squinting eyes straight into the camera, and warned viewers in his slow-paced style, "Nobody should come to see this movie unless he believes in heroes."

The next day, he continued promoting his personal message as much as the film, telling *The Hollywood Reporter,* "I think we've all gone soft, taking freedom for granted . . . I think [the film] will be a timely reminder to Americans and the world that freedom does not come cheap and easy."

THE ALAMO **PROVED A GIANT** step forward in Wayne's self-assigned mission to be, on film at least, America's Great Defender of Freedom, but a giant step backward in Wayne's development as a filmmaker and the complexity of his acting, which had reached its zenith in *The Searchers*. Everything that film was, *The Alamo* wasn't. Any trace of Ethan Edwards's dark, ambiguous, existential antihero was nowhere to be found in Wayne's two-dimensional portrayal of Davy Crockett as loyal chauvinist. Ethan questioned everything and by doing so upset the status quo. Crockett questioned nothing and fought to maintain the status quo. In *The Searchers,* prejudice and vengeance set up the film's redemptive climax. In *The Alamo,* there is nothing revelatory about the film's inevitable climax. Wayne's vainglorious performance as Crockett is sometimes painful to watch. At one point Crockett greets a blind man, the allusion to Jesus Christ unmistakable and completely out of place. If *The Searchers* was Ford's great and existential epic poem, *The Alamo* was Wayne's unspectacular and bloated propaganda prose.

Lacking either surprise or suspense—virtually everybody knows how the movie ends before they see it—at the premiere, which ran 202 minutes, *The Alamo* felt even longer than the real thirteen-day battle. After it opened for general release, at UA's insistence, and over Wayne's vehement objections, it was cut to 167 minutes. At thirteen minutes under three hours it was still too long

to allow for as many plays-per-day as the standard two-hour film, and as UA feared, it hurt the film's gross.*

The critics were neither thrilled nor enthralled by the film. Most shared a similar complaint, too much Wayne, not enough Crockett. The *New York Times'* Bosley Crowther compared the film unfavorably to the immensely popular Disney version and wondered if the generation that grew up on coonskin caps and "b'ar-killing" would accept Davey Crockett as an older, more preachy character: "Whatever the case, we can assure you that [Davey Crockett] in 'The Alamo' is much less a convincing figure from history than he is a recreation of Mr. Wayne."

The *Southern California Prompter* pointed out the film's unmistakable allegory: "If he is saying that America needs about 10 million men with the courage of Davey Crockett, Jim Bowie and Colonel Travis, the point is well-taken. It may also occur to some he is suggesting that the easy answer to today's complex problems is to pit this raw courage against Russia's 10 million Santa Annas."

The *New Yorker* dismissed the film as "sentimental and preposterous flapdoodle . . . a model of distortion and vulgarization."

Even conservative *Time* magazine could not find anything good to say about it: "Wayne & Co. have not quite managed to make it the worst [big western ever made]."

Wayne was determined to find an audience for film, despite all the negative reviews, and asked Birdwell to devise a new advertising campaign. However, before any of that could happen, Wayne received a phone call that brought tears to his hard eyes. On November 5, 1960, fifty-seven-year-old Ward Bond was dead. He had been Wayne's closest friend from their earliest days together at USC, and they had made twenty-three films together. Bond had finally gained a measure of real stardom with his portrayal of Major Seth Adams in the hit TV series *Wagon Train,* for which he had completed 134 episodes starting in 1957. That November weekend he had flown to Dallas during a break in production from the TV show to watch the L.A. Rams play the Cowboys. Shortly after arriving, he was taking a shower in his hotel room when he died from a massive heart attack.

* The original 202-minute version was released in VHS and laser-disc formats, but not on DVD due to the deterioration of the original negative. A massive new painstaking restoration is currently under way that will result in the original 202-minute version being made available in DVD and Blu-ray.

Wayne was sickened by the news. Other friends had passed, most notably Grant Withers, a member of the John Ford stock company, who couldn't get over his addiction to pills and alcohol and committed suicide in March earlier that year. Wayne had felt bad about not being able to do more for Withers, but Bond's passing was worse. When Bond's TV show became a hit, as if on cue his eating and drinking increased, one long celebration of his long overdue stardom. After the show's producers began to complain about his excessive weight for a man supposed to be rugged and in shape enough to lead wagon trains across the rough and dangerous terrain of the country, he did what everybody did in Hollywood in those years when told to shed pounds: he went on amphetamines. He popped the little pills like they were nuts on a bar top.

At the time of Bond's death, Ford also happened also to be in Texas, directing *Two Rode Together* with Jimmy Stewart and Richard Widmark. He interrupted filming to take Bond's body back to California, accompanying his widow, Mary Lou. The funeral was held at Field Photo Farm in Hollywood. Ford didn't stay for it; he had to get back to Texas and resume production on his film. Wayne gave the eulogy, during which he called Bond "a wonderful, generous, big-hearted man."

He was devastated by this loss but knew he had to keep his focus on *The Alamo*. His goal was to turn it not just into the biggest film of the year, but the biggest of his career. In the first three months of release, *The Alamo* earned only $2 million in rentals, far short of the $17 million needed to break even. Wayne then knew that the only thing that could save his film now was a big showing at the Oscars. Out of his own pocket he gave Birdwell an additional $75,000 to devise an Oscar campaign and, at Wayne's directive, to aim it squarely at the Academy voters.

One of Birdwell's industry ads listed the sizable number of paychecks that went to "American citizens" during the making of *The Alamo*, to remind everyone in the business of Wayne's contribution to employment in Hollywood during a period when hiring had dipped. And Wayne allowed himself to be interviewed by several L.A.-based journals, during which he talked about the film's Oscar-worthiness in political, rather than cinematic terms. In an interview with Dick Williams of the *Los Angeles Mirror,* he said, "The eyes of the world are upon us. We must sell America to countries threatened with Com-

munist domination." In response, an unimpressed Williams, wary of Wayne's proselytizing disguised as promoting, in his piece compared Wayne's Oscar tactics to the pressure he had applied during the height of the blacklist: "The impression is left that one's proud sense of Americanism may be suspected if one does not vote for *The Alamo* . . . Obviously, one can be the most ardent of American patriots and still think *The Alamo* was a mediocre movie."

WHEN THE NOMINATIONS WERE ANNOUNCED the morning of February 27, 1961, *The Alamo* had seven—Best Picture (John Wayne/Batjac, UA); Supporting Actor (Chill Wills); Best Film Editing (Stuart Gilmore); Best Sound (Gordon E. Sawyer, Fred Hynes); Best Score (Dimitri Tiomkin); Best Song (Dimitri Tiomkin and Fred Francis Webster); Best Cinematography (William H. Clothier). Sidney Skolsky, in his syndicated column, made fun of both Wayne's campaign for Oscar, and its apparent success: "The biggest surprise . . . was the Best Picture nod for *The Alamo*. It appears more people voted for the film than have seen it."

Wayne's campaign seemed to be working, until Chill Wills, who was in the film only to provide some (much-needed) comic relief, went on a desperate campaign of his own for what likely would be his only chance at a coveted golden statuette. He wrote each member of the Academy a personal note, ending with: "You're all my cousins and I love you all." Groucho Marx, a voting member, published his response in the trades to Wills's campaign: "Dear Mr. Chill Wills. I am delighted to be your cousin but I voted for Sal Mineo [for his performance in Otto Preminger's *Exodus*]." At the Screen Writers Guild Awards dinner not long after, comedian Mort Sahl quipped that Groucho Marx should be given an Oscar for Best Ad.

The fact was, for all the joking about it, Wills's personal campaign had turned off a lot of industry voters and by doing so hurt *The Alamo*'s overall chances. The day after Marx's response to Wills ran, an infuriated Wayne placed an ad in *Variety,* denying he had known of, or given his approval to, Wills's self-promotion campaign. Not long after, Darryl F. Zanuck, the head of Twentieth Century–Fox, who was disgusted with both Chill's bone-headed actions and Wayne's self-important public rebuke, and for that matter the film's entire "vote for my film to prove you're really an American" Oscar campaign, publicly re-

ferred to Wayne as a "poor old man" out of touch with the Hollywood of the poststudio era. That put Chill Wills in even hotter water with Wayne, who then took out *another* ad in the trades, insisting that he had had nothing to do with his own campaign, and blamed all the intimidating implications on Birdwell, which infuriated *him*, while all Hollywood ignored Wayne's cop-out and continued laughing at Wills's campaign and what was mostly viewed at Wayne's pathetic attempts to somehow link voting for *The Alamo* with the Waldorf Statement.

THE ACADEMY AWARDS CEREMONIES WERE held on April 17 at the Santa Monica Civic Auditorium, hosted by Bob Hope and televised in the United States over the American Broadcasting Company and seen all over the world. Wayne attended the Oscars with Pilar, he in black tie, she in full gown. In his opening monologue, Hope got the biggest laugh when he made fun of the brouhaha over Wills's ill-conceived self-promotion: "The members of the Academy will decide which actor and actress has the best press agent. I didn't know there was any campaigning until I saw my maid wearing a Chill Wills button!" Later, deep into the endless show, just before Hope brought on Eva Marie Saint to present Best Supporting Actor, he couldn't resist taking one last shot at Wills: "There are five actors being held down by their psychiatrists and their cousins."

Saint then came out, read the names of the nominees—Wills, Sal Mineo, Peter Falk for his performance in Stuart Rosenberg and Bob Balaban's *Murder, Inc.,* Jack Krushen for Billy Wilder's *The Apartment,* and Peter Ustinov for Stanley Kubrick's *Spartacus.* Saint opened the envelope and a roar went up when she announced the winner—Peter Ustinov. Wills, in the audience, caught in close-up by a TV camera, looked deflated. Wayne, meanwhile sat stone-faced, showing no expression.

As the evening dragged on, it became clear that even if *The Alamo* had deserved to win, the Academy was not going to reward Wayne's movie, not because it wasn't a good film, but because of the misguided, politically offensive campaign he had waged for it. Except for one Oscar the film won for Best Sound, which went to a group of unnamed technicians from the Sam Goldwyn and Todd-AO sound departments, *The Alamo* was completely shut out. Best

Picture went to Billy Wilder's *The Apartment,* produced by the director and Mirisch/UA, Color Cinematography went to Russell Metty, for *Spartacus,* Best Song went to Manos Hadjidakis for the title song to Jules Dassin's *Never on Sunday,* and Best Score went to Ernest Gold for *Exodus.*

Then it was over. The lights came up, and everybody shot for the exits racing to get to the post-Oscar parties to follow. Wayne, not wanting to appear angry or disappointed, took Pilar. Going through the motions was something they were never good at, not just for the public, but in their relationship, in which, increasingly, they acted as if they were making a movie of their marriage for some invisible camera, rather than actually living it.

BY THE SPRING OF 1961, Wayne was filled with emotions, none of them good. He was facing financial ruin because the public had not supported *The Alamo.* He was disgusted at the election of John Kennedy over Richard Nixon, the effective end of the blacklist, and had ongoing grief over the death of Ward Bond.

Approaching fifty-five, bloated and balding, he felt over-the-hill. He was convinced no studio would ever hire him to direct another movie, and he was no longer in any position to finance one himself. Zanuck's words haunted him like some hit song playing endlessly in his head that he couldn't stop hearing. *Poor old man . . . poor old man . . . poor old man.*

Chapter 22

Wayne's next acting job was *Hatari!* made for Paramount Pictures, directed by Howard Hawks. *Hatari!* had been filmed in 1960, but not released until 1962. It was a purely action film, light on plot, heavy on action. According to Hawks, "*Hatari!* in a way was a Western . . . We never knew in the morning what we were going to do that day—we had three or four spotting airplanes, and just as dawn broke, they would go up and radio back to us. One would say, 'I found a really good herd of rhino,' and by that time we'd be on our way . . . we had fun." The film was, ostensibly, about big game hunting in Africa, but really about the special joy of male bonding past the age of adolescence (or at the prime of an extended one). Much of it was filmed in Tanganyika and was long on macho and short on meaning; it was nonetheless highly entertaining, and upon its release well received by critics and audiences, and further helped replenish Wayne's depleted coffers. Much of the dialogue was improvised, according to Bogdanovich: "'Well,' Hawks said, 'you can't sit in an office and write what a rhino is going to do . . . we had to make up scenes in an awful hurry.'" Wayne had flown to Africa in November, just weeks after completing *North to Alaska*.

He next appeared in 1961's *The Comancheros,* directed by Michael Curtiz at Fox (made after but released before *Hatari!*). At fifty-four, he had gotten too old to play romantic heroes and wisely let others be the lovers in his movies, here the younger, virile Stuart Whitman.

Wayne wanted to be surrounded by families and friends while making the film. William Clothier, *The Alamo*'s brilliant cinematographer, was back behind the lens, and two of Wayne's children had roles in the film, his son Patrick and his daughter Aissa. Pilar came along for the duration of the location shoot that took place in the part of the Mojave Desert that reached into the southern tip of Utah. In the film, Wayne plays a Texas Ranger trying to stop a gunrunning band of renegade Comancheros.

Curtiz was sick during filming, and Wayne directed most of the picture, unaccredited out of respect for Curtiz, who passed shortly after the film was finished and before its release.

Not long after they returned home from Utah, Pilar announced she was pregnant again. If anyone thought it odd that Wayne was still having children at his age, he had the same answer for all questioners, should any have the nerve to ask: "The difference in our ages is not a problem! And if it ever gets to be one, I'll just have to find a younger woman!"

Pilar was excited about having another baby. One night late in her pregnancy, watching *The Searchers* together on TV, she suddenly turned to Wayne and asked if they could name their child Ethan if he was a boy. He happily said yes.

An hour later, on the morning of February 22, 1962, she went into labor and an hour after that gave birth to John Ethan Wayne. Wayne had two grandchildren older than his new baby boy.

Wayne was reenergized by this new round of fatherhood, and his productivity showed it. In the two years that followed he made *The Man Who Shot Liberty Valance, The Longest Day, How the West Was Won, Donovan's Reef,* the long-delayed *McLintock!, Circus World,* and *In Harm's Way,* an output of films ranging from awful—*Circus World*—to one of the finest films of his career, John Ford's *The Man Who Shot Liberty Valance.*

When *Valance* was released in 1962, it appeared to critics and whatever audiences who saw it as something of a throwback, a black-and-white western with three actors all too old for their roles—Jimmy Stewart as a young lawyer, Wayne as a gunfighter—and Andy Devine back in the Andy Devine comic-relief role. It also had one over-the-top villain, the title's ironically named Liberty Valance (valiant liberty?), played with high-end menace by Lee Marvin,

who had been a member of the Ford stock company for years without being able to land the right role to turn him into an A star. Although *Valance* didn't do it, a few years later in Elliot Silverstein's 1965 western spoof, *Cat Ballou,* he cleverly sent up his role of Valance and won a Best Actor Oscar for it, an award overdue, won, at least in part, to Wayne's insistence to Ford that Marvin play the murderous villain in *The Man Who Shot Liberty Valance.*

Bogdanovich once described *Valance* as "a deceptively simple Western which concludes, metaphorically, with a U.S. that has buried its heroes in legends that are false, that has built out of the wilderness an illusory garden and left us tragically longing for the open frontiers and ideals we have lost." On a more tangible level, *Valance* is a hard-edged, bitterly ironic drama told against the backdrop of the decline of the Wild West and the displacement of the tough men who made it fit for decent people to live by the politicians, who take it over for profit and self-aggrandizement. In other words, as one character says in the film, *when the truth becomes the legend, print the legend.*

Valance begins with the arrival of so-called civilization, in the guise of Jimmy Stewart, pushing sixty in real life, heavily made up to play young Ransom "Rance" Stoddard, an eastern tenderfoot lawyer come to the western town of Shinbone to start his practice. Even before his stagecoach arrives, it is held up and he is brutally beaten and robbed by Valance and his gang. Stoddard barely makes it to town and takes a job in a kitchen to try to earn enough money to open his own law practice. One night while serving a steak to Tom Doniphon (John Wayne), a horse-trader, he is tripped by Valance, who then tries to make Stoddard pick up the steak. At that point, Doniphon intervenes, stands up to Valance, and humiliates him with a display of genuine toughness that sets up their eventual showdown. In the interim, Stoddard falls in love with Hallie, played by the beautiful Vera Miles, and without knowing it, he steals her away from Doniphon, who was building a house for himself and Hallie to live in after their marriage. She leaves the past behind to find her future. Stoddard's presence marks the end of Doniphon's time, and the Wild West he helped conquer.

At this point, politics enters the film, via the free press, which Valance detests. One night in a rage he burns down the town's only newspaper. He then sets up a shoot-out with Stoddard. Stoddard, shaking with fear, takes pistol

lessons from Doniphon, and when the final confrontation takes place, a trembling Stoddard somehow kills the drunken Valance and then uses his newfound celebrity as the basis to jump-start a political career that will take him all the way to the Senate. The film is told in flashback, as Hallie and Rance Stoddard return to Shinbone to pay their last respects to Doniphon, after they learn of his passing. Rance, known by everyone as the man who shot Liberty Valance on the train, finally tells Hallie the true story of what really happened that night. We watch that story as Stoddard tells it to Hallie.

The Man Who Shot Liberty Valance was made five years after *The Searchers*, and it was a disappointing flop when it opened, written off by most critics as just another John Wayne western, the most memorable thing about it being Wayne's use of the word *pilgrim* to describe Rance. It became an overnight touchstone for every Vegas impersonator, added to their stock Wayne imitation of the pigeon-toed walk and the choppy monotone speech pattern. Today the film is regarded as among the greatest westerns ever made, an antithetical dialectic to *The Searchers*. Each film clarifies the other.

Ford first became interested in *Valance* in 1960 when he'd come across a 1949 short story in *Cosmopolitan* magazine, written by Dorothy M. Johnson, a journalism professor at the University of Montana. Having secured the rights, Ford approached Wayne about being in it. Wayne couldn't say no to Ford, especially with the Old Man's health so fragile. Every film they made together now could be the last. Ford also cast the immensely popular Jimmy Stewart. Stewart had recently made *Two Rode Together* for Ford, costarring Wayne's old enemy Richard Widmark. Ford hired James Warner Bellah and Willis Gorbeck to write the script, with Gorbeck also coproducing, and took the whole package to Paramount, knowing they had just made a new ten-picture, $6 million deal with Wayne (one picture a year at six hundred thousand dollars per) and wouldn't want to do anything that might upset their new star by turning down a film he wanted to do. They offered Ford a modest deal, $3.2 million to make the movie, with his new company, Ford Productions company having to put up half of it. Ford managed to raise the money, and the film was officially green-lighted.

Whereas *The Searchers* was shot on location at Monument Valley, in beautiful Technicolor and Todd-AO, with the expansive visuals forming part of the thematic ambiguity of the film—the sky the ultimate existential backdrop—

Valance was shot in black-and-white, almost entirely on the interiors of Paramount's back lot. It has always been thought that Ford did that out of necessity, that there simply wasn't enough money to make the movie in Monument Valley, and even if there were, he wouldn't have been able to withstand the physical endurance. However, a closer look at *Valance* suggests Ford's choices were deliberate, to make this an inverted version of *The Searchers*. *Valance*'s stagy unreality is an essential part of its mise-en-scène. The night of the big shootout, we discover—that is, Ford allows us to discover—what really happened, that Doniphon was hiding down the street and killed Valance with his gun and then let Stoddard take all the glory. By simply moving the camera to another placement, Ford made a powerful statement about how cinematic truth depends not just on visual information but also point of view, and that the camera is an instrument of revelatory truth. In *Valance,* it reveals a secret only Doniphon and the director know, until we learn it when Stoddard reveals it to Hallie during his confession.

In *Valance,* Doniphon's is an open book, ambitious—he raises horses—in proper love with Hallie, with a sense of honor and entitlement. He is two-fisted tough, knows how to use a gun, and will never start a fight but will always finish one. He is the living fiber of the frontier, a veteran of all the wars that expansionism brought, but has no future, no place in the new West. In *The Searchers,* Ethan is swathed in mystery. He and Scar represent the past, they battle in the present, they too have no future. They are remnants of a time of the law of the gun. In *Valance,* when Doniphon realizes that Hallie is no longer in love with him, that he has been left behind (in his dying world), he goes to the home he had been building for them and burns it down (an act that further connects the film to *The Searchers* and Scar's fiery attack on Ethan's brother's house). For both Scar and Doniphon, the burning of houses represents an external expression of their fires inside. Scar hurts others by burning down their house; Doniphon hurts himself by burning his. Both Ethan and Doniphon (and Scar and Valance) will not be welcomed in the new West. Each in his way helps explain why.

Production on the film was not easy, with Ford determined to tell the story the way he wanted, often not bothering to explain to his actors why he told them how to play a scene. Lee Marvin later remembered how and why Wayne always acquiesced to whatever Ford wanted: "Ford would talk to him all the

time while directing him. He directed Duke and I think Duke relied on him very much to direct him. I don't think Duke ever forgot what Jack, Coach, Pop, Pappy, whatever they called him, had done for his career. Ford would say, 'Oh, don't do that Duke!,'" and Duke would do what he told him to instead and it was just brilliant. I think Ford was tremendously responsible for Wayne's persona."

And Hawks: "The relationship between Wayne and Ford was very interesting. Ford still treated him as a beginner. And Wayne would do anything that Coach, or 'Pappy' as he called him, asked him to do." It didn't happen right away. Jimmy Stewart was an easier fit for Ford, and Marvin could play a character like Valance in his sleep; his naturally muscular build and facial snarl were perfect for the part. Wayne was the only one in *Valance* who was not really clear about his character. Years later he complained to Dan Ford that "Pappy had Jimmy Stewart for the shitkicker role, he had Edmund O'Brien for the quick-wit intellect, and Andy Devine for the clumsy humor. Add Lee Marvin for a flamboyant heavy, and shit, I've got to walk through the entire picture." Wayne was totally at a total loss as to why Doniphon would let a character like Jimmy Stewart steal his woman (there is no evidence in the film that Hattie has any real intention to marry Doniphon, and there are no romantic scenes between them). And why would he burn his own house down? Or not take credit for killing *Valance*? If he had done that, he might have at least had a shot at Hattie.

Nonetheless, Wayne's performance is no less dramatic, if one level less profound then the one he gave as Ethan, and in the end, it was probably better that he didn't fully understand what was going on. It gave his character a sense of distance that kept him apart from the others, which made the film even more of a shock when he saves Stoddard's life by killing Valance. The film reaffirms John Ford's eternal place in the pantheon.

THE MAN WHO SHOT LIBERTY Valance began production the first week of September 1961 and ended the first week in November. Except for a very few outdoor sequences at the Paramount Ranch in Agoura Hills, California, the entire film was shot at the studio. Wayne received a $750,000 guarantee against 7.5 percent of the gross receipts. Stewart received $300,000 and the same percentage. Shooting was contentious, with Ford saving most of his vitriol for Wayne, who always seemed to do better work under Ford's directorial

birch. Marvin was too oblivious to feel the lash, and Stewart too sensitive for Ford to use it on. And Vera Miles brought out Ford's courtliness, such as it was, tempered by age and a general lack of interest in her sexual charms.

Despite mixed reviews, the film did moderately well, grossing $8 million in its initial domestic release, and placed seventeenth in the highest-grossing films of 1962.* A. H. Weiler in the *New York Times* chose to review Wayne's performance rather than the film: "Mr. Wayne again proves, if it is necessary at this late date, that he can sit a horse well, shoot from the hip and throw a haymaker with the best of them. And, fortunately, he is more laconic than most." *Variety* called it "[a]n entertaining and emotionally involving western . . . yet it falls distinctly shy of its innate story potential . . . Stewart and Wayne do what comes naturally in an engagingly effortless manner." The *New York Daily News* got closer to what the film was really all about: "Nostalgic, sour and powerful, it is one of the most memorable of all [Ford's] westerns." So did the *New York Herald Tribune*'s Paul V. Beckley: "John Ford, as usual, shows how to make a Western really western. What under many a director would be only a series of plot clichés, under his direction achieves character."

They were all good reviews, but it would take the new American Auteurists to eventually put the film into its proper cinematic context, and to recognize it as the masterwork it was. Andrew Sarris: "*The Man Who Shot Liberty Valance* is a political Western, a psychological murder mystery and John Ford's confrontation of the past—personal, professional and historical . . . [The film] achieves greatness as a unified work of art . . . [and] must be ranked along with (Max Ophuls' 1958) *Lola Montes* and (Orson Welles' 1942) *The Magnificent Ambersons* as one of the enduring masterpieces of that cinema which has chosen to focus on the mystical processes of time."

Peter Bogdanovich: "A Ford masterpiece, perhaps his final word on the West in the era when the gun was the law . . . Wayne, Stewart and Vera Miles are superb in their simplicity, and Ford's direction is a masterpiece of understatement and economy . . . it is one of the saddest movies ever made, by a man who very well may be the American Cinema's greatest director. Its reverberations echo through the years and shadows of his other work."

* David Lean's *Lawrence of Arabia* was the highest-grossing film of the year, at $44 million domestic. Just ahead of *Valance* was Blake Edwards's *Days of Wine and Roses* at $8.3 million, just behind it Jose Ferrer's *State Fair* at $7 million.

The Man Who Shot Liberty Valance will forever stand alongside the greatest westerns of all time. It proves, once and for all, that film is a director's medium, and that Wayne was underrated as a two-dimensional, cardboard cowboy. Taken together, *The Searchers* and *The Man Who Shot Liberty Valance* definitively reveal the beauty of his physical strength, the power of his verbal vernacular, and the authenticity of his emotional depth.

Chapter 23

It was extremely gratifying to Wayne the day in 1962 when he picked up the phone and heard Darryl Zanuck's voice on the other end, offering him $25,000 to make a two-day cameo appearance as Lieutenant Colonel Benjamin Vandervoort in the producer's *The Longest Day*, a grand-scale re-creation of the Allied landing at Normandy on June 6, 1944. After several years in corporate exile in Europe, Zanuck had retaken control of Twentieth Century–Fox from Skouras, who had nearly bankrupted the studio with its disastrous ongoing production of *Cleopatra*. Zanuck wanted to complete his World War II saga before Skouras's Egyptian one, and, after paying Cornelius Ryan $125,000 for the rights to his bestselling book of the same name, looked to hire every big-name star in Hollywood to play cameos. John Wayne was the actor he sought most; no other American movie star was as closely identified with on-screen World War II–style heroics as Wayne. His presence, Zanuck knew, would give the film an added sense of validation. Zanuck had to swallow his pride over his "poor old man" remark and humble himself by personally calling Wayne to ask him to be in the film.

Wayne took great delight in saying no.

Zanuck called again four hours later and upped his offer to $50,000. Wayne again said no and hung up on the studio head. It wasn't until Zanuck offered Wayne $250,000 that he finally agreed to do it. He then turned to Pilar and smiled, his lips tight, his eyebrows raised, his forehead wrinkled. *He had shown the old bastard just how poor and old John Wayne was.*

THAT SAME YEAR HE REUNITED with Ford in the Civil War sequence for the Cinerama epic *How the West Was Won,* playing General William Tecumseh Sherman (a role he had played on an episode of *Wagon Train* Ford had helmed as a favor to Ward Bond not long before his untimely passing). The other two segment directors for *How the West Was Won* were Henry Hathaway and George Marshall. The film remains a curio in the technological history of cinema, and Wayne's bit, as a cigar-chewing, drunken, and unkempt Sherman, is too brief to be memorable, but an interesting snapshot of his acting style in the first half of the 1960s as the studios struggled to find ever-larger venues and subjects to lure TV viewers back into theaters.

Wayne liked the easy money and even easier work. Ford was too busy and time too short for the director to ride all over him. Wayne did one more of these cameos, right after *How the West Was Won,* but that one would take another three years before it reached the screen: *The Greatest Story Ever Told,* directed by George Stevens and David Lean (uncredited). This was UA's version of the life of Jesus Christ, cradle to cross. Every studio made one. Wayne played one of the centurions who lead Jesus (Max von Sydow) to his crucifixion. "Truly this man was the son of God," was Wayne's single line of dialogue. He had to do it several times until Stevens was satisfied Wayne had captured enough "awe" in his reading. After one take too many, Wayne took a deep breath, looked up, and read his line in his own inimitable style: "Awwww, truly, this man was the son of God!" The director yelled cut and everybody laughed. They got it right on the next take.

AT A DINNER PARTY IN 1962, Wayne happened to run into Edward Dmytryk, threw his arms around the director, and asked him why he'd done it, as if he had placed the wrong bet on a horse. Dmytryk was bewildered. Did Wayne mean why was he a Communist, or why did he betray his friends? Wayne's peculiar compassion for those who repented, like Larry Parks, made it hard to tell. Dmytryk was less than thrilled by the hug the former president of the MPA gave him that night. Maybe Wayne was too big a man for Dmytryk. Or maybe it was the other way around.

WAYNE WAS NOW WELL SUITED financially and he decided to replace his beloved boat, *The Nor'wester,* which he'd given up to help finance *The Al-*

amo, with a new, larger yacht, *The Wild Goose,* a 136-foot onetime minesweeper that had been refurbished for civilian use by its original private owner. The makeover was impressive: a master suite, three guest staterooms each with its own bath, a salon, a sixty-foot afterdeck for sunning, a dining room that could easily seat ten, a liquor cabinet and bar, and enough room for eight full-time crew members. Wayne added a fireplace and a projection room.

It was around this time that the Republicans began looking for a new leader of the party. Kennedy's election had shattered the party's foundation, and they were searching for someone with the necessary leadership qualities to take the country back from the Democrats. Because of his presidency of the MPA, and his enormous popularity, Wayne's name continually came up at meetings. When he was finally approached by representatives of the party, Wayne laughed at the idea. "I can't afford the cut in pay," was his famous replay. "Besides, who in the world would ever vote for an actor?" Eventually, the job went to Barry Goldwater, and after Nixon's resignation in 1974 and Carter's one term presidency, Ronald Reagan, actor and former head of SAG, in 1981 became president of the United States.

IN 1962, WAYNE RETURNED TO feature filmmaking, with John Ford at the helm for what would be their final film together, *Donovan's Reef* (a.k.a. *The Climate of Love*). Ford would make only three more films in his long and storied career (he would start a fourth, *Young Cassidy,* but not live long enough to complete it).

Donovan's Reef, made at Paramount, is decidedly minor Ford, and therefore minor Wayne. It is the story of two ex-navy men, played by Wayne and Jack Warden, who stay on a South Pacific Island after the war, operating a bar called "Donovan's Reef." Lee Marvin also stars in the film. All three actors are too old for their roles, their comic timing is leaden, and the physical fights border on the pathetic; they look like old men trying to regain their youth by punching each other out, and Wayne knew it. Elizabeth Allen, who plays the daughter of Jack Warden, snails the plot forward when Wayne becomes involved with her in what can in no way be described as a romantic coupling. Dorothy Lamour appears as breathing scenery. The production was plagued by Marvin's out-of-control drinking, which, in turn, led Ford and Wayne to increase theirs.

Wayne made the film partly for Ford, partly as an excuse to spend the summer with his family in Hawaii, and partly for $600,000 and a piece of the gross (which never materialized). According to Marvin, when Ford asked him to be in the film, he wouldn't send him the script, knowing how bad it really was. "'Look,' Ford said, 'don't you want to spend eight weeks in Hawaii this summer?' . . . he took all his old buddies to Hawaii to have some fun . . . it was kind of his goodbye to his boat, the South Pacific, and all the great days." It was a dispiriting experience, a sad swan song for Ford and Wayne's creative collaboration of spirit, talent, and brilliance.

When the film wrapped, and after a monthlong rest in Encino, Wayne, Pilar, and Aissa headed for Arizona so he could begin shooting the long-promised *McLintock!*, a Batjac Production for UA. Wayne's son Patrick was one of the stars, Aissa had a small part, and the chore of directing fell to Andy McLaglen, Victor's son. It signaled the start of the final phase of Wayne's film career, where, with rare exception, he chose to make low-budget films to cash in by playing "John Wayne."

For Wayne, the best thing about *McLintock!* was the chance to make another movie with Maureen O'Hara, in a James Edward Grant screenplay that was a takeoff on Shakespeare's *Taming of the Shrew*. During one fight O'Hara stabs Wayne in the butt with a hairpin. The film's plot deals with George Washington McLintock, cattle baron, banker, and leading citizen of the town of McLintock, whose wife (O'Hara) has left him because she suspected him of being unfaithful. She is determined to divorce him; he is determined to win her back. A good old-fashioned spanking on her pantaloons brings her to her senses (of course), and they live happily ever after in that fantasy world that the Hollywood studios loved so much—that love/hate relationship that is really a love/love relationship. This being the early '60s, nothing gives a man back control of his wife better than a good couple of whacks on her bottom, especially if she struggles and squeals. The centerpiece of the McLaglen film involves forty-two cast members who wind up battling each other in a mud pit.

O'Hara later remembered, "When I read the script, I thought, by God, they wrote this for the two of us! Duke sent me the script and said, 'That's it, you're doing it . . .' There isn't another woman I know of who could have

played those scenes . . . he was a naturally macho human being. I think God made him that way."

The film, released in the fall of 1963, was a huge hit, with a gross of $11 million in its initial domestic release, from a budget of $2 million. Audiences loved seeing Wayne and O'Hara together again on-screen. The rights to *McLintock!* eventually reverted to Batjac, and the film continues to be a big earner for the Wayne estate.

Wayne then took an extended vacation with Pilar and Aissa aboard *The Wild Goose,* making occasional stops in various ports to socialize with friends. Their hiatus ended when Wayne received a call from Henry Hathaway and Paramount that he was wanted back in Hollywood as soon as possible to start *Circus World,* his next film for the studio under his ten-year contract, to be shot in a new single-lens version of Cinerama. He promptly left for Barcelona, where the production was located from September 1963 through February 1964, with interiors later shot in London. *Circus World* is the story of an American circus traveling through Europe, and one of the least known of Wayne's '60s films. There is a missing-mother plot, and not much else besides the luminous presence of Claudia Cardinale, and Rita Hayworth, whose best days on and off film were behind her.

The last day of shooting involved a scene in which the circus burns down. Wayne, who insisted he wanted to do the scene without a double, was slightly injured during filming, his hair burned and his lungs scorched from smoke. After, he developed a nagging cough.

It was early in production of *Circus World* that word reached Wayne that John Kennedy had been assassinated. He cried openly in front of the entire cast and crew.

After the film was completed, Wayne, Pilar, and Aissa returned to *The Goose,* as they called it, for an extended stay in Acapulco, to give him time to recover. But he would have little time to do so, because Wayne was called by Paramount and told to leave immediately for Hawaii to film Otto Preminger's World War II epic *In Harm's Way,* about the days following the attack on Pearl Harbor. His costar in the film was his good friend Patricia Neal, with whom he had worked together before on *Operation Pacific,* and Kirk Douglas, his longtime friend despite their political differences. Preminger, true to his repu-

tation, played the director-as-tyrant role to perfection and made no friends as he worked his cast, stars, and extras alike, in a merciful, relentless fashion under the hot Hawaiian sun. The only one to whom Preminger deferred was Wayne, who in this film did his best work in years.

By the time the production wrapped, in late August 1964, the fifty-seven-year-old Wayne, tipping the scales at 260 and with that persistent cough that got so bad, filming of several of his scenes had to be stopped several times, was exhausted and sick. He refused to see a doctor until the producers of his next scheduled film, *The Sons of Katie Elder,* forced him to have a complete medical checkup prior to the start of filming. It was performed at the Scripps Clinic in La Jolla.

Pilar went with him and later recalled what happened when she came to see him in his room after all the tests were completed. "I've got a little problem," he said to her, averting his eyes. "The doc says I've got a spot on my lung." After four decades of 40 to 50 cigarettes a day, excessive drinking, poor dietary habits, and a rugged physical career, time and age had caught up with him. After five more days of tests, chest X-rays, and endless tubes of blood taken, followed by two weeks of detailed analyses, the doctors gave him the bad news.

He had lung cancer.

CHARLES FELDMAN URGED WAYNE TO keep his diagnosis a secret, and issued a statement that Wayne was having an operation to fix a long-standing ankle injury. At the Good Samaritan Hospital in Los Angeles, Dr. John E. Jones headed the treatment team. Wayne pleaded with the doctor for some alternative other than being cut open, as he had a film to shoot and didn't want to hold up the start of production. Dr. Jones quietly spelled out the situation to him. He was going to have to take out the left lung and perform a number of biopsies to see if the cancer had spread.

Wayne called Hal Wallis, the Paramount executive in charge of *Katie Elder,* who agreed to try to shoot around him as much as he could, to make it easier to replace him if it came to that. Henry Hathaway, the film's director and himself a cancer survivor, spent long hours visiting Wayne in the hospital, holding his hand and telling him he could beat it.

The morning of the big operation, September 17, 1964, Wayne was sur-

rounded by his children as he was wheeled into the operating room. Pilar had been there the night before and gone home exhausted. During the six-hour surgery, Dr. Jones cracked open Wayne's chest and removed several ribs and most of what remained of his deteriorated left lung. The operation left a permanent twenty-eight-inch scar from Wayne's chest to his back. When he awoke post-op, his body had tubes coming out of every orifice. He suffered severe head and neck swelling that kept his eyes shut for days. An infection had set in and Wayne's condition turned critical.

After a few more rough days, he began to improve, and Dr. Jones gave him the good news—the cancer had not spread. With any luck, and a lot of rest and recuperation, he had a very good chance of pulling through. Wayne stayed in the hospital another three weeks, and was finally released October 7, 1964, wearing a fedora on his head, a heavy coat buttoned up, and a scarf around his head to avoid being recognized by the press. He was barely able to make it home before the reporters started to call, wanting to know about his condition. Later that same day, Wayne told one reporter from the *Los Angeles Herald Examiner,* "There's nothing wrong with me that getting out of the hospital won't cure. I haven't had a heart attack and I don't have cancer."

His recovery proved more difficult than he had hoped. He was frail and congested. He suffered from shortness of breath and extreme nicotine withdrawal from having to give up his beloved cigarettes. Sometimes he would hold one unlit between his fingers and smell it.

No matter how much he tried to deny the story, rumors persisted in Hollywood that Wayne had cancer. To do some damage control, he invited one of his good friends from the newspaper business, James Bacon, to tell his version of the truth. The interview took place December 29, 1964, in Wayne's Encino home. "Jim," he said, "I'm going to tell you the truth about my operation, and you have permission to quote me. I had lung cancer, the big C, but I've beaten the son of a bitch. Maybe I can give some [other] poor bastard a little hope."

The story ran the next day in Bacon's syndicated column with the headline "John Wayne Beats Cancer." The reaction was overwhelmingly positive and reinforced Wayne's image as the indestructible titan of Hollywood. What Rock Hudson would do for AIDS in the '80s, Wayne did for cancer in the '60s. He

helped reduce the fear and the shame of having it and also proved it wasn't an automatic death sentence. The bravery he showed going public was as great a real-life action as any of the heroics he performed in his long film career.

FOUR MONTHS AFTER WAYNE WENT under the knife, he was back at work, on location in Durango, in the Mexican Sierras, where breathing was normally difficult, and which for Wayne meant having to use oxygen out of a can whenever he wasn't filming; and in Chupaderas, Mexico, with interiors done at the Churubusco Studios in Mexico City. He was noticeably overweight, a good sign for his health, but not so for his screen image. The added pounds and the overall weakness he experienced recovering from surgery made it even more difficult, but somehow he got through the tough shoot. Directed by Hathaway and working with Dean Martin, his old pal and costar from *Rio Bravo*, Wayne toughed it through a very physical ordeal. He knew his future in Hollywood depended on his completing this film.

The Sons of Katie Elder opened July 1, 1965, to good reviews and great business. Off a budget of $2 million, it earned $16 million in North America in its initial run, and placed number 15 on that year's top-grossing films.* Wayne was paid $600,000 by Paramount, payable at $60,000 a week. To publicize the film, Wayne appeared on Dean Martin's popular TV variety show, in which they both looked relaxed and healthy.

IN 1964, THE COUNTRY WAS at war again. Until the Gulf of Tonkin incident the previous summer, few, if any, Americans had even heard of Vietnam. But the enemy was an old and familiar one to Wayne. Communism. Once again he meant to do something about it. He determined to make a movie even bigger and more patriotic than *The Alamo*. He wanted to call it *The Green Berets*.

* The top-grossing film of 1965 was *The Sound of Music*, at $163 million. The fourteenth film was Guy Green's *A Patch of Blue* ($13.5 million). Number 16 was Richard Lester's *Help!* ($12 million). The three top box-office westerns that year were Elliot Silverstein's *Cat Ballou* ($20 million); Andrew V. McLaglen's *Shenandoah*, starring Jimmy Stewart ($17 million); and *The Sons of Katie Elder*.

Chapter 24

On August 2, 1964, while the American destroyer USS *Maddox* was conducting a routine maneuver off the coast of North Vietnam and southern China, the United States claimed the ship was attacked by three North Vietnamese torpedo boats (the attack was later proved to not have taken place). In retaliation, a week later, what became known as the Gulf of Tonkin Resolution was passed by Congress giving President Lyndon B. Johnson authority to engage in limited conventional warfare in Southeast Asia.

It was a convincing victory for the unelected president, in power less than a year following the tragic assassination of JFK. Before his death, Kennedy had hinted that he was going to either limit or withdraw all U.S. ground forces in Vietnam. Johnson's views were decidedly more hawkish, and the war, "his" war, along with the historic Civil Rights Act of 1964, formed the platform that Johnson would run on that fall against the Republican candidate, Barry S. Goldwater. After his landslide election, Johnson put forth his "Great Society" of social reform and escalated the still officially undeclared war in Vietnam, outraging those young Americans eligible for the draft. The country was ill at ease.

The youth rebellion that followed reignited Wayne's nationalistic fervor. Out of the past came the cinematic spirits of Sergeant Stryker and Davy Crockett, and they energized Wayne in a way that no traditional medicine

could. He would take on the protesters and he would take on the enemy as he soon as could get his Green Beret movie green-lighted.

MEANWHILE, A BURGLARY AT THE Encino house when no one was there finally prompted a disgusted Wayne to put it up for sale. With so many of the old gang gone, infirm, or out of touch, he had no reason to stay within card-dealing distance of Hollywood. He told Pilar to find a more suitable home for them, maybe in Malibu, or somewhere along the coast where they could have easier access to *The Wild Goose*. This was great news for Pilar, who felt it was a sign from her husband that he was warming up to her again.

She found a place she liked in Newport Beach, fifty miles south of Los Angeles. When she told Wayne about it, he directed her to buy it. He didn't actually see it until the first day he walked through the door. Pilar wanted him to praise her house-hunting abilities. His response was less enthusiastic. He told her disapprovingly that the house needed a lot of work.

They both spent a bit of time with architects and contractors, but neither Wayne's head nor heart was in it. He couldn't wait to returning to filmmaking, and when Melville Shavelson approached him about starring in *Cast a Giant Shadow,* he jumped at the chance. Shavelson was a successful screenwriter, director, and producer. When he had read the bestselling book of the same name by Ted Berman, the "true" story of David "Mickey" Marcus, he immediately secured the film rights.

Marcus was a West Point graduate who had worked for a time in the Fiorello La Guardia administration of the '30s, when the diminutive and extremely popular "Little Flower" was mayor of New York City. He became a colonel during World War II and participated in the D-Day invasion. After the war, the Jewish officer helped build the Palestinian Jews into a trained, disciplined army in their fight for the right to independence and the formation of Israel.

Wayne had known Shavelson since 1953, when he had produced *Trouble Along the Way.* They remained friends despite their political differences; Shavelson was a die-hard liberal. When he first approached Wayne about being in *Cast a Giant Shadow*, Shavelson, a shrewd manipulator, pointed out the similarities between Marcus and Davy Crockett. Wayne was interested, but he soon found out what Shavelson already knew—that a movie about a Jewish American war hero was a difficult project to get made. Jews were almost never

portrayed in Hollywood as characters on-screen, despite the industry being filled with Jewish talent, and of course the predominantly Jewish moguls. For a brief period, after World War II, there were several films made about Jews, including *Gentleman's Agreement,* directed by Elia Kazan, in which Gregory Peck impersonated one to understand what being Jewish meant in mainstream, or gentile America. Despite *Gentleman's Agreement* having won an Oscar for Best Picture, and one for Kazan, Jewish stories and subjects soon faded from Hollywood's must-do lists of subjects and remained largely invisible on-screen. More often than not, Jewish leading men, like Kirk Douglas, played non-Jewish parts, like *Spartacus,* far more than they did "Jewish" roles. Audiences might accept Wayne as Attila the Hun (they didn't), but as Mickey Marcus, there was no way. He still wanted to be involved in the film and agreed to take a much smaller role, that of General Mike Randolph, the American officer who lends his experience and support to Colonel Marcus.

Wayne also declined the chance to coproduce the film through Batjac. When the Mirisch Company (Mirisch-Llenroc) offered to come in if Batjac did, Wayne changed his mind and invested in the production (Mirisch Llenroc Batjac). The film was directed, written, and coproduced by Shavelson. After Wayne came aboard, other big names followed. Kirk Douglas agreed to play Colonel Marcus, Yul Brynner and Frank Sinatra appeared in cameo roles, and Senta Berger and Israeli actor Topol filled out the rest of the cast. Wayne played a scene where he said "L'chaim" during a toast, about as close to anything Jewish he was associated with during production.

The film was shot from mid-May to July 1965, on location in Israel, utilizing eight hundred Israeli soldiers and over a thousand extras, with additional exterior scenes filmed in Rome and the Alban Hills, and interiors at Italy's famed Cinecittà Studios. Wayne spent several months abroad prior to filming, to help Shavelson with preproduction, while Pilar remained in Newport Beach, blueprints in hand, pencil behind her ear, supervising the construction of their new home.

He returned home only once before filming was completed, and Pilar took the occasion to tell him she was pregnant again.

Wayne found it difficult to believe his body could still produce life, but he was happy to be proven wrong. At fifty-eight years old, he had fathered yet another child with Pilar. Marisa Carmela Wayne, his seventh, and third with

her, was born February 22, 1966. 2/22 was a very lucky number for Wayne and Pilar. Marisa shared the same birthday with John Ethan, born four years earlier.

The event was life-affirming to Wayne, a physical, psychological, and moral victory, but not for Pilar. What began as a postpartum depression didn't subside, and after a few months she began to emotionally withdraw. She felt something had changed in Wayne, that he had become increasingly distant, and it made her even more depressed. It was true, his fuse was shorter. He could go into rages over the smallest of things that used to make him laugh. The doctors had warned her to expect some changes in his personality after what he had been through. *What he had been through? What about me?*

With all that going on, after a brief stay at home, Wayne quickly took off to make another movie, leaving Pilar alone with the new baby. It further upset her that he would risk his health just to play another cowboy. She worried that if something happened to him on-set she would be left alone to raise not just Marisa, but the entire family by herself. Justified or not, her emotional demons this time threatened to end her marriage. She had, in her words, turned into "a virtual zombie."

A nervous Wayne started chewing tobacco to calm himself down.

CAST A GIANT SHADOW OPENED March 30, 1966, to mixed-to-negative reviews. The *New York Times*' A. H. Weiler came in on the downside: "A confusing, often superficial biography that leans a good deal on comic and extremely salty dialogues and effects . . . full of sound and fury and woefully short on honest significance." *Variety* liked it better: "Overlong pic has some exciting action highlights, fine production values and other assets." At two hours and twenty-two minutes, the film lost one screening a day, which significantly cut into its profits.

Wayne had wanted it to come in under two, but was overruled by Mirisch and Shavelson. The film failed to make back its negative cost of $4.3 million, but Wayne still liked the film's statement, that under certain conditions war was noble and defending an ideal more important than anything. It was a message he hoped would resonate with a younger audience, and not just Jews, but all American youth now caught in the stranglehold of the Vietnam War. He had been surprised and disappointed when the nation's young didn't under-

stand who the real enemy was. To Wayne, any country's fight for freedom was a fight for the freedom of all countries. Why didn't they see that?

LIVING IN NEWPORT BEACH ON what amounted to a house on a pier, Wayne was so close to the water he could hop out of his back door and be on *The Wild Goose.* That part wasn't so bad, but Pilar's continuing depression put a damper on what he hoped would be a new start for their marriage.

When it proved otherwise, Wayne couldn't wait for his new film project to begin production. He needed space, and he needed money. The seemingly endless renovation was draining his cash, Batjac had taken a loss with Shavelson, and Pilar was making him crazy, so when Howard Hawks had come along with *El Dorado* before *Shadow* opened, Wayne jumped at it. Being home, amid the banging, the buzz sawing, the dust that aggravated his chronically sore throat, and Pilar's behavior pushed him to leave as soon as possible for Tucson, Arizona, to join Robert Mitchum, who had, since the debacle of *Blood Alley*, become a friend, in Hawks's paean to friendship, the Old West (the *real* Old West, according to Hawks), and getting old.

Hawks had recently made a series of films that were not up to his usual standards. *Hatari!* had been a box-office hit due more to Wayne's star power than any great rush on the public's part to see it because Howard Hawks made it. After two more films went nowhere, Hawks needed a real hit. He purchased the rights to a Harry Brown novel, *The Stars in Their Courses,* and assigned Leigh Brackett, Hawks's favorite screenwriter, to adapt it. After several tries, the final script for *El Dorado* resembled nothing so much as a remake of *Rio Bravo.* According to Howard Hawks: "The Western takes, really, a couple of forms. One is how the West started, the formation of the great cattle herds. Actually, *Red River* started as the story of the King Ranch . . . [one is] the period of law and order. *Rio Bravo* and *El Dorado* fell into that. We had a lot of fun in writing *Rio Bravo.* Because we ran into so many good situations, we said, 'We'll save that for another picture.' In making Westerns, I've worked practically just with John Wayne. He is by far the best . . . the young fellow in *Rio Bravo* was a really good shot. Ricky Nelson played him—in *El Dorado,* when we started to work on that, I said, 'Let's get a boy who can't shoot'—and that was Jim Caan. And in *Rio Bravo,* Wayne was the sheriff and the deputy was a drunk; in *El Dorado,* the drunk was the sheriff. You just take opposites

of everything . . . a sheriff who's any good would say, 'You better hope your friends don't catch up because the first man shot is going to be you.' [That line made it into] *Rio Bravo* . . . in *El Dorado,* we had a scene where the jailer said, 'You better hope nobody comes in here, because you're going to be the first one shot.'"

Wayne was happy to be working on a film again with Hawks, who was much easier to act for than Ford. Peter Bogdanovich met Wayne on the set of *El Dorado* and conducted a long interview: "We chatted for an hour and when he was finally called away he told me how great it was to have spent some time talking about movies. 'All people ever want to talk about with me these days is politics and cancer,' he said. Wayne's rightwing politics had become notorious while his acting abilities were largely written off. He was considered for most of his career to be a one-trick pony. But he brought such strong personality to his roles and still tops polls of America's all-time favorite movie stars. Wayne loved the process of acting. He couldn't get enough of it. On a movie set he was like a kid in a candy store. On the set of *El Dorado* I watched him spend hours playing with props, talking with the crew and watching it all happen. He'd never go to his trailer. He was too excited to be around the film-making process."

In the film the vulnerability of its two stars, Wayne and Mitchum, and the inevitability of aging—for them as well as for Hawks—was contrasted by the presence the young and intense James Caan, in the pre-*Godfather* stage of his career when he was still relatively unknown. Wayne received $750,000 for this Paramount film, Mitchum $300,000, Caan $14,000.

WAYNE FELT HE WAS ONCE more at the top of his game, but he still couldn't find the financing to get *The Green Berets* made. To his dismay, no studio would go near what they considered not just a political hot potato, but at the time, a film about a war that had no cinematic potential or appeal. How could anybody make a popular movie about such an unpopular confrontation, with no real-life heroes, no decent women roles, and no end in sight?

Instead, Wayne, impatient to get back in front of a camera after the exhilarating experience working with Hawks, signed on to *The War Wagon,* a Batjac production for Universal. The film was part of a new two-picture deal Feldman had made for Batjac, hoping he could convince Universal to make *The Green*

Berets the second picture. As of now the studio execs were not out, but they were not in. It was a possibility, they told Wayne.

On September 15, 1966, production began on _The War Wagon,_ a tale of justice and revenge set in the Old West starring John Wayne. It was shot on location in Durango and Mexico City with a script by Clair Huffaker, based on his novel _Badman,_ a score by Dimitri Tiomkin, Bill Clothier as cinematographer, and a solid cast that included Bruce Cabot as the bad guy, Kirk Douglas as a gunslinger, Howard Keel in the Indian role, Valora Nolan as the love interest, and Wayne as a framed and paroled ex-con.

During production, Wayne and Douglas got into some heated discussions about the war—Wayne was for it, Douglas against it—and California politics. Douglas was a big supporter of incumbent governor Pat Brown, up for reelection in the midyear between presidential campaigns. Douglas, Wayne could not forget, had broken the blacklist, which never sat well with him, and Douglas supported Brown's ample public support programs. He wanted more of that from the government, while Wayne felt that Brown was too far to the left to be running California, and that his ideas bordered on socialism. Despite their differences, Wayne and Douglas were close friends and remained so.

On-set during production, Wayne received a phone call from his friend Nancy Reagan. The Reagans were longtime friends of the Waynes, and she told him she needed a favor from him. Wayne temporarily closed down production on the film and returned to Los Angeles to help Reagan's campaign for governor. Reagan had been a Roosevelt Democrat before changing parties and was fond of telling everyone that he hadn't left the party, the party had left him. Wayne happily went on the stump with his friend. That fall, Reagan won by a landslide and there was talk of the Republican Party making Wayne a candidate on the 1968 Republican national ticket. Once again Wayne rejected any notion of his running for political office. He was just an actor, he insisted, and besides, he wasn't sure his health would be up for the intensity of such a physically taxing campaign.

However, Wayne certainly appeared "presidential," whether that was his intention or not (perhaps to drum up business for his dormant war project), when in June 1966 he traveled to Vietnam as part of a three-week USO tour and to narrate a Department of Defense film. He began the trip in Saigon and traveled all over South Vietnam. In Chu Lai, the Vietcong shot off hundreds

of rounds at the entourage, some coming uncomfortably close to Wayne, the nearest he had ever been to real enemy fire in any war. He was so unfazed he made a joke out of their poor aim. Everywhere he went, he was recognized and cheered by both Americans and South Vietnamese as a hero.

THE POSITIVE PUBLICITY HE RECEIVED while in Vietnam convinced Universal to finally give Batjac a tentative green light for *The Green Berets,* and Wayne immediately started his son Michael working on the film's preproduction. With a budget of $6.1 million, Wayne wanted a screenwriter he had worked with before and knew he could rely on. Jimmy Grant had always been his first choice for the project but had just passed away from lung cancer. Michael now suggested Robin Moore, who had written the original novel *The Green Berets,* already owned by Batjac. Moore was a Vietnam veteran, and his book had the feel of authenticity about it. However, Wayne rejected him after Moore ramped up his public criticism of the Defense Department. Wayne didn't mind Moore's comments, but he was afraid using him might result in the government not cooperating with the film, which would make it too expensive to do. Instead he chose James Lee Barrett, a former marine turned screenwriter, who had written a hard and tough novel about the Marine Corps's training techniques. Using Barrett, the film had no trouble acquiring the cooperation of the Pentagon. When he finished a draft of the script, Michael delivered it to Universal, along with a signed letter from Wayne agreeing to star in the film.

Universal liked the script and was ready to go with it when it was unexpectedly rejected by the Pentagon because it depicted Special Forces carrying out covert missions in North Vietnam, which they weren't supposed to be doing and had always denied, including an elaborate kidnapping of an NV general. At Wayne's directive, Barrett revised the script so that the general is taken while he is in South Vietnam, an unlikely scenario—what would a North Vietnamese general possibly be doing in South Vietnam—but a necessary change. It satisfied the Pentagon and they gave their much-needed approval of the script.

Wayne then made a guest appearance on Lucille Ball's highly rated *The Lucy Show* playing himself, and soon after the *Merv Griffin* nightly talk show, to promote his movies but also to demonstrate to the world, to the Pentagon, and especially to Universal that he was in good enough condition to make the film, that he had indeed "beat the big C."

THE WAR WAGON WAS RELEASED May 23, 1967, just two weeks before *El Dorado*. That same month the list of the top ten most popular box-office stars of 1966 was issued. Despite having only released one film that year, *Cast a Giant Shadow,* which hadn't done all that well, Wayne placed seventh.* He was the second-oldest star to make it; Cary Grant beat him by three years. It was a powerful demonstration of Wayne's enduring star power.

The War Wagon was an immediate hit. It grossed just over $6 million in its initial North American release, and double that overseas, where it was released first. *El Dorado* opened June 9, 1967, a full two years after the completion of principal shooting, due mostly to extensive problems Hawks had in editing, similar to what had happened with *Red River.* He cut at least a dozen versions of the film before he was satisfied. When it did finally arrive in theaters, it received excellent reviews and did well at the box office, grossing nearly $16 million from a $4.5 million negative cost. Paramount had wanted both films out in the summer even if it pitted one Wayne film against another.

The *New York Times* called *El Dorado* "a tough, laconic and amusing Western that ambles across the screen as easily as the two veteran stars." The *New York Daily News:* "The heavyweight crown in boxing may be up for grabs, but in the movies it is still firmly planted on the balding head of John Wayne. In *El Dorado,* though he may be a bit arthritic, Wayne still greets the opposition on a first-come, first-served basis and the wrongo [*sic*] who tries to outdraw him and winds up feeling kind of shot." And *Variety:* "An excellent oater drama, laced with adroit comedy and action relief, and set off by strong casting, superior direction and solid production." In 2014, film critic and historian A. J. Hoberman, writing in the *New York Times* on the occasion of its rerelease (and its inclusion in a forty-DVD reissue of a number of Wayne's films), offered this reevaluation: "City of Gold indeed: For one who grew up in the heyday of the post–World War Two western . . . two self-aware relics, John Wayne and Robert Mitchum, star in Howard Hawks' equally self-aware movie [that leisurely summarizes] many of Hawks' career-long concerns."

Wayne was now ready to turn his full attention to getting *The Green Berets* made. However, one day, in what seemed like a moment of déjà vu, from the

* The top ten box-office stars in America for 1966 were Julie Andrews, Sean Connery, Elizabeth Taylor, Jack Lemmon, Richard Burton, Cary Grant, Wayne, Doris Day, Paul Newman, Elvis Presley.

Roos days, he was stunned to find a department store had sent a collection letter to Pilar, with a $3,200 bill from Saks Fifth Avenue that had gone unpaid. Wayne was furious, had a long talk with his son-in-law, La Cava, and decided from now on, it was best that, if it was true, he take care of his own expenses.* He figured he couldn't do any worse than his son-in-law, who, like Roos, had charged him a fortune to lose his money.

WAYNE WAS SO EAGER TO get *The Green Berets* into production he turned down an attractive offer to be in *The Dirty Dozen,* from producer Ken Hyman, in association with MGM. It was Wayne's kind of picture, a bunch of tough guys taking on the Nazis. And it would have reteamed him with Lee Marvin, one of his favorite tough-guy costars. But it was a World War II film and he wanted to make one about the war raging now, and take on the North Vietnamese and the Vietcong, all in the name of freedom and liberty. That was the war he wanted to fight now.

On-screen, of course.

* Toni and La Cava separated a year later and divorced in 1981. They had eight children. Toni, an actress in her younger years, became something of a recluse after the marriage ended.

Part Five

With *True Grit* and an Oscar
by His Side into the Sunset

Chapter 25

Wayne had wanted to film *The Green Berets* on location in Vietnam, but nobody else thought it was a good idea, especially the Pentagon. They suggested instead Fort Benning, Georgia. Early in 1967, Wayne and Michael visited the base. In return for letting him use their facilities, Wayne promised to build an exact replica of a South Vietnamese village that he would leave standing when filming was completed to use as a training facility.

And then the bottom fell out of the project. Universal, which had never finalized its commitment, notified Batjac that it was pulling out of its end of the deal. The problem wasn't the movie, they said, it was the war itself, and the increasing protests that were taking place in the streets. Who was going to see this film, the executives wondered? Who would want to see this war glorified? Colonel Mike Kirby (John Wayne) was no Sergeant Stryker, the North Vietnamese and VC were not the Japanese, the Gulf of Tonkin was no Pearl Harbor, and Universal was not Republic Pictures. There was too much to lose, they concluded, and not enough to gain. Perhaps, they suggested, Wayne should wait until the war was over, and then the film could have a happy, meaning victorious, ending.

Angry but undeterred, Wayne took the project to every other studio, and they all said no. His last hope was a personal appeal to Jack L. Warner, who, like all the other studio heads, didn't think the film could earn any money. Warner, however, had made a fortune from John Wayne movies in the past

and was a big supporter of the war. It didn't hurt that the number-one song of 1967 was Lieutenant Barry Sadler's "The Ballad of the Green Berets," cowritten by Robin Moore and Sadler. It sold more than four million copies and was on every radio station in America, playing over and over. Even the most radical young leftists found themselves humming the song's catchy, deep-throated marchlike cadence. What it told Jack Warner was that maybe there was an audience for this film after all. Meeting again with Wayne, Warner agreed the studio would coproduce with Batjac because it was Warner Bros' patriotic duty to support the war.

If Wayne took no salary.

HE ASSEMBLED A SOLID CAST to support him on-screeen, with Aldo Ray as the tough master sergeant, Sergeant Muldoon. Ray, with his wrestler's body and raspy voice, had been for a time Hollywood's other go-to war movie actor. He had made an especially big splash in Raoul Walsh's *Battle Cry,* based on the Leon Uris bestseller, also at Warner Bros. Next Wayne wanted David Janssen, extremely hot after his successful long-running TV series *The Fugitive.* The dark-haired, good-looking Janssen was hired to play George Beckworth, a skeptical journalist who gets his head turned around (after its nearly blown off) and winds up writing favorably about the heroism of the Green Berets. It was believed but never confirmed that the character Beckworth was based on the liberal newspaper columnist Pete Hamill. The cast was rounded out by Jim Hutton, as Sergeant Petersen, a recruit who is destined for a date with Punjab sticks. Hutton was the only actor cast as a soldier who looked young enough to be a recruit, although in the film he does not play a Green Beret.

Then Captain, now Major Ron Miller was assigned as the consultant to the film, for helicopter accuracy and safety: "Aldo Ray had had his troubles in Hollywood and needed a job. Wayne liked him and cast him as one of the Green Berets. Both Wayne and Ray looked a bit too old and too out of shape to be Green Berets, but the army gave them a lot of real ones to surround them, to give the film a bit of a more authentic look.

"All the stars had private little apartments near Fort Benning. It was no problem for anyone except David Janssen, who had just finished shooting the final two episodes of the TV show *The Fugitive*, which hadn't as yet aired. We had to have special security around him 24 hours a day, especially at night.

Everyone wanted to know what happened between Richard Kimble and the one-armed man, and by contract he was not allowed to tell. Maybe it was one of the reasons he decided to make the film, to get out of Hollywood for awhile, where it must have been impossible for him to breathe. The other thing was women. Janssen was a very handsome man, and women just swarmed all over the location trying to get to him. At night there was a soldier stationed at his door to protect him from the hordes of young girls wanting to break in to his place to be with him.

"I supervised the kidnapping of the General, one of the more ridiculous scenes in the film. I think he was sneaking into the South to see a woman, or something, as if there weren't enough women in North Vietnam. I remember advising not shooting the scene the way Wayne wanted it done, in real time, because it was too dangerous. He had Hutton run underneath the blades, something a stunt man should have done, and almost got his head cut off. Wayne was having a little fun with the young actor, and it did look great on film, but it was a risky move."

Wayne, Pilar, Ethan, and Marisa relocated to Ford Benning the last week of July so he could be ready to start filming August 9, 1967, and stayed there for the rest of the year. Early in 1968, a few additional scenes were filmed at Warner's Burbank studios. By then, everyone had deserted the surefire-hit bandwagon, fearing the film was going to be rejected by a nation that was being torn apart by the war. And then the Tet Offensive happened.

IT BEGAN JANUARY 31, 1968, and although it proved to be a strategic disaster for the Vietcong, it was a strong moral victory. The message they wanted to send came through loud and clear. This war was not going to be a one-night stand. They were there and were going to stay there until every VC was dead, or every American soldier. The Tet Offensive proved the turning point in the public's opinion against the war. After that, even though the military withstood the attack, Americans increasingly believed the war might be unwinnable and it should end immediately before more lives were lost. In February, TV anchorman Walter Cronkite, the "most respected man in America," declared on CBS TV that Vietnam was unwinnable. Losing Cronkite, Johnson feared, meant he had lost the American public.

Everyone's, that is, except Wayne, who believed more than ever *The Green*

Berets was another *The Alamo,* a film about heroes, courage, the bravery of fighting men, and the inevitability of the righteous power of the American way. He wanted to see LBJ reelected, even though he was a liberal Democrat, because Wayne didn't believe a wartime president should be replaced and thought *The Green Berets* would help Johnson stay in office. Wayne told *Variety,* "I think our picture will help re-elect LBJ because it shows that the war in Vietnam is necessary."

By the time the film was set to open that June, the mood of the country had sharply turned. Vietnam was becoming a hated war, and not just by the hippies, college students, and draft dodgers. Mothers were losing sons, wives were losing husbands, and nobody could say for sure exactly why. Johnson read the handwriting on the wall and realized that Americans were no longer willing to go all the way with LBJ. On March 31, 1968, on live television, the president announced to the nation that he would not run for reelection in the fall. Jack L. Warner then wanted to pull the film, but too much money had been spent on it that the studio could not afford to lose.

The Green Berets opened at New York's Warner Theater on June 17, 1968. Wayne then accepted an offer to be the grand marshal of the Fourth of July Salute to America Parade in Atlanta, Georgia. He attended the gala premiere in what Wayne hoped would be as good a launch for his film as Atlanta had been for *Gone with the Wind* twenty-nine years earlier.

The film received notoriously bad reviews—the one most remembered was by the *New York Times'* film critic, Renata Adler, who eviscerated the film on every level, including plain logic: "*The Green Berets* is a film so unspeakable, so stupid, so rotten and false in every detail that it passes through being fun, through being funny, through being camp, through everything, and becomes an invitation to grieve, not for our soldiers or for Vietnam (the film could not be more false or do a greater disservice to either of them) but for what has happened to the fantasy-making apparatus in the country. Simplicities of the right, simplicities of the left, but this one is beyond the possible. It is vile and insane. On top of that, it is dull. . . ."

Ten days later, the *New York Times* ran Adler's review of the film again, a Sunday piece that was essentially an expanded version of her first hand grenade critique. The rest of the print reviews fell into lockstep, one after the other. The

film was too simplistic. The film was too political. The film was too ridiculous (many reviews pointed out that all the Green Berets, especially Wayne and Ray, seemed far too old and paunchy to be believable as America's fighting elite who jump and die).

And yet, for all the criticism and the war's growing disapproval among the American public, Wayne's star power turned what could have been a disaster into a big hit at the box office. From a negative cost of $6.1 million, the film's initial domestic gross was more than $24 million, with another $8 million in foreign. The film was especially popular in Japan and other non-communist countries of Southeast Asia.

Just as he did with *The Alamo,* Wayne had turned a familiar story into powerful political propaganda. Many in America wanted to see it precisely because the reviews were so bad, to see the ship sink for themselves, regardless of what the message was. The single biggest problem with *The Green Berets*—and there was a lot wrong with it—was that it inverted the schemata of *The Alamo* and by doing so neutralized its dramatic and emotional impact. In the Crockett saga, the heroes of the Alamo are defending it against foreign invaders, sacrificing their lives for freedom, to preserve the American way. In *The Green Berets* the heroes are the invaders, fighting against natives defending their homeland.

Whether or not one supported the war, the factor of aggression was inseparable from the rest of the story, and it was hard to make a case for any foreign army to be seen as anything but an invader, no matter what the cause, even if invited in to help fight the enemy, to serve as the cops of the world. The French had learned that lesson (to a degree) in Vietnam and again in Algiers, and the Germans in France and Russia. Because the premise of the film was so flawed, no matter how many people went to see it—to laugh at it, to see John Wayne back in a war picture, or as a personal statement of support for the war—*The Green Berets* could not overcome the critical avalanche that struck it down, and despite its financial success the film remains an odd artifact of self-aggrandizement, a monument to America's mistaken involvement in a war that killed more than fifty thousand GIs.

To Wayne the film was a moral victory because it was a financial success, and no one could convince him otherwise.

FOR HER PART, PILAR HOPED that *The Green Berets* was going to be her husband's cinematic swan song. He had done it all, he had said it all, and he was getting on in years. He was sixty-one when the film opened, a cancer survivor, the father of seven, the grandfather of nine, and one tired man. Wayne talked it over with Pilar, thought about it, even considered buying a big spread in Baja and spending the final years of his life sailing.

There was only one problem with that plan. Because of the structure of the funding, most of the profits from *The Green Berets* went to Warner Bros. Wayne found himself once again a few bucks shy of broke.

To generate immediate income, he agreed to star in Universal's *Hellfighters*, directed by Andrew McLaglen. The film reunited him with Jim Hutton, and also starred newcomer Katharine Ross, hot off the success of Mike Nichols's 1967 *The Graduate* (a picture Wayne loathed). *Hellfighters* was a formula film about oil rig fighters, loosely based on the life of "Red" Adair, set in Latin America and filmed in Casper and Jackson Hole, Wyoming, and Texas, the script tailored to Wayne's acting strengths and physical weaknesses. It was made quickly and opened December 14, 1968, to mostly negative reviews, but did well at the box office, grossing a little more than $9 million. Wayne received a million dollars plus a percentage to be in it, and that money greatly eased his cash flow problems. As a career move, however, it was a definite step backward.

And then out of nowhere came *True Grit*.

AFTER HUFFING AND PUFFING HIS way through *Hellfighters*, Wayne was certain time had finally caught up with him and that the big parts in major movies were no longer going to come his way. He wasn't just older, his weight was up, he wore a bad toupee, and he could no longer make the kind of physical moves he used to be able to do so effortlessly. As 1968 dragged to a close, Wayne took a break to do some sailing with his family.

Not long after, he received a call from an old friend and director Henry Hathaway, who had just read a galley (proof) of a new novel by Charles Portis and immediately thought of Wayne for the role of Rooster Cogburn. He messengered the galley over; Wayne read it and immediately agreed to do it. He loved the character, felt it was perfectly suited for him, and wondered if Portis hadn't based the character on "John Wayne." He made an offer through Batjac

of $400,000 for the rights to the book, only to discover he was not the only one who wanted them.

Portis had taken Wayne's offer to Hal Wallis at Paramount, and Wallis put $500,000 on the table for *two* Portis novels, *True Grit* and *Norwood,* with penalty guarantees for the author if either one of them didn't get made. Batjac couldn't match Wallis's offer and he easily won the rights. And then the first thing he did was call Wayne and offer him the part of Rooster, which he accepted before he hung up the phone. His deal was finalized the next day, $750,000 plus $1,500-a-week living expenses, and 35 percent profits from all related film and television revenues.

Wallis, at Wayne's request, hired Henry Hathaway to direct *True Grit* (a.k.a. *Alma Mater*), whose first job was to find the right actress to play Mattie Ross, the fourteen-year-old who resurrects Rooster from his life of drunkenness and his surrender to the ravages of old age. The first one Hathaway approached was Mia Farrow. Although she was much older than Mattie, the waifish Farrow could have pulled it off. However, she wanted Wallis to replace Hathaway with Roman Polanski. She had worked with Polanski on his *Rosemary's Baby* and thought he could make *True Grit* a much better film. Wallis refused and Farrow backed out. Although in the years that followed Farrow would come to regret her decision, for now, it left Wallis having to continue his search for Mattie. He auditioned many actresses but it wasn't until he saw Kim Darby on a TV show that he found the one he was looking for. Darby, however, had just had a baby with actor Jim Stacy and wanted to be a stay-at-home mother for a while. Eventually, however, Wallis convinced Darby to sign on for $6,200 a week. Stacy demanded an agent's fee to let his wife be in the film, and Wallis told him where to go to get it.

Filming was set to begin on September 5, 1968, and continue through December, on location in Montrose, California, and Mammoth Lake, at a production cost of $4.5 million. However, before production began, Hathaway and Wallis had to deal with Portis, who objected to the story's locale being changed from Arkansas in the novel to Colorado, and the flashback aspect of the novel being missing from the script. He next insisted he didn't want Wayne to play Rooster Cogburn. Wallis then gave Portis a hard reality check, explaining as calmly as he could that the author should get down on his hands and knees and thank whatever Lord he favored that John Wayne had agreed to play Rooster.

If he didn't accept the casting, over which he had no legal control, Wallis told him he could take his book and leave and that would be the end of the movie.

It was the last time Portis complained about anything.

WAYNE LOVED FILMING IN MONTROSE. It was quiet, peaceful, and gorgeous, with clean air and not a film critic as far as the eye could see. What he didn't love was the way Wallis wanted him to look in the film, over-the-hill, creaky, with a patch over one eye. Wayne insisted his fans didn't want to see him that way. He went to Hathaway, who backed up Wallis and told Wayne this was the way the film was going to be made. He had no more complaints. Instead, he threw himself into the part, playing a character different from any he had ever done before. And for once, he didn't have to go on one of those studio-mandated killer diets. Hathaway actually wanted him to gain twenty pounds, something Wayne had no trouble doing.

The director had problems with Robert Duvall, who played Lucky Ned Pepper, another hot-shot would-be director/actor (this was after his debut in *To Kill a Mockingbird* and before his star-making turns in *The Godfather* and *The Godfather II*). Duvall, who was being paid $4,500 a week, didn't particularly like or respect Hathaway. He considered him one of the old guard of directors out of touch with the new wave of independent filmmakers.[*]

Besides Duvall's complaints about Hathaway, Darby had little respect for Wayne and made no secret of it. At one point, he referred to her on-set as a spoiled brat, but he held in most of his anger at her in for the sake of the film.

Rooster Cogburn is a washed-up U.S. marshal; his wife and child long gone, the only love he has left is for booze. When young Mattie Ross comes to him to catch the man who killed her father, she tells him he can do it because she knows he has "true grit." He accepts the job and through it rediscovers the meaning of his life and redeems his soul.

Wayne's favorite scene in the film was the last, when he tells Mattie to "Come see a fat old man sometime" and then rides off on his horse and jumps a four-rail fence. Despite his missing lung, being grossly overweight, and sixty-one years old, he did the jump in one take with no stunt double. He meant to show

[*] Darby and Glen Campbell each received $6,500 a week. Jeremy Slate (Emmett Quincy) received $5,000 a week. Strother Martin (Colonel G. Stonehill) was paid $3,000 a week; Jeff Corey (Tom Chaney), $2,500 a week; and Dennis Hopper (Moon), $1,500 a week.

the world that he was not just still alive but kicking, and Hollywood that he could still do the job.

Advance screenings went well, and word began to buzz through Hollywood that *True Grit* was a real winner. When it opened, June 12, 1969, the critics raved about it, especially Wayne's performance, and all was forgiven for *The Green Berets*. Charles Champlin, in the *Los Angeles Times,* wrote that "Rooster Cogburn sits like a crown atop [Wayne's] forty years of playing John Wayne . . . until you've seen John Wayne with the reins in his teeth, you haven't seen it all."

Time: "By growing old disgracefully as the fat, swaggering Rooster Cogburn, Wayne proves he can act—and solves his own senior citizen problem in one master stroke."

The *New York Times*: "John Wayne has the best role of his career . . . the last scene in the movie . . . will probably become Wayne's cinematic epitaph . . . This is only July but I suspect that *True Grit* will stand as one of the major entertainments of the year."

And so it went, one critic after another heaping praise on Wayne. Soon enough there was talk of an Oscar for him, but Wayne brushed it off, not wanting to let the buildup get to him. The higher his expectations, he knew, the harder the fall would be when he lost, as he was sure he would.

ONLY A MONTH AFTER COMPLETING *True Grit*, Wayne made *The Undefeated,* directed by Andrew McLaglen, costarring Rock Hudson, one of the many heir apparents to Wayne's throne. The only problem, as Wayne saw it, was Rock's homosexuality, common knowledge throughout Hollywood, but unknown to the public. At first, he was reluctant to work with Hudson because of it, but as he got to know him, he was able to put his apprehensions aside and do some good work. He and Hudson played a lot of cards together between scenes and by the end of filming had forged the unlikeliest of friendships. It did a lot for Wayne to be able to cross this late-in-the-day divide. The film put a million dollars in his pocket, plus 10 percent of the profits after the film earned back its negative cost.

AFTER HIS ANNUAL CHECKUP, WHICH showed no signs of his lung cancer having returned, Wayne and his assistant, Mary, flew to Durango to

film *Chisum,* a Batjac production that brought him a million dollars from Warner Bros, $5,000 a week for expenses and 10 percent of the film's profits. *Chisum* was originally commissioned by Twentieth Century–Fox, but after a series of big-picture failures (Robert Wise's *Star* with Julie Andrews; Gene Kelly's *Hello Dolly!* with Barbra Streisand), they put it into turnaround. Warner Bros immediately picked it up for distribution.

Filming ended in December 1969, just as Wayne got word he was going to be nominated for an Academy Award for Best Actor in *True Grit.*

Chapter 26

Despite Wayne's being at the top of his game, named the fourth-most-popular actor in Hollywood for the year 1969, the twenty-first time he'd made the list, the film he was working on, *Rio Lobo,* had an undeniably elegiac feel to it.*
When Wayne returned to the set after having won his Oscar for *True Grit,* everyone in the cast and crew wore an eye patch in honor of his first-ever Academy win. *Rio Lobo,* Wayne's 158th feature film, and Hawks's forty-sixth (and last of his career), was essentially a remake of two of his earlier collaborations with Wayne, *Rio Bravo* and *El Dorado,* and the weakest of the trilogy. Produced and directed by Hawks and Batjac, and distributed by National General, *Rio Lobo* closed the door on big studio westerns. The film was released in December 1970 and barely made back its production costs; it competed with Arthur Hiller's fabulously fatalistic college romance, *Love Story,* which earned the most money of any film at the box office that year; Robert Altman's *MASH,* set in the Korean War but pointedly critical of the seemingly never-ending war in Vietnam; Michael Wadleigh's documentary of the hippie-laden *Woodstock;* Bob Rafelson's *Five Easy Pieces,* his postmodern look at the clash between existentialism and true love, starring Jack Nicholson; and Ted Post's *Beneath the Planet of the Apes.* There were "war" pictures, too, but they looked like nothing

* The top ten stars of 1969 were Paul Newman, Clint Eastwood, Steve McQueen, John Wayne, Elliot Gould, Dustin Hoffman, Lee Marvin, Jack Lemmon, Barbra Streisand (the only female on the list), and Walter Matthau.

that Wayne had ever made. The biggest, Franklin J. Schaffner's *Patton,* reportedly Richard Nixon's favorite film, was darker and more complex than most World War II films. And there was Brian G. Hutton's *Kelly's Heroes,* a heist movie disguised as a war film, with soldiers stealing gold from the Germans for their own use. While Wayne continued to promote the heroics of the Great American Western Hero, American films began to move in other directions, leaving him and his style behind. It was as if the Academy had said to him, Okay, here is your Oscar, now fade away.

DURING THE MAKING OF *RIO* *Lobo,* Wayne had a tendency, as he had during *True Grit,* to show the younger actors in the picture how to act. *Rio Lobo* had originally been written for Wayne and Robert Mitchum, but the budget couldn't afford both of them. The producers felt Wayne could carry the picture by himself, and hired Mitchum's son, Christopher, for a much lower fee. Watching him try to pick up a pistol drove Wayne crazy. Finally he grabbed it from his hand and said, "If you're gonna pick up that handgun, Chris, for Christ's sake, don't do it *that* way." He then looked at Hawks and said, "Isn't that right, Mr. Hawks?" "That's right, Duke." Wayne was always mindful of his directors, and never wanted to show them up on set.

While filming, Wayne received news that his brother had died of cancer. He had always taken care of Robert, who had lived off the Wayne name all his life. Wayne disappeared for a day before returning and completing work on the film.

Wayne's next film was *Big Jake,* made by Batjac for Warner Bros, and directed by George Sherman. It starred Ethan in his first major role, as Wayne's grandson. Michael Wayne produced, and Patrick Wayne had a big role. The film also featured Christopher Mitchum again and reunited Wayne with Maureen O'Hara, although much of her role was left on the cutting-room floor. The film went nowhere at the box office, confirming Wayne's fears that his days as an important filmmaker had ended with *True Grit.*

ALSO THAT YEAR, WAYNE'S MOTHER, Mary, passed away after a long bout with lung cancer. She had moved to Long Beach after she and Clyde divorced, remarried, and lived there for the rest of her life with her second husband and Robert.

IN 1971, WAYNE GAVE AN interview to *Playboy* magazine, of all places, a hard-hitting, no-holds-barred Q and A. Hugh Hefner, the magazine's flamboyant and extremely liberal publisher, couldn't have asked for a better subject. It was as if now that Wayne had his Oscar behind him, he could say what he really wanted to but couldn't. Besides his harsh condemnation of *High Noon,* his unabashed pride in running Carl Foreman out of the country, and rude comments about race the most shocking part of the entire interview was Wayne's putting the blame on the U.S. military for the failure to end the war in Vietnam: "If Douglas MacArthur were alive, he would have handled the Vietnam situation [*sic*]. He was a proven administrator, certain a proven leader. And MacArthur understood what Americans were and what American stood for." He also praised President Truman for his "great guts" in taking on the North Koreans. He blamed the State Department for holding Truman back from widening the war. He explained the reason he never wanted to run for office was that America was too much of a system of checks and balances. He claimed he was offered an opportunity to run as George Wallace's vice presidential candidate on the 1968 American Independent ticket and turned it down for two reasons, the first being he was busy producing *True Grit* and, second, he was a solid, loyal Nixon man. He also blamed his politics as the reason for the critical failure of *The Green Berets* and referred to the *New York Times* critic Renata Adler as an "irrational liberal." This water-cooler interview got the entire country talking about John Wayne again.

AFTER *BIG JAKE,* HE MADE *The Cowboys,* his only 1972 release (January), directed by Mark Rydell, at Universal, for which Wayne was paid $1 million and 15 percent of the net profits. The film was a hit, grossing over $7 million, and gave Wayne's audiences everything they wanted from his movies—lots of action and a tough but understanding hero. In this film, he hires eleven young boys to help him drive his cattle four hundred miles from his ranch to the railroad. There are obvious echoes of *Red River* in the story, with Wayne helping these young boys grow to manhood, experiencing prostitutes, fights, thieves, and rustlers. The villain in the film is played by Bruce Dern, who shoots and kills Wayne's character. When they were making that scene, Wayne turned to Dern, whom he didn't particularly like, seeing him as part of the new wave of

long-haired actors who had no respect for "old" Hollywood, and said, "Ooh, they're going to hate you for this," to which Dern replied, "Maybe, but in Berkeley I'll be a fucking hero."

It was one of those shoots where Wayne didn't bring his children along, perhaps because he was "killed" in the film and he didn't want them to see that. When his young son Ethan asked when him he'd be back, Wayne answered using one of his favorite expressions, "In about three months, God willing and the river don't rise."

In some ways, *The Cowboys* is the best of Wayne's post–*True Grit* films, suffering only from his advancing age that kept him from being more physical. As Rex Reed crudely put it in his review of the film for the *New York Daily News*: "Old Dusty Britches can still act!"

In the winter of 1972, Wayne made *The Train Robbers,* a Batjac production in association with Warner Bros, produced by Michael and written and directed by Burt Kennedy. Bill Clothier was the cinematographer. Shot in Durango, the film costarred Ann-Margret as a beautiful widow who enlists Wayne to recover a half million in gold stolen by her late husband, from the train that is now carrying it. To help him, he hires Ben Johnson and Rod Taylor. Bobby Vinton was added to the cast to attract younger audiences. The film climaxes in a grand shoot-out. After Wayne and company return the gold to Ann-Margret, she is promptly arrested by a Pinkerton man from Wells Fargo. She has made up the whole story to get Wayne and his boys to rob the train for her. The film came in at a negative cost of $3.5 million and was one of Wayne's few post–*True Grit* failures.

He stayed in Durango to shoot his next film, *Cahill, U.S. Marshal,* without bothering to return home.

WAYNE AND PILAR FORMALLY SEPARATED that same year, after having lived in separate bedrooms for the past three; Pilar had told the children it was because of Wayne's snoring, but of course that wasn't the reason. Wayne had been slowly drifting away from his family, even more so after his Oscar win. He was cranking out films and spending more and more time on the road, always leaving Pilar behind, he said, to run the household.

Fully recovered from her addictions, she soon developed interests of her own to try to create an identity separate and apart from her husband's. Pilar did give

him one final chance to save their marriage with an ultimatum, either go to marriage counseling with her or give her a divorce. He agreed to the counseling but quit after two sessions. To a friend, he said, "Hell, it's over with Pilar."

And there was something else. Wayne had a new woman in his life.

The story of his May-December seven-year involvement with Pat Stacy, an attractive, petite, thirty-year-old brown-haired divorcée from Indiana he had chosen to replace the retiring Mary St. John as his personal assistant, is a complicated one and difficult to parse. She was a graduate of Northeastern University, had moved to Los Angeles in 1968, and landed a job at Arthur Andersen & Co., Wayne's new tax accountants. There she was handpicked by Mary St. John to be her eventual replacement. When Mary ran her choice by Wayne, he enthusiastically agreed. He liked what he'd heard and even more what he saw.

There is no question Pat Stacy was enamored of Wayne as well, and soon after became his constant traveling companion while Pilar remained at home. In 1973, he took *The Wild Goose* up the coast to Seattle, to film *McQ*, a contemporary detective thriller directed by John Sturges along the lines of Steve McQueen's 1968 *Bullitt*. It was now easier for the sixty-six-year-old Wayne to get in and out of cars than on and off horses. Pat accompanied him on the trip. It was during the making of this film that she and Wayne became lovers. Stacy: "We finished shooting one day, and we all went to our staterooms. I was headed for mine when Duke put his arm around me and led me to his. It seemed like the most natural thing in the world to do. I went with him. We had a great admiration and affection for each other, but I don't think we said we loved each other."

Wayne made no effort to hide the affair from anyone and Pilar heard about it almost immediately. Once again she offered to divorce him. He refused. According to Pilar, Mary St. John told her that Wayne spent the next three days without Pat, fighting back tears.

Wayne recovered quickly, knowing that Stacy had awakened something in him that had been dormant for a long while. He was still capable of having sex, but there was something inside that was not so easily touched, and Pat had been able to reach it. They even talked about marriage, but Wayne told her he had already failed at it three times, that if he were still in his fifties he might try again, but now it was too late for any of that. He liked things the way they

were. Stacy accepted the truth of their relationship, that he would never marry her; it was what it was and what it would always be.

JOHN FORD DIED AT 6:35 P.M. on August 31, 1973, in the arms of Woody Strode, a longtime member of Ford's stock company of actors. Wayne knew that he had been seriously ill for a time and had lived for the past several years in unofficial retirement in Palm Desert, California, an upscale, unofficial village for Hollywood's most privileged seniors. Ford had made his last feature, *7 Women*, in 1968, which was critically well received but did not do well at the box office (Andrew Sarris named it his favorite American film of that year).* Ford rarely went into Hollywood after that, but did once more, early in 1973, to receive the American Film Institute's first Life Achievement Award. Wayne gave a touching tribute to his longtime friend and mentor.

Near the end the bedridden Ford had called Wayne and asked him to come out to the desert. As soon as he completed *McQ,* Wayne made the trip and sat by Ford's bedside, grimly smiling as he reminisced with the director, whose body was shrunken and ravaged by cancer. Ford drank a little brandy and berated Wayne for making frequent appearances on the popular TV show *Laugh-In,* saying that it would hurt his career. Wayne listened and said nothing, holding Pappy's hand to try to comfort the Old Man.

The next day Ford died and Wayne fell into a deep depression. He turned for comfort not to Pilar, but to Pat.

NOT LONG AFTER FORD'S DEATH Wayne made no secret of the fact to everyone, including Pat, that he missed being with Pilar. They even toyed with the idea of reconciling, but neither could make the first move back. Pilar was aware of Pat's loving role in Wayne's life and wasn't sure she would put up with it. She decided to move ahead with her own life without him.

Early in 1974, the *Harvard Lampoon* lightheartedly laid the gauntlet down, publicly daring Wayne to show up in Cambridge, accept their annual "Brass Balls" award, and face the crowd in person in the square. He called Pilar and asked her what she thought he should do. She warned him against it, telling him they would ridicule him, that college students could be vicious. He de-

* It also made Sarris's Most Misappreciated American Films of All Time list he issued in 1977.

cided to go anyway. He had never shied away from a fight in his life, on- or off-screen, and he wasn't about to start now. At whatever way they came to him, he could and would come back the same way. He saw it as an opportunity to try to connect to a part of his audience that had turned away from his films in favor of the new, independent movies that spoke more directly to them, like Mike Nichols's 1967 *The Graduate,* Dennis Hopper's *Easy Rider,* and Bob Rafelson's *Five Easy Pieces,* none of which could possibly have been made at the height of the studio system's golden era. Wayne detested them. None looked anything like the kind of movies he had made for nearly fifty years. He wanted to show the students that he had a sense of humor and didn't mind being made fun of.

The day of the big visit, he was driven around the square in an armored personnel carrier, looking like nothing so much as a cross between a head of state and a prisoner of war. Students shouted insults at him, which he responded to with a broad smile and a wave. He was then delivered to the Harvard Square Theater for a question-and-answer session that pushed the limits of good taste but made everybody laugh, including him. Where did he get that phony toupee? Wayne chuckled and said it was real hair, just not his. Women's lib? Women can do anything they want as long as they have dinner on the table when men get home. Did he look at himself as the fulfillment of the American Dream? He tried not to look at himself any more than he had to. By the end of the day, the students were cheering for Wayne, who had taken everything they could throw at him and was still standing.

IN JUNE 1974, WAYNE FLEW to Chicago and then London to film *Brannigan,* another *policier,* part of his ongoing attempt to look more contemporary, or more relevant. Taking its cue from Clint Eastwood, *Brannigan* is a modern-day western on the order of *Dirty Harry.* The film, a Batjac/Jules Levy/Arthur Gardner production, was executive-produced by Wayne's son Michael and distributed by United Artists. Tough talk, fistfights, car chases—all more of the same. Wayne moved with difficulty, felt old, and looked it. It was another paycheck movie—Wayne received $750,000 and a good percentage of the profits. While filming *Brannigan,* Wayne came down with a bad cold, followed by a fever and a cough, then began to cough up blood, immediately triggering fears that something was seriously wrong. Despite Pat's presence and willingness to care for him, Wayne now insisted he needed Pilar. He called and invited her to

take the kids and join him in the big house he was staying in for the duration of filming. Pilar accepted his offer. Pat Stacy picked them all up at the airport. Wayne was too busy filming.

He had presents waiting for everybody, and when after that day's shoot, he met everybody at a small dinner party he had arranged for that evening. Pat did not attend. After, Wayne confessed to Pilar that he had lost his sexual vitality.

By the third week Pilar was ready to go home. When she told Wayne she was leaving, he looked sad and depressed and reassured Pilar he hoped they could all live together again when he got back to California, the whole family under the same roof, the way it used to be.

Pilar returned to Newport Beach, happy and optimistic, after thinking it over during the long flight home and deciding she wanted to reconcile with her husband. She placed a call to him in London to tell him her decision. The phone in his suite was answered by a butler, who informed her that he had gone to Paris. Pilar asked to speak to Pat. He said she wasn't there, that she had accompanied him on the trip. Pilar thanked him and hung up the phone.

In Paris, Wayne and Pat stayed in their suite, leaving it only when they had to, except when he wanted to buy her expensive designer clothes. If Pat tried three or four dresses, Wayne would insist she take all of them.

When Wayne finally returned to California, Pilar confronted him about his trip to Paris with Stacy and again asked him if he wanted a divorce. He said no, they should stay together for the sake of the children. He didn't deny the trip to Paris or elaborate on it, or on his relationship with Pat. Pilar knew they would never live together as husband and wife again.

In her book, Pilar wrote of what followed after that day: "From then on we were to meet as intimate strangers. I even began dating, although my thoughts and my heart were still with Duke . . . it is still difficult for me to write about Pat Stacy and the role she played in our lives."

That September 1974, after doing a series of public service commercials for the American Cancer Society—"Get yourself a checkup and send in a check"— Wayne went off to film *Rooster Cogburn* with Pat by his side, as she was constantly now. Produced by Hal Wallis for Universal Pictures, *Rooster Cogburn* was shot on location in September and October, in Bend, Oregon, the Cascade Mountains, Deschutes National Forest, and the Rogue River. Wayne received $750,000 plus a percentage of the profits. His costar in this sequel to *True Grit*

was Katharine Hepburn, who received $150,000 plus $12,500 in expenses and a small piece of the net profits (which eventually totaled $100,000). The film had a script by Martha Hyer (writing as Martin Julien) that resembled the 1951 Hepburn/Bogart Huston film *The African Queen* more than the original *True Grit,* with Hepburn a spinster version of Mattie Ross and Wayne in the Bogart role, slovenly, coarse. The two got along well during production, despite their political differences (Hepburn was a well-known liberal and champion of women's rights). They were professionals there to do a job, and did it the best they could.

As is the proven rule in Hollywood, sequels cost twice as much as originals and gross half the amount. *Rooster Cogburn* was no exception. *True Grit* grossed $35 million in its first domestic release, *Rooster Cogburn*, released in October 1975, did $18.4 million.

During filming, Wayne's old cough returned, not helped by the high altitudes of the Oregon locations, and he soon developed what was diagnosed as walking pneumonia. He was hospitalized once during filming and once after. He had lost fifteen pounds. He also suffered through an inner ear infection, and exhaustion, but managed to overcome all of it, except that cough.

A month after finishing *Rooster Cogburn* Wayne checked into Hoag Hospital in Newport Beach to have a knee he had injured during filming corrected. He was never comfortable in hospitals, and this time was no different. He was released a week before Christmas. Although he had given up smoking after his lung cancer, he was back up to a pack a day.

Brannigan was released in March 1975, and it, too, failed to capture the imagination of the public, barely making back its production costs.

Wayne was back in the hospital again the same month, unable to shake his hacking cough. This time he was treated with antibiotics, developed a staph infection, and remained an inpatient for the rest of the month.

Upon his release, a frail-looking Wayne made an appearance at the Dorothy Chandler Pavilion for the April 8, 1975, Oscar presentations, hosted that year by Bob Hope, Sammy Davis Jr., Shirley MacLaine, and Frank Sinatra, telecast live over NBC in America and beamed around the world via satellite. He had agreed to present the Honorary Academy Award for Lifetime Achievement to Howard Hawks.

Wayne was introduced by Shirley MacLaine, and he received a standing ova-

tion. When the applause died down, Wayne spoke, his voice slightly strained. "Actors hate directors, and then the movie comes out, and they get great notices, and then they don't hate the director anymore." The audience laughed appreciatively, recognizing the truth of Wayne's observation. After he read a list of Hawks's best movies, he said, "He's made a lot of actors jump. I'm the director tonight. Hawks! Roll 'em. Get your skinny whatchamacallit out here!" Hawks walked slowly out, thin as ever, his head crowned with cotton-white hair, and the audience rose to its feet. Wayne handed him the Oscar, saying "From movie fans everywhere." The Grey Fox, as Hawks was known in Hollywood, then approached the mike and said, "I remember visiting John Ford when he became sick and went out into the desert to die. And he said, 'There's something I stole from you that tops the whole thing. I won the Oscar but you made a better picture. You're going to get one.'" The audience was puzzled by the reference. Hollywood has a short memory when it comes to who won an Oscar what year. Wayne pointed the way off, stage right. "No, this way," Hawks said and led Wayne off in the other direction, leaving everyone scratching their heads.*

Backstage, at the mandatory press conference, a so-called reporter shouted to Wayne, asking him if he was a racist. "You're mistaken," Wayne said, angered but not wanting to sound confrontational. The reporter asked the question again and he was hustled out of the room by security guards.

WAYNE WAS EXHAUSTED BY HIS appearance at the Oscars and began an extended period of convalescence spent mostly alone on *The Wild Goose,* with an occasional stop at the house in Newport Beach. His downtime ended January 13, 1976, when he reported for the start of production on what would be his 164th and final film.

The Shootist was directed by Don Siegel from a screenplay by Miles Hood Swarthout and Scott Hale. Cinematographer Bruce Surtees was behind the camera, and the music score was by Elmer Bernstein. It was not a Batjac film, produced by Dino De Laurentiis and Mike Frankovich, distributed by Paramount domestically and De Laurentiis internationally. Wayne was hired to act in it for $750,000 plus an unspecified percentage of the net to star in the film. His costars were Jimmy Stewart, reuniting the two legends for the first (and

* Ford won Best Director in 1941 for *How Green Was My Valley* over Hawks, who was nominated for *Sergeant York.*

last) time since *The Man Who Shot Liberty Valance,* and Lauren Bacall, whom he'd worked with on *Blood Alley*; Stewart and Bacall each received $50,000 for their relatively small roles.*

Set in 1901, the film is yet another tale of the disappearing Old West at the dawn of the twentieth century. J. B. Books (Wayne) is an aging gunfighter who visits his old friend, Dr. E. W. Hostetler (Stewart), who tells Books he is terminally ill with cancer. Wishing to die in peace and with dignity, Books rents a room at the widow Bond Rogers's (Lauren Bacall's) boardinghouse, where he strikes up a paternal relationship with her boy, Gillom Rivers. When the town learns of Books' presence, several gunfighters come to make their reputations by shooting him down. A climactic fight scene ensues, Books kills all his challengers, and then is shot in the back by Murray the bartender, of all people. Gillom then kills the bartender, played by Charles G. Martin. Siegel originally wanted Wayne to shoot Murray, but he refused, telling Siegel that John Wayne would never shoot anyone in the back.

The film bore more than a casual resemblance to Henry King's 1950 *The Gunfighter,* with Gregory Peck in the role of a gunfighter who can never retire because there is always someone out there who wants to make his reputation as the man who outdraws him. It also had something of *True Grit* in it, the old gunslinger befriended by young Gillom, played by Ron Howard in the Kim Darby role.

Siegel used the opening sequence of *The Shootist* to pay tribute to Wayne with a montage from some of his earlier westerns, including *Red River, Hondo, Rio Bravo,* and *El Dorado,* in effect melding all his cowboy characters into one iconic figure.

Released July 19, 1976, it was one of thirty-three westerns made during the United States' bicentennial year, and among the most popular. From a negative cost of $8 million, split between Paramount and De Laurentiis, *The Shootist* grossed $13 million domestically, and nearly doubled that internationally. *Variety* raved about it, declaring that "*The Shootist* will stand as one of John Wayne's towering achievements . . . Don Siegel's terrific film is simply beautiful . . . The entire film is in totally correct balance, artistically and technically . . . It is one of the great films of our time." Kathleen Cornell of the *New York Daily News*

* Wayne and Jimmy Stewart had no scenes together in *How the West Was Won*. This was Stewart's first film in five years, since 1970's *Fool's Paradise*. He made five more movies after *The Shootist*.

understood that "[t]his is unmistakably Wayne's valedictory performance. Only a great actor could have this skillfully delineated performance." Frank Rich, writing for the *New York Post,* said, "When Wayne warms up to a role and lets loose with his sour twang of a voice, he can still command an audience's undivided attention—and he can still wipe most any other actor off the screen." *Newsweek* wrote that "Wayne's proud, quietly anguished performance . . . has a richness that seems born of self-knowledge; he lends the film a tremendous sense of intimacy and a surprisingly confessional mood."

That fall, in *Boxoffice* magazine's ranking of the nation's top male stars, Wayne placed seventh, his twenty-fourth appearance among its top ten. The *Motion Picture Herald*'s survey of theater owners had Wayne at eleventh. According to the survey, the top ten male and female stars of 1976 were Robert Redford, Jack Nicholson, Dustin Hoffman, Clint Eastwood, Mel Brooks, Burt Reynolds, Al Pacino, Tatum O'Neal, Woody Allen, and Charles Bronson. And then came Wayne, fifty years after his first appearance in *Brown of Harvard.*

HIS COUGH, WHICH HAD NEVER completely gone away, continued to get worse, a wet, sticky, grating hack that often bent him over and turned his face red. His voice had been noticeably hoarse during the filming of *The Shootist,* and after, his weight ballooned. He looked bloated and uncomfortable, and when he finally and reluctantly did go to a doctor, he was diagnosed with congestive heart failure, a complication of a defective mitral valve. He was put on digitalis and digoxin and, to rid him of his excess water weight, the diuretic Lasix. He was also given regular doses of potassium. That spring he was also diagnosed with having an enlarged prostate.

All the treatments and medications weakened him considerably, but he insisted he was fine and went on a publicity blitz for *The Shootist.* He appeared at an "All-Star Tribute to John Wayne," to raise funds for a children's hospital and also plug the film. He also campaigned for Ronald Reagan during his quest to win the Republican nomination and represent the party in that fall's presidential election. When Gerald Ford won it, Wayne then actively campaigned for him.

After the 1976 election (Jimmy Carter won and Wayne promptly sent him a mailgram "congratulating the loyal opposition"), Wayne quietly checked in

to Hoag to have routine surgery to relieve pressure on his urethra from the enlarged prostate. He was released from the hospital in time to receive an unexpected invitation from President-elect Carter to attend his inauguration.

The night of January 19, 1977, he spoke briefly but with great elegance at the preinaugural reception: "Good evening. My name is John Wayne. I'm here tonight to pay my respects to our thirty-ninth president, our new commander-in-chief—to wish you Godspeed, sir, in the uncharted waters ahead. Tomorrow at high noon, all our hopes and dreams to into that great house with you. For you have become our transition into the unknown tomorrows, and everyone is with you. I'm pleased to be present and accounted for in this capital of freedom to witness history as it happens—to watch a common man accept the uncommon responsibility he won 'fair and square' by stating his case to the American people—not by bloodshed, beheadings, and riots at the palace gates. I know I'm considered a member of the loyal opposition—accent on the loyal. I'd have it no other way."

The applause filled Wayne's ears with his favorite sound, the freedom of expression. For him, there would be no opposition to that as long as he lived.

However much longer that might be.

DURING THE RECEPTION, WHILE PRESIDENT Carter was on the receiving the line of celebrities waiting to shake his and Vice President–elect Mondale's hands, he broke away to personally thank Wayne for his kind words. It was a warm moment for him. He hadn't voted for Carter, but he saw something of himself in the new president, someone who didn't hold personal grudges, who could rise above an adversary to extend the hand of friendship. When President Carter wanted a new treaty with Panama that would grant them a greater measure of freedom and turn control of the Panama Canal over to the Panamanians, the Republicans opposed giving up the canal, but Wayne thought it was the right thing to do and supported Carter on this issue.

Less than a month after the inauguration, Wayne lost another of his close friends, a charter member of the old guard, when Andy Devine, a veteran of more than four hundred movies, died of leukemia. Devine was buried at Pacific View Memorial Park. After the ceremony, Wayne told his family that was where he wanted to be buried, overlooking Newport Harbor.

WAYNE STRUGGLED ON, BATTLING HIS ailments, all the while believing he would make at least one more movie. He bought the rights to *Beau John,* an as yet unpublished novel by Buddy Atkinson he hoped to film with Ron Howard as his costar.

Early in 1978, President Carter invited Wayne to witness the signing of the Panama Canal Treaty, but he was too sick to attend. His mitral valve had deteriorated to the point where he had to have it replaced. He agreed to open-heart surgery, an operation that itself might kill him, especially with only one lung to support him during and after it was performed. On March 29, 1978, the night of that year's Oscar ceremony, where he was supposed to present an award, he was instead accompanied by Michael, Patrick, Aissa, and Pat Stacy (but not Pilar) to Massachusetts General Hospital in Boston to receive a pig's valve to replace his worn-out one. The three-hour surgery on the seventy-year-old Wayne was performed the morning of April 3, 1978.

After a brief stay in the hospital, he felt well enough to be released, and by the end of April, he flew back to Newport Beach. All seemed well until he came down with hepatitis, which he likely contracted from blood transfusions during his heart surgery, and a persistent fever. That May he checked back into Hoag. After his release, he spent most of his time recuperating on *The Wild Goose,* fighting what had become a new problem, a persistent burning heartburn and severe stomach pains that nothing would relieve. It became so bad that he finally had to check back in to Hoag, where the doctors told him they wanted to remove his gallbladder.

He didn't want to have to go through the ordeal of another surgery and toughed it out through December, until the pain became unbearable and he agreed to the operation on January 12, 1979. However, before it could be performed, Wayne's doctors urged him to transfer the surgery to UCLA. He suspected the worst and told Pilar, who agreed to meet with him at the restaurant she had opened in Newport Beach. They hadn't seen each other for a while. Pilar recalled her first impression seeing him that day: "He was thin, too thin, and new lines of pain had drawn his face into a mask." They made some awkward small talk, and at one point Wayne told her how much he had enjoyed their good times together. Then he admitted that he was very sick, that he couldn't eat anymore, and that he was sure this time he was dying. He made

her promise to take care of the kids. She was weeping when he got up and left. It was the last time she saw him alive.

HE THEN CHECKED INTO THE UCLA Medical Center, and exploratory surgery confirmed his greatest fear. He had stomach cancer, and it had metastasized to his lymph nodes. Most of his stomach was removed, and he could only eat very small meals, six a day, to keep his energy up. Upon his release he returned to Newport Beach, where Pat Stacy became his twenty-four-hour nurse. Pilar stayed away.

One of the last things Wayne did was to make his son Michael the executor of the estate. He reluctantly submitted to radiation therapy, but there was no getting around it. He was riddled with cancer that was eating him alive from the inside out.

Also, during this time, a bill to award John Wayne a Congressional Gold Medal was introduced in Congress by his friend Senator Barry Goldwater on May 22, 1979. Part of Goldwater's testimonial included these words: "John Wayne has dedicated his entire life to America and I am safe in saying that the American people have an affection for John Wayne such as they have had for very few people in the history of America." Maureen O'Hara, who attended the hearings, said, "John Wayne is not just an actor, and a good actor, he *is* the United States of America. I feel this gold medal should say just one thing: *John Wayne American* . . . I beg you to order the President to strike it."

Others present were Elizabeth Taylor, Kathleen Nolan, who was then president of the Screen Actors Guild, and General Albert Coady Wedemeyer.

Congress took it under consideration.

SICK AS HE WAS, WAYNE had one more public appearance left in him he was determined to make. He had been invited by the Academy to present the award for Best Picture. Even if he had to crawl there, he swore nothing and no one was going to stop him making what he knew would be his final public appearance.

Epilogue

The Oscar ceremony took place April 9, 1979, at the Dorothy Chandler Pavilion in downtown Los Angeles. The host was Johnny Carson and the presentation was broadcast live to viewers around the world.

That afternoon, at 4:30, Wayne's trailer pulled into the private parking area of the pavilion. Accompanied by his daughter Aissa, an extremely frail Wayne made it to the backstage area, where he received an ovation of appreciation and respect from the other stars and the show technicians and runners. He grinned and said, in a voice choked with emotion, "Hell, I'd have gotten sick before if I knew I'd get this kind of treatment." He was led by Aissa to a bed where he could rest until, several hours later, he would be called onto the stage.

At the designated time, Wayne was led to his entrance spot while out front, Johnny Carson made the introduction. He was nervous, more so than usual, as the audience sensed something special was about to happen. A hush fell over the crowd as they waited for Carson to say something. "Last year," he began, "an American institution stood right here and said some heartfelt words about another American institution." The light went down and a clip of Bob Hope came up from the year before, the same night Wayne was entering the hospital for his heart operation. "Wayne," Hope said, with that familiar side-of-the-mouth speech pattern, "we expect to see you amble out here in person next year, because nobody else can walk in John Wayne's boots." The lights went up and Carson said, simply, "Ladies and gentlemen, Mr. John Wayne."

At first the crowd gasped. Wayne's weight was down to 160 pounds and he looked thin and frail. His toupee looked too big for his head, and despite wearing makeup, he appeared pale as a ghost. The place then erupted in cheers and stood as one as he slowly walked down a curved flight of stairs until he reached the microphone. He waited for the audience to sit before he started speaking, his voice a whisper of what it once was. He stood steadily on his own two feet, his face crinkled into a smile that hid his eyes until he spoke: "That's about the only medicine a fella'd ever really need," he said. "Believe me when I tell you that I'm mighty pleased that I can amble down here tonight. Well, Oscar and I have something in common. Oscar first came to the Hollywood scene in 1928—so did I. We're both a little weather-beaten but we're still here, and plan to be around a whole lot longer. My job here tonight is to identify our five choices for the outstanding picture of the year (producer) and announce the winner, so let's move 'em out." Wayne went on to mispronounce most of the names of the nominees. Michael Cimino came out Michael Chipino; Warren Beatty, Warner Beatty; Paul Mazursky, Paul Masurki.

Cimino, a onetime protégé of Clint Eastwood, and three others won for *The Deer Hunter,* a picture Wayne especially hated, but he kept his opinion to himself as he politely handed the brash young director his award. Then, before Wayne could leave, Carson came out and told him "a few friends want to say hello." All the presenters and winners that night, regardless of their politics, came onstage to pay their respects to this Hollywood legend while the closing credits rolled and the orchestra played "That's Entertainment." Sammy Davis Jr. gave Wayne a big, warm hug as the broadcast ended.

Backstage, after the show, fistfights nearly broke out over the political polarities of many of the nominees. Hostile words were said, some shoving took place. Wayne, however, stayed above the fray, either oblivious to what was happening, uninterested, or simply too weary to do battle on this front. When someone asked Wayne for his opinion about what was taking place, he shrugged them off, saying, "Go ask Marlon Brando."

Pilar watched the show on TV and had wept when Wayne came out, realizing that the end for him was very near.

He was exhausted by the time Aissa got him home and put him to bed. He was told by his doctors to stay in it, and this time he listened. Several friends came to visit, among them Henry Fonda and Maureen O'Hara, the last time

they ever saw him. Pat Stacy tried to comfort him as best she could, but she knew it was close to the end, especially when he asked her for his .38 pistol so he could blow his own brains out.

According to Pilar, who couldn't bear to see him die, "I really prayed that God would take him. I hated to see a man who was so strong and powerful in his lifetime deteriorate little by little by little."

On June 11, 1979, barely awake, with his last breaths, Wayne converted to his first wife's religion, Catholicism. Later that afternoon, surrounded by his seven children, he fell into a coma and never regained consciousness.

AS HE WISHED, HE WAS buried atop a low hill overlooking the ocean at Pacific View Memorial Park in Corona del Mar, in Orange Country, California. His burial plot is located at Bayview Terrace, section 525, not far from where John Ford was laid to rest.

Although Wayne had told his family he wanted his tombstone to read, *"Feo, Fuerte y Formal,"* a Spanish proverb that means "ugly, strong, and dignified," in fear of grave robbers, and the family wanting to have him finally all to themselves, his resting place would be left unmarked until a generation had passed. A bronze marker was finally placed at the site in 2001, showing Wayne astride a horse with a Fordian horizon behind him. Above his name is the following inscription:

Tomorrow is the most important thing in my life. Comes into us at midnight very clean. It's perfect when it arrives and it puts itself in our hands. It hopes we've learned something from yesterday.

In July 1979, a month after his death, Congress approved the awarding of the Congressional Gold Medal to John Wayne. It was officially presented to Wayne's family by President Carter at the U.S. Capitol on March 6, 1980. On one side of it is the image of John Wayne riding his horse through Monument Valley. On the other is an impression of John Wayne's face.

Above it are the words: JOHN WAYNE—AMERICAN.

He was surely that.

Author's Note
and Acknowledgments

By Auteurist standards, this must necessarily be a revisionist biography of the life and art of John Wayne. If hearing Wayne's body of work described as "art" jars your cinematic sensitivities, then welcome to the Wonderful World of Auteurism, a place where Wayne's prodigious and consistent output cannot be thought of as anything less. Auteurism, it should be noted, is not a tool of the filmmaker, but a critical method, an evaluation. Directors often, and absurdly, refer to themselves as "Auteurists." They should not. Nor should actors. Or producers. Or screenwriters. Or even heads of studios.

Auteurism was introduced into American film criticism in the 1950s and early 1960s by the late Andrew Sarris as a reaction to the relatively uninformed, scattershot film criticism that existed, from which a reader could not tell if the critic was reviewing a book, a stage performance, or a film. During that time, film was not yet generally recognized in America as a separate, unique, and invaluable art form. Nor were the individual films of a director (or actors, etc.) perceived to be linked in any way as part of a larger body of work.

Auteurism really began with the influential French film magazine *Cahiers du Cinéma,* founded in 1951 by André Bazin, Jacques Doniol-Valcroze, and Joseph-Marie Lo Duca and featured among its prime writers Jacques Rivette,

Jean-Luc Godard, Claude Chabrol, and François Truffaut. During World War II, films from the West were not allowed to be shown in France. After, the French critics were able to see all they had missed, not once a year, but once a day. It was then that the notion of Auteurism was born, that individual films of a single director do not exist in a vacuum, they are linked stylistically.

After spending a year in Paris with the *Cahiers* crowd, Sarris returned to America and began writing about films from the perspective of a single film belonging to a unified body of work, most often (but not always) of the director. In 1968, Sarris published *The American Cinema* and a new generation of filmgoers, and critics, was upon us. Originally released in paperback, this was the book that turned my generation on to the deeper joyful experience that films could be—seeing them over and over, arguing about them, studying them in graduate school, writing them, making them, criticizing them, categorizing them. We carried that book around in our back pocket, like the generation before did *The Catcher in the Rye*. For us, it was not just another book about film, it was the bible. Others, many of whom were competitors of Sarris, especially *The New Yorker*'s Pauline Kael, hated it and him, and the Kael-Sarris feud became extremely loud and absurdly personal. Now, both are gone, and much of the controversy about auteurism died with them.

Today, every filmmaker mistakenly thinks of him- or herself as an Auteur. In Henry Jaglom's 2013 book of interviews with Orson Welles with an introduction by the esteemed writer and film historian Peter Biskind, I was surprised by what Biskind wrote about Auteurism in his introduction: "Auteurs [was] a term popularized in America by Andrew Sarris in the Sixties . . . Sarris argued, controversially, that even studio directors such as Howard Hawks, John Ford, and Alfred Hitchcock . . . displayed personal style, were the sole authors of their pictures and were therefore authentic artists."

It saddens me to see how Sarris and his work remain so misunderstood. In 1996, he addressed this issue, years before Biskind wrote the above: "If all that Auteurism represents is an emphasis on directors, this so-called theory should be banished for its banality." What it was, and what it remains, is an examination of a director's overall body of work, in search first of a style, and then a *consistency* of style. That is why it is necessary for any serious student to see as many films of a director as possible.

Later on, Sarris expanded on his theory, and admitted that screenwriters,

producers, cinematographers, even actors could be auteurs. Here is part of Sarris's perceptive Auteurist evaluation of John Wayne, actor, that appeared in the August 1979 edition of *New Republic,* not long after Wayne's death:

"There was always more to the legend of John Wayne than met the eye. To judge by most of the obituaries, the unifying effect of his long war against cancer had transcended the divisive effect of his long war against communism. His illness was thus regarded as a metaphor for all the problems that plague Western man in his descent from power. With Wayne's passing, we were told by solemn editorialists, the last simplistic American Hero had bitten the dust . . . The squint, the rolling walk, the roundhouse right, the clipped cadences of his speech were not granted to Marion Michael Morrison at his birth . . . Toward the end of his life Wayne acknowledged the high-brow veneration accorded him by serious cineastes here and abroad. 'I was just the paint for the palettes of Ford and Hawks,' he once remarked with rueful modesty. This may have been true at the time of Ford's *Stagecoach* (1939) and Hawk's *Red River* (1948), but by the time of Ford's *The Man Who Shot Liberty Valance* (1962) and Hawk's *El Dorado* (1967), they needed him more than he needed them. To a great extent he had become his own Auteur . . . Wayne was dismissed [in his lifetime] not only because he lacked the wide classical range of the great British actors, but also because he lacked the emotional depth of the great method actors. Wayne was thus less than Olivier on one level, and less than Brando on another. Indeed, nothing could be more alien to Wayne's temperament and upbringing than the Freudian-Stanislavskian mix of the method. Instead of reaching back into his past to dredge up the feelings that would bring his characters to life, Wayne followed a relatively Jungian process of building up a new persona into which he gradually grew . . . Wayne's most enduring image, however, is that of the displaced loner vaguely uncomfortable with the very civilization he is helping to establish and preserve . . . It took me a long time to appreciate him as an actor . . ."

Of course, not every movie star qualifies for Auteurist examination; not every actor is an auteur. John Wayne not only does, he holds a well-deserved place in the pantheon. Every film biography I have written, including ones on Walt Disney, Cary Grant, Jimmy Stewart, Clint Eastwood, Ronald Reagan (the Hollywood Years), Steve McQueen, and Michael Douglas, is, by Auteurist standards, revisionist, because most of those that precede them suffer from a

haphazard approach to the artist's work, and offer mostly a voyeuristic view of the sensational details of his or her life. Or the subjects are so revered, they devolve into hagiography.

What I wanted to do in this biography was to reach beyond the precious idea that Wayne was a symbol, perhaps the definitive one, of twentieth-century America, to the point where in a world of political correctness to criticize him at all is to criticize John Wayne's America. I wanted to examine him from an Auteurist point of view, to put the emphasis on his work, to show how the films reflected his personal life, and how, in turn, his personality was reflected in his films. Wayne's is a life illuminated by a style born out of the lives of the characters he played, personalized through his own. Everything from his childhood to his death, including his still-controversial resistance to military service, his difficulties with women, and, perhaps most important, his collaborations with John Ford and Howard Hawks, especially, helps us to better understand Wayne as a man and Wayne as an Auteur.

Finally, most movie actor biographers know about their subjects largely through (and mostly useless) interviews with friends, associates, family, and so on, which are too often distorted through self-glorification disguised as fact; biographers then use them as the foundation of their authority. What most don't have is an understanding of the medium of film, and their subjects' placement in them. I prefer to bring my point of view to my work, rather than having a point of view influenced by "experts." To my thinking, Auteurist biographies offer emotional reality. A hundred years from now, only scholars will remember the malignancy of the film industry at midcentury and how it tried to preserve democracy by taking freedom away from those who might have had another point of view. But in the future, anyone who wants to know how those who made films in the twentieth century viewed the nineteenth will have to look no further than *The Searchers*.

I am not a Democrat (what people assumed after my Disney book), I am not a Republican (although after my Reagan book many people thought I must be), I am not a radical (although that is how I was labeled after my biography of Phil Ochs). I am an American pure and simple. I have no party affiliation, other than the Brotherhood of Man. John Wayne's motto could, in a way, also be mine: "Felo, Furete, y Forman"—Ugly, Strong, and Dignified. (Well, maybe I'm not that ugly, maybe not that strong, and certainly not that dignified.)

Thanks to all who helped, especially Mark Chait, my editor, and Alan Nevins, my agent. Thanks to my mentor at Columbia University's Graduate School of the Arts, Andrew Sarris. Thanks to the Margaret Herrick Library of the Academy of Motion Pictures Arts and Science.

New York City gave me the best education I could ever have hoped for. I am a graduate of the High School of Performing Arts, when it was the Fame School on Forty-Sixth Street. I used to cut academic classes to go to the movie theaters on nearby Forty-Second Street, before it was underwent its Disney-fication, when tourists stayed as far away from "Forty-Deuce" as possible. It was there I could spend an afternoon watching three movies in one theater for twenty-five cents. I then went to City College of New York, where I took a film class with Herman G. Weinberg, who had written a book about Josef von Sternberg. It was there I was first introduced to the exotic word of Marlene Dietrich, Gary Cooper, and Cary Grant. After I received my B.A., I attended Columbia University's School of the Arts, with the gracious help of a fellow-ship. I received my MFA in 1972. I chose Columbia because it was in New York City and because I knew Andrew Sarris was teaching film there. I had first heard of him while he was still lecturing nights at New York University. My girlfriend at the time told me how much she thought I would enjoy his class. I began to sit in, so easy to do in those days. Sarris continued for me what Weinberg had started, the process of prying my eyes open to see what was before me on the screen. But, whereas Weinberg was a functionary, restricted by his own adoration for Dietrich, Sarris was a visionary, liberated by his own quest for much-needed revision of the history of American movies. I was captured equally by his classroom critiques as I was by his personal persona. A few years later when I found out he was at Columbia, that sealed the deal for me. One day while discussing with me the early Auteurist battles he'd had, he warned me always to be careful not to open too many fronts against the mainstream or the politically correct unless I was sure I could defend them.

This biography is another one of those fronts.

And finally, I thank you, my faithful readers, for the many years of your wonderful loyalty and support. I will leave you now, but know we'll meet again, a little further on up the road . . .

Bibliography

BOOKS

Bach, Steven. *Marlene Dietrich: Life and Legend*. University of Minnesota Press, 1992 (revised).

Bazin, Andre. *Orson Welles*. Venice, CA: Acrobat Books, 1991 (English translated edition).

Bazin, Andre., *What Is Cinema?* University of California Press, revised edition (translated from the French), 1984, Volumes I and II.

Bogdanovich, Peter. *John Ford*. Berkeley and Los Angeles: University of California Press, 1978, expanded edition.

Bogdanovich, Peter. *Who the Devil Made It*. New York: Alfred A. Knopf, 1997.

Bosworth, Patricia. *Montgomery Clift: A Biography*. New York: Limelight Editions, 2001.

Bosworth, Patricia (essay), Scorsese, Martin (Forward), O'Hara, Maureen (Remembrance), Reagan, Ronald (Remembrance). *John Wayne, The Legend and the Man: An Exclusive Look Inside Duke's Archive*. New York: PowerHouse Books (undated).

Carey, Harry Jr. *A Company of Heroes*. Lanham, MD: Taylor Trade Publishing, an imprint of Rowman & Littlefield, 2013 (first trade edition).

Ceplair, Larry, and Englund, Steven. *The Inquisition in Hollywood*. Garden City, NY: Anchor Press, 1980.

Cowie, John. *John Ford and the American West*. New York: Harry N. Abrams, 2004.

Davis, Ronald L. *Duke: The Life and Image of John Wayne*. Norman: The University of Oklahoma Press, 1998.

Dmytryk, Edward. *Hollywood's Golden Age: As Told by One Who Lived It All*. Albany, GA, and Duncan, OK: BearManor Media, 2003.

Eliot, Marc. *Walt Disney, Hollywood's Dark Prince*. New York: Birch Lane Press, 1993.

Everson, William K. *A Pictorial History of the Western*. Secaucus, NJ: The Secaucus Press, 1972 (second bound printing).

Fleischer, Richard. *Just Tell Me When to Cry: A Memoir*. New York: Carroll and Graf, 1993.

Fonda, Henry, Teichmann, Howard, *Fonda: My Life*, New York, Signet, reissue edition 1982.

Fonda, Peter. *Don't Tell Dad: A Memoir*. New York: Hyperion, 1999.

Ford, Dan. *Pappy*. Boston: Da Capo Press, 1998.

Frankel, Glenn. *The Searchers: The Making of an American Legend*. New York: Bloomsbury USA, 2013.

Goldman, Michael. *John Wayne: The Genuine Article*. San Rafael, CA: Insight Editions, 2013.

Holden, Anthony. *Behind the Oscar*. New York: Simon and Schuster, 1993.

Kinn, Gail, and Piazza, Jim. *The Academy Awards*. New York: Black Dog and Leventhal Publishers, Inc., 2002.

Landesman, Fred. *The John Wayne Filmography*. Jefferson, NC: McFarland and Company, 2004.

McBride, Joseph. *Searching for John Ford*. New York: St. Martin's Press, 2001.

Moldea, Dan E. *Dark Victory*. New York: Viking Penguin, 1986.

O'Hara, Maureen, with John Nicoletti. *'Tis Herself: An Autobiography*. New York: Simon and Schuster, 1994.

Riggin, Judith M. *John Wayne: A Bio-Bibliography*. New York: Greenwood Press, 1992.

Roberts, Randy, and Olson, James S. *John Wayne: American*. New York: The Free Press, 1995.

Sarris, Andrew. *The American Cinema*. New York: First Da Capo Press edition, 1996 (an unabridged reproduction of the Chicago 1985 edition with birth and dates amended). Originally published by Dutton in paperback form in 1968, copyright Andrew Sarris.

Sarris, Andrew. *The John Ford Movie Mystery*. Bloomington: Indiana University Press, 1975.

Sarris, Andrew. *You Ain't Heard Nothin' Yet: The American Talking Film History and Memory 1927–1949*. New York: Oxford University Press, 1998.

Schickel, Richard. *The Men Who Made the Movies*. New York: Atheneum, 1975.

Stacy, Pat. *Duke: A Love Story, An Intimate Memoir of John Wayne's Last Years*. New York: Atheneum, 1983.

Stempel, Tom. *Screenwriter: The Life and Times of Nunnally Johnson*. London: WH Smith, 1980.

Thomas, Bob. *King Cohn: The Life and Times of Harry Cohn.* New York: Bantam, 1967 (paperback edition).

Wayne, Pilar. *John Wayne: My Life with the Duke.* New York: McGraw-Hill Book Company, 1987.

Wiley, Mason, and Bona, Damien. *Inside Oscar: The Unofficial History of the Academy Awards.* New York, Ballantine Books, 1986.

Zolotow, Maurice. *Shooting Star: A Biography of John Wayne.* New York: Simon and Schuster, 1974.

SPECIAL ADDITIONAL JOURNALS AND MAGAZINE RESEARCH BY JESSE HERWITZ

1949

1. *Alliance Will Install Officers Tuesday,* Hollywood Citizen-News, 3.24.49

1953

2. *Mother-in-Law Loses Wayne's $650 a Month,* Los Angeles Examiner, 5.2.53

3. *John Wayne Tells Hard Times Story,* Los Angeles Examiner, 5.9.53

4. *John Wayne Puzzled Man in Alimony Row,* Los Angeles Herald-Express, 5.15.53

5. *Actor John Wayne's Alimony Case Delayed,* Los Angeles Times, 5.16.53

6. *Wayne Support Case Delayed,* Los Angeles Examiner, 5.16.53

7. *Wayne Asks for Cut in Alimony,* Hollywood Citizen-News, 5.16.53

8. *Wayne in Court Bares Income,* Herald-Express, 5.18.53

9. Handsaker, Gene, *Alimony Fight: 'No Savings,' Wayne Says,* Hollywood Citizen-News, 5.19.53

10. *John Wayne Earnings,* Variety, 5.19.53

11. *Star Declares: Had to Borrow For Taxes,* Herald Express, 5.19.53

12. *$900 Alimony Enough, John Wayne Contends,* Los Angeles Times, 5.19.53

13. *John Wayne Bares Income in Divorce Court Battle,* Los Angeles Examiner, 5.19.53

14. *Wayne Airs Finances in Suit by Estranged Wife,* Daily News, 5.19.53

15. *Actor Wayne Says Wife Budget Shy,* Los Angeles Daily News, 5.20.53

16. *Bookkeepers May Toss Wayne for Loss,* Herald Express, 5.20.53

17. *John Wayne's Fiscal Affairs Engross Court,* Los Angeles Times, 5.20.53

18. *'Couldn't Make Ends Meet on $160,000,' Wayne Says,* Hollywood Citizen-News, 5.20.53

19. *Wayne's Wife Tells $56,103 Spending,* Herald Express, 5.21.53

20. *Wayne's Expense Record Aired in Court Hearing,* Los Angeles Times, 5.21.53

21. *Lawyers in Court Row on Wayne 'War Fund,'* no primary source cited, 5.21.53

22. *High Cost of Living Told by Mrs. Wayne,* Los Angeles Times, 5.22.53

23. *High Cost of Living Told by Mrs. Wayne,* Los Angeles Times, 5.22.53

24. *Esperanza Suspects Figures,* Los Angeles Herald-Express, 5.22.53

25. *High Living Cost – Mrs. Wayne Tells Court of Expenses,* Hollywood Citizen-News, 5.22.53

26. *Mrs. Wayne Tells Need for Alimony,* Los Angeles Daily News, 5.22.53

27. *Mrs. Wayne Explains Why She Needs $9350 Monthly,* Los Angeles Herald-Examiner, 5.22.53

28. *Esperanza Itemized $9,000 Living Cost Each Month,* Los Angeles Herald-Examiner, 5.22.53

29. *John Wayne Enraged by 'Liar' Charge,* Los Angeles Examiner, 5.23.53

30. *John Wayne's Hidden Assets Discounted,* Los Angeles Daily News, 5.23.53

31. *Hidden Assets Hint Under Fire in John Wayne Case,* Los Angeles Daily News, 5.23.53

32. *Figure Wayne Would Need $3,000,000 to Pay Off Wife,* no primary source cited, 5.23.53

33. *Mrs. Wayne Asks Mother-in-Law 'Alimony,'* Herald Express, 5.23.53

34. *Wayne Earned $1026,072 in 3 Yrs, L.A. Suit Shows,* Variety, 5.26.53

35. *John Wayne Accused of Tax Hedging,* Mirror, 5.26.53

36. *Gave It To Mother – Wants Star to Pay for It,* Los Angeles Herald Express, 5.26.53

37. *Wayne Wife Seeks Sum for Mother,* primary source not cited, 5.26.53

38. *Mrs. Wayne Cites Needs in Insurance,* Los Angeles Times, 5.27.53

39. *2 Attorneys Ask $25,000 Fees in Wayne Marital Troubles,* Los Angeles Herald Express, 5.27.53

40. *Wayne Demise Wife's Topic at Alimony Trial,* Hollywood Citizen-News, 5.27.53

41. *Wife Asks Million John Wayne Insurance So Alimony Will be Safe,* Los Angeles Herald Examiner, 5.27.53

42. *John Wayne's Wife Asks Court For $1,000,000 Life Insurance,* Mirror, 5.27.53

43. *Bare Wayne Wife Expenses For 4 Months Topped His,* Herald Express, 5.28.53

44. *Attorney Fees Cited in Wayne Alimony Suit,* Los Angeles Times, 5.28.53

45. *Mrs. John Wayne Tells Court Rep Paid Her 78G As 'Spending Money,'* Variety, 5.28.53

46. Ruark, Robert C., *Finds Parable in Wayne Case,* Hollywood Citizen-News, 5.28.53

47. *Wayne Tells Money Woes – Via Charts,* Mirror, 5.29.53

48. *Waynes' Feud Still Goes On,* Hollywood Citizen-News, 5.29.53

49. *Attorney Suit Holds Up Film,* Los Angeles Herald Express, 5.29.53

50. *Woman Marine Meets 'Hero' John Wayne,* Los Angeles Times, 5.29.53

51. *Wayne Hits Cost Figures,* Los Angeles Herald Examiner, 5.29.53

52. *John Wayne's Accountant on Hearing Stand,* Los Angeles Times 5.30.53

53. *Wayne's Tax Aide Grilled in Bitter Alimony Battle,* Los Angeles Times, 6.1.53

54. *Wayne Denies Striking Wife: Tells Pleas,* Mirror, 6.2.53

55. *Actor Wayne Tells of His Wife's Temper,* Hollywood Citizen-News, 6.2.53

56. *Never Struck Wife, John Wayne Testifies,* Los Angeles Times, 6.2.53

57. *Wayne Testifies in Private Life He Was 'Woman-handled',* Los Angeles Daily News, 6.2.53

58. *'Manhandled by Wife' Wayne Tells Court: Hits Her 10-Day Tesimony,* Los Angeles Herald Examiner

59. *Much of Wayne Riches Hidden 'Like Iceberg' Plea in Court,* 6.3.53

60. *'Hidden' Wayne Fund Charged,* Los Angeles Times, 6.3.53

61. *Wayne Asked to Pay Sleuths to Track Him,* Los Angeles Times, 6.3.53

62. *'Decision Day' In Wayne Suit,* Los Angeles Herald Examiner, 6.3.53

63. *Wayne Alimony Case Decision Seen Today,* Hollywood Citizen-News, 6.4.53

64. *Wayne's Lawyer Attacks 'Build-Up',* Los Angeles Times, 6.4.53

65. *Wayne, Wife Rise Early to Hear Alimony Ruling,* Mirror, 6.4.53

66. *Alimony Fight – Wayne Asks Fair Split,* Herald Express, 6.4.53

67. *Mrs. Wayne Loses, Gets Only $1,100,* Hollywood Citizen-News, 6.5.53

68. *Wayne Alimony to Stay at $1,100,* Hollywood Citizen-News

69. *John Wayne's Wife Granted $1,100 Alimony,* Los Angeles Times, 6.5.53

70. *Mrs. Wayne, Attorney Ired, Mum on Ruling,* Herald Express, 6.5.53

71. *Happy Wayne Off to Mexico for Film Work,* Mirror, 6.5.53

72. *Mrs. John Wayne's Auto Seized,* Hollywood Citizen-News, 6.22.53

73. *John Wayne – Wife Loses Cadillac For Grocery Bill,* Los Angeles Herald Express, 6.23.53

74. *Marshals Seize Mrs. Wayne's Last Car for Debts,* Los Angeles Times, 6.23.53

75. *John Wayne's Wife Loses Her Temper – And Her Auto,* primary Source not identified, 6.23.53

76. *2 'Eyes' Spying on Wayne Pry in Wrong room – Governor's,* Los Angeles Herald Examiner, 7.7.53

77. *Wayne Frees Detectives Who Were Trailing Him,* Los Angeles Times, 7.7.53

78. *Mrs. Wayne Wears $90 Hat, Drives to Court in Truck*, Los Angeles Herald Examiner, 7.31.53

79. *Wife of John Wayne Appeals Alimony Award*, Los Angeles Times, 7.21.53

80. *Mrs. Wayne Renews Plea*, Los Angeles Examiner, 7.21.53

81. *Wayne's Wife Plans Appeal on Alimony*, Los Angeles Daily News, 7.21.53

82. *'Can't Live on $1,100' – Mrs. Wayne in Fund Plea*, Herald Express, 7.30.53

83. *Mrs. Wayne Pushes Her Alimony Fight*, Los Angeles Examiner, 7.31.53

84. *Mrs. Wayne Pushes Her Alimony Fight*, Los Angeles Times, 7.31.53

85. *Mrs. Wayne In New Fight For Alimony*, Los Angeles Daily News, 7.31.53

86. *Mrs. Wayne Denied Raise in Alimony*, Los Angeles Times. 8.1.53

87. *Demand Wayne Put Up $20,000 to Prove Self*, Los Angeles Herald Express

88. *John Wayne – Actor Silent on Alimony Battle*, Los Angeles Herald Express

89. *Court Gets Tough – Ultimatum To Esperanza*, Los Angeles Herald Express, 8.17.53

90. *Mrs. Wayne – Estranged Wife Back*, Los Angeles Herald Express, 8.18.53

91. *Esperanza in Court Over Grocery Bill*, Los Angeles Daily News, 8.19.53

92. *Mrs. Wayne Must Pay for Food, Liquor*, Los Angeles Daily News, 8.19.53

93. *John Wayne's Ex Gets 10 Days to Pay Grocery Bill*, Hollywood Citizen-News, 8.19.53

94. *Mrs. Wayne Loses Suit on Grocery Bill*, Los Angeles Times, 8.19.53

95. *Wayne in New Legal Victory*, Los Angeles Examiner, 8.21.53

96. *Wayne Wins Again in Joust With His Wife*, Mirror, 8.21.53

97. *Wayne Escapes On Wife's Bill*, Los Angeles Herald Express, 8.21.53

98. Itria, Helen, *Big John*, Look Magazine, 8.53

99. *Shots Rout Prowler Taking Hub Caps Off Wayne's Auto*, Los Angeles Herald Examiner, 9.10.53

100. *Shots Miss Intruder in John Wayne Garage*, Los Angeles Times, 9.10.53

101. Churchill, Reba and Bonnie, *Hollywood diary – John Wayne Forsaking Acting For Producing*, News Life, 10.2.53

102. Parsons, Louella O., *Wayne Case Delay Asked*, Los Angeles Times, 9.10.53

103. *Wayne's Wife Trial Delay Plea Refused*, Los Angeles Daily News, 10.17.53

104. *Court Orders Wayne Trial Next Monday*, Hollywood Citizen-News, 10.17.53

105. *Wayne's Divorce Trial Set Monday*, Los Angeles Times, 10.17.53

106. *Wayne Wins Divorce Fight Round*, Los Angeles Herald Examiner, 10.17.53

107. Parsons, Louella O., *Louella O. Parsons in Hollywood*, Los Angeles Herald Examiner, 10.18.53

108. *Esperanza Late, Wayne Irked at Trial Opening,* Hollywood Reporter, 10.19.53

109. *Wayne Battle Comes Up in Court Today,* Los Angeles Herald Examiner, 10.19.53

110. *John Wayne Set to 'Sling Mud' in Juicy Divorce,* The Mirror, 10.19.53

111. *Waynes Hurl Torrid Charges,* Los Angeles Daily News, 10.20.53

112. *Waynes Hurl Charges,* Newslife, 10.20.53

113. *Fell at Dance – Tell Wife's Drinking,* Herald-Express, 10.20.53

114. *Mrs. Wayne, on Stand, Accuses Film Actor of Beatings and Liquor Bouts,* Los Angeles Times, 10.20.53

115. *Women Crowd Court As Chata Tells All,* The Mirror, 10.20.53

116. Santley, Joe, *Wayne, Wife Trade Charges in Court,* Los Angeles Examiner, 10.20.53

117. *Wayne Autographs For Fans & Thought He Was Intruder,* Herald-Express, 10.20.53

118. Parsons, Louella O., *Gail Russell Shocked, Denies Impropriety,* Los Angeles Examiner, 10.21.53

119. O'Conner, Dick, Crenshaw, James, *Speeding to Court – 'Chata' Cited on Freeway,* Herald Express, 10.21.53

120. Santley, Joe, *Chata Late to Court, But Tells Much,* Los Angeles Examiner, 10.21.53

121. *Almost Shot Wayne After Night Out, Wife Testifies,* Los Angeles Times, 10.21.53

122. *Nearly Shot Wayne, Says Esperanza,* Los Angeles Daily News, 10.21.53

123. *Nicky Hilton Names in Wayne Trial as Visitor,* Newslife, 10.21.53

124. Batt, Leo, *Nicky Hilton Gets Call in Wayne Feud,* The Mirror, 10.21.53

125. Rochlen, Kensi, *They Want John's Signature – Gals Giggle but Chata's 'Chilly' –* The Mirror, 10.21.53

126. Santley, Joe, *Wayne's Meet Face to Face, End Cask Row,* Los Angeles Herald Examiner, 10.22.53.

127. *Wayne, Wife End Sizzling Trial; Settlement Reached,* Los Angeles Daily News, 10.22.53

128. *Wayne and Wife in Surprise Pact,* Los Angeles Times, 10.22.53

129. O'Connor, Dick, Crenshaw, James, *Wayne To Tell His Side Despite Cash Agreement,* Los Angeles Herald Express, 10.22.53

130. *Waynes' Cash Agreement Halts Hot Trial,* Los Angeles Daily News, 10.22.53

131. Heard, Roby, *Wayne Mud Battle May Flare Up Anew,* The Mirror, 10.22.53

132. *Wayne Divorce Trial Halted by Settlement,* Hollywood Citizen-News, 10.22.53

133. Santley, Joe, *Wayne Prepared to 'Clear' Self,* Los Angeles Herald Examiner, 10.23.53

134. *Mrs. Wayne Missing Traffic Count,* no primary source given, 10.23.53

135. *Wayne Says Wife to Pay for Charges,* Hollywood Citizen-News, 10.23.53

136. *But Enough – Less Cash Likely for Esperanza,* Los Angeles Times, 10.23.53

137. Mosby, Aline, *Aline Mosby in Hollywood*, Newslife, 10.23.53

138. Scott, Vernon, *A Frightened Woman – Chata Discusses Her Future Without Wayne*, Los Angeles Examiner, 10.23.53

139. Scott, Vernon, *Esperanza Says Future Insecure*, Newslife, 10.26.53

140. *John, Chata Sign Deal; Plan New Court Slugfest*, The Mirror, 10.27.53

141. *Wayne Trial to Resume Tomorrow*, Hollywood Citizen-News, 10.28.53

142. *Wayne Due to Hit Back at Chata Today*, Los Angeles Daily News, 10.28.53

143. *Curtain Goes Up Today on New Wayne Episode*, Los Angeles Times, 10.28.53

144. *Wayne Lashes Back, Tells His Version*, Hollywood Citizen-News, 10.28.53

145. *Both Wayne, Chata Win Divorces*, Los Angeles Herald-Express, 10.28.53

146. Ridgway, Charles, George, Getze, *Chata Wayne, the Fiery*, The Mirror, 10.28.53

147. *Wayne on Stand – Calls Her Drunk, Fishwife*, Los Angeles Herald-Express, 10.28.53

148. O'Connor, Dick, *Fights For Friends – Wayne Drops Silent Role*, Los Angeles Herald-Express

149. Ridgway, Charles, *Double Divorce Climaxes Juicy Wayne Stories*, Hollywood Citizen-News, 10.29.53

150. Bacon, James, *But Nicky Claims 'Foul' – Divorce for Each in John Wayne Case*, no primary source given, 10.29.53

151. *Wayne – Court Battle is Draw – Each is Granted Divorce*, Los Angeles Daily News, 10.29.53

152. *Both Wayne and Wife Given Divorces on Cruelty Grounds*, Los Angeles Times, 10.29.53

153. *Nicky Says He's Only Loser*, Los Angeles Herald-Express, 10.29.53

154. Santley, Joe, *Wayne, Chata in Draw, Both Get Divorce*, Los Angeles Examiner, 10.29.53

155. *'I'm the Loser' says Nicky of Wayne Divorce Battle*, Los Angeles Daily News, 10.30.53

156. *John Wayne Seriously Ill, Has Relapse After Court Tilt*, Los Angeles Times, 10.31.53

157. *Two Home Titles Transferred in Wayne Settlement*, Los Angeles Times, 10.31.53

158. *Wayne Gets Two Houses From Ex-Wife*, Los Angeles Daily News, 10.31.53

159. Hedda Hoppa: *They Call Him Mr. Box Office*, Chicago Tribune Magazine, 11.22.53

1954

160. O'Conner, Dick, *The John Wayne Story – How Great Western Star Shot His Way to Number one Spot Told*, Los Angeles Herald-Express, 1.5.54

161. Wayne, John (filling in for Mike Connolly), *Rambling Reporter*, The Hollywood Reporter, 4.30.54

162. *Wayne-Fellows Becomes Batjac,* no attribution, 5.26.54

163. Carroll, Harrison, *Esperanza Seeks Change in Wayne Settlement Suit,* Los Angeles Herald-Express, 8.3.54

164. *Wayne Property Settlement May Go to Court Again,* Los Angeles Herald-Express, 8.2.54

165. Carroll, Harrison, *Thumbs Down on Hawaii Nuptials – John Wayne to Wed Pilar But Not Now,* Los Angeles Herald-Express, 8.24.54

166. *John Wayne Denies Island Nuptial Plan,* 8.25.54

167. *Island Wedding for Wayne Hinted,* Los Angeles Examiner, 10.29.54.

168. *John Wayne to Wed Pilar Palette* (sic) *Today on Big Island,* Honolulu Star-Bulletin

169. Graham, Sheila, *John Wayne, Pilar Pallette* (sic) *Wed Today,* Hollywood Citizen-News, 11.1.54

170. Carroll, Harrison, *John Wayne Plans Hawaii Wedding,* Los Angeles Herald-Express, 11.1.54

171. *John Wayne, Pilar Palette* (sic) *Wed in Kona,* no attribution, 11.1.54

172. *Wayne Honeymoons With Peruvian Bride,* Los Angeles Herald-Express, 11.2.54

173. Hopper, Hedda, *John Wayne Weds Actress in Hawaii,* Los Angeles Times, 11.2.54

174. Parsons, Louella O., *By The Time This Is in Print,* Los Angeles Examiner, 11.2.54

175. *John Wayne Divorce Final: Weds Latin Lovely,* Los Angeles Daily News, 11.2.54.

176. Parsons, Louella O., *John Wayne, Pilar Married in Hawaii,* Los Angeles Examiner, 11.2.54

177. *John Wayne and New Bride Fly Home Tonight,* Hollywood Citizen-News, 11.2.54

178. *John Wayne, Bride Due from Hawaii Today,* Los Angeles Times, 11.3.54

179. *Island Honeymooners,* Unnamed international news network, 11.3.54

180. *John Wayne and Bride Fly Home, Tell Happiness,* Los Angeles Times, 11.4.54

181. Wayne, John (as told to Maurice Zolotow), *It Happened Like This,* Los Angeles Examiner/American Weekly, 11.14.54

182. *Married: John Wayne,* Time Magazine, 11.15.54

183. Wayne, John (as told to Maurice Zolotow), *It Happened Like This* (con't), Los Angeles Examiner/American Weekly, 11.21.54

184. Wayne, John (as told to Maurice Zolotow), *It Happened Like This* (con't), Los Angeles Examiner/American Weekly, 11.28.54

185. Scott, Martin, *John Wayne,* Cosmopolitan Magazine, 11.54 (cover story)

186. Press Release, *Wayne Recaptures Motion Picture Herald Poll Leadership,* Quigley Publications, 12.30.54

187. Press Release, *John Wayne Has Been Voted Number One,* Motion Picture Herald, 12.30.54

188. RKO Studios press release, *Biography – John Wayne,* 1954

1955

189. Hoppa, Hedda, *John Wayne Taking Over Mitchum's Role,* Los Angeles Times, 1.17.55

190. Hopper, Hedda, '*Blood Alley' Delayed Again,* Los Angeles Times, *1.26.55*

191. Skolsky, Sidney, *Hollywood is My Beat,* Hollywood Citizen-News, 2.11.55

192. *John Wayne Expecting Baby in April,* Los Angeles Times, 10.18.55

193. Parsons, Louella O., *John Wayne Expects Baby,* Los Angeles Examiner, 10.18.55

194. Hopper, Hedda, *John Wayne Daughter Plans June Wedding,* Los Angeles Times, 12.31.55

1956

195. *Wayne Films Go to Hughes,* partial - no primary source identified, 1.6.56

196. *Paris Elite Attend Premiere of Wayne in 'The Conqueror,'* no primary source identified, 1.21.56

197. Schallert, Edwin, *Movie Tours Build Goodwill, Says Wayne,* Los Angeles Times, 2.8.56

198. Conchita, Princess, Pignatelli, Sepulveda, *Toni Wayne Betrothal Told,* Los Angeles Examiner, 2.16.56

199. Zunser, Jesse, *John Wayne – Conqueror at the Box-Office,* Cue Magazine, week of 3.22-29.56 (Cover story)

200. Hopper, Hedda, *John Wayne Presented Daughter by Third Wife,* Los Angeles Times, 4.1.56

201. Hopper, Hedda, *Mother of Girl,* Los Angeles Herald-Examiner, 4.1.56

202. *Wayne Takes Wife and Baby Girl Home,* Los Angeles Times, 4.7.56

203. *Mr. and Mrs. John Wayne,* Variety, 4.2.56

204. Williams, Dick, *John Wayne's Two Sons Planning Film Careers,* Mirror, 5.10.56

205. *John Wayne's Daughter and Fiance Get License,* Los Angeles Times, 5.18.56

206. *Pacts OKd for Singer and John Wayne's Son,* Los Angeles Times, 5.25.56

207. *John Wayne Kin Weds Tomorrow,* no primary source listed, 5.25.56

208. *Actor John Wayne's Daughter Married,* Mirror, 5.26.56

209. Conchita, Princess, Pignatelli, Sepulveda, *Toni Wayne and Donald LaCava Wed Here by Cardinal McIntyre,* Los Angeles Examiner, 5.27.56

210. *Cardinal Reads Wedding Rites for Donald LaCavas,* Hollywood Citizen-News, 5.28.56

211. *Theater Films' $10,000-a-Minute,* Variety, 6.6.56

212. *John Wayne to Get $2,000,000 for Four Pictures at 20th-Fox,* Hollywood Reporter 6.25.56

213. *Studios Frantic Over Bigger Pay for Top Talent,* Hollywood Reporter, 6.26.56

214. *Actor John Wayne Dubs Self 'B.O. Plenty' In $2 Million Deal,* Hollywood Citizen-News, 7.2.56

215. Schallert, Edwin, *John Wayne Signs to $2,000,000 Contract,* Los Angeles Times, 7.13.56

216. *John Wayne Honored by Legion Auxiliary,* Los Angeles Times, 8.7.56

217. *Tell of Row in Shooting of Publisher,* Los Angeles Examiner, 9.5.56

218. *Trapper's Story of How He Shot Publisher of 'Confidential' in Jungle,* no primary source listed, 9.5.56

219. Levine, Phil, *Scandal Editor Shot; A Slip, Says Hunter,* Los Angeles Daily News, 9.6.56

220. *Argument Was About Them,* No primary source listed, 9.6.56

221. Mosby, Aline, *Producer Stupidity Profitable,* Hollywood Citizen-News, 10.6.56

222. *Batjac's Boss,* The New York Times, 11.18.56

223. *Union Goes After Wayne for Using British Lensers,* Hollywood Reporter, 11.20.56

224. *Biography – John Wayne,* Warner Bros, 1956 (publicity release)

225. Brand, Harry, *Biography – John Wayne,* Twentieth Century-Fox, 1956 (publicity release)

Notes

PROLOGUE

4 **"I'll never regret . . ."** John Wayne, *Playboy,* interviewed by Richard Warren Lewis, May 1971.

4 **"forty years of movie acting . . ."** Sarris, *The Village Voice,* August 21, 1969.

4 **"I remember responding to him . . ."** Sarris, "John Wayne's Strange Legacy: A Revisionist View," *The New Republic,* August 4, 1974.

4 **Details of the night of the Oscar** From Kim and Piazza, "The Academy Awards," Mason Wiley, *The Academy Awards,* and YouTube clip of Wayne accepting his Oscar, April 7, 1970.

5 **"perverted"** and **"A love story . . ."** John Wayne to Richard Warren Lewis, "The Playboy Interview," *Playboy,* May 1971; Pilar Wayne, *John Wayne: My Life with the Duke,* pp. 136–138, Holden, *Behind the Oscar,* pp. 274–275, *Los Angeles Herald Examiner,* April 8, 1970.

8 **"If I'd known . . ."** John Wayne, from his acceptance speech to the Academy of Motion Picture Arts and Sciences, on the occasion of his first win as an actor, for his performance as Rooster Cogburn in Henry Hathaway's 1969 *True Grit.*

CHAPTER ONE

Some background and information regarding the history of the Morrisons is from a rare interview Wayne gave to *Ulster Heritage Magazine,* published August 14, 2009. The actual interview took place some time in the early 1950s. No specific date was available.

15 **"He couldn't pay his bills . . ."** John Wayne, quoted in Roberts and Olson, *John Wayne: American,* p. 19.

16 **"The happiest part . . ."** Pilar Wayne, *John Wayne,* p. 9.

16 **"Doc gave me advice . . ."** John Wayne, as told to Maurice Zolotow, "It Happened Like This," *The American Weekly,* November 7, 1954.

18 **"Riding a horse . . ."** Ibid.

20 **"From the time I was in the seventh grade . . ."** Ibid.

23 **"Most of the Glendale small-fry . . ."** Ibid. .

23 **"I went, on average,"** John Wayne, interviewed by James Gregory, "John Wayne's Boyhood Memories," *Photoplay* 82, November 1972.

23 **"There is a period in every child's life . . ."** Everson, *A Pictorial History of the Western,* p. 1.

24 **"I copied Harry Carey . . ."** Davis, *Duke: The Life and Image of John Wayne.*

25 **"After the cake and ice cream . . ."** John Wayne, quoted in Zolotow, *Shooting Star,* p. 26.

CHAPTER TWO

27 **"In September 1925,"** and **"At the end of my freshman year . . ."** John Wayne, from an interview with Maurice Zolotow, "It Happened Like This," *American Weekly,* November 7, 1954.

28 **"Man . . ."** Tom Mix, quoted by Wayne, ibid.

29 **"What had excited me . . ."** John Wayne, *John Wayne: The Genuine Article,* p. 29.

29 **"Ford was the founder and guru . . ."** Pete Martin, "The Ladies Like 'Em Rugged," *Saturday Evening Post,* December 23, 1950.

29 **"At that point . . ."** John Ford, to Martin, ibid.

30 **"They sent me . . ."** John Wayne, ibid.

30 **" . . . 'Hey, gooseherder!' . . ."** and **"You call yourself a guard? . . ."** John Ford, ibid.

31 **" . . . the beginning . . ."** John Wayne, ibid.

31 **"I could see that here was a boy . . ."** John Ford, to *Time,* March 3, 1952.

31 "... he still would have made a notable mark ..." Sarris, *The American Cinema*, p. 44.

32 **"By train."** McBride, *Searching for John Ford*, p. 75.

35 **"happened to look into Josephine's eyes ..."** Zolotow, "It Happened Like This," *American Weekly*, November 14, 1954.

36 **"They don't tell you that love hurts. ..."** John Wayne, quoted in Zolotow, *Shooting Star*, p. 50.

37 **"In the years to come ..."** John Wayne, quoted in Goldman, *John Wayne: The Genuine Article*, p. 33.

CHAPTER THREE

39 **"In those days ..."** John Wayne, quoted in Zolotow, *Shooting Star*, p. 63.

40 **"John Wayne was ..."** John Ford quoted in Bogdanovich, *John Ford*, pp. 49–50, 51.

41 **"I want the big ugly guy"** John Ford, quoted in Martin, "The Ladies Like 'Em Rugged."

42 **"Ford turned to Wayne ..."** Hedda Hopper, quoting John Ford, *Chicago Tribune Magazine*, November 23, 1953.

42 "... **'Show these chicken-livered slobs up.'"** John Ford, quoted in Martin, "The Ladies Like 'Em Rugged."

42 **"A blank of a blank ..."** John Ford, quoted by Gladwyn Hill, *The New York Times*, November 7, 1949.

42 **"I haven't a thing to squawk about ..."** John Wayne, to Hedda Hopper, *The Los Angeles Times*, and syndicated November 27, 1953.

43 **"He was just a rangy ..."** John Ford, "Man Alive," *Photoplay*, March 1952.

44 **"By any standard ..."** Sarris, *The John Ford Movie Mystery*, p. 40.

46 **"Had a western hang ..."** John Wayne, in Zolotow, *Shooting Star*, p. 73.

46 "... **He was tripping ..."** Raoul Walsh, quoted by Don Allen, *The American Weekly*, November 30, 1967.

46 **"Don't be silly ..."** and **"Maybe you could learn,"** John Wayne and Raoul Walsh, quoted by Donald Hough, *The Los Angeles Times*, June 29, 1941.

47 **"I had to find someone immediately . . ."** Raoul Walsh, ibid.

47 **"We called him Joe Doakes . . ."** Raoul Walsh, quoted in Schickel, *The Men Who Made the Movies,* p. 37.

47 **"The studio decided . . ."** From an interview Wayne gave to BBC4, London, 1974.

47 **"I was determined . . ."** John Wayne, from his unpublished memoir, portions of which are reproduced in Goldman's *John Wayne: The Genuine Article.*

47 **"My teacher had me rolling my r's . . ."** John Wayne as told to Zolotow, "It Happened This Way," part 2, *American Weekly,* November 28, 1954.

49 **"Sheehan and [Bill Fox's executive assistant] Sol Wurtzel . . ."** Raoul Walsh, in Schickel, *The Men Who Made the Movies,* p. 38.

49 **Information about the usage of Grandeur photography, its footage, and equipment breakdown**—From Arthur Edeson, "Wide Film Photography," *American Cinematographer,* September 1930. In the article, Edeson predicts that Grandeur is the format of the future and will quickly replace standard 35 mm filming.

51 **"I was three weeks on my back . . ."** John Wayne, to Richard Warren Lewis, *Playboy,* May 1971.

53 **"So I was the star . . ."** John Wayne, told to Zolotow, "It Happened Like This," pt. 2, *American Weekly,* November 21, 1954.

CHAPTER FOUR

55 **"I can't act . . ."** Donald Hough, *Los Angeles Times,* June 29, 1941.

55 **"He was obsessed . . ."** An unidentified "lifelong friend," quoted in Dick O'Conner, "The John Wayne Story," *Los Angeles Herald Examiner,* January 5, 1954.

57 **"When you work for this studio . . ."** Harry Cohn, quoted in Thomas, *King Cohn,* p. 98.

65 **"They made me a singing cowboy . . ."** John Wayne, interviewed by Richard Warren Lewis for *Playboy,* May 1971.

66 **"A notorious philistine . . ."** McBride, *Searching for John Ford,* p. 422.

CHAPTER FIVE

73 **"To accept it . . ."** Dudley Nichols's letter to Frank Capra, Wiley and Bona, *Inside Oscar,* p. 65.

74 **"Duke knocked Ward into a row of lockers . . ."** An unnamed source, quoted in Martin Scott, "John Wayne," *Cosmopolitan,* November 1954.

76 **"Duke, you are a disgrace! . . ."** The quote is from Zolotow, *Shooting Star,* p. 128.

76 **"Duke was so frightened . . ."** Harry Carey Jr., *Company of Heroes,* p. 72.

78 **"When is it my turn . . ." "Christ, if you learned . . ." "Just wait . . ."** from McBride, *Searching for John Ford,* p. 280.

79 **"Duke, I want you to play . . ."** Many versions of this story exist, including those found in Roberts and Olson, *John Wayne: American,* p. 49, and Bogdanovich. In Glenn Frankel, *The Searchers,* p. 233, the exchange is reported this way: " 'You idiot, couldn't you play it?' 'Which is what Ford had in mind all along." All versions suggest that Ford was playing with Wayne and that he was Ford's only choice for the role.

79 **"I wanted . . ."** John Ford, "Man Alive," *Photoplay,* March 1952.

79 **"Well, I had made . . ."** John Wayne, to Louella O. Parsons, "In Hollywood with Louella Parsons," *The Herald Examiner* (and syndicated), December 31, 1949.

80 **"Yeah, four times in ten years . . ."** John Wayne to Beverly Barnett, as quoted in Zolotow, *Shooting Star,* p. 116.

CHAPTER SIX

85 **"*Stagecoach* has been clarified . . ."** Sarris, *The John Ford Movie Mystery,* p. 83.

86 **"A dumb bastard," "Big oaf," "Can't you even walk . . ."** Pilar Wayne, *John Wayne,* p. 113.

86 **"Wayne would meet with Paul,"** Harry Carey, *Company of Heroes,* p. 73.

86 **"With this film . . ."** Bosworth, *John Wayne: The Legend and the Man,* p10.

88 **"A superb film [that] caught . . ."** Everson, *Pictorial History of the Western,* p. 166.

88 **"transformed Monument Valley . . ."** Roberts and Olson, *John Wayne: American,* p. 159.

88 **"My favorite location [became] Monument Valley . . ."** John Ford, quoted in Cowie, *John Ford and the American West,* p. 186.

89 **"*Stagecoach* was the ideal example . . ."** Bazin, *What Is Cinema?,* p. 149.

89 **"Orson Welles has never sought to conceal . . ."** Francois Truffaut, from his introduction to Bazin's *Orson Welles,* p. 10.

89 *"Stagecoach was more the beginning . . ."* Sarris, *The John Ford Movie Mystery,* pp. 82–85.

89 **Bogdanovich** Information about Orson Welles's running of *Stagecoach* is from Bogdanovich, *The Observer,* September 26, 2010.

90 **"I had never in my life . . ."** John Wayne, from his unpublished memoirs, excerpted in Goldman, *John Wayne: The Genuine Article,* p. 39.

90 **"When I first got into this business . . ."** John Wayne, "Rambling Reporter," column guest-written by John Wayne while Mike Connolly was on vacation, *The Hollywood Reporter,* April 30, 1954.

91 **"At an age . . ."** John Wayne, from his unpublished memoirs, excerpted in Goldman, *John Wayne: The Genuine Article,* p. 39.

CHAPTER SEVEN

102 **"Duke couldn't even spell politics . . ."** Henry Fonda, Howard Teichmann, *Fonda: My Life,* p. New York, Signet, 1982.

103 **"Count the times . . ."** John Ford, to editor Robert Parrish, in response to a question by Parrish about how Ford was able to elicit such great performances from John Wayne. McBride, *Searching for John Ford,* p. 319.

103 **"The American leftists . . ."** McBride, *Searching for John Ford,* p. 270.

104 **"The film is suitably moody . . ."** Sarris, *The John Ford Movie Mystery,* pp. 99–101.

104 **"The role I liked best . . ."** John Wayne, "The Role I Liked Best," *The Saturday Evening Post,* July 7, 1949. The magazine regularly invited celebrities to talk about "The role I liked best." It is likely Wayne did not actually write the piece, but talked it to an unsigned interviewer.

105 **"I noticed something . . ."** John Wayne, quoted in Roberts and Olson, *John Wayne: American,* from files contained in the Maurice Zolotow Papers, University of Texas, Austin, Texas, "The Politics of Glamour, Ideology and Democracy in the Screen Actors Guild," interview by David Prindle.

CHAPTER EIGHT

111 **"Daddy, buy me *that!*"** Marlene Dietrich, quoted in Bach, *Marlene Dietrich: Life and Legend,* pp. 257–258.

111 " . . . Duke recalled that day . . ." The story is retold in John Wayne's third wife's memoir, Pilar Wayne's *John Wayne,* p. 39.

CHAPTER NINE

116 "It was impossible . . ." Bö Christian Roos, quoted in Zolotow, *Shooting Star,* p. 166.

121 "Wayne had tried to enlist . . ." Ibid., p. 160.

122 "The office sent Wayne a letter . . ." Frankel, *The Searchers,* p. 237. Frankel quotes from Dan Ford's biography of his grandfather, *Pappy.*

122 "I didn't feel . . ." John Wayne, Dan Ford, quoted in Frankel, *The Searchers,* pp. 238–239.

122 "super-patriot . . ." John Wayne, quoted by Pilar Wayne, *John Wayne,* p. 43.

122 "The most intriguing woman . . ." John Wayne, quoted in Pilar Wayne, *John Wayne,* p. 40.

122 "The best lay . . ." The source of the quote is not named, in Roberts and Olson's *John Wayne: American,* p. 194.

126 "When I first see Duke . . ." Esperanza Baur, to Ruth Waterbury, related to Maurice Zolotow, *Shooting Star,* p. 168.

127 "Whenever I've been in trouble . . ." John Wayne, to Hedda Hopper, "Wayne for the Money," *Chicago Tribune* (and syndicated), February 13, 1949.

127 "I've shared Josie's anxieties . . ." John Wayne as told to Zolotow, "It Happened Like This," pt. 2, *American Weekly,* November 28, 1954.

129 "John Wayne will soon be a triple-threat man in the industry . . ." Herb Yates, quoted by Hedda Hopper, "John Isn't on the Wane: Looking at Hollywood with Hedda Hopper," The Chicago Tribune Syndicate. The article appeared on May 11, 1947, in the *Chicago Tribune.*

129 "In our special field . . ." and "Turn off the faucets . . ." are noted by Ceplair and Englund, *The Inquisition in Hollywood,* p. 211.

130 "The boys are starved . . ." and "The kids . . ." From the *Los Angeles Herald Examiner,* March 22, 1944.

130 "What the guys down there need . . ." Ibid.

CHAPTER TEN

133 **"cruel and inhuman treatment . . ."** Details of Wayne's divorce are from public records, and reports in the *Los Angeles Times,* November 30, 1944. Additional articles that appeared related to the divorce and used as source material include the *Los Angeles Examiner* and *Hollywood Citizen News.*

133 **"When we split up . . ."** John Wayne quoted in Zolotow, *Shooting Star,* p. 179.

138 **"Why don't you buy me a bigger house?"** Reported in the *Los Angeles Examiner,* January 18, 1946, and the *Los Angeles Times,* January 17, 1946.

139 **"Our marriage was like . . ."** John Wayne as told to Zolotow, "It Happened This Way," pt. 2, *American Weekly,* November 29, 1954.

139 **"the stupidest damn thing . . ."** John Wayne, quoted without direct attribution, in Roberts and Olson, *John Wayne: American,* p. 257.

CHAPTER ELEVEN

141 **"Ford remained furious . . ."** Robert Parrish, quoted in McBride, *Searching for John Ford,* p. 343.

141 **"If you can take . . ."** From a letter written by John Ford to John Wayne, quoted in McBride, ibid., p. 344.

142 **"less history than mythology . . ."** Sarris, *The John Ford Movie Mystery,* p. 113.

144 **"Any war *I* was in . . ."** John Ford, interviewed by Bogdanovich, *John Ford,* pp. 83–84.

146 **"I started in three-day productions . . ."** From an interview John Wayne gave to Louella O. Parsons, who billed herself as the Motion Picture Editor, International News Service. This interview appeared in her syndicated column, which appeared in Los Angeles in the *Los Angeles Examiner,* September 8, 1946.

146 **"Earlier in the day . . ."** Gail Russell, to Louella O. Parsons, the *Los Angeles Examiner,* and syndicated, October 1, 1953. Russell was responding to accusations by Wayne's wife, made during their divorce proceedings, that she had had an affair with Wayne during the making of *The Angel and the Badman.* She threatened to sue, but did not.

148 **"Every time I kiss Laraine . . ."** John Wayne, quoted in Martin, "Women Like 'Em Rugged."

148 **"I do believe that one man . . ."** John Wayne, to Hedda Hopper, "Looking at Hollywood with Hedda Hopper." The Chicago Tribune Syndicate. This article appeared in the *Chicago Tribune* and other newspapers in the syndicate on May 11, 1947.

CHAPTER TWELVE

150 **"Communism is getting a toehold . . ."** "Pinks Plan to Stalinize Studios," *Variety*, September 16, 1933, pp. 1 and 3.

150 **"Hollywood screenwriters . . ."** Ceplair and Englund, *The Hollywood Inquisition*, p. 76.

152 **"I was the victim . . ."** John Wayne, to Zolotow, *Shooting Star*, p. 242.

154 **"Our organization . . ."** John Wayne, to Richard Warren Lewis, *Playboy*, May 1971.

CHAPTER THIRTEEN

158 **"*The Fugitive* marked the last occasion . . ."** Sarris, *The John Ford Movie Mystery*, p. 125.

160 **"Having Wayne put his arm on your shoulder . . ."** Frank Nugent, quoted in Martin, "The Ladies Like 'Em Rugged."

162 **"John Ford, John Ford, John Ford . . ."** Howard Hawks, to Schickel, *The Men Who Made the Movies*, p. 101.

163 **"God, it was a terrible day . . ."** Harry Carey Jr., *A Company of Heroes*, pp. 2–4.

164 **" . . . 'They laughed and drank . . .'"** Clift, quoted in Bosworth, *Montgomery Clift: A Biography*, pp. 118–119.

164 **"When [Wayne] saw Clift for the first time . . ."** Ibid., p. 120.

166 **"I made a very good burial scene . . ."** Howard Hawks, interviewed by Richard Schickel, *The Men Who Made the Movies*, p. 101.

166 **"Billy the Kid resists the efforts . . . ,"** Hedda Hopper, *The Los Angeles Times*, date unknown. The story is told in a slightly different version in Zolotow, who quotes Hopper, but gives no date of publication.

168 **" . . . Montgomery Clift, every inch a star . . ."** Andy Webster, "Still Duke, With Cracks," *The New York Times*, October 6, 2013.

168 **"I never knew the big son-of-a-bitch could act!"** Ford, quoted in McBride, *Searching for John Ford*, p. 459.

CHAPTER FOURTEEN

169 **"Shove it up [director] Robert Rossen's ass . . ."** Roberts and Olson, *John Wayne: American,* p. 328.

171 ***Red Witch* is a film . . ."** David Kehr, *The New York Times,* June 2, 1913.

171 **"Even the home-bound . . ."** Gladwin Hill, *The New York Times,* November 7, 1948.

172 **"We regard our Hopalong Cassidy . . ."** An unnamed spokesperson quoted in Martin, "Women Like 'Em Rugged."

172 **"carries dynamite in his fists . . ."** *Quick Newsweekly,* December 19, 1949. The article is not signed.

173 **"I'm looking for some security . . ."** John Wayne, quoted in Zolotow, *Shooting Star,* p. 255.

173 **"That finishes me . . ."** John Wayne, to Ward Bond, quoted in Edwin Schallert, *The Los Angeles Times,* March 4, 1951.

173 **"I think four [pictures] a year . . ."** John Wayne, quoted in William R. Weaver, *The Motion Picture Herald,* September 10, 1949.

174 **"I'm just a guy trying to make a living in the movies."** John Wayne, quoted in Gladwyn Hill, *The New York Times,* November 7, 1948.

174 **"I have to make . . ."** Wayne to Hedda Hopper. The comment appeared in one of her 1950 syndicated columns. The specific date is unavailable.

175 **"I hit the ground . . ."** John Wayne, quoted in Zolotow, *Shooting Star,* p. 254.

175 **"It was an emotional reaction . . ."** From the John Ford Papers, Lilly Library, Indiana University, John Wayne interview, tape 80, I.

177 **"Yates was one of the smartest businessmen . . ."** Wayne, quoted in Zolotow, *Shooting Star,* p. 252.

177 **"[He] will have to make me a damn good offer . . ."** Wayne, ibid., pp. 254–255.

180 **"The great movie stars . . ."** Alan Dwan, quoted in Peter Bogdanovich, *Who the Devil Made It,* p. 67.

180 **"It was a beautiful personal story . . ."** Wiley and Bona, *Inside Oscar,* p. 194.

180 **"After twenty-five years in the business . . ."** John Wayne, as told to Zolotow, "It Happened Like This," *American Weekly,* November 7, 1954.

181 **"I worry about it . . ."** Wayne quoted in Martin Scott, "John Wayne," *Cosmopolitan*, November 1954.

CHAPTER FIFTEEN

187 **"My name is John Ford . . ."** This, and DeMille's deliberate mispronunciations are from McBride, pp. 481–482.

187 **"You can take your party . . ."** and **"He's a shit . . ."** John Ford, quoted in Tom Stempel, *Screenwriter: The Life and Times of Nunnally Johnson*, pp. 123–124.

187 **"Send the Commie bastard to me . . ."** Ford, quoted in McBride, *Searching for John Ford*, p. 461.

189 **"For me, the most special part . . ."** Maureen O'Hara, *'Tis Herself*, p. 137.

189 **"Mr. Ford's vicious treatment of John Wayne . . ."** Ibid., p. 140.

192 **"too bad that Larry . . ."** Wayne, quoted in *Time*, March 3, 1952.

192 **"I have read the papers . . ."** Hedda Hopper, quoted in the *Los Angeles Times*, March 23, 1951, and the *Los Angeles Daily News*, March 23, 1951.

193 **"It gives me a genuine feeling . . ."** John Wayne, "The Hollywood Scene," by Lowell E. Redelings, motion picture editor for the *Hollywood Citizen-News*, October 5, 1951.

193 **"It was to be . . ."** Maureen O'Hara, *John Wayne, The Legend and the Man*, p. 122.

194 **"Esperanza is like every other person . . ."** John Wayne to Louella Parsons, "In Hollywood with Louella Parsons," *The Los Angeles Examiner* and syndicated, February 18, 1951.

CHAPTER SIXTEEN

198 **"I can't think of a better time . . ."** John Ford, "Man Alive," *Photoplay*, March 1951.

198 **"There is no other actor . . ."** Ward Bond, to Edwin Schallert, *The Los Angeles Times*, March 4, 1951.

199 **"I want to get out . . ."** John Wayne, quoted in Edwin Schallert, *The Los Angeles Times*, March 4, 1951.

200 **"Duke and I . . ."** Maureen O'Hara, *'Tis Herself*, p. 281.

200 "I was the only leading lady . . ." Ibid., p. 166.

201 "We had a disagreement . . ." Wayne, quoted in *The Los Angeles Times*, January 18, 1952.

201 "Choose between your mother and me," John Wayne quoted in an identified memo in the Academy Library's files on John Wayne.

202 "To millions of moviegoers . . ." and "How often . . ." are from *Time*, March 3, 1952.

202 "If it's a bad scene . . ." John Wayne, quoted by Jack O'Conner, "The John Wayne Story" *The Los Angeles Herald*, January 5, 1954.

202 "I got nothin' to sell but sincerity . . ." John Wayne, to Martin Scott, "John Wayne," *Cosmopolitan*, November 1954.

204 "I knew two fellas . . ." John Wayne, interviewed by Richard Warren Lewis, *Playboy*, May 1971.

205 "We were not blacklisting . . ." John Wayne, in an interview with BBC4, London, 1974.

207 "I happen to know . . ." Louella O. Parsons, "John Waynes Part Again," *The Los Angeles Examiner* and syndicated, June 18, 1952.

207 "Wayne went into his wife's room . . ." An unidentified eyewitness, quoted in Martin Scott, "John Wayne," *Cosmopolitan*, November 1954.

210 "I was making a movie . . ." Pilar Pallette, quote *John Wayne Biography*, executive producer Ken Burns, made in association with Van Ness Productions, Fox Star Productions and 20th Century-Fox, 1996.

210 "I had never been so immediately and powerfully affected . . ." Pilar Wayne, *John Wayne*, p. 63.

211 "We are now in the process . . ." Jerry Giesler, *The Los Angeles Times*, September 11, 1952.

212 "A man has to have some self-respect . . ." John Wayne, talking to the press, quoted by the *Los Angeles Examiner*, September 13, 1952.

213 "I went down . . ." John Ford, to Peter Bogdanovich, *John Ford*, p. 141.

213 "Jesus Christ . . ." John Wayne, quoted in McBride, *Searching for John Ford*, p. 529.

214 "We had pretty good times . . ." John Wayne to Hedda Hopper, quoted in Bosworth, *John Wayne: The Legend and the Man*, p. 19.

214 **Details of the divorce** From public court records, *The Los Angeles Times,* October 11, 1952, and *The Los Angeles Examiner,* October 11, 13, 1952.

217 **"The minute I became a success . . ."** John Wayne, "The Rambling Reporter," guest columnist for vacationing Mike Connolly, *The Hollywood Reporter,* April 30, 1954.

219 **"We're celebrating the fact . . ."** John Wayne with Chata, quoted by a reporter at "Mocambo," from *The Los Angeles Times,* January 21, 1954.

220 **"I decided to write it . . ."** Oscar Millard, *Los Angeles Times,* April 26, 1955. Additional material from Roberts and Olson, *John Wayne: American,* p. 410.

221 **John Wayne and lung cancer** Several sources were used here. The story linking all the celebrity and crew deaths to the filming of *The Conqueror* was first reported in the November 10, 1980, issue of *People* magazine, in which it was stated that "Of *The Conqueror's* 220 cast and crew members from Hollywood, an astonishing 91 have contracted cancer." In *HealthNewsDigest.com,* September 14, 2009, in an article entitled "Was the Movie *The Conqueror* Really Cursed? A Look at Radiation Paranoia," by Michael D. Shaw, the author stated: "Few environmental myths have stood the test of time better than the notion that a significant number of the cast and crew of *The Conqueror* (1956) were felled by cancer, contracted as a result of exposure to radioactive fallout . . . Several above ground atomic tests were run at Yucca Flats in Nevada from 1951 to 1953, including 11 in 1953 under the name 'Operation Upshot-Knothole.' The movie was shot from May–August of 1954 in Snow Canyon State Park, located 11 miles (18 km) northwest of St. George, Utah, 137 miles (downwind of Yucca Flats). The movie premiered on February 22, 1956, in Los Angeles, and less than seven years later, director Dick Powell died of cancer. After Powell, several of the leading actors succumbed to cancer, as well. There was Pedro Armendáriz, who killed himself in June of 1963, rather than live with his terminal diagnosis. Agnes Moorehead was the next star of the film to die of cancer, in April of 1974. She was followed by Susan Hayward (March 1975) and John Wayne, who first contracted lung cancer in September of 1964 and finally died of stomach cancer on June 11, 1979 . . . The *People* article quoted Dr. Robert C. Pendleton, director of radiological health at the University of Utah: 'With these numbers, this case could qualify as an epidemic. The connection between fallout radiation and cancer in individual cases has been practically impossible to prove conclusively. But in a group this size you'd expect only 30-some cancers to develop. With 91, I think the tie-in to their exposure on the set of *The Conqueror* would hold up even in a court of law.' This sounds impressive until you do some basic research. According to the National Cancer Institute, at the time the article was written, the overall incidence of being diagnosed with cancer in a person's lifetime (age-adjusted) was about 40%. As it happens, this number still holds today. Thus, in a cohort of 220 people, 88 would be diagnosed with cancer at some point. I have no idea how Pendleton came up with his '30-some.' If anything, given the heavy smoking habits of many in the movie business at the time, including Dick Powell, Agnes Moorehead, Pedro Armendáriz, Susan Hayward, and John Wayne at five packs a day, 91 is completely within the expected range. The only 'astonishing' thing is that the *People* article did not mention the smoking habits of any of the deceased stars."

224 "This is the greatest thing . . ." John Wayne, as reported in the *Honolulu Star-Bulletin,* November 1, 1954.

224 "Some men collect stamps . . ." John Wayne, to Sheilah Graham, *Hollywood Citizen-News* and syndicated, November 1, 1954.

CHAPTER SEVENTEEN

228 "Wayne is a nice guy . . ." William Wellman, to Martin Scott, "John Wayne," *Cosmopolitan,* November 1954.

CHAPTER EIGHTEEN

234 "The biggest, roughest . . ." Part of the advertising campaign designed by Whitney for *The Searchers,* referenced in McBride, *Searching for John Ford,* p. 553.

234 "I can't say whether my father . . ." Patrick Wayne, quoted in Frankel, *The Searchers,* p. 244.

238 "representative of a peculiarly American wanderlust" Sarris, *The John Ford Movie Mystery,* p. 171.

238 "Suddenly, this character, this lonely character . . ." Martin Scorsese, from an interview by the American Film Institute for its archives, published March 13, 2013.

239 Bogdanovich's question and Ford's answer about the relationship between Ethan and his sister-in-law Bogdanovich, *John Ford,* pp. 93–94.

241 "The first scene I was in with Duke . . ." Harry Carey Jr., *Company of Heroes,* p. 170.

244 "How can I hate John Wayne . . ." Godard claimed to have wept at the end of the film, overwhelmed by the "mystery and fascination of this American cinema . . ." Sarris, *The John Ford Movie Mystery,* p. 173.

245 "You know . . ." John Wayne, from an interview quoted by Frankel, *The Searchers,* p. 315.

245 "Blithering idiot . . ." Pilar, quoted in *John Wayne Biography,* executive producer Ken Burns, made in association with Van Ness Productions, Fox Star Productions and 20th Century-Fox, 1996.

245 "This is my second chance . . ." John Wayne, quoted in Pilar Wayne, *John Wayne,* p. 18.

CHAPTER NINETEEN

251　**"I didn't want to do the picture . . ."** John Ford, to Peter Bogdanovich, *John Ford,* p. 96.

252　**" . . . I reported happily to the set . . ."** O'Hara, *'Tis Herself,* pp. 200–201.

253　**"My problem is . . ."** From Emanuel Levy, *Cinema 24/7* (blog), posted November 10, 2006.

CHAPTER TWENTY

257　**"I came in and said to Jack Warner . . ."** Howard Hawks, quoted in Bogdanovich, *Who the Devil Made It,* p. 357.

258　**"I don't like *High Noon.* . . ."** Howard Hawks, in Schickel, *The Men Who Made the Movies,* p. 121.

258　**"The scenes we were in . . ."** Angie Dickinson, *John Wayne Biography,* executive producer Ken Burns, made in association with Van Ness Productions, Fox Star Productions and 20th Century-Fox, 1996.

259　**"*Rio Bravo* is a work . . ."** Godard, quoted by Peter Bogdanovich, *The New York Observer,* July 24, 2007.

CHAPTER TWENTY-ONE

268　**"It's all gone . . ."** From Pilar Wayne, *John Wayne,* p. 138.

272　**"I have everything . . ."** John Wayne, quoted in Zolotow, *Shooting Star,* p. 303.

275　**"One smart-aleck remark . . ."** John Wayne, quoted in Wiley and Bona, *Inside Oscar,* p. 319.

278　**"The eyes of the world . . ."** John Wayne, quoted in Holden, *Behind the Oscar,* p. 229.

CHAPTER TWENTY-TWO

284　**"*Hatari!* in a way . . ."** Howard Hawks, in Schickel, *The Men Who Made the Movies,* pp. 122–123.

285　**"'Well,' Hawks said, 'you can't sit in an office . . .'"** Howard Hawks in Bogdanovich, *Who the Devil Made It,* p. 364.

285 **"The difference in our ages . . ."** John Wayne, quoted in Pilar Wayne, *John Wayne,* p. 155.

286 **"a deceptively simple Western . . ."** Bogdanovich, *Who the Devil Made It,* p. 10.

289 **"Ford would talk to him . . ."** Lee Marvin to John A. Gallagher, "The Directors Series," New York City, February 10, 1986.

289 **"The relationship between . . ."** Howard Hawks, to Schickel, *The Men Who Made the Movies,* p. 120.

289 **"had Jimmy Stewart for the shitkicker . . ."** John Wayne, as told to Dan Ford, quoted in Roberts and Olson, *John Wayne: American,* p. 492.

291 **"*The Man Who Shot Liberty Valance* is a political Western . . ."** Sarris, *The John Ford Movie Mystery,* pp 175–182.

291 **"A Ford masterpiece . . ."** Bogdanovich, "Directed by John Ford—35 Movies and a Lifetime, in One Weekend," *The New York Observer,* August 9, 1999.

CHAPTER TWENTY-THREE

296 **" 'Look,' Ford said, 'don't you want to spend . . .'"** Lee Marvin, "The Directors Series."

296 **"When I read the script . . ."** Maureen O'Hara interviewed about the making of *McLintock!* For a promotional film that accompanied the DVD.

298 **"I've got a little problem . . ."** John Wayne, quoted in Pilar Wayne, *John Wayne,* p. 117.

CHAPTER TWENTY-FOUR

304 **"A virtual zombie . . ."** Pilar Wayne, *John Wayne,* p. 201.

305 **"The Western takes, really, a couple of forms . . ."** Howard Hawks, in Schickel, *The Men Who Made the Movies,* pp. 119, 121–122.

306 **"We chatted for an hour . . ."** Peter Bogdanovich, quoted by Sam Delaney, *The Guardian,* November 19, 2004.

CHAPTER TWENTY-FIVE

314 **"Also Ray had had his troubles . . ."** Major Ron Miller, interview with author, July 2014.

316 Here is the complete controversial Renata Adler review in full as it appeared in the *New York Times*:

June 20, 1968

'Green Berets' as Viewed by John Wayne

By RENATA ADLER

"The Green Berets" is a film so unspeakable, so stupid, so rotten and false in every detail that it passes through being fun, through being funny, through being camp, through everything and becomes an invitation to grieve, not for our soldiers or for Vietnam (the film could not be more false or do a greater disservice to either of them), but for what has happened to the fantasy-making apparatus in this country. Simplicities of the right, simplicities of the left, but this one is beyond the possible. It is vile and insane. On top of that, it is dull.

The film, directed by John Wayne and nominally based on a novel by Robin Moore, has no hero. It is vaguely about some Green Berets, led by John Wayne, trying to persuade Wayne's idea of a liberal journalist (David Jansen) that this war is a fine thing for Vietnam and for America. The movie has human props taken from every war film ever made: a parachute jump; an idea of Vietcong soldiers, in luxury, uniform, champagne and caviar, apparently based on the German high command; a little Asian orphan named Hamchunk, pronounced Hamchuck but more like Upchuck than anything; battle scenes somewhere between "The Red Badge of Courage" and "The Dirty Dozen"; a pathetically dying dog.

There is inadvertent humor: "He's dying," a Negro medic says, thoughtfully spooning Jim Beam bourbon down the throat of an elderly Oriental. "Poor old thing can't even keep his rice down anymore." What is clearly an Indian extra in a loincloth somehow straggles in among the montagnards. A Vietcong general is dragged from a bed of sin (which, through an indescribable inanity of the plot, the Green Berets have contrived for him) with his trousers on. He is subsequently drugged and yanked off into the sky on a string dangling from a helicopter. A Green Beret points out to the journalist some American-made punji sticks (the movie is obsessed with punji sticks): "Yup," the Green Beret says, "it's a little trick we learned from Charlie. But we don't dip them in the same stuff he does."

What the movie is into is another thing entirely. What is sick, what is an outrage and a travesty is that while it is meant to be an argument against war opposition while it keeps reiterating its own line at every step, much as soap operas keep recapitulating their plots* it seems so totally impervious to any of the questions that it raises. It is so full of its own caricature of patriotism that it cannot even find the right things to falsify. No acting, no direction, no writing, no authenticity, of course, but it is worse. It is completely incommunicado, out of

touch. It trips something that would outrage any human sensibility, like mines, at every step and staggers on.

The first Green Beret comes on speaking German, to show his versatility in languages. When the VC have just been sprayed with flames, a Green Beret is asked about his apparent affinity for this kind of thing. "When I was a kid," he says modestly, "my dad gave me a chemistry set. And it got bigger than both of us." When the VC, nonetheless, win the Special Forces camp in hand-to-hand combat, a soldier calls in air support. "It'll only take a minute," he says, like a dentist, as the VC are mowed down from the air. The journalist, "the former skeptic about the war," the press kit synopsis chooses to say at this point, "leaves to write about the heroic exploits of the American and South Vietnamese forces."

The point is that Wayne is using spoken German, lunatic chemistry sets, machine killing of men who have won fairly hand-to-hand, without apparently noticing that this is not exactly the stuff of which heroic fantasies are made. This is crazy. If the left-wing extremist's nightmare of what we already are has become the right-wing extremist's ideal of what we ought to be we are in steeper trouble than anyone could have imagined. The movie opened yesterday at the Warner Theater.

CHAPTER TWENTY-SIX

324 **"If you're gonna . . ."** The anecdote and quotes of Wayne showing Chris Mitchum how to handle a gun are from Bogdanovich, *Who the Devil Made It,* p. 244.

326 **"Ooh, they're going to hate you,"** and **"Maybe, . . ."** from an interview with Bruce Dern, *Entertainment Weekly,* January 24, 2014.

326 **"In about three months . . ."** Ethan Wayne, in his preface to *John Wayne: The Genuine Article,* August 2012.

327 **"Hell, it's over with Pilar . . ."** John Wayne to Wayne Warga, from the John Wayne Collection of papers at the University of Oregon, reprinted in *John Wayne: The Genuine Article,* p. 17.

327 **"We finished shooting . . ."** Pat Stacy, from a televised interview with Connie Martinson, 1983.

330 **"From then on . . ."** Pilar Wayne, *John Wayne,* pp. 261–262.

336 **"He was thin . . ."** Pilar Wayne, *John Wayne,* p. 268.

EPILOGUE

339 **"Hell, I'd have gotten sick . . ."** John Wayne, quoted by Wiley and Bona, *John Wayne: American,* p. 562.

341 **"I really prayed . . ."** Pilar Wayne, *John Wayne Biography.* executive producer Ken Burns, made in association with Van Ness Productions, Fox Star Productions and 20th Century-Fox, 1996.

Filmography

MOST RECENT FIRST

A Turning of the Earth: John Ford, John Wayne and the Searchers (1998)

The 51st Annual Academy Awards (1979) (TV) [Actor Himself—Presenter: Best Picture]

The Barbara Walters Summer Special: Episode dated January 10, 1979 (1979) TV Episode [Actor Himself] a.k.a. *The Barbara Walters Special:* (1979-01-10)"—USA (original title)

Early American Christmas (1978) (TV) [Self] a.k.a. "Perry Como's Early American Christmas"—USA (complete title)

General Electric's All-Star Anniversary (1978) (TV) [Actor Himself/Host]

Happy Birthday, Bob (1978) (TV) [Actor Himself]

AFI Life Achievement Award: A Tribute to Henry Fonda (1978) (TV) [Actor Himself] a.k.a. *The American Film Institute Salute to Henry Fonda*—USA (original title)

ABC's Silver Anniversary Celebration (1978) (TV) [Actor Himself]

An All-Star Tribute to Elizabeth Taylor (1977) (TV) [Actor Himself]

The 3rd Annual People's Choice Awards (1977) (TV) [Actor Himself—Winner: Favorite Movie Actor]

Jimmy Carter's Inaugural Gala (1977) (TV) a.k.a. *Inaugural Concert for President Jimmy Carter*—USA [Actor Himself]

America Salutes Richard Rodgers: The Sound of His Music (1976) (TV) [Actor Himself]

CBS Salutes Lucy: The First 25 Years (1976) (TV) [Actor Himself]

An All-Star Tribute to John Wayne (1976) (TV) [Actor Himself—Guest of Honor]

The Mike Douglas Show: Episode dated September 21, 1976 (1976) TV Episode
[Actor Himself]

The Shootist (1976) [Actor, Soundtrack performer: "Willow, Tit Willow"]

Chesty: A Tribute to a Legend (1976) a.k.a. *Chesty* [Actor Narrator]

Backlot USA a.k.a.—USA (complete title) a.k.a. *Dick Cavett's Backlot USA* (1976) (TV)
[Actor Himself]

The 2nd Annual People's Choice Awards (1976) (TV) [Actor Himself—Winner:
Favorite Movie Actor]

The Tonight Show Starring Johnny Carson January (1976) [Actor Himself]

V.I.P.-Schaukel: Episode #5.4 (1975) TV Episode [Actor Himself]

Texaco Presents: A Quarter Century of Bob Hope on Television (1975) (TV)
[Actor Himself] a.k.a. *A Quarter Century of Bob Hope on Television*—USA (short
title)

Rooster Cogburn (1975) [Actor Rooster Cogburn]

a.k.a. *Rooster Cogburn (. . . and the Lady)*—USA (promotional title)

The Tonight Show Starring Johnny Carson: Episode dated October 15, 1975 (1975) TV
Episode [Actor Himself]

Backstage in Hollywood: Episode dated July 24, 1975 (1975) TV Episode
[Actor Himself]

Bob Hope on Campus (1975) (TV) [Actor Himself]

The 47th Annual Academy Awards (1975) (TV) [Actor Himself—Presenter: Honorary
Award to Howard Hawks]

Brannigan (1975) [Actor Lt. Brannigan]

The 17th Annual TV Week Logie Awards (1975) (TV) [Actor Himself]

The Dean Martin Celebrity Roast: Bob Hope (1974) (TV) [Actor Himself]

Maude: "Maude Meets the Duke (#3.1) (1974) TV Episode [Actor Himself]

John Wayne and Glen Campbell & the Musical West (1974) (TV) [Actor Himself]

AFI Life Achievement Award: A Tribute to James Cagney a.k.a. *The American Film Institute
Salute to James Cagney* (1974) (TV) [Actor Himself] (uncredited)

Parkinson: Episode #3.19 (1974) TV Episode [Actor Himself]

McQ (1974) [Actor McQ]

RCA's Opening Night (1973) (TV) [Actor Himself]

Cahill U.S. Marshal (1973) [Actor J.D. Cahill] [executive producer] (uncredited)

AFI Life Achievement Award: A Tribute to John Ford (1973) (TV) [Actor Himself]
a.k.a. *The American Film Institute Salute to John Ford*—USA (original title)

Cavalcade of Champions (1973) (TV) [Actor Himself—Presenter]

The Tonight Show Starring Johnny Carson Episode dated March 22, 1973 (1973) TV Episode [Actor Himself]

Rowan & Martin's Laugh-In Episode #6.20 (1973) TV Episode [Actor Himself]

The Train Robbers (1973) [Actor Lane] [executive producer] (uncredited)

The Wayne Train (1973) (TV) [Actor Himself]

Cancel My Reservation (1972) [Actor Himself, John Wayne] (uncredited)

Rowan & Martin's Laugh-In Episode #6.1" (1972) TV Episode [Actor Himself—Guest Performer]

The Tonight Show Starring Johnny Carson Episode dated 7 June 1972 (1972) TV Episode [Actor Himself]

The David Frost Show Episode #4.185 (1972) TV Episode [Actor Himself]

The 44th Annual Academy Awards (1972) (TV) [Actor Himself- Presenter]

Rowan & Martin's Laugh-In Episode #5.23 (1972) TV Episode [Actor Himself]

Rowan & Martin's Laugh-In Episode #5.18 (1972) TV Episode [Actor Himself]

The Tonight Show Starring Johnny Carson Episode dated 14 January 1972 (1972) TV Episode [Actor Himself]

The Cowboys (1972) [Actor Wil Andersen]

The Breaking of Boys and the Making of Men in 'The Cowboys' (1972) [Actor Himself]

The American West of John Ford (1971) (TV) [Actor Himself—Narrator]

The Bob Hope Show Episode dated 7 November 1971 (1971) TV Episode [Actor Himself] (uncredited)

Rowan & Martin's Laugh-In Episode #5.8 (1971) TV Episode [Actor Himself—Guest Performer]

Directed by John Ford (1971) [Actor Himself] (uncredited)

The Glen Campbell Goodtime Hour Episode #4.1 (1971) TV Episode [Actor Himself]

V.I.P.-Schaukel Episode #1.2 (1971) TV Episode [Actor Himself]

Big Jake (1971) [Actor Jacob McCandles] [executive producer] (uncredited) [Director] (uncredited)

Sehnsucht nach dem wilden (1971) (TV) [Actor Himself]

Everything You Always Wanted to Know About Jack Benny But Were Afraid to Ask (1971) (TV) [Actor Himself]

The Tonight Show Starring Johnny Carson Episode dated 7 February 1971" (1971) TV Episode [Actor Himself]

Rio Lobo (1970) [Actor Col. Cord McNally]

Plimpton! Shoot-Out at Rio Lobo (1970) (TV) [Actor Himself]

Swing Out, Sweet Land (1970) (TV) [Actor Himself] a.k.a. *John Wayne's Tribute to America*—USA (DVD box title)

Chisum (1970) [Actor John Chisum]

Raquel! (1970) (TV) [Actor Himself]

The 42nd Annual Academy Awards (1970) (TV) [Actor Himself—Winner: Best Actor in a Leading Role & Presenter: Best Cinematography]

The Movie Game Episode dated 16 March 1970 (1970) TV Episode [Actor Himself]

The 27th Annual Golden Globes Awards (1970) (TV) [Actor Himself—Winner: Best Actor in a Motion Picture-Drama and Presenter: Cecil B. DeMille Award]

Harry Jackson: A Man and his Art (1970) (TV) [Actor Narrator]

John Wayne and Chisum (1970) [Actor Himself]

No Substitute for Victory (1970) [Actor Narrator]

The Red Skelton Hour: John Wayne's 40th Anniversary or *Hominy and True Grits* (#19.6) (1969) TV Episode [Actor Himself/Rooster Cogburn] a.k.a. *The Red Skelton Show: John Wayne's 40th Anniversary or Hominy and True Grits* (#19.6)—USA (original title)

The Undefeated (1969) [Actor Col. John Henry Thomas]

The Joey Bishop Show: Episode #3.238 (1969) TV Episode [Actor Himself]

True Grit (1969) [Actor Rooster Cogburn]

The Glen Campbell Goodtime Hour: Episode #1.4 (1969) TV Episode [Actor Himself]

Hellfighters (1968) [Actor Chance Buckman]

Rowan & Martin's Laugh-In: Episode #2.2 (1968) TV Episode [Actor Himself]

Rowan & Martin's Laugh-In: Episode #2.1 (1968) TV Episode [Actor Himself] (uncredited)

The Green Berets (1968) [Actor Col. Mike Kirby] [Director]

The Joey Bishop Show: Episode #2.203 (1968) TV Episode [Actor Himself]

Rowan & Martin's Laugh-In: Episode #1.14 (1968) TV Episode [Actor Himself]

Rowan & Martin's Laugh-In: Episode #1.13 (1968) TV Episode [Actor Himself]

Rowan & Martin's Laugh-In: Episode #1.12 (1968) TV Episode [Actor Himself]

Rowan & Martin's Laugh-In: Episode #1.11 (1968) TV Episode [Actor Himself]

Rowan & Martin's Laugh-In: Episode #1.9 (1968) TV Episode [Actor Himself] (uncredited)

Rowan & Martin's Laugh-In: Episode #1.8 (1968) TV Episode [Actor Himself]

Rowan & Martin's Laugh-In: Episode #1.7 (1968) TV Episode [Actor Himself]

The Moviemakers (1968/II) [Actor Himself]

Hondo and the Apaches (1967) (TV) [producer]

The War Wagon (1967) [Actor Taw Jackson]

Dateline: Hollywood: Episode dated 19 May 1967 TV Episode [Actor Himself]

Dateline: Hollywood: Episode dated 18 May 1967 TV Episode [Actor Himself]

Dateline: Hollywood: Episode dated 17 May 1967 TV Episode [Actor Himself]

Dateline: Hollywood: Episode dated 16 May 1967 TV Episode [Actor Himself]

Dateline: Hollywood: Episode dated 15 May 1967 TV Episode [Actor Himself]

The Beverly Hillbillies: The Indians Are Coming (#5.20) (1967) TV Episode
[Actor Himself] (uncredited)

A Nation Builds Under Fire (1967) [Actor Narrator]

El Dorado (1966) [Actor Cole Thornton]

The Lucy Show: Lucy and John Wayne (#5.10) (1966) TV Episode [Actor Himself]

The Dean Martin Comedy Hour: Episode dated 27 October (1966) TV Episode
[Actor Himself] a.k.a. *The Dean Martin Show*: (1966-10-27)—USA (original title)

Magic Mansion: Ride 'em Cowboy (#1.27) (1966) TV Episode [Actor John Wayne]

Cast a Giant Shadow (1966) [Actor Gen. Mike Randolph]

The Merv Griffin Show: Episode dated 16 March 1966 (1966) TV Episode
[Actor Himself—Guest]

The Red Skelton Hour: Red Skelton Scrapbook 66 (#15.24) (1966) TV Episode
[Actor Himself—Guest Host] a.k.a. *The Red Skelton Show*: Red Skelton Scrapbook
66 (#15.24)—USA (original title)

The Dean Martin Comedy Hour: Episode dated 23 September 1965 (1965) TV Episode
[Actor Himself] a.k.a. *The Dean Martin Show*: (1965-09-23)—USA (original title)

The Sons of Katie Elder (1965) [Actor John Elder]

In Harm's Way (1965) [Actor Captain Rockwell 'Rock' Torrey]

The Greatest Story Ever Told (1965) [Actor Centurion at crucifixion] a.k.a. *George
Stevens Presents The Greatest Story Ever Told*—UK (complete title), USA (complete title)

Cinépanorama: Episode dated 26 December 1964 (1964) TV Episode [Actor Himself]

Circus World (1964) [Actor Matt Masters]

McLintock! (1963) [Actor George Washington McLintock]

Donovan's Reef (1963) [Actor Michael Patrick 'Guns' Donovan]

The Dick Powell Theatre: The Third Side of a Coin (#2.26) (1963) TV Episode
[Actor Himself--Host] a.k.a. *The Dick Powell Show*: The Third Side of a Coin
(#2.26)—USA (original title)

How the West Was Won (1962) [Actor Gen. William Tecumseh Sherman]

Alcoa Premiere: Flashing Spikes (#2.1) (1962) TV Episode [Actor Sergeant-Umpire in Korea] (as Marion Morrison)

The Longest Day (1962) [Actor Lt. Col. Benjamin Vandervoort]

Hatari! (1962) [Actor Sean Mercer]

The Man Who Shot Liberty Valance (1962) [Actor Tom Doniphan]

The Comancheros (1961) [Actor Capt. Jake Cutter] [Director] (uncredited)

The Challenge of Ideas (1961) [Actor Himself—Narrator]

Cinépanorama: Episode dated 17 December 1960 (1960) TV Episode [Actor Himself]

Wagon Train: The Colter Craven Story (#4.9) (1960) TV Episode [Actor Gen. William Tecumseh Sherman]

The Jack Benny Program: John Wayne Show (#11.5) (1960) TV Episode [Actor Himself]

The Ed Sullivan Show a.k.a. *Toast of the Town*: Episode #14.6 (1960) TV Episode [Actor Himself]

What's My Line?: Episode dated 13 November 1960 TV Episode [Actor Himself—Mystery Guest]

North to Alaska (1960) [Actor Sam McCord]

The Alamo (1960) [Actor Col. Davy Crockett] [producer] [Director]

The 32nd Annual Academy Awards (1960) (TV) [Actor Himself—Presenter: Best Director]

The Horse Soldiers (1959) [Actor Col. John Marlowe]

The 31st Annual Academy Awards (1959) (TV) [Actor Himself—Presenter: Best Actor]

Rio Bravo a.k.a. *Howard Hawks' Rio Bravo* (1959) [Actor Sheriff John T. Chance]

Escort West (1958) [producer] (uncredited)

The Barbarian and the Geisha (1958) [Actor Townsend Harris]

China Doll a.k.a. *Frank Borzage's China Doll* (1958) [producer] (uncredited)

Wide Wide World: The Western (#3.20) (1958) TV Episode [Actor Himself]

I Married a Woman (1958) [Actor Leonard/John Wayne] (uncredited)

Screen Snapshots: Salute to Hollywood (1958) [Actor Himself]

The 30th Annual Academy Awards (1958) (TV) [Actor Himself—Presenter: Best Actress]

Legend of the Lost (1957) [Actor Joe January]

Jet Pilot (1957) [Actor Col. Jim Shannon]

The Wings of Eagles (1957) [Actor Frank W. 'Spig' Wead]

Man in the Vault (1956) [producer] (uncredited)

Gun the Man Down a.k.a. *Arizona Mission* a.k.a. *Seven Men from Now* (1956) [producer]

Good-bye, My Lady a.k.a. *Good Bye My Lady* a.k.a. *The Boy and the Laughing Dog* (1956) [producer]

- USA (reissue title)

Screen Directors Playhouse: Markheim (#1.23) (1956) TV Episode [Actor Himself]

The Searchers (1956) [Actor Ethan Edwards]

Climax!: The Louella Parsons Story (#2.23) (1956) TV Episode [Actor Himself]

The Conqueror (1956) [Actor Temujin, later Genghis Khan]

Screen Directors Playhouse: Rookie of the Year (#1.10) (1955) TV Episode [Actor Mike Cronin]

The Colgate Comedy Hour: Episode #6.9 (1955) TV Episode [Actor Himself—Awards Presenter]

Producers' Showcase: Dateline II (#2.3) (1955) TV Episode [Actor Himself]

I Love Lucy: Lucy and John Wayne (#5.2) (1955) TV Episode [Actor Himself]

Blood Alley (1955) [Actor Capt. Tom Wilder] [producer] (uncredited) [Director] (uncredited) . . . a.k.a. *William A. Wellman's Blood Alley*—UK (complete title), USA (complete title)

Casablanca: Who Holds Tomorrow? (#1.1) (1955) TV Episode [Actor Himself] (uncredited)

The Buick-Berle Show: Episode #8.1 (1955) TV Episode [Actor Himself] a.k.a. *The Milton Berle Show* (#8.1)—USA (original title)

Gunsmoke: Matt Gets It (#1.1) (1955) TV Episode [Actor Himself—Host]

Screen Snapshots: The Great Al Jolson (1955) [Actor Himself]

The Sea Chase (1955) [Actor Captain Karl Ehrlich]

Sheilah Graham in Hollywood: John Wayne (1955) TV Episode [Actor Himself]

This Is Your Life: William Wellman (1954) TV Episode [Actor Himself]

Track of the Cat (1954) [producer] (uncredited) a.k.a. William A. *Wellman's Track of the Cat*—UK (complete title), USA

Ring of Fear (1954) [producer] (uncredited)

The High and the Mighty (1954) [Actor Dan Roman] [producer] (uncredited) a.k.a. *William A. Wellman's The High and the Mighty*—UK (complete title), USA (complete title)

Hondo (1953) [Actor Hondo Lane] [producer] (uncredited)

The Colgate Comedy Hour: Episode #4.2 (1953) TV Episode [Actor Himself—Actor]

Island in the Sky (1953) [Actor Capt. Dooley] [producer] (uncredited) a.k.a. *William A. Wellman's Island in the Sky*—UK (complete title), USA (complete title)

Plunder of the Sun (1953) [producer] (uncredited)

Trouble Along the Way (1953) [Actor Steve Aloysius Williams]

The 25th Annual Academy Awards (1953) (TV) [Actor Himself—Accepting Best Actor Award for Gary Cooper]

Three Lives (1953) [Actor Commentator]

Big Jim McLain (1952) [Actor Jim McLain] [producer] (uncredited)

The Quiet Man (1952) [Actor Sean Thornton] [second unit director uncredited]

Miracle in Motion (1952) [Actor Narrator]

Flying Leathernecks (1951) [Actor Maj. Daniel Xavier Kirby]

Screen Snapshots: Hollywood Awards (1951) [Actor Himself]

Bullfighter and the Lady (1951) [producer] a.k.a. *Torero-* (alternative title)

The Screen Director (1951) [Actor Himself (staged 'archive' footage)] (uncredited)

Operation Pacific (1951) [Actor Lt Cmdr. Duke E. Gifford]

Screen Snapshots: Reno's Silver Spur Awards (1951) [Actor Himself]

*Santa and the Fairy Snow Queen (*1951) [producer] (uncredited)

Rio Grande (1950) [Actor Lt. Col. Kirby Yorke] a.k.a. *John Ford and Merian C. Cooper's Rio Grande*—UK (complete title), USA (complete title)

Screen Snapshots: Hollywood's Famous Feet (1950) [Actor Himself] (uncredited)

The Dangerous Stranger (1950) [producer uncredited]

Sands of Iwo Jima (1949) [Actor Sgt. John M. Stryker]

Screen Snapshots: Hollywood Rodeo (1949) [Actor Himself]

She Wore a Yellow Ribbon (1949) [Actor Capt. Nathan Cutting Brittles]

The Fighting Kentuckian (1949) [Actor John Breen] [producer]

Wake of the Red Witch (1948) [Actor Capt. Ralls]

3 Godfathers (1948) [Actor Robert Marmaduke Hightower] a.k.a. *Three Godfathers*— UK, USA alternative spelling

Red River (1948) [Actor Thomas Dunson]

Fort Apache (1948) [Actor Capt. Kirby York]

Tycoon (1947) [Actor Johnny]

Angel and the Badman (1947) [Actor Quirt Evans] [producer] (uncredited)

Without Reservations (1946) [Actor Rusty]

They Were Expendable (1945) [Actor Lt. (J.G.) 'Rusty' Ryan]

Dakota (1945) [Actor John Devlin]

Back to Bataan (1945) [Actor Col. Joseph Madden]

Flame of Barbary Coast (1945) [Actor Duke Fergus]

Tall in the Saddle (1944) [Actor Rocklin]

Memo for Joe (1944) [Actor Himself]

The Fighting Seabees (1944) [Actor Lt. Cmdr. Wedge Donovan]

In Old Oklahoma (1943) [Actor Daniel F. Somers] . . . a.k.a. *War of the Wildcats*—UK (reissue title), USA (reissue title)

A Lady Takes a Chance (1943) [Actor Duke Hudkins] a.k.a. *The Cowboy and the Girl*—USA (reissue title)

Reunion in France (1942) [Actor Pat Talbot]

Pittsburgh (1942) [Actor Pittsburgh Markham]

Flying Tigers (1942) [Actor Capt. Jim Gordon]

In Old California (1942) [Actor Tom Craig]

The Spoilers (1942) [Actor Roy Glennister]

Reap the Wild Wind (1942) [Actor Capt. Jack Stuart] a.k.a. *Cecil B. DeMille's Reap the Wild Wind*—USA (complete title)

Lady for a Night (1942) [Actor Jackson Morgan]

Meet the Stars #8: Stars Past and Present (1941) [Actor Himself] a.k.a. *Stars Past and Present*—USA (short title)

The Shepherd of the Hills (1941) [Actor Young Matt]

Lady from Louisiana (1941) [Actor John Reynolds] a.k.a. *Lady from New Orleans*—USA (working title)

A Man Betrayed (1941) [Actor Lynn Hollister] a.k.a. *Wheel of Fortune*—USA (reissue title)

Seven Sinners (1940) [Actor Dan]

The Long Voyage Home (1940) [Actor Olsen]

Three Faces West (1940) [Actor John Phillips]

Screen Snapshots Series 19, No. 8: Cowboy Jubilee (1940) [Actor Himself]

Dark Command (1940) [Actor Bob Seton]

Allegheny Uprising (1939) [Actor Jim Smith]

New Frontier (1939) . . . a.k.a. *Frontier Horizon* [Actor Stony Brooke]

Wyoming Outlaw (1939) [Actor Stony Brooke]

Three Texas Steers (1939) [Actor Stony Brooke]

The Night Riders (1939) [Actor Stony Brooke]

Stagecoach (1939) [Actor Ringo Kid]

Red River Range (1938) [Actor Stony Brooke]

Santa Fe Stampede (1938) [Actor Stony Brooke]

Overland Stage Raiders (1938) [Actor Stony Brooke]

Pals of the Saddle (1938) [Actor Stony Brooke]

Born to the West (1937) [Actor Dare Rudd] a.k.a. *Hell Town*—USA (reissue title)

Adventure's End (1937) [Actor Duke Slade]

Idol of the Crowds (1937) [Actor Johnny Hanson]

I Cover the War (1937) [Actor Bob Adams]

California Straight Ahead! (1937) [Actor Biff Smith]

Conflict (1936) [Actor Pat Glendon]

Sea Spoilers (1936) [Actor Bob Randall]

Winds of the Wasteland (1936) [Actor John Blair] a.k.a. *Stagecoach Run*—USA (DVD title)

The Lonely Trail (1936) [Actor Captain John Ashley]

King of the Pecos (1936) [Actor John Clayborn]

The Lawless Nineties (1936) [Actor John Tipton]

The Oregon Trail (1936) [Actor Capt John Delmont]

Lawless Range (1935) [Actor John Middleton]

The New Frontier (1935) [Actor John Dawson]

Westward Ho (1935) [Actor John Wyatt]

Paradise Canyon (1935) [Actor John Wyatt/John Rogers] a.k.a. *Guns Along the Trail*—USA (DVD title)

The Dawn Rider (1935) [Actor John Mason] a.k.a. *Cold Vengeance*—USA (DVD title)

The Desert Trail (1935) [Actor John Scott/John Jones]

Rainbow Valley (1935) [Actor John Martin]

Texas Terror (1935) [Actor John Higgins]

'Neath the Arizona Skies (1934) [Actor Chris Morrell]

The Lawless Frontier (1934) [Actor John Tobin]

The Trail Beyond (1934) [Actor Rod Drew]

The Star Packer (1934) [Actor John Travers] a.k.a. *The Shadow Gang*—USA (DVD title)

Randy Rides Alone (1934) [Actor Randy Bowers]

The Man from Utah (1934) [Actor John Weston]

Blue Steel (1934) [Actor John Carruthers] a.k.a. *Stolen Goods*—USA (alternative title)

West of the Divide (1934) [Actor Ted Hayden—a.k.a. Gat Ganns]

The Lucky Texan (1934) [Actor Jerry Mason] a.k.a. *Gold Strike River*—USA (alternative title)

Sagebrush Trail (1933) [Actor John Brant]

College Coach (1933) [Actor Student Greeting Phil] (uncredited)

Riders of Destiny (1933) [Actor Singin' Sandy Saunders]

The Man from Monterey (1933) [Actor Captain John Holmes]

Baby Face (1933) [Actor Jimmy McCoy Jr.]

His Private Secretary (1933) [Actor Dick Wallace]

The Life of Jimmy Dolan (1933) [Actor Smith]

Somewhere in Sonora (1933) [Actor John Bishop]

Central Airport (1933) [Actor Co-Pilot in Wreck] (uncredited)

The Three Musketeers (1933) [Actor Lt. Tom Wayne]

The Telegraph Trail (1933) [Actor John Trent]

Haunted Gold (1932) [Actor John Mason]

The Big Stampede (1932) [Actor Deputy Sheriff John Steele]

That's My Boy (1932) [Actor Football Player] (uncredited)

Ride Him, Cowboy (1932) [Actor John Drury]

The Hollywood Handicap (1932) [Actor Himself]

The Hurricane Express (1932) [Actor The Air Pilot]

Lady and Gent (1932) [Actor Buzz Kinney]

Two-Fisted Law (1932) [Actor Duke]

Texas Cyclone (1932) [Actor Steve Pickett]

The Shadow of the Eagle (1932) [Actor Craig McCoy]

Running Hollywood (1932) [Actor Himself]

The Voice of Hollywood No. 13 (Second Series) (1932) [Himself, Announcer]

Maker of Men (1931) [Actor Dusty Rhodes]

The Range Feud (1931) [Actor Clint Turner]

The Deceiver (1931) [Actor Richard Thorpe as a corpse]

Arizona (1931) [Actor Lt. Bob Denton] a.k.a. *Men Are Like That*—USA

Three Girls Lost (1931) [Actor Gordon Wales]

Girls Demand Excitement (1931) [Actor Peter Brooks]

The Big Trail (1930) [Actor Breck Coleman] a.k.a. *Raoul Walsh's The Big Trail*—USA (complete title)

Cheer Up and Smile (1930) [Actor Roy] (uncredited) [property assistant uncredited)

Rough Romance (1930) [Actor Lumberjack uncredited, (props uncredited)

Born Reckless (1930) [Actor Extra uncredited]

Men Without Women (1930) [Actor [Radioman on Surface uncredited]

The Forward Pass (1929) [Actor Extra] (uncredited)

Salute (1929) [Actor Midshipman Bill] (uncredited) (costumer, uncredited)

Words and Music (1929) [Actor Pete Donahue] (as Duke Morrison) [property assistant uncredited]

The Black Watch (1929) [Actor 42nd Highlander uncredited] [props uncredited] a.k.a. *King of the Khyber Rifles*—UK, USA working title

Speakeasy (1929) [Actor Extra uncredited[

Noah's Ark (1928) [Actor Flood Extra uncredited]

Hangman's House (1928) [Actor Horse Race Spectator/Condemned Man in Flashback uncredited]

Four Sons (1928) [Actor Officer uncredited, props uncredited)

Mother Machree (1928) [Actor Extra uncredited, props uncredited]

The Drop Kick (1927) [Actor Football Player/Extra in Stands uncredited]

Annie Laurie (1927) [Actor Extra uncredited]

The Great K & A Train Robbery (1926) [Actor Extra uncredited, property boy uncredited]

Bardelys the Magnificent (1926) [Actor Guard uncredited]

Brown of Harvard (1926) [Actor Yale Football Player uncredited]

Index

About the Author

Rebel Road Inc.

Marc Eliot is the *New York Times* bestselling author of more than a dozen books on popular culture, among them the highly acclaimed *Cary Grant*, the award-winning *Walt Disney: Hollywood's Dark Prince*, and *American Rebel: The Life of Clint Eastwood*. He writes for a number of publications and frequently speaks about film to universities and film groups, and often appears on radio and television. He lives in New York City and upstate near Woodstock.